C000174611

GAME OF THRONES™

THE STORYBOARDS

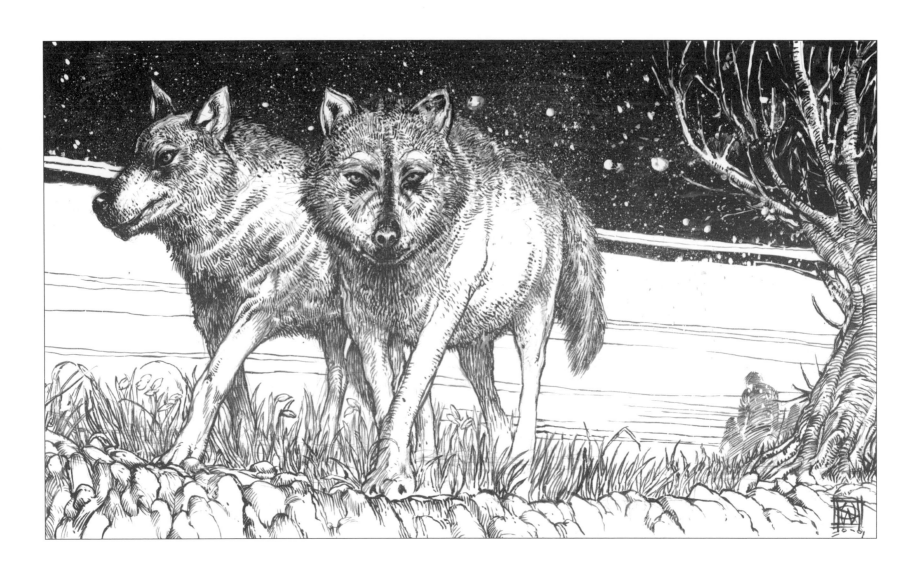

GAME OF THRONES™

THE STORYBOARDS

BY WILLIAM SIMPSON

WITH MICHAEL KOGGE

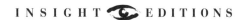

INSIGHT EDITIONS

San Rafael, California

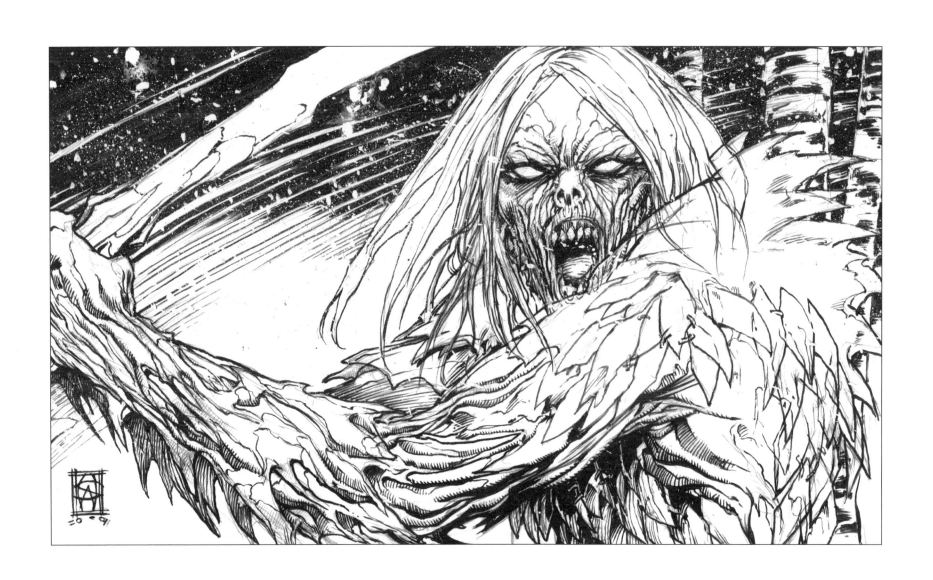

CONTENTS

INTRODUCTION
By William Simpson

I was employed on *Game of Thrones* before I knew what it was. When I was working as a conceptual illustrator on a feature film, a producer approached me with an opportunity to moonlight on a potential television series. Intrigued, I inquired what it was. He said it was medieval fantasy but couldn't disclose the title. This secrecy only further piqued my interest. He asked me to meet with the supervising art director and production designer to work on a few things they would need. I agreed, and they gave me bits of the pilot script that had references to castles, knights, and giant wolves. They also showed me descriptions from a book without title headers. At that stage, I'd never read any of the novels in the A Song of Ice and Fire series, but the world appealed to me straight away. I was a fan of all things fantasy, having drawn comic books for years before entering the film industry.

At first I was the only illustrator on the crew, and my job was to develop preliminary concepts for some of the weapons, sets, and props, and to conceptualize some of the early scenes of Winterfell, including the discovery of the direwolf pups and Bran's fall from the tower. Over a few nights and a weekend or two, I made a series of drawings and returned to my day job on the film. It was halfway through that production that the producer told me that the mysterious project I had worked on was none other than *Game of Thrones*! I was invited to continue working on it, and shortly thereafter, my creative responsibilities evolved into storyboarding, which I was thrilled to pursue for all eight seasons of the show.

When I break down an episode into storyboards, I immerse myself in the script. Frequently the sweeping shots that establish a scene will lead to a conversation between a couple of characters. I'll ask myself, who's delivering this line? Who are we focusing on in this moment in time? Where does this piece of dialogue come from that's going to cross over into this image? All of the characters have their own thought processes, and their motivations swirl around in my head as I'm drawing. I want to bring as much as I can to every panel so that when the crew shoots with the actors, there's an extra bit of information that might assist the crew in figuring out the emotional intent of the scene. I get so mentally involved in the characters that I probably end up doing more drawings than I need to!

There are always a couple of jobs in an artist's life when whatever is inside you starts to flow through your hands, and everything comes out onto that drawing board. All the things that you have read, all the art that has influenced you in the past—it all goes into imagining and creating the characters and scenes you are tasked to draw. You feel that you've achieved your goal as an artist if the storyboards get others emotionally involved in the story and help strengthen the scene on-screen. I was given a reasonably free hand to come up with concepts. I was so happy to be there, scribbling away each day and I've loved this job every step of the way.

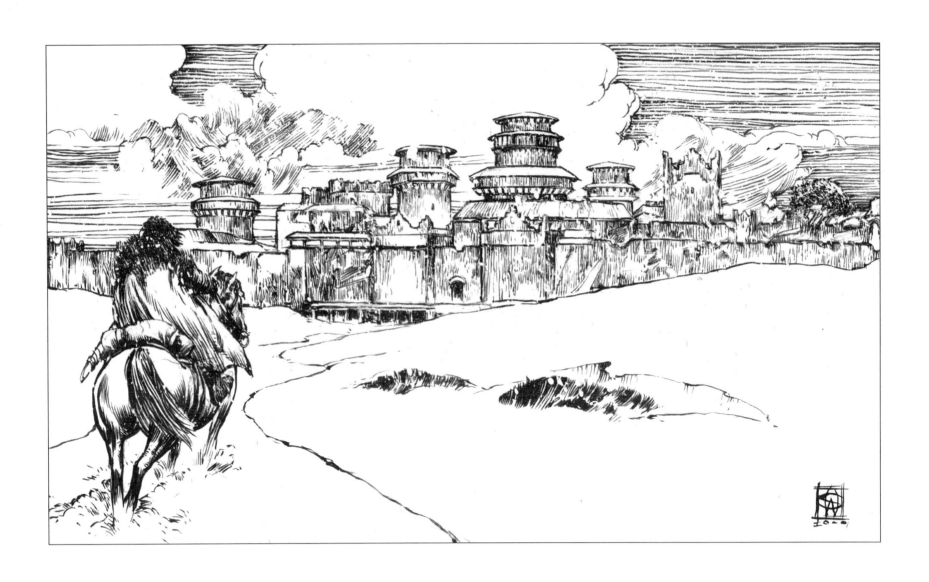

SEASON 1

The inaugural season of *Game of Thrones* introduces viewers to the world and characters first depicted in the novels. The series quickly differentiates itself from other shows by forgoing tropes of fairy-tale heroism and happy endings in favor of the grim realism that was established in the novels. Characters aren't pure good or evil but a mix of the two, capable of doing something reprehensible one moment and honorable the next. Misfortune can strike the innocent. Fate can turn at any time. Bad things can happen to good people. Kings can receive fatal wounds in recreational boar hunts. Beloved heroes can lose their heads. Evil acts can cement victory.

The series begins with a ranger's sighting of a monstrous White Walker, awake for the first time in millennia. But soon after, the story moves south, first to Winterfell and then to the capital of Westeros, King's Landing, where Ned Stark, Warden of the North, becomes King Robert Baratheon's trusted advisor. Two of his children, Sansa and Arya, join him in the capital, where they unwittingly become ensnared in nefarious plots concocted by the brothel owner Petyr "Littlefinger" Baelish and the Lannisters, including Queen Cersei, Jaime, and Tyrion. As the title of the series implies, a nasty game begins wherein its players commit the most heinous deeds in their quest for the ultimate prize: to rule the Seven Kingdoms from the Iron Throne.

Meanwhile, on the eastern continent of Essos, a young woman named Daenerys Targaryen also sets her sights on the same throne lost by her father, the "Mad King" Aerys II Targaryen. Her older brother Viserys weds her to Khal Drogo of the Dothraki and she becomes his *khaleesi*.

As a lifelong fan of mythic tales, William Simpson found the opportunity to work on *Game of Thrones* a logical and exciting culmination of years of other professional experiences that spanned genres from sci-fi to superheroes to Westerns and horror. "I'll never forget sitting at my drawing board during those first days on the pilot, feeling an immediate connection to the story and understanding that my contributions were going to be part of something very special," he notes. Within that context, inspiration had the potential to seem almost effortless, and ideas flowed through his pencil with ease.

Simpson notes that his all-time favorite scene is the one that launched the *Game of Thrones* extravaganza: the sequence in which viewers first catch a glimpse of the mysterious White Walkers. "I remember the director of the pilot, the director of photography, and me standing in a forest in Northern Ireland on a dry summer's day. We discussed the shot, and I created thumbnails on the spot so the director could approve what I was going to draw," he recalls. "Afterward, I went back to my desk at the production base to draw the snowed-in version, with Night's Watch rangers and the spooky arrival of the dark lords of ice and snow and their penchant for lopping off heads. A year later I viewed the first twenty minutes [of the pilot], released as the online teaser trailer. This was the moment that rocked my world, when everything became more than worthwhile, and I realized what a great show this would turn out to be."

Episode 101
Winter Is Coming

 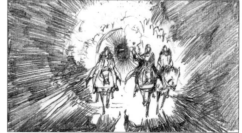 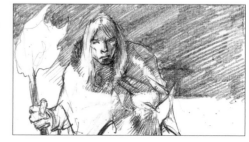

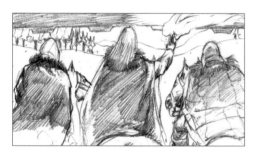 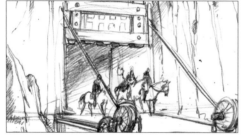 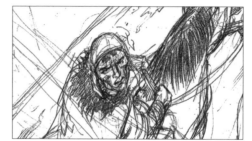

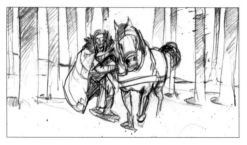 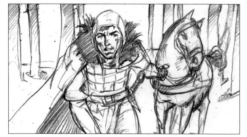 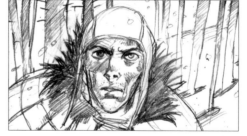

The Free Folk, rugged men and women who live north of the Wall and whom the rangers vilify as "wildlings," have been sighted near the Wall. The rangers' orders are to track any incursions. What lies at the end of their trail proves to be something far more deadly than wildling marauders.

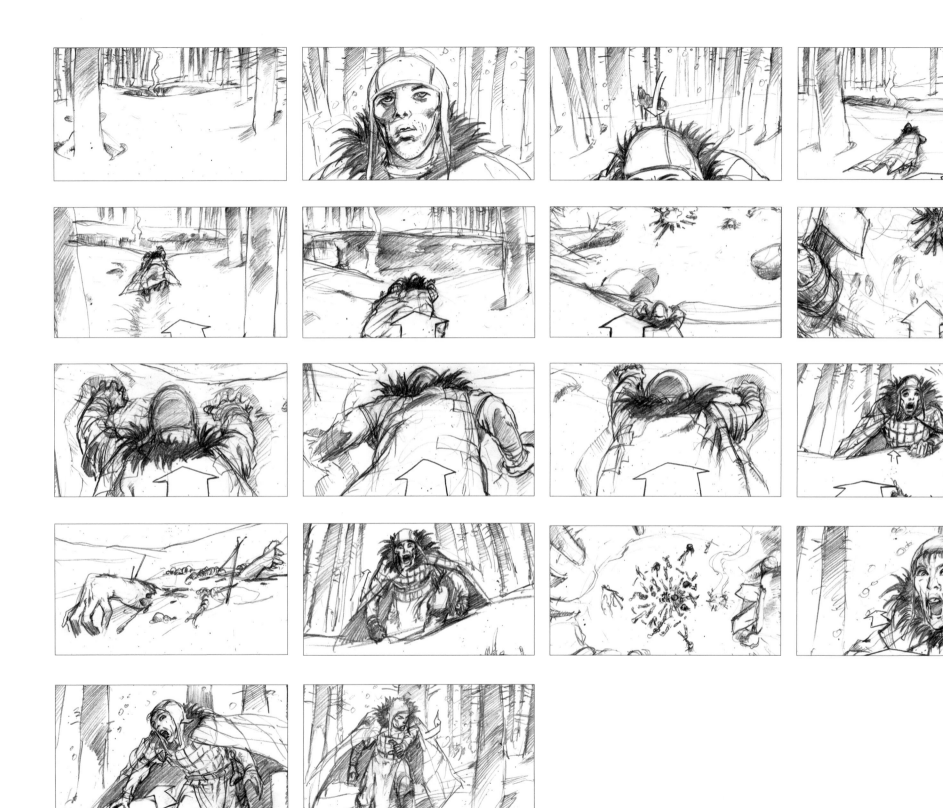

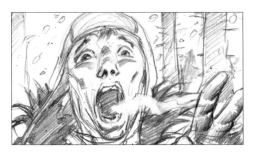

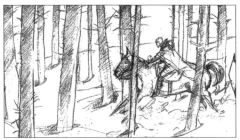

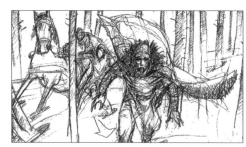

Will rushes to his colleagues and reports his findings to Waymar Royce, who wants to investigate further. A humanoid figure with glowing blue eyes rises behind Waymar and cuts him down. Will and the rangers' horses run through the forest.

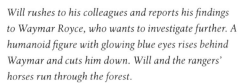

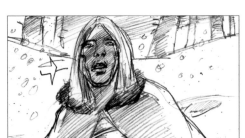

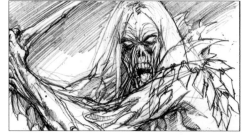

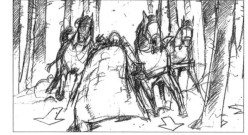

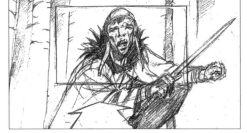

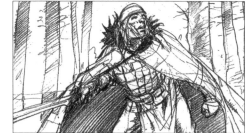

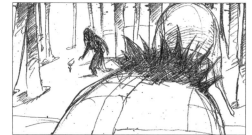

"This is my all-time favorite scene, which launched the whole Game of Thrones extravaganza: the opening sequence when we first catch a glimpse of the mysterious White Walkers. It was a precisely worked out scene," says William Simpson.

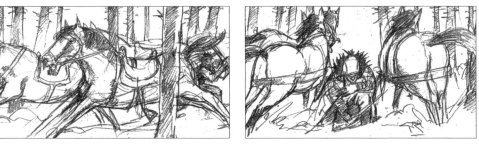

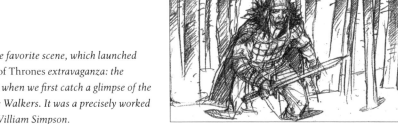

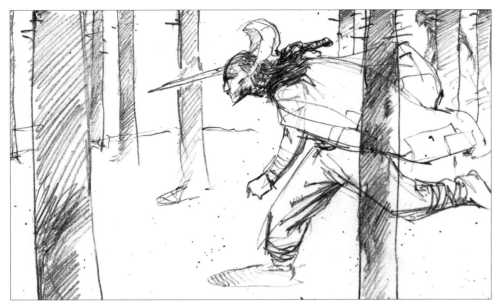
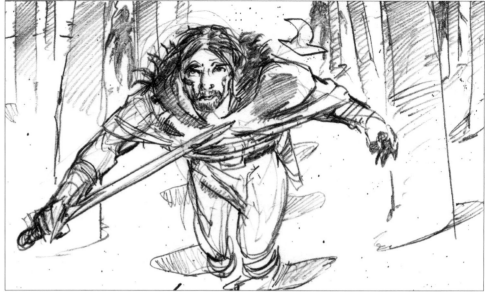

Gared and Will flee through the forest as creatures pursue them.

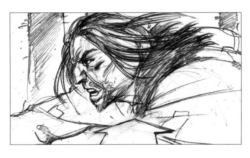
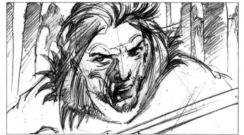
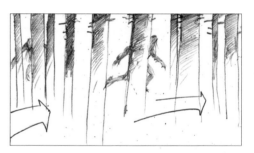

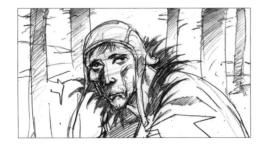
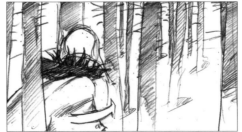
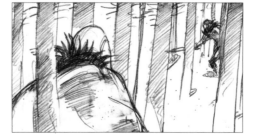
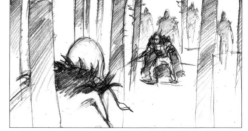

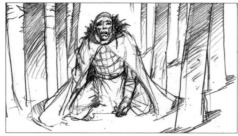
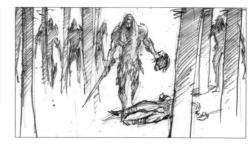
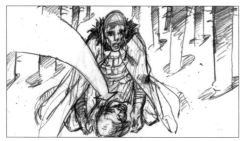

GAME OF THRONES, EP 1 SCENE 22 EXT. FOREST RIVER DAY

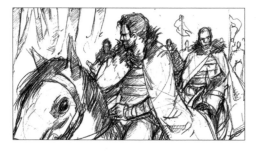

Eddard "Ned" Stark, lord of Winterfell and Warden of the North, and his party come across a dead stag on their way back to Winterfell. They find its killer is also dead—a massive direwolf.

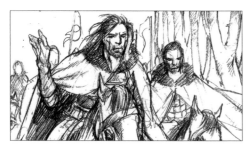
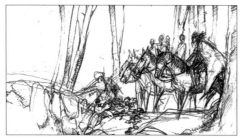
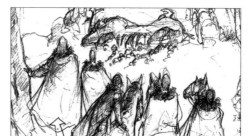
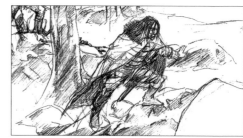

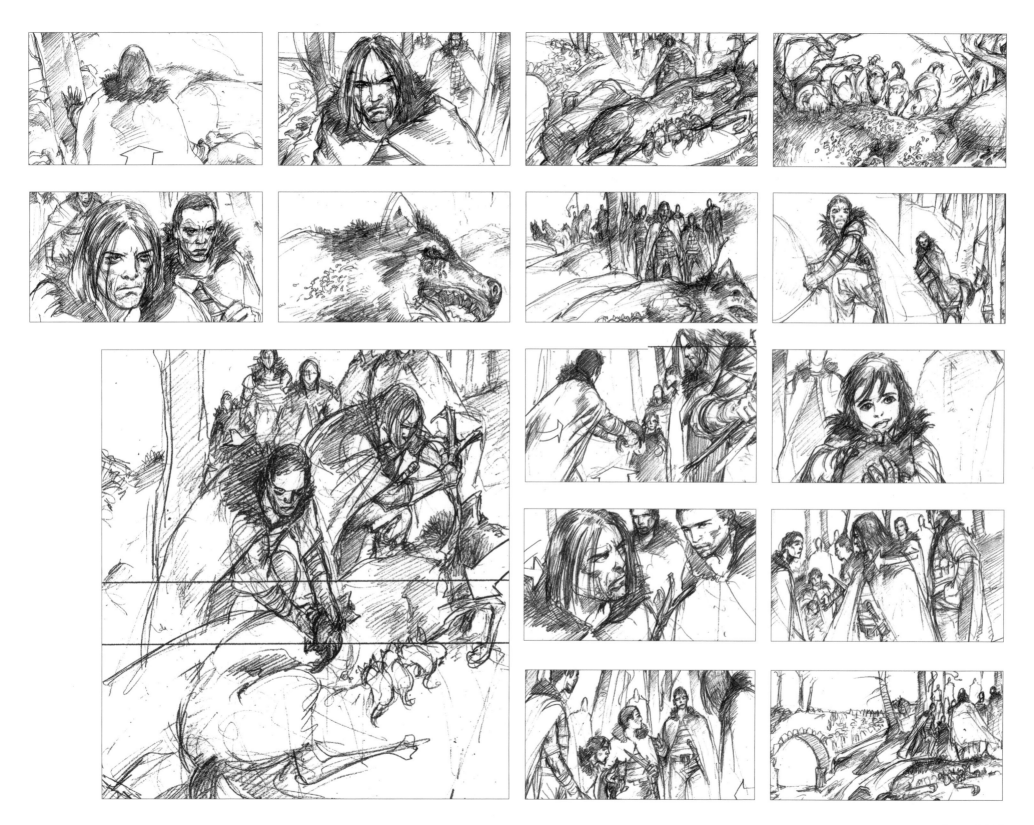

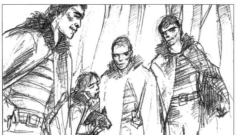
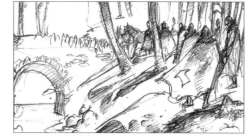
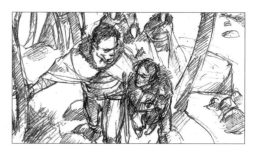
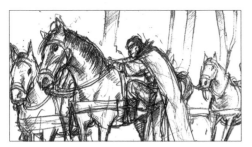

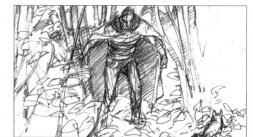

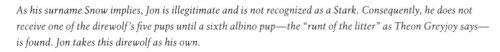

The storyboards show Ned considering the banner of House Stark, which is emblazoned with the sigil of the direwolf. In the episode, Jon Snow reminds his father of this connection through dialogue.

As his surname Snow implies, Jon is illegitimate and is not recognized as a Stark. Consequently, he does not receive one of the direwolf's five pups until a sixth albino pup—the "runt of the litter" as Theon Greyjoy says—is found. Jon takes this direwolf as his own.

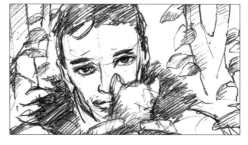
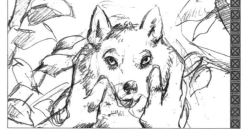

Episode 102
THE KINGSROAD

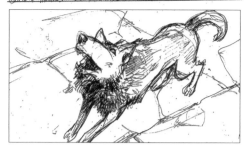 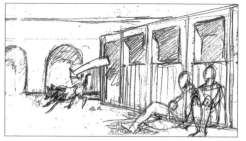 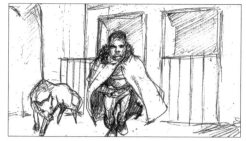

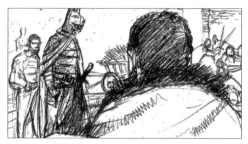 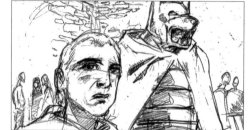 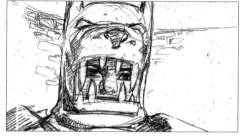

 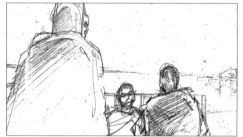 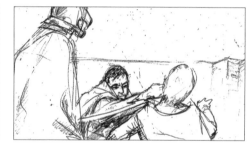 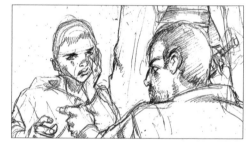

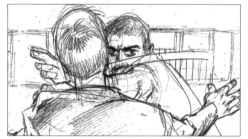 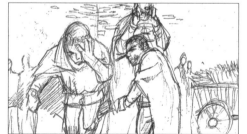 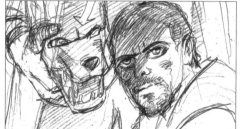 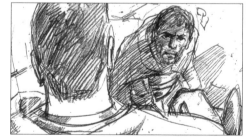

 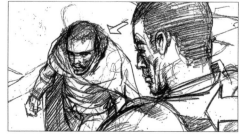 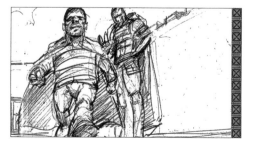

Tyrion encounters Prince Joffrey, heir to the Iron Throne, and his bodyguard, Sandor Clegane.

Prince Joffrey and his betrothed, Sansa Stark, walk by the river. They find Sansa's sister, Arya, practicing her swordplay using sticks with the butcher's boy, Mycah, who accidentally strikes Arya.

GAME OF THRONES – EP 2 – SCENE 26 EXT. TRIDENT RIVER – DAY

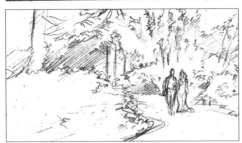
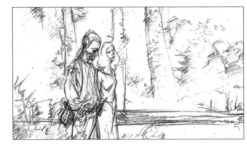
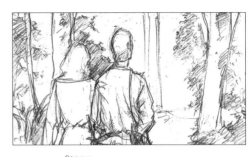

GAME OF THRONES – EP 2 – SCENE 27 EXT. RIVERSIDE CLEARING – MOMENTS LATER. PAGE 2

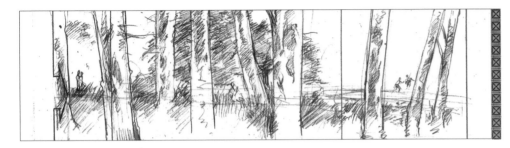
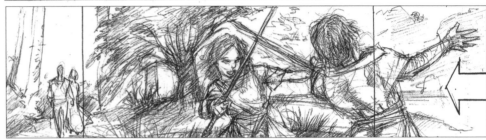

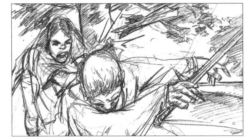

Joffrey punishes Mycah for the action by pulling out his real sword and slicing Mycah on the cheek, but Arya retaliates and attacks Joffrey.

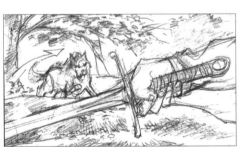
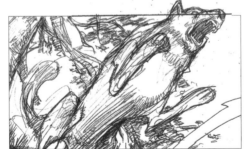
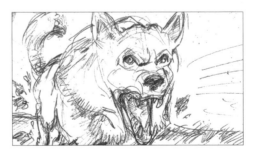
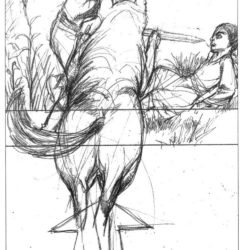

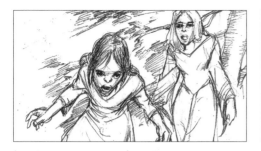

GAME OF THRONES - EP 2 - SCENE 28. EXT WOODS. - DUSK.

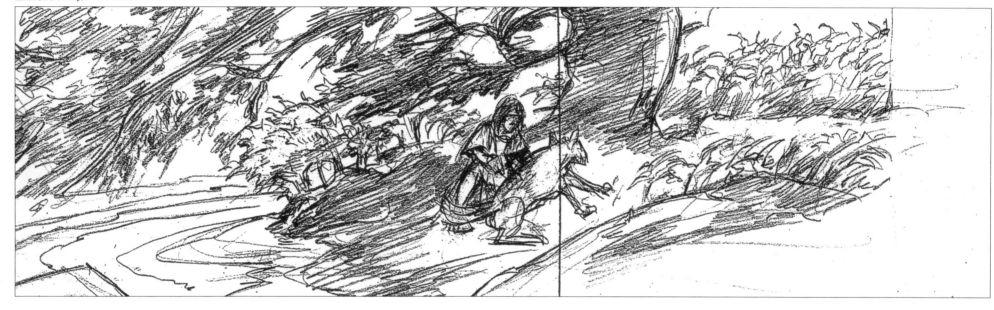

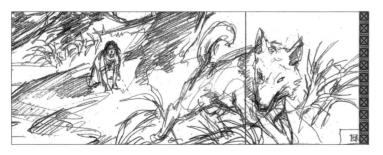

*Arya wrenches Nymeria off the prince, and the two
flee and hide in the forest. They hear soldiers searching
for them. Arya tosses a stone at Nymeria to save the
wolf's life and make her scamper away.*

Episode 103
Lord Snow

Simpson offers a bird's-eye view of Daenerys Targaryen, Khal Drogo's new khaleesi, riding with the Dothraki on the continent of Essos.

...THE DOTHRAKI CARAVAN...

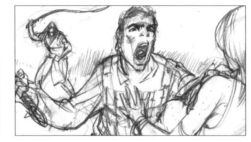
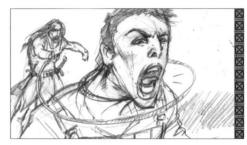

GAME OF THRONES EP 3 — SCENE 2 EXT RED KEEP — MALTA.

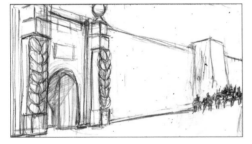
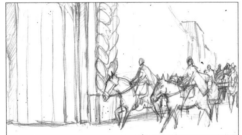

SHOT 2

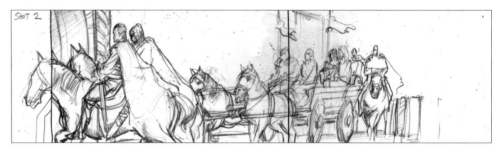

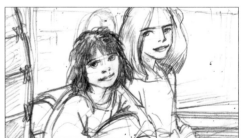

Meanwhile, Ned and his daughters, Arya and Sansa, ride with the royal company into the Red Keep at King's Landing.

Episode 104

CRIPPLES, BASTARDS, AND BROKEN THINGS

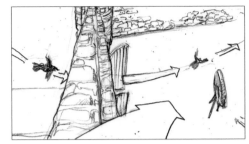
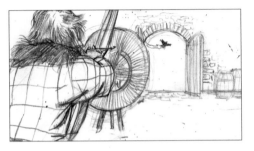

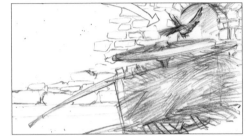
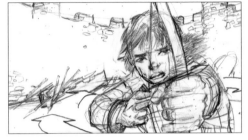
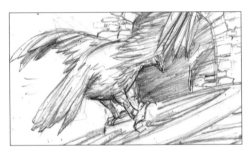

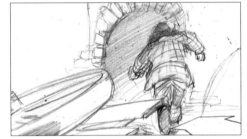

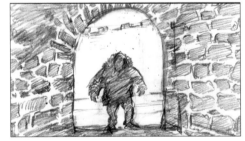

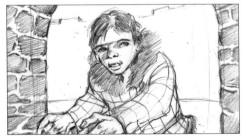

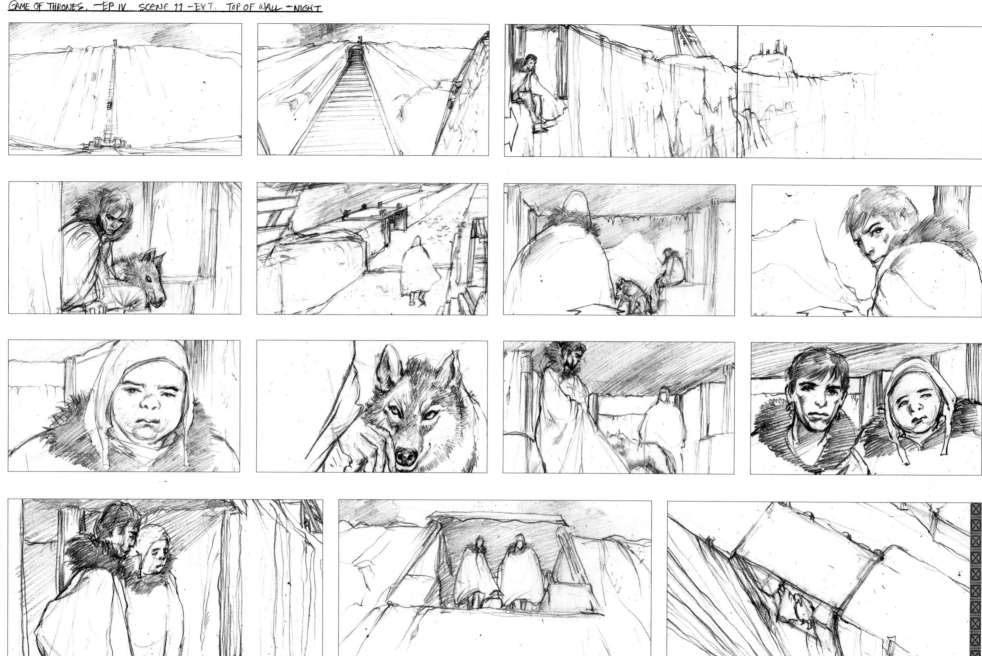

"You can't fight. You can't see. You're afraid of heights
and almost everything else, probably. What are you
doing here, Sam?"

—JON SNOW

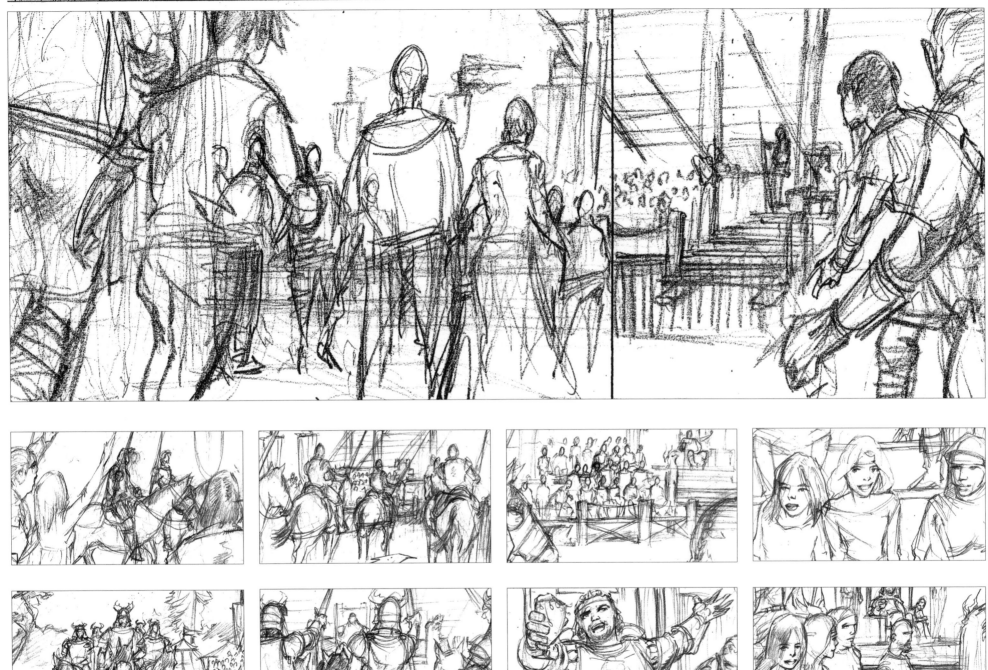

Sansa and two women watch the knights parade into the tournament grounds. In the episode, Sansa sits next to Arya instead.

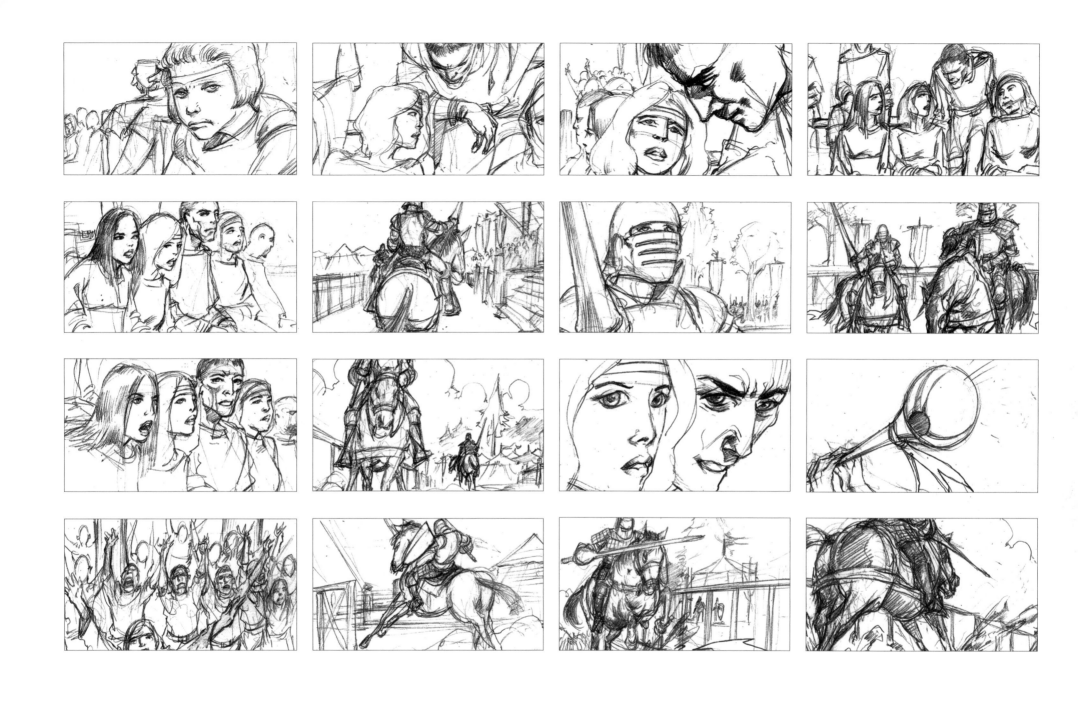

Littlefinger informs Sansa about Ser Hugh's background.

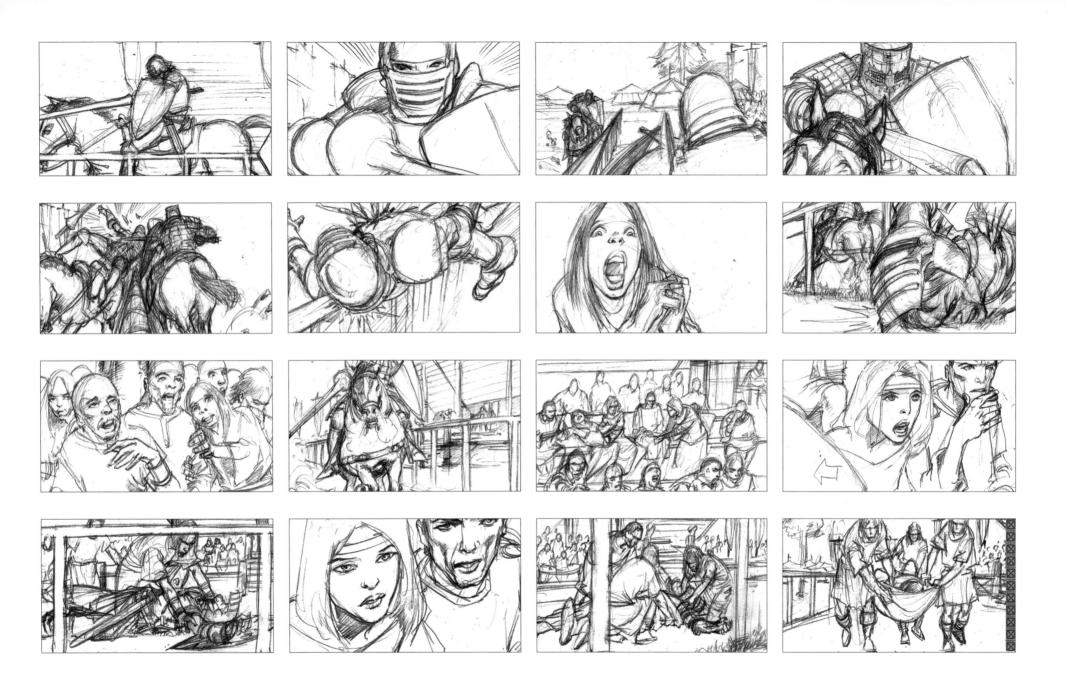

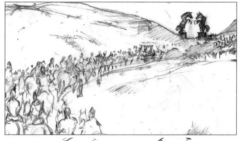
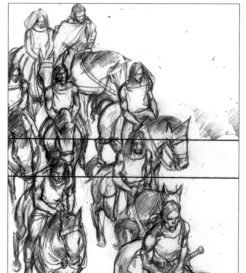

Khal Drogo leads the khalasar past an arch of two horses into the city of Vaes Dothrak. Originally storyboarded for the fifth episode, this scene appears in the fourth episode instead. Daenerys's brother Viserys tries to assert his claim over the Dothraki army.

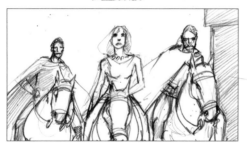

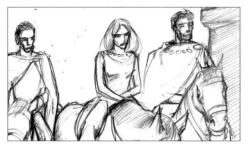
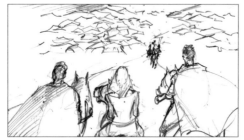
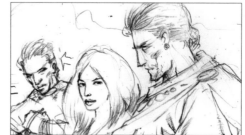
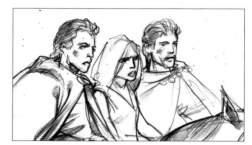
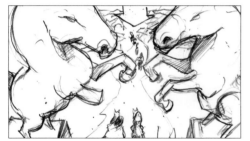
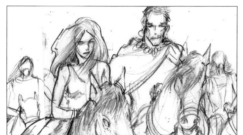
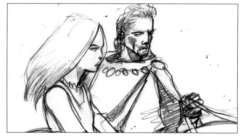
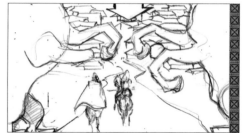

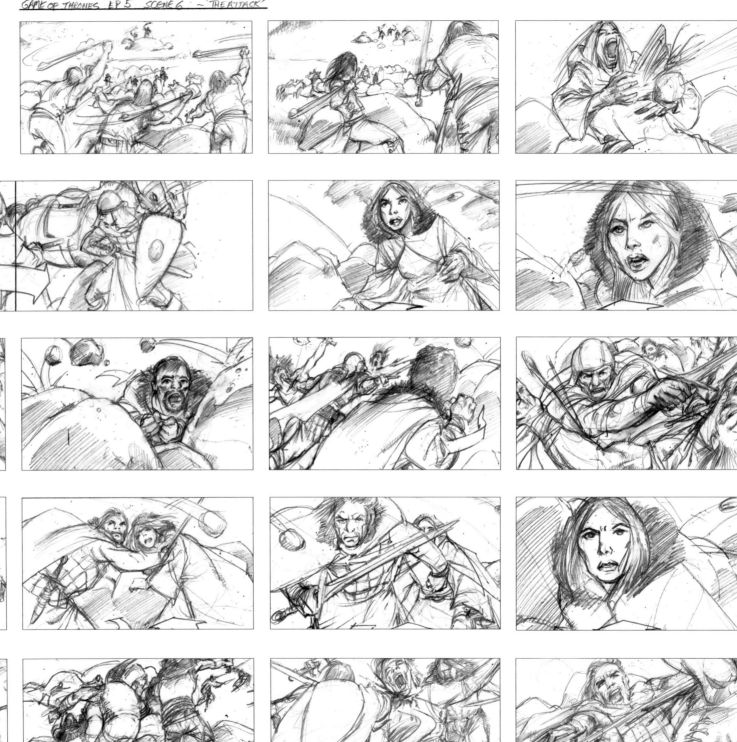

Episode 105

The Wolf and the Lion

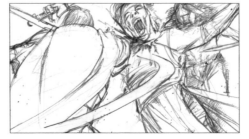

Warriors from the hill tribes near the Vale of Arryn launch a surprise attack on Catelyn Stark's small company, which includes Catelyn's prisoner, Tyrion Lannister, who stands accused of trying to kill Catelyn's son Bran.

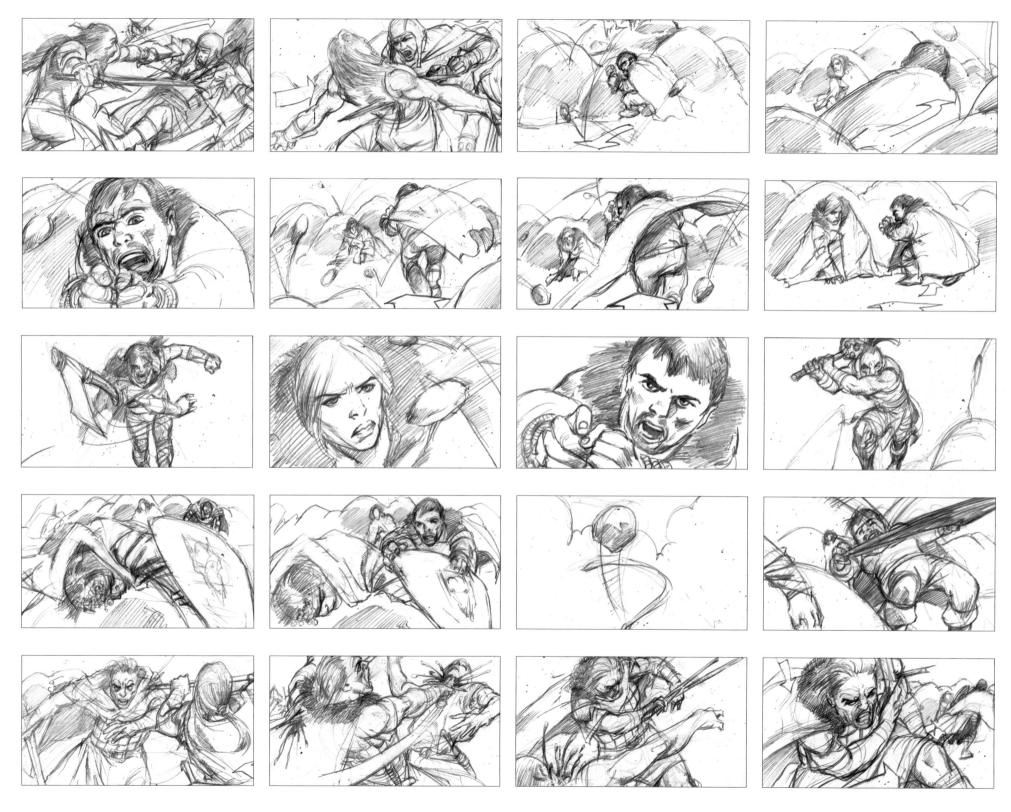

During the fight, Tyrion runs to Catelyn and begs her to cut free his bonds. She does.

 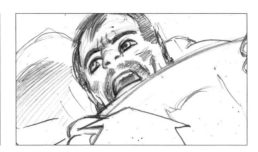 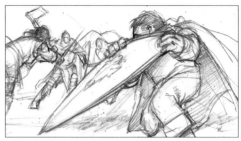

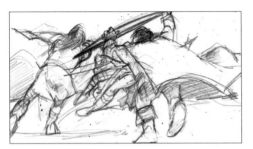

 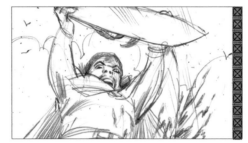

"This scene was based on a set of overhead position drawings detailed to me by the director. We'd worked out what side people would attack from and where the defenders were. Then, my job was to become a camera and go for the most dramatic shots within the given scenario, based on what the director wanted and the action," says Simpson.

GAME OF THRONES, EP V. SCENE 8. EXT KINGS LANDING - TOURNAMENT GROUNDS

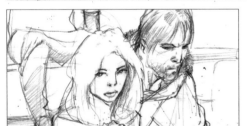 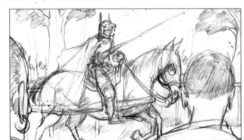 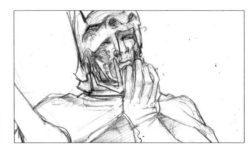 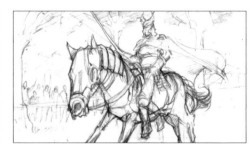

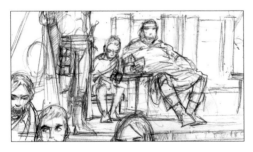 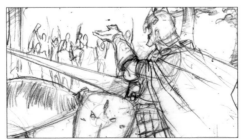 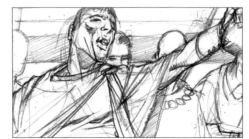

Sansa and Ned Stark watch as the Hound and Jaime Lannister face each other in the tournament.

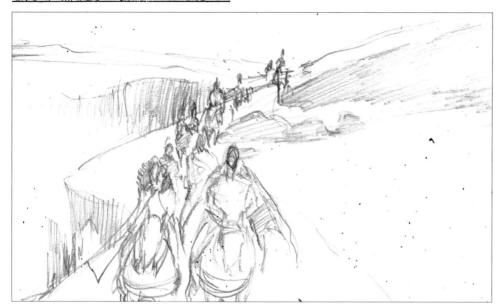

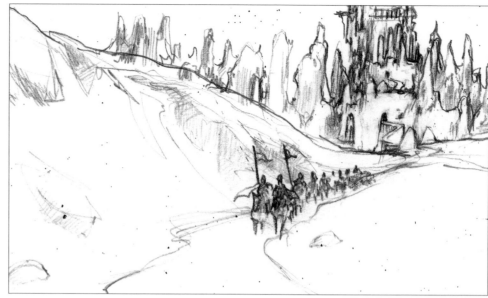

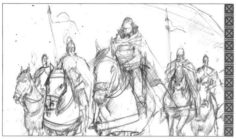

As Catelyn's party nears the Eyrie, soldiers sent by Catelyn's sister, Lady Lysa Arryn, come to escort them. Tyrion mentions the belief that the Eyrie is impregnable. Bronn disagrees, saying he could do it with ten men and climbing spikes.

Angry that Catelyn brought the alleged murderer of her husband to the Eyrie, Lady Arryn orders Tyrion Lannister to be locked up in the sky cell. Tyrion's sky cell has three walls, a door, and a ledge open to the mountain cliff. To fall would mean death.

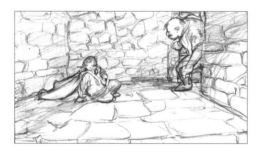

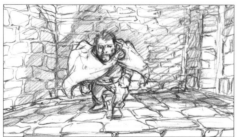

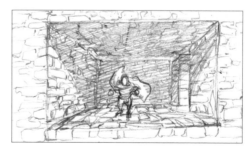

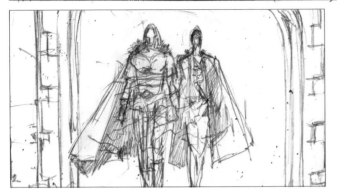

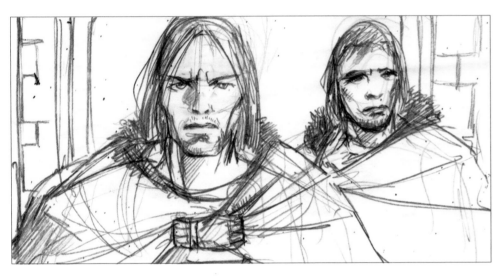
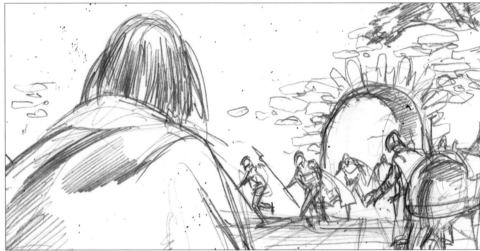

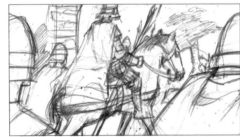
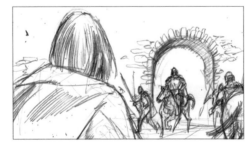
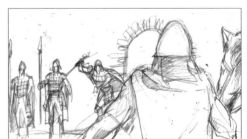

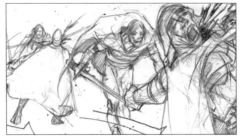
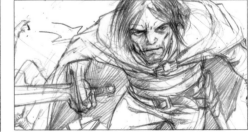

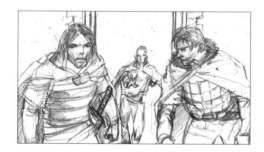 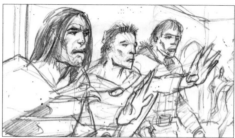

In front of Littlefinger's brothel in Flea Bottom, Ser Jaime Lannister and his soldiers surround Ned Stark and his guards, led by Jory Cassel. Jaime is upset that Ned's wife, Catelyn, captured his brother, Tyrion.

The Lannister soldiers outnumber and easily dispatch the men of House Stark.

Ned rushes to duel Jaime, but Jaime is a far more skilled swordsman, and Ned is subdued.

Episode 106
A Golden Crown

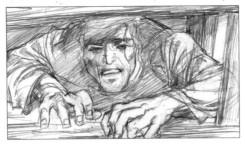
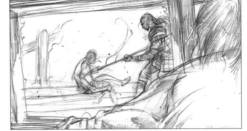
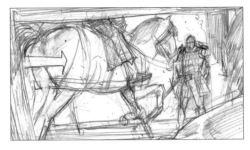

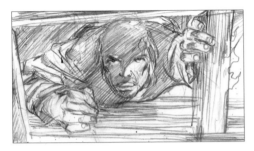
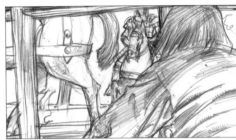
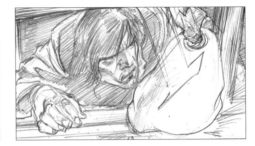

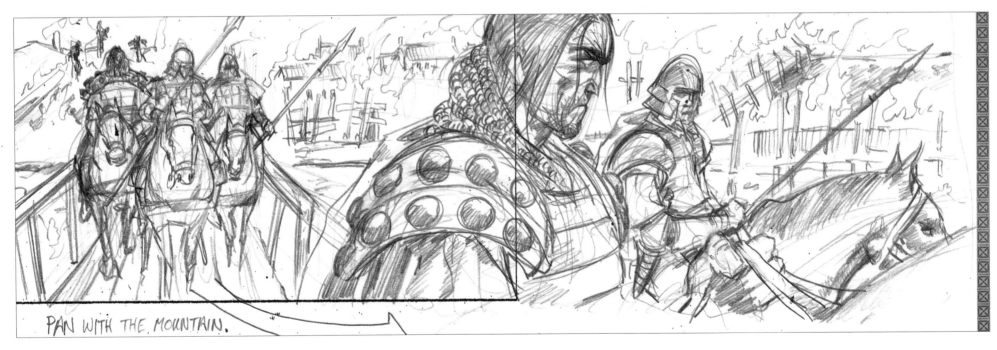

PAN WITH THE MOUNTAIN.

A band of soldiers led by Ser Gregor Clegane burn
a village in the Riverlands and butcher many
inhabitants.

While Robb Stark and Theon Greyjoy discuss how to respond to the Lannisters' attack on Lord Stark, Bran rides a horse through the forest. Metal rods and leather straps secure his legs to the saddle. Four wildlings—three men and a woman—surround Bran and try to steal his horse and silver pin.

GAME OF THRONES — EP 6 — SCENE J — EXT. FOREST — STREAM — MINUTES LATER

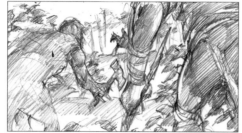

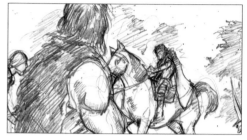

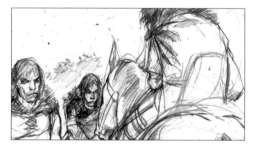
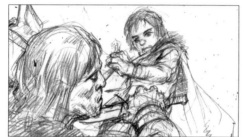

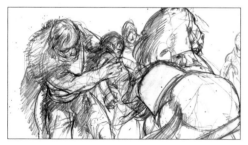

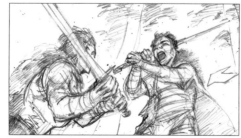
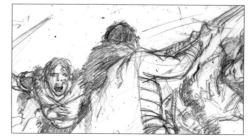
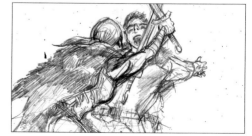

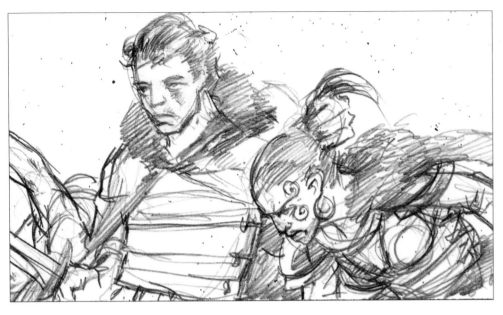
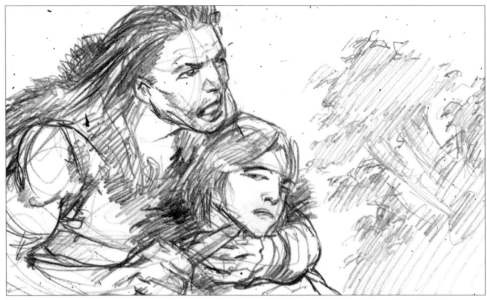
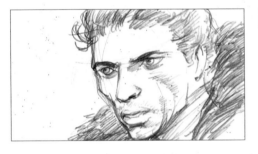

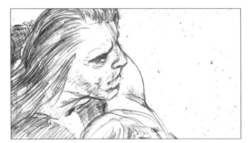

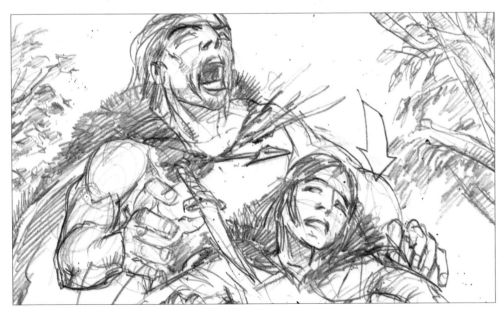
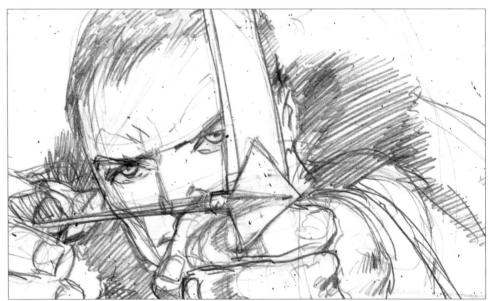

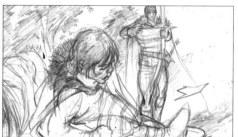
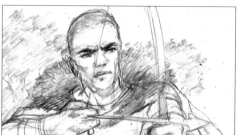

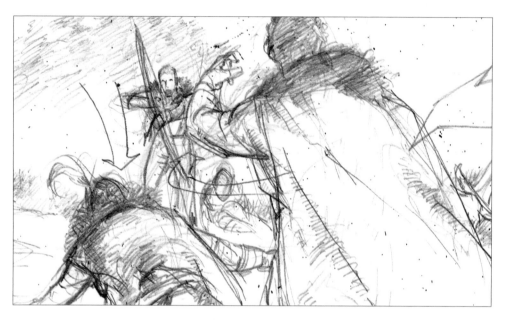
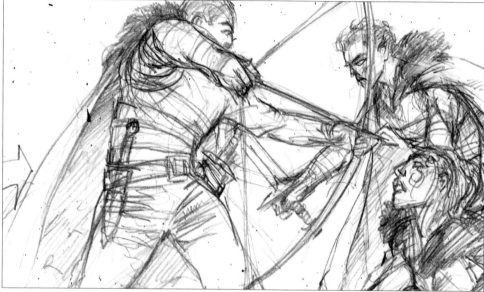

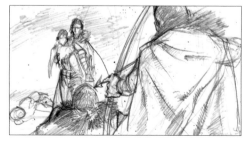

*Robb and Theon arrive in time to kill some wildlings,
but Robb spares the life of the wildling named Osha
and takes her with them.*

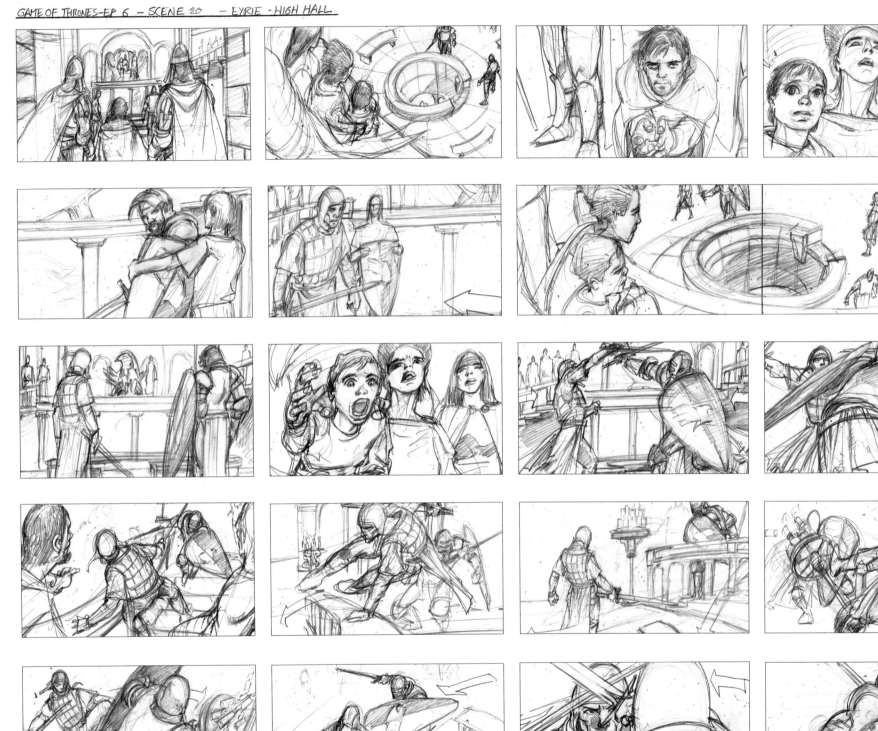

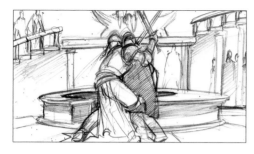 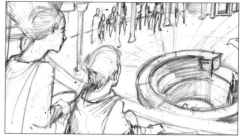

 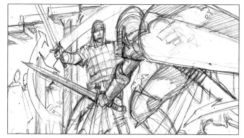 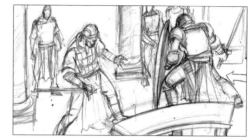

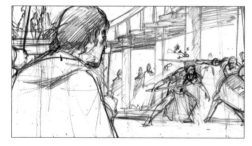 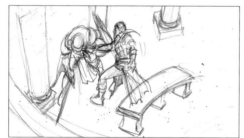

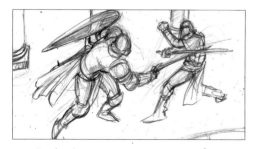 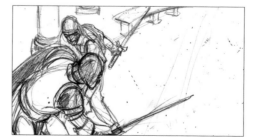

Tyrion makes a joke out of confessing his crimes before Lady Lysa Arryn and her court. She orders the moon door open. Tyrion demands a trial by combat. Ser Vardis Egan agrees to be Lysa and her son's champion in combat. Bronn volunteers to be Tyrion's champion.

Bronn and Ser Vardis battle.

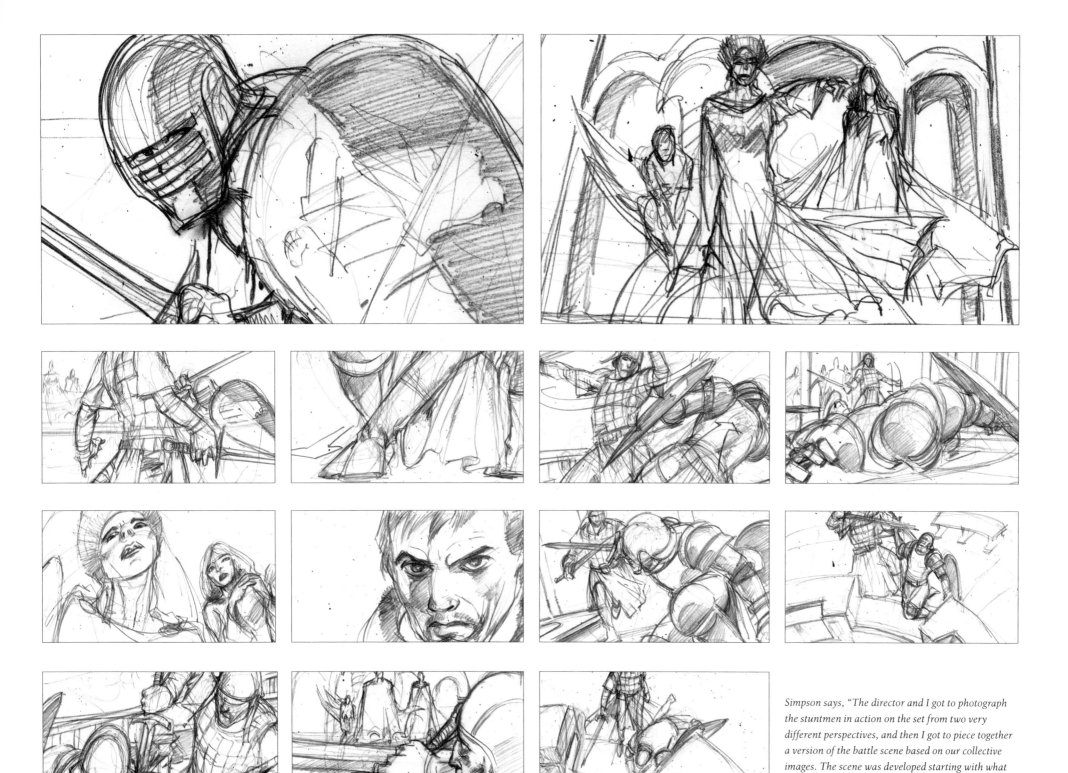

Simpson says, "The director and I got to photograph the stuntmen in action on the set from two very different perspectives, and then I got to piece together a version of the battle scene based on our collective images. The scene was developed starting with what the director was envisaging, and then he would make the final decisions on the days of shooting."

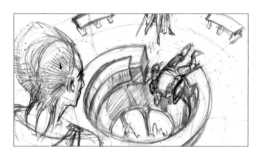

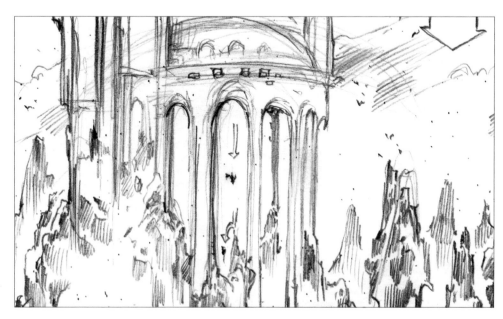

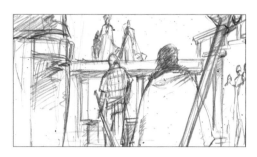
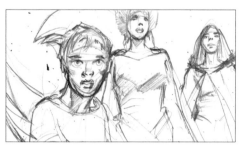
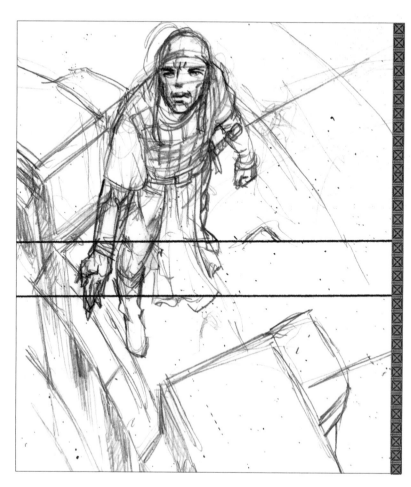

In the storyboards, Vardis slips out of the moon door, while in the episode, Bronn shoves him. Lysa and her son stand shocked as Tyrion grins, having won the contest and his freedom to leave.

Khal Drogo hosts a feast in the Temple of the Dosh Khaleen. Viserys arrives, demanding that Drogo give him his promised golden crown.

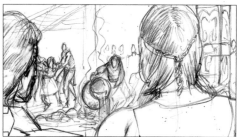

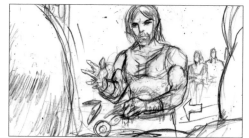

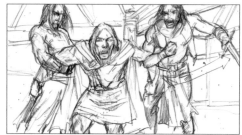

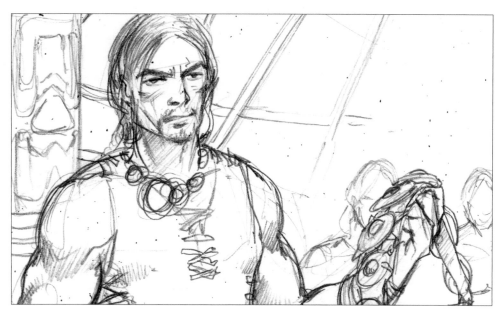

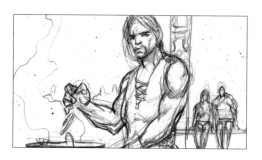

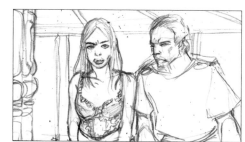
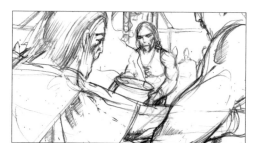

"The characters were mostly defined by the actors that were cast, except in the very beginning when there were gaps," says Simpson. "I began drawing Khal Drogo before there was an actor cast. He was my Conan or Genghis Khan character. I did two character drawings that were to feel out the Dothraki weaponry."

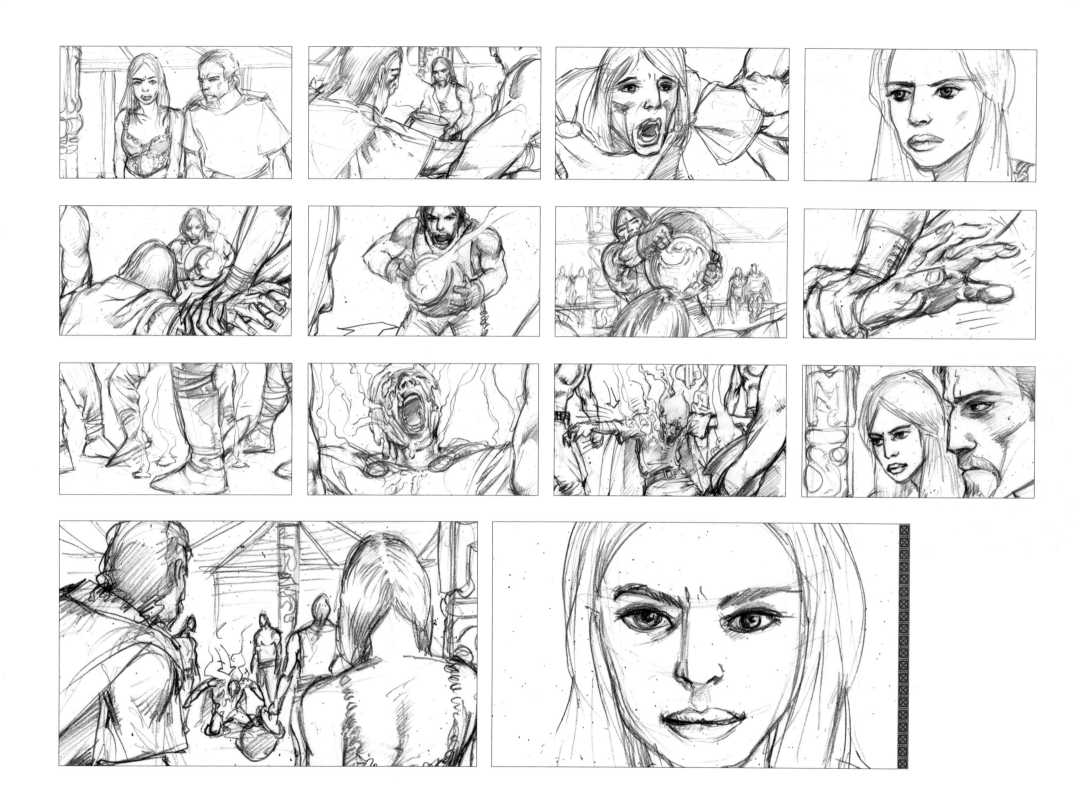

Episode 108

The Pointy End

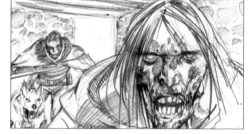

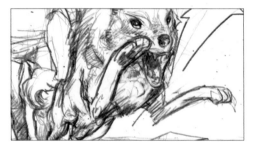
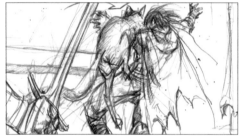

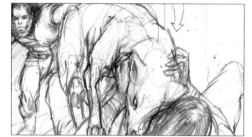

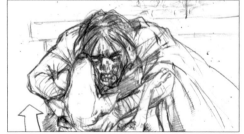
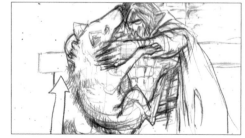

Alerted by his direwolf, Ghost, about something suspicious in Castle Black, Jon Snow goes to investigate and is assailed by a wight.

The storyboards show Ghost pouncing on the wight, but in the episode, Jon Snow orders the wolf to stay behind and confronts the wight alone.

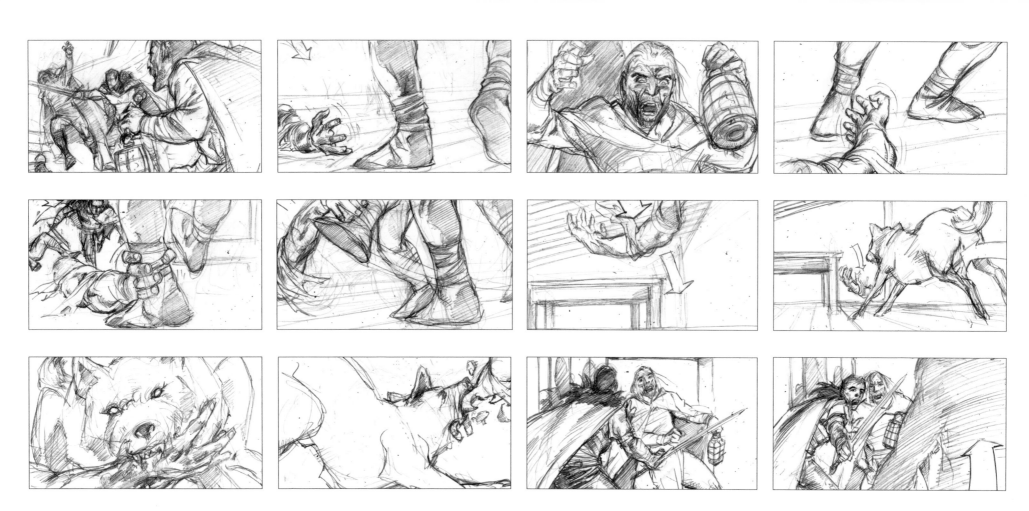

"There are so many decisions based on a myriad of elements. Even when a scene is worked out dramatically on paper, [resources] become a major issue. What is easy to depict in drawings becomes a logistical [puzzle] for the screen," says Simpson. "Storyboarding is a plan, and it can be adhered to or deviated from, but it takes a bit of pressure off when it comes to shooting. There are many different versions that can be drawn, all in an effort to enhance the story."

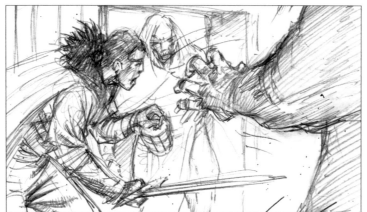

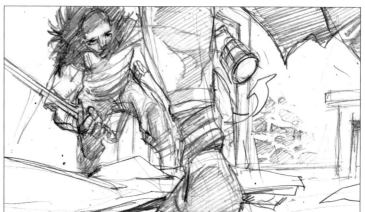

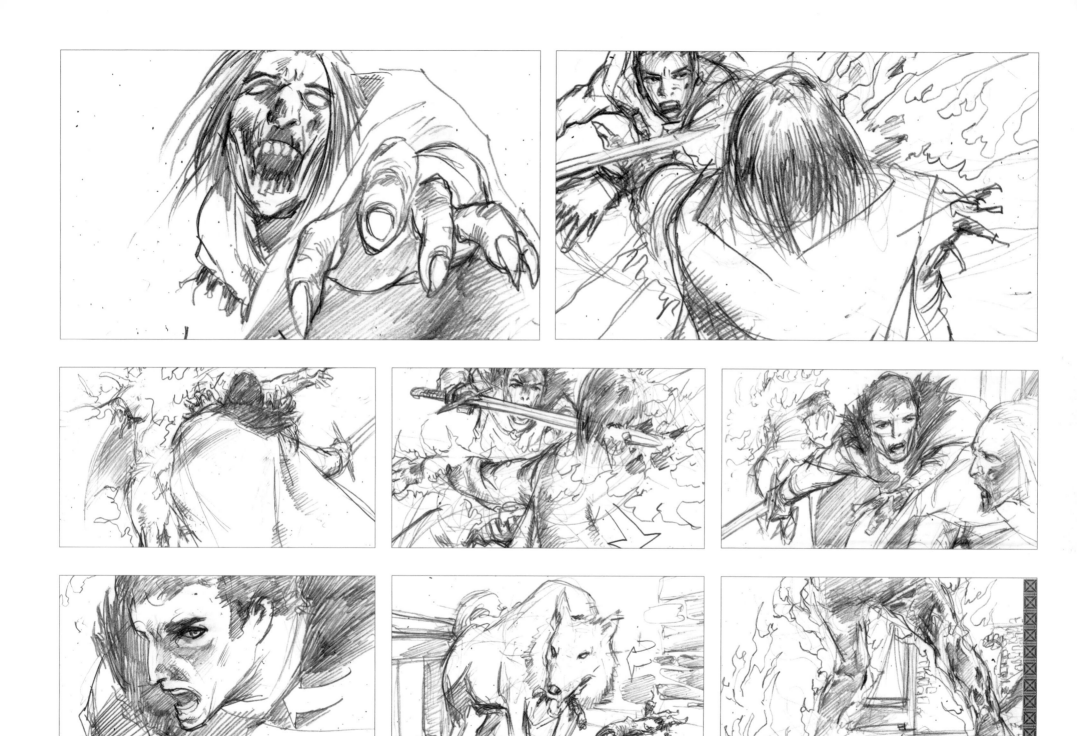

When the Lord Commander arrives in his chambers with an oil lamp, Jon pushes
him back, grabs the oil lamp from him, and throws it at the wight. Fire finally
destroys the creature.

Episode 109
Baelor

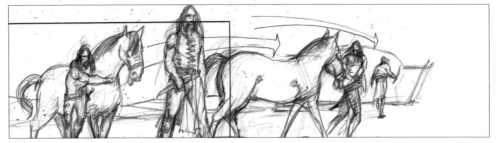

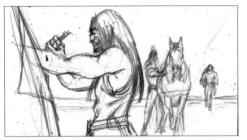

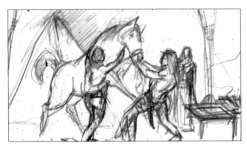 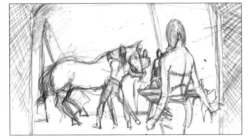

With Khal Drogo gravely ill from a festering wound, Daenerys demands a Lhazareen witch practice her blood magic and save him.

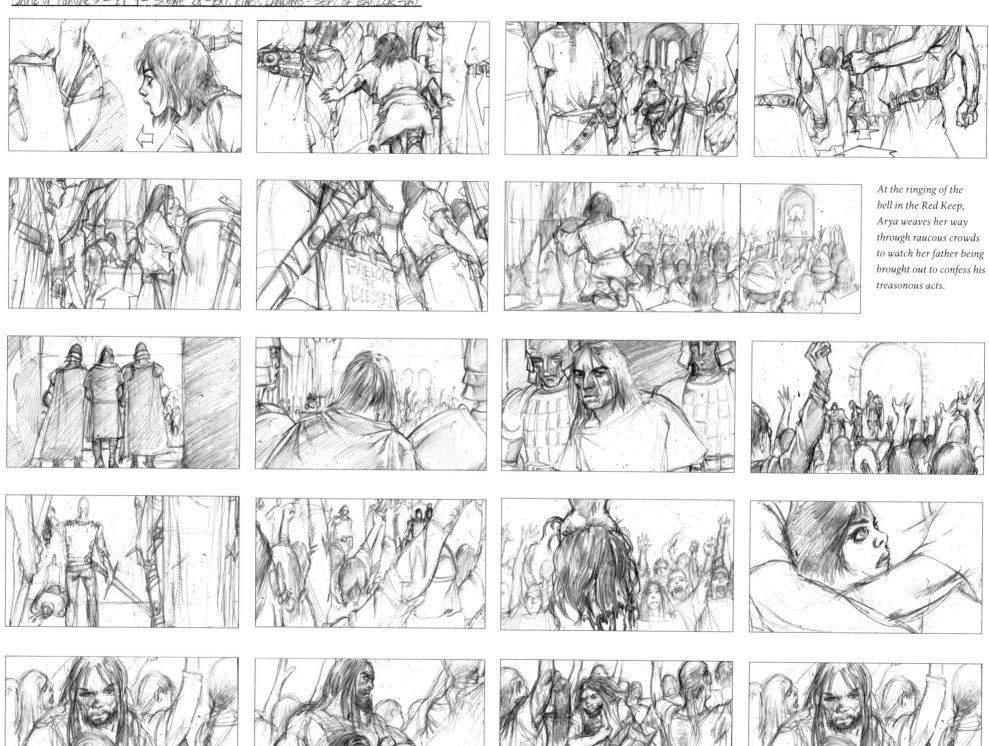

At the ringing of the bell in the Red Keep, Arya weaves her way through raucous crowds to watch her father being brought out to confess his treasonous acts.

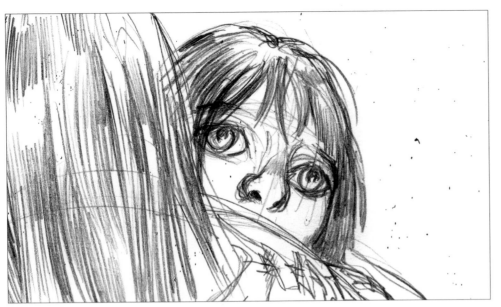

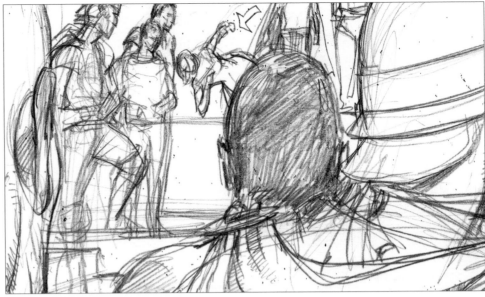

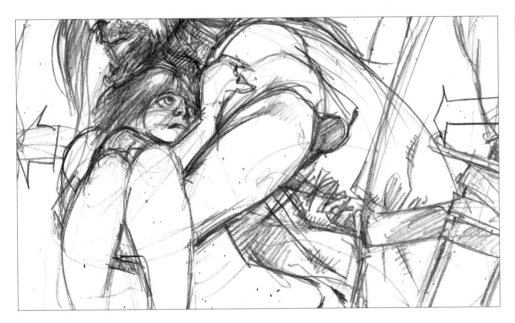

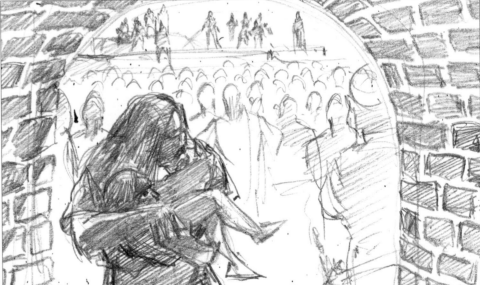

Ned Stark sees his daughter and alerts Yoren, a recruiter for the Night's Watch, to her presence. The episode ends just as Yoren reaches Arya and blocks her view as Ned is beheaded.

Episode 110
FIRE AND BLOOD

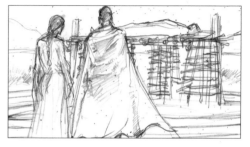

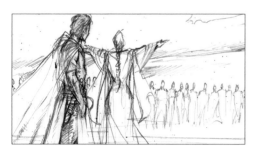

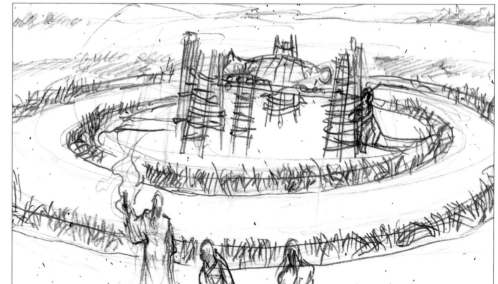

"I am Daenerys Stormborn of House Targaryen, of the blood of Old Valyria. I am the dragon's daughter, and I swear to you that those who would harm you will die screaming."

—DAENERYS TARGARYEN

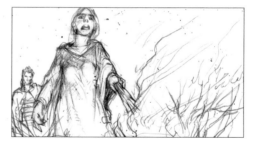

After Duur's blood magic leaves Khal Drogo in a catatonic state, Daenerys chooses to end his life to spare him. A funeral pyre is constructed for him. In the episode, Daenerys orders the dragon eggs placed next to Drogo's body. Daenerys lights the pyre with a torch and walks into the flames.

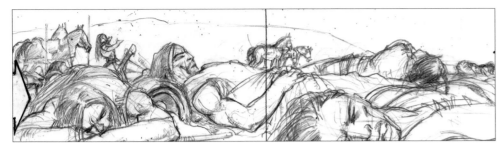

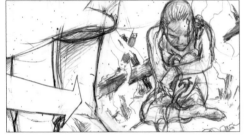

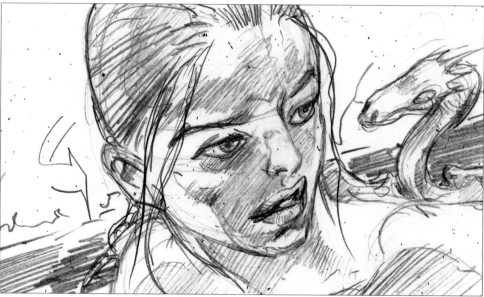

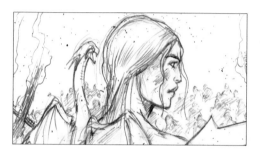
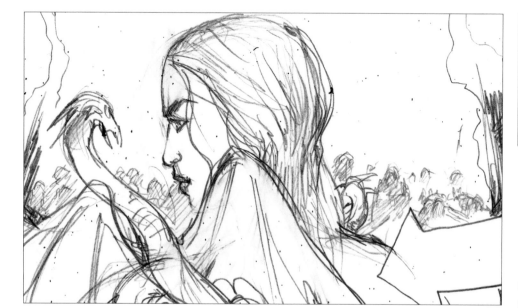
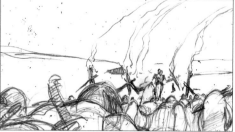

In the morning, Ser Jorah finds a soot-covered Daenerys sitting in the smoking pyre. Three baby dragons crawl around her, having hatched from their eggs.

SEASON 2

Civil war breaks out in Westeros after the deaths of King Robert Baratheon and Ned Stark. In what is called the War of the Five Kings, Robb Stark, Stannis Baratheon, Renly Baratheon, Joffrey Baratheon, and Balon Greyjoy all vie for the Iron Throne. Stannis Baratheon seems to have the upper hand, possessing not only the largest army but a tactical genius few can match.

Meanwhile, Daenerys Targaryen rises in stature in the eastern continent of Essos, gathering more people to her cause as her dragons grow in size. Queen Cersei Lannister begins her machinations as a strong power behind her son Joffrey, spinning a spider's web of malice around the court as she searches for ways to free her twin, Jaime, from his captor, Robb Stark.

Following her father's execution, Arya flees King's Landing, dressing like a boy and hiding amongst Night's Watch recruits on the road. Sansa remains in the city, betrothed to the newly crowned and tyrannical King Joffrey. Their mother, Catelyn Stark seeks alliances for the army of her oldest son, Robb. Jon Snow ranges with the Night's Watch north of the Wall. In a stunning betrayal, Ned's former ward, Theon Greyjoy, turns on the Stark family and claims Winterfell for his father, Balon. The youngest of the Starks, Bran and Rickon, escape Greyjoy's attempts to capture them and travel north.

Simpson's role as storyboard artist provided each episode's director with the first chance to determine where the more complicated challenges may occur, especially for the big effects-heavy scenes or wide panoramic shots. Simpson recounts, "In the early days, when you drew exactly what was in the script, it was then that the producers would look at the storyboards and realize a scene was going to require CGI."

He adds, "I loved the conversations back in the beginning when there was a small bunch of people on the project and you drew the most amazing things you could imagine. Anything that would fulfill the idea of what *Game of Thrones* was, that was it. They just let me loose on this thing."

The stunning Battle of the Blackwater as seen in episode seven was the first long set of scenes consisting of over thirty script pages and required Simpson to produce four iterations. "Blackwater was a prime example of me indulging in anything I felt would be dramatic, given what was suggested in the script," says Simpson.

"I had the pleasure of working with a director who has an amazing eye for compacting the essential form into dramatic moments," Simpson says. In the sequence's first iteration, a producer gave Simpson the freedom to draw and solve some of the physical issues that were in the original draft of the script. This gave the production team a chance to determine which elements in the huge sequence were going to work and which were not. "It was an incredibly intense episode and remains a favorite of mine because of the hard work we put into it," Simpson says.

Episode 201

The North
Remembers

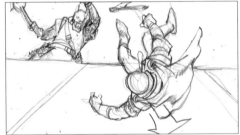
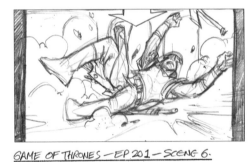

After Robert Baratheon's death, Joffrey becomes king. He celebrates his name day with his betrothed, Sansa Stark, by watching Sandor Clegane fight another knight on the battlements of the Red Keep.

GAME OF THRONES – EP 201 – SCENE 6.

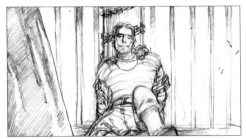

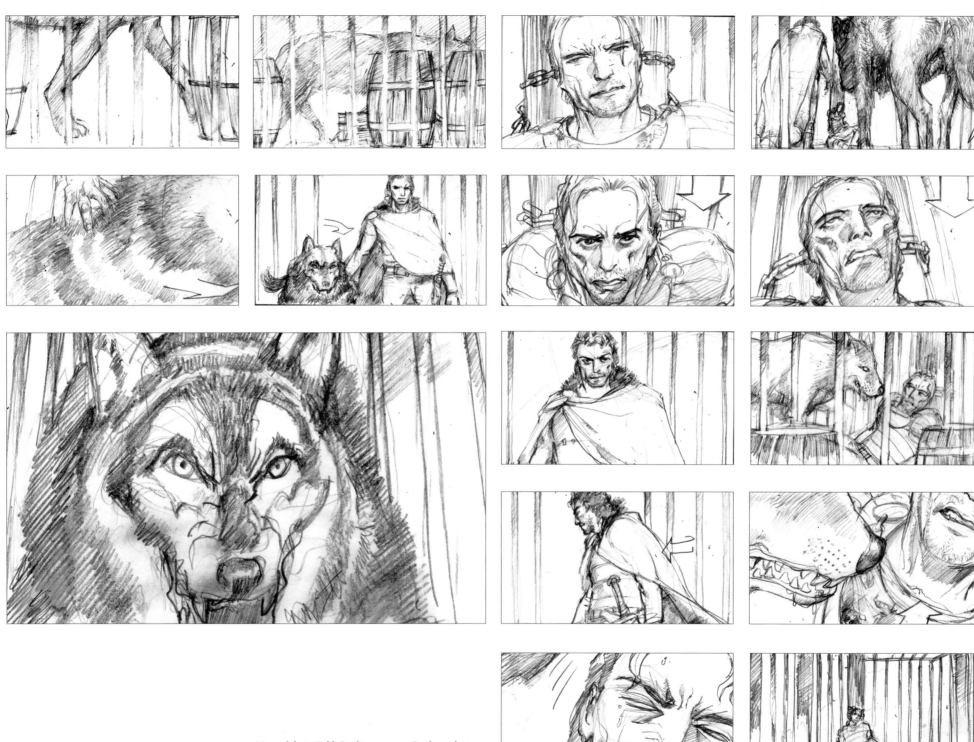

Meanwhile, in Robb Stark's war camp, Stark speaks to
Jaime Lannister, who is bound and locked in a cage as
Robb's direwolf, Grey Wind, circles the cage, growling.

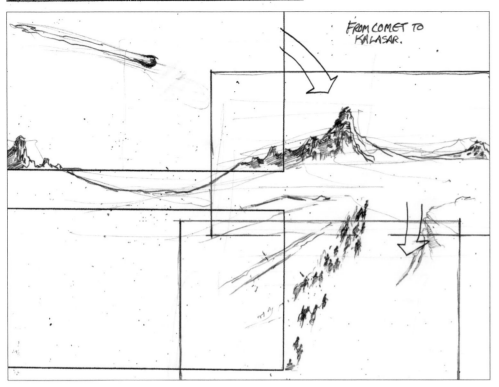

FROM COMET TO KALASAR.

A fiery comet streaks through the sky above the Red Waste, where Daenerys and her khalasar travel on foot. As she talks to Doreah about her brother, Daenerys tries to feed a morsel of meat to the dragon on her shoulder.

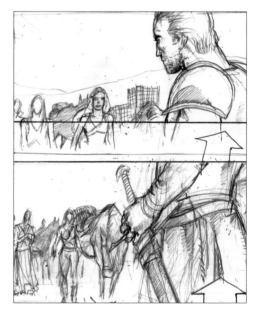

The horse that was Khal Drogo's wedding gift to Daenerys falls over, dead. Daenerys and Jorah discuss where she should lead her people, and she sends bloodriders ahead to scout the best path forward.

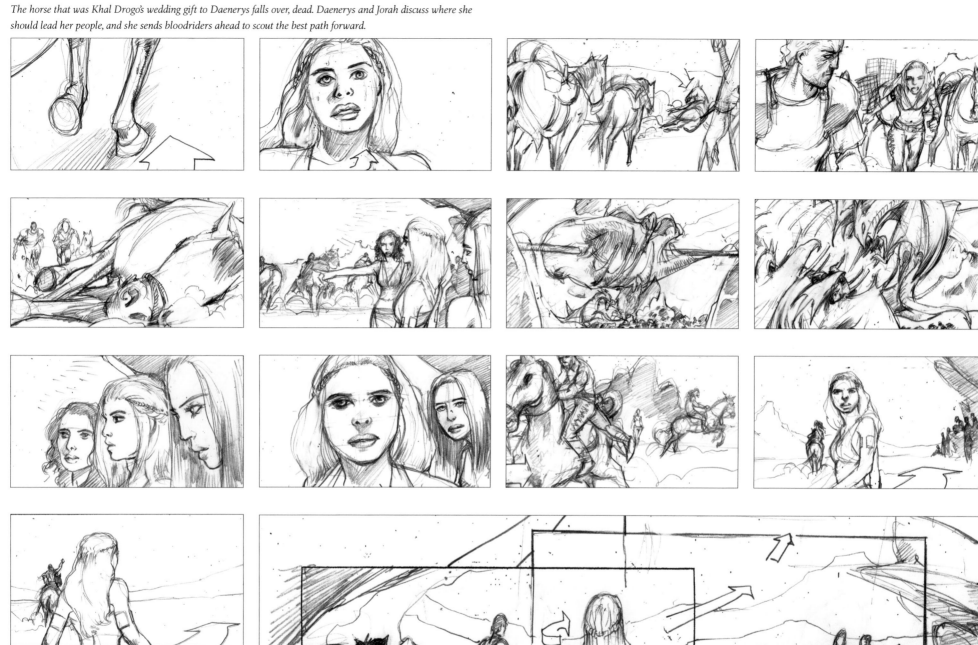

The comet in the sky astounds Daenerys. The episode doesn't show the comet in the same shot as Daenerys but rather uses it to transition to the next scene in the North, where Jon Snow and the Night's Watch range beyond the Wall.

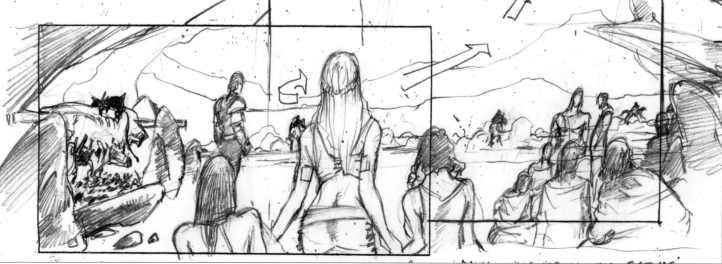

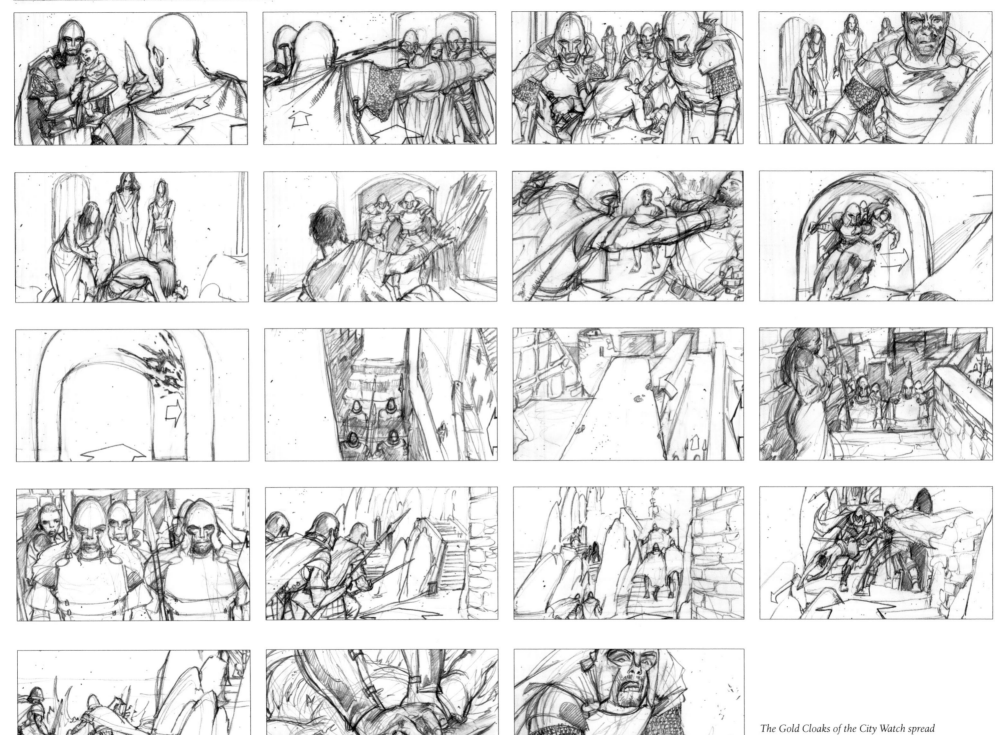

The Gold Cloaks of the City Watch spread throughout King's Landing, killing all of Robert Baratheon's illegitimate children who could potentially lay claim to the Iron Throne.

 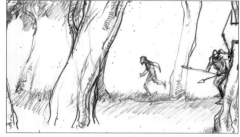

"Find him."

—LORD JANOS SLYNT

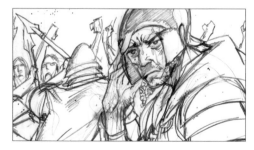 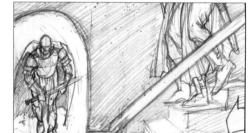 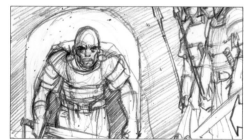

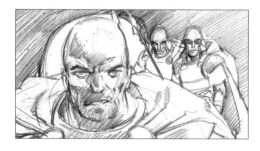 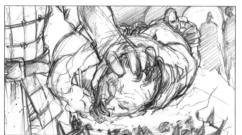 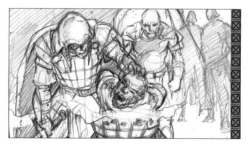

The captain of the City's Watch questions the blacksmith, who reveals his former apprentice is named Gendry and owns a bull's head helmet he forged himself.

Episode 202
THE NIGHT LANDS

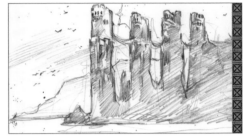

GAME OF THRONES – EP 202 – SCENE 206

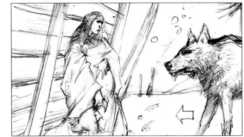
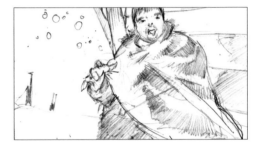

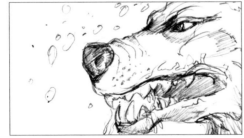
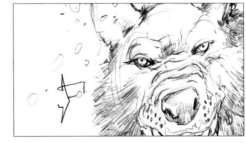
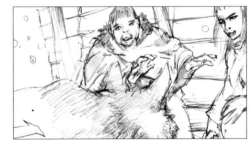

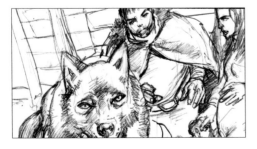

On the deck of a merchant vessel, Theon Greyjoy smiles, seeing his homeland of the Iron Islands after many years in Winterfell.

At Craster's Keep, Samwell hears a scream and a growl. Jon Snow's direwolf, Ghost, has cornered the pregnant wildling woman named Gilly.

Episode 203

What Is Dead May Never Die

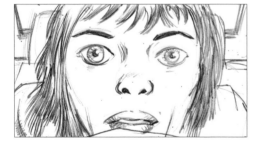
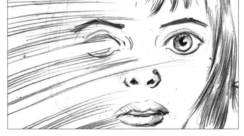

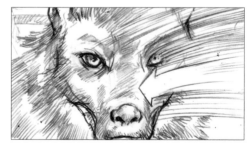

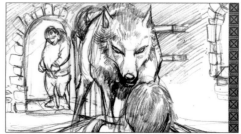

Bran dreams of the world through his direwolf, Summer.

"*I'm trusting the council with these plans, but the Queen mustn't know. We can't have her meddling in affairs that could determine the future of the realm.*"

—TYRION LANNISTER

Tyrion has been appointed the Hand of the King in his father's absence. Tyrion meets with Maester Pycelle and tells Pycelle of his plan to marry off Princess Myrcella Baratheon.

The scene cuts to his conversations with Varys and Petyr Baelish, where he reveals differing matrimonial plans for Myrcella.

Ser Amory Lorch and the Gold Cloaks under his command find Yoren, a sworn brother of the Night's Watch, and his recruits traveling on the Kingsroad. A battle ensues between the Gold Cloaks and Yoren.

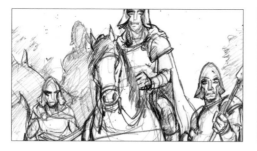

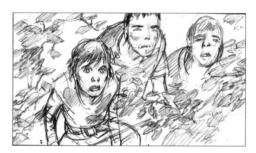
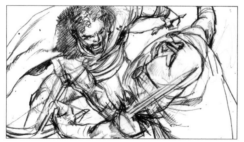
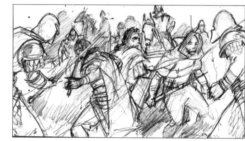
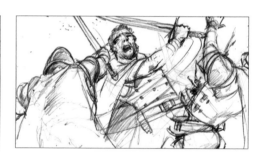

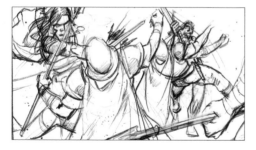
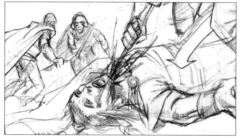
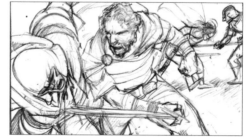
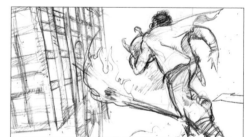

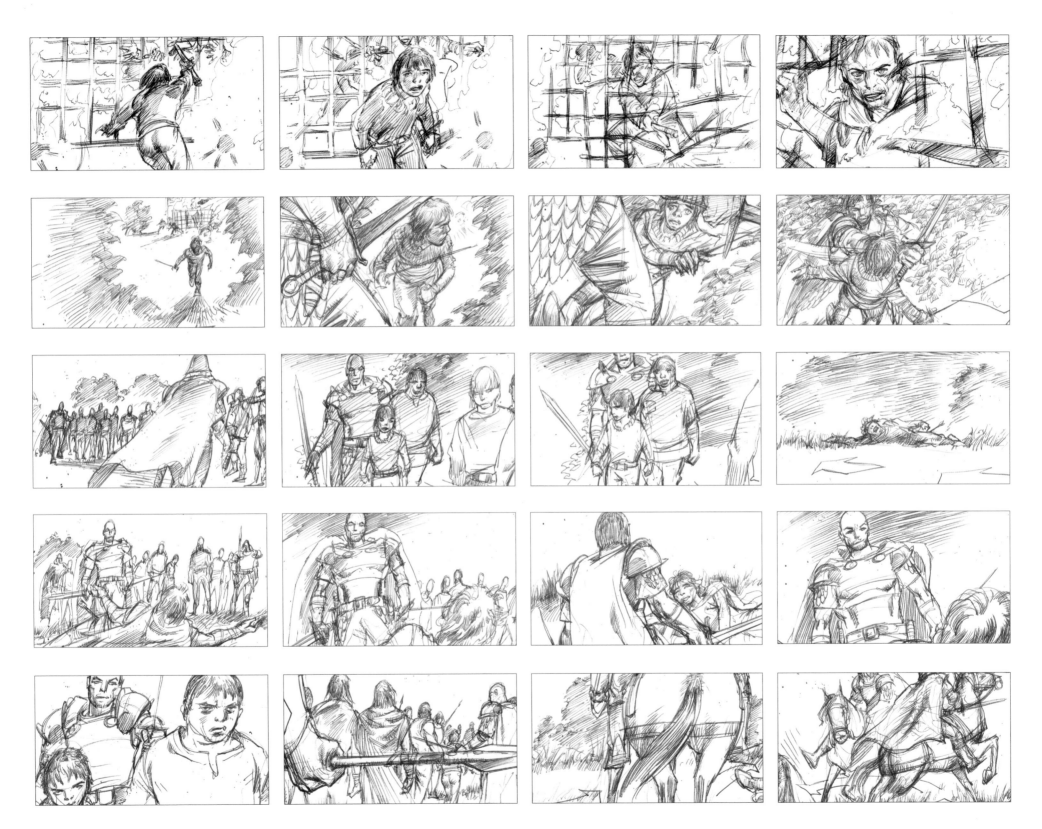

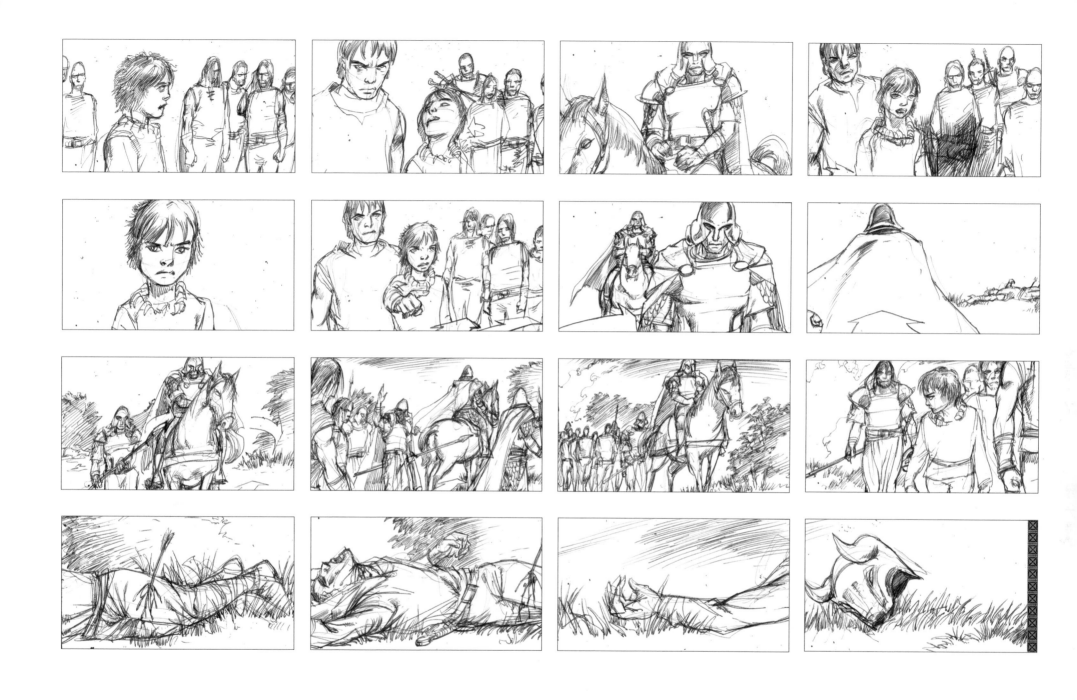

In the fray, Lommy, one of Yoren's young recruits, takes Gendry's bull's head helmet and flees but is hit in the leg by a crossbow bolt.

When Lorch and his Gold Cloaks are victorious, he announces he's looking for Gendry. Arya indicates they already killed him by stabbing Lommy, for Gendry's bull's head helmet is with him.

Episode 204

GARDEN OF BONES

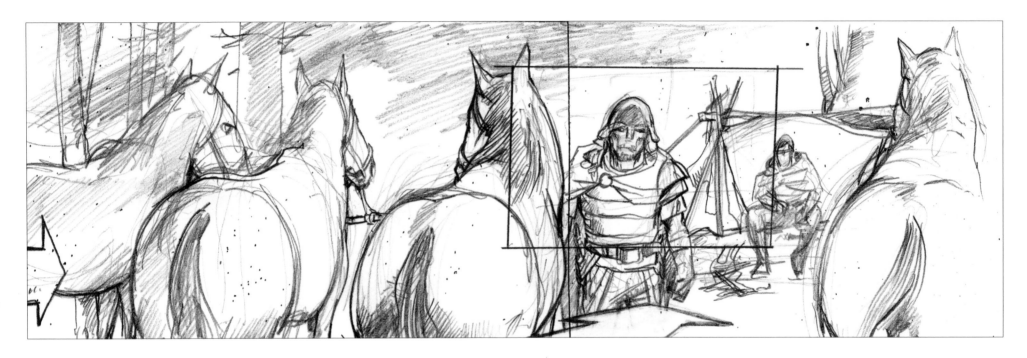

The horses of the Lannister army are spooked.
A soldier calls for his sentry companion, Rennick, who
has stepped away. Grey Wind, Robb Stark's direwolf,
pounces at Rennick from the shadows.

Episode 205

The Ghost of Harrenhal

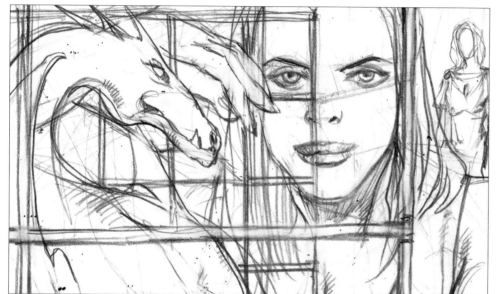

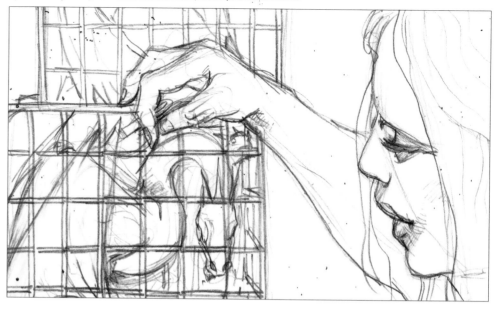

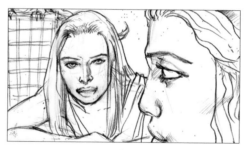

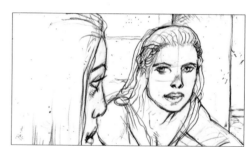

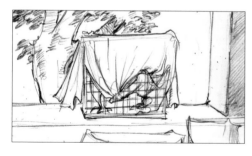

These scenes, originally planned for the fourth episode of season two, instead appear in the fifth. Doreah and Daenerys look upon Drogon in his cage. In Daxos's gardens, Pyat Pree introduces himself to Daenerys as a warlock of Qarth. He invites Daenerys to the House of the Undying if she bores of Daxos.

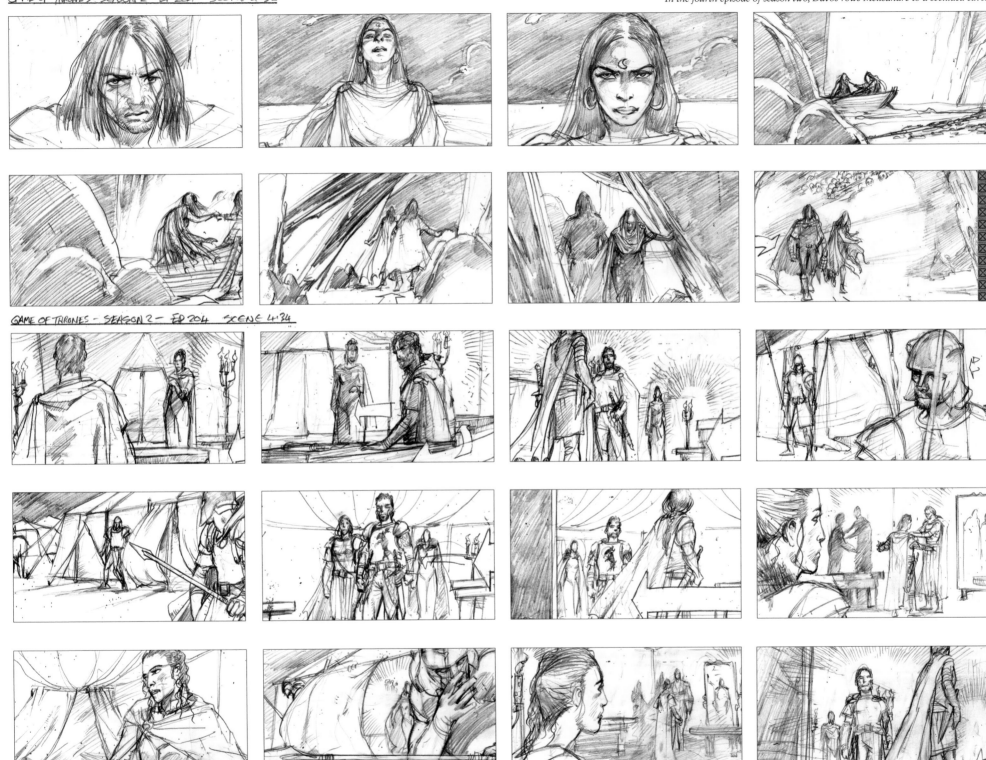

In the fourth episode of season two, Davos rows Melisandre to a secluded cave.

GAME OF THRONES - SEASON 2 - EP 204 SCENE 4:34

In Renly Baratheon's tent, Catelyn Stark assures him that her son Robb has no interest in the Iron Throne. This sequence, originally planned for the end of episode four, occurs in episode five.

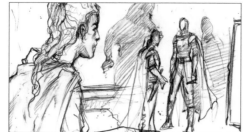
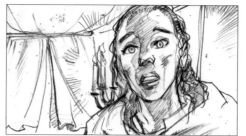

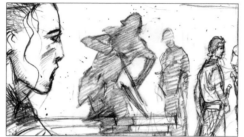
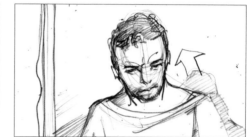

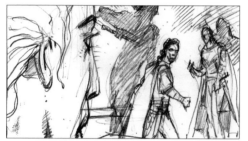

A gust of wind whips up the tent's flaps, and a smoky shadow slips inside, materializes behind Renly, and stabs him from behind with an inky blade.

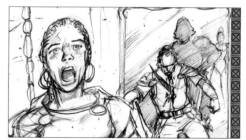

The Night's Watch trudges toward the Fist of the First Men, an ancient ring of standing stones on the summit of a hill that serves as a strong defensive position against wildlings and other creatures. The ranger Qhorin Halfhand will meet them there.

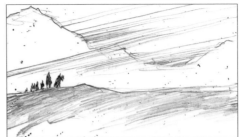
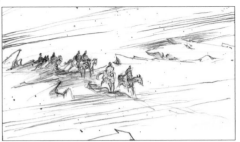

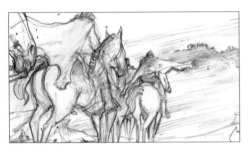
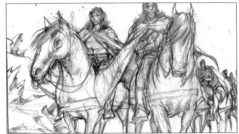
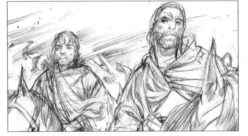

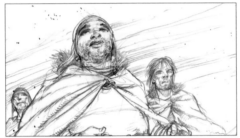

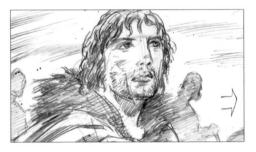

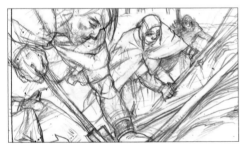
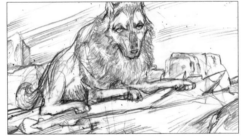
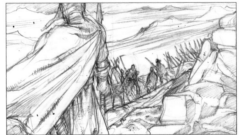
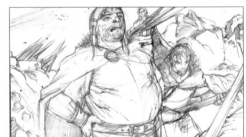

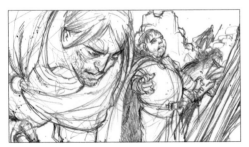

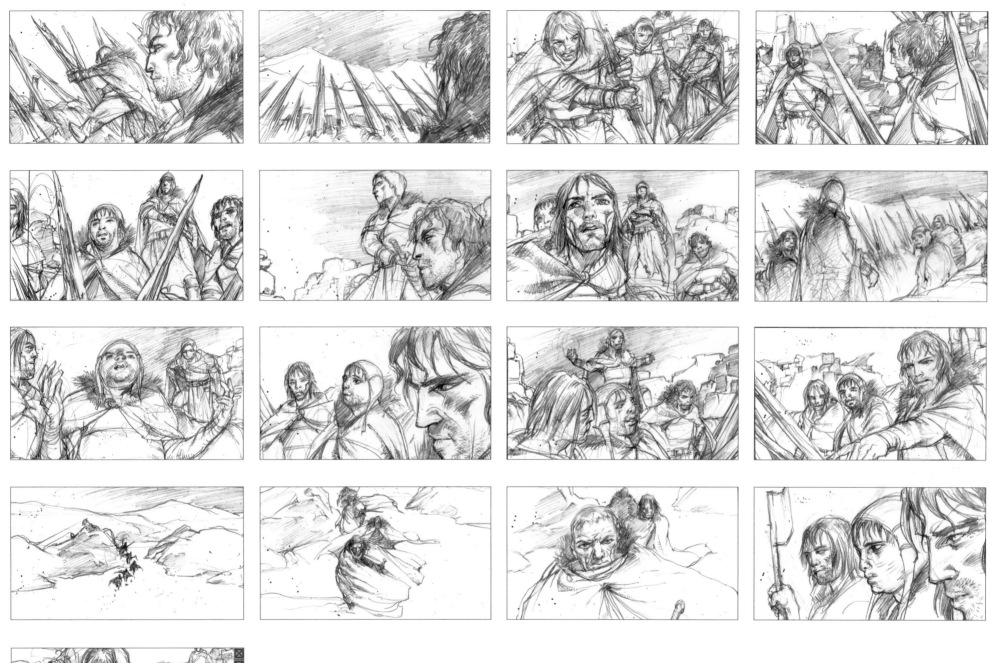

The storyboards have the company riding on horseback. In the episode, however, they are all on foot in a single-file line. In the storyboards, the Night's Watch further fortify the Fist of the First Men by laying down spikes around the rim of the hill to make a cheval-de-frise. The episode shows them digging, dragging sleds, and making camp rather than planting spears.

Episode 206

THE OLD GODS AND THE NEW

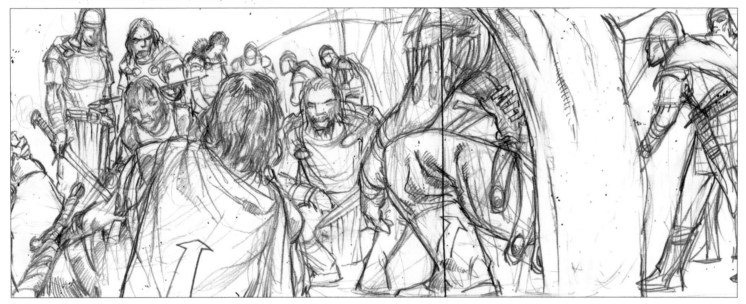

Robb Stark walks through his camp, encouraging his soldiers after their victory over the Lannister army. The storyboards show Robb staring at a young woman with her back to a tree—in the episode we see it is Talisa Maegyr, seated on a log in the camp.

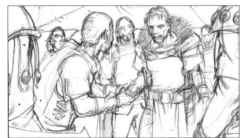

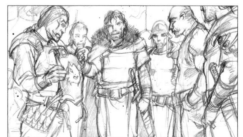

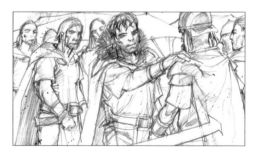

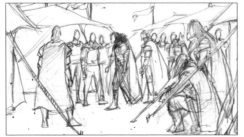

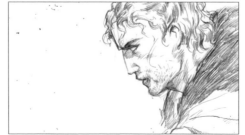

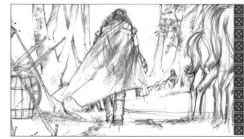

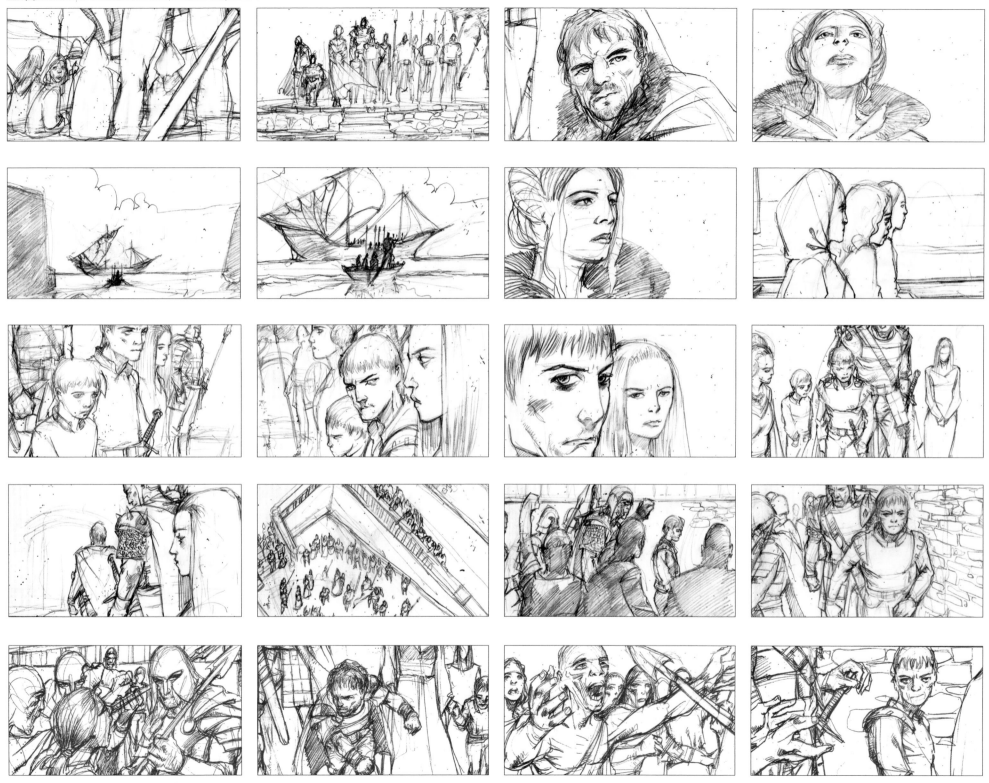

Sansa and Joffrey watch his sister, Princess Myrcella, leave King's Landing in a ship at the docks. Tommen cries at his sister's departure, and his tears irk Joffrey.

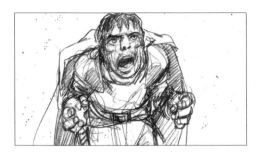
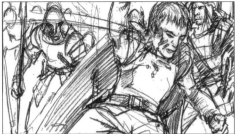
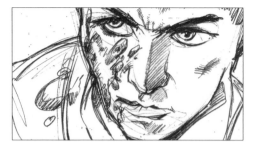
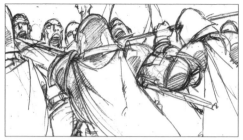
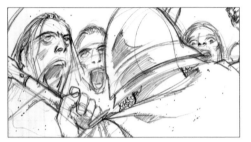
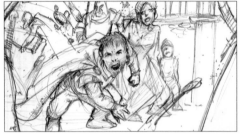
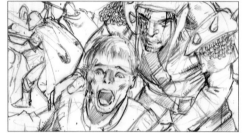

As Joffrey's royal company moves through King's Landing, a mob of rabble-rousers surrounds them and mocks Joffrey. When a pile of dung is thrown in Joffrey's face, the young king orders his Kingsguard to kill the peasants. Sansa is separated from the guards.

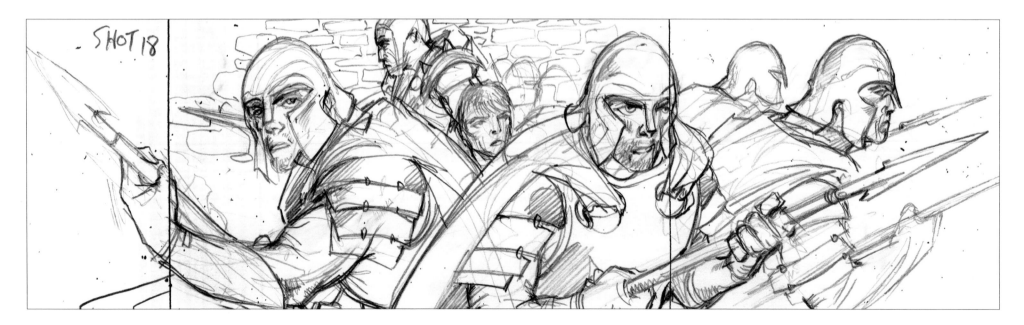

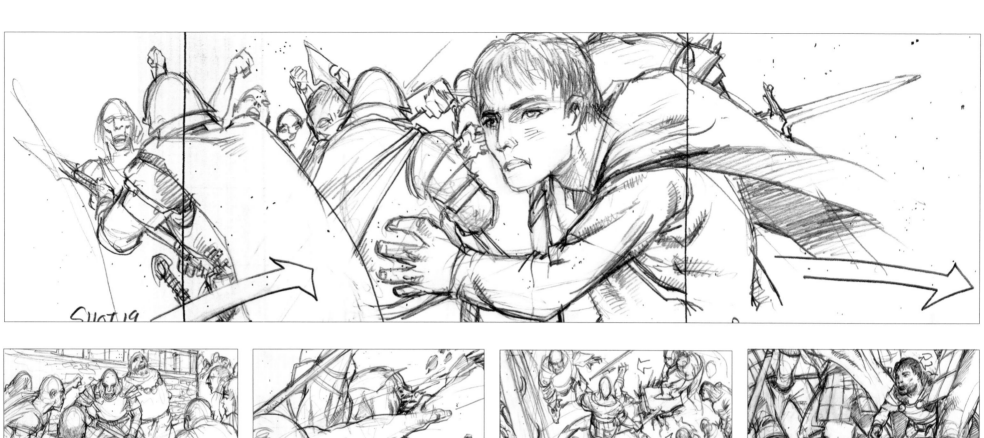

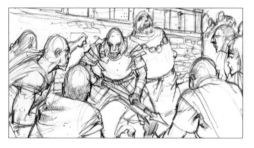

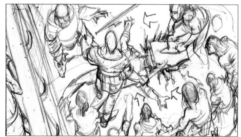

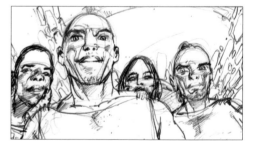

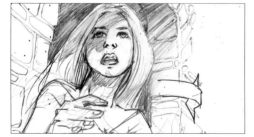

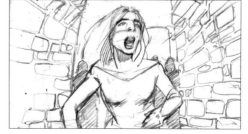
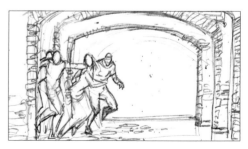

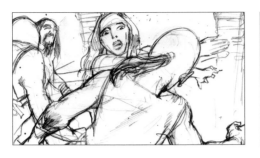
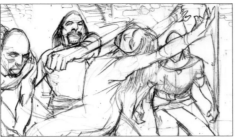
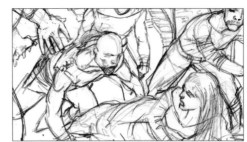
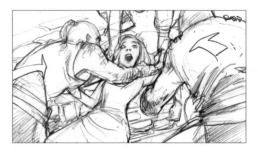

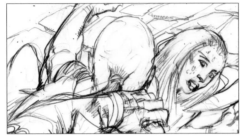
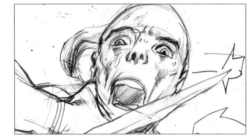

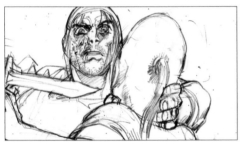
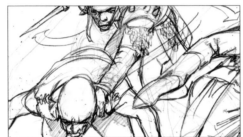

"A producer asked me to draw up the riot scene because they wanted to visualize a part of the sequence and were trying to suss out problems that might occur while filming. I was given a layout and a set of photographs of this little area in Dubrovnik, Croatia, which doubled as King's Landing. I drew my storyboards from the script and these photographs," says Simpson.

"When I eventually visited Dubrovnik, [I walked] through the gates [and] saw everything I'd already drawn but had never seen in reality," adds Simpson. "A lot of what I had worked out appeared on the screen, and that was incredibly satisfying."

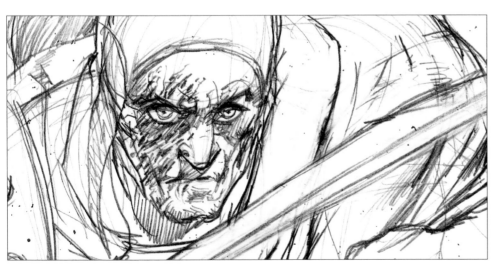
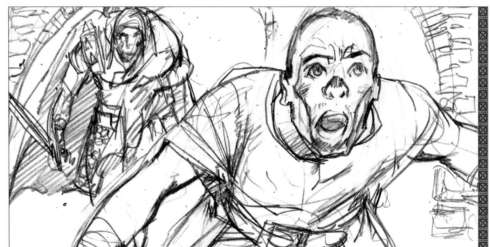

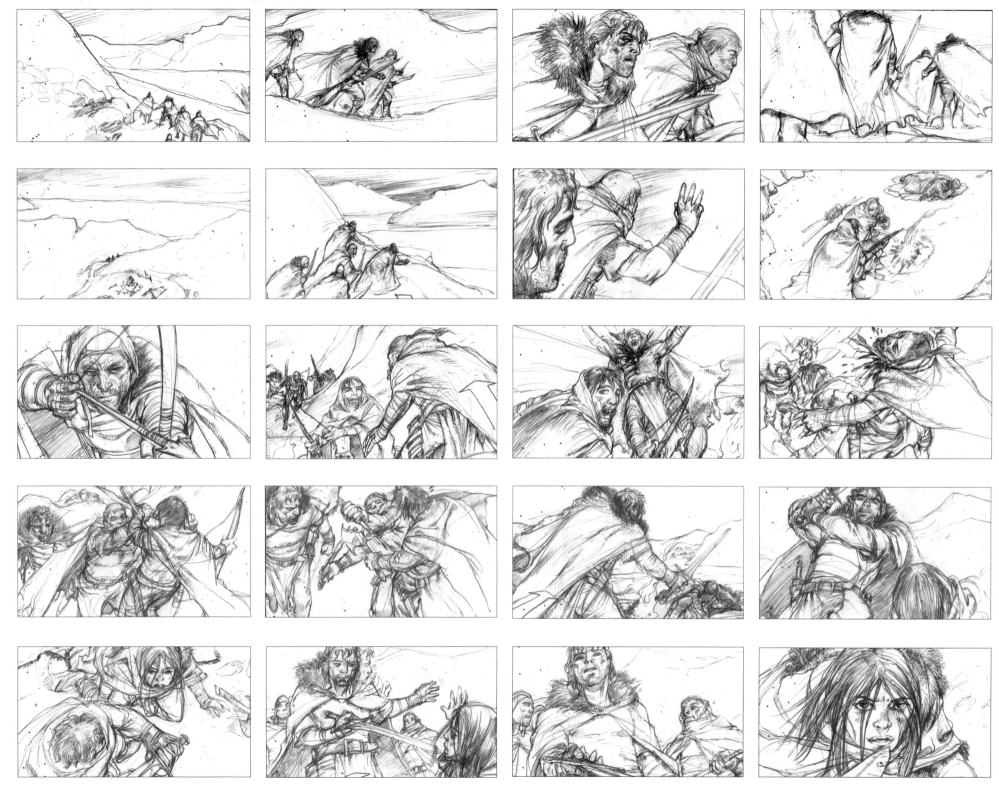

Qhorin Halfhand's rangers come across a wildling camp.

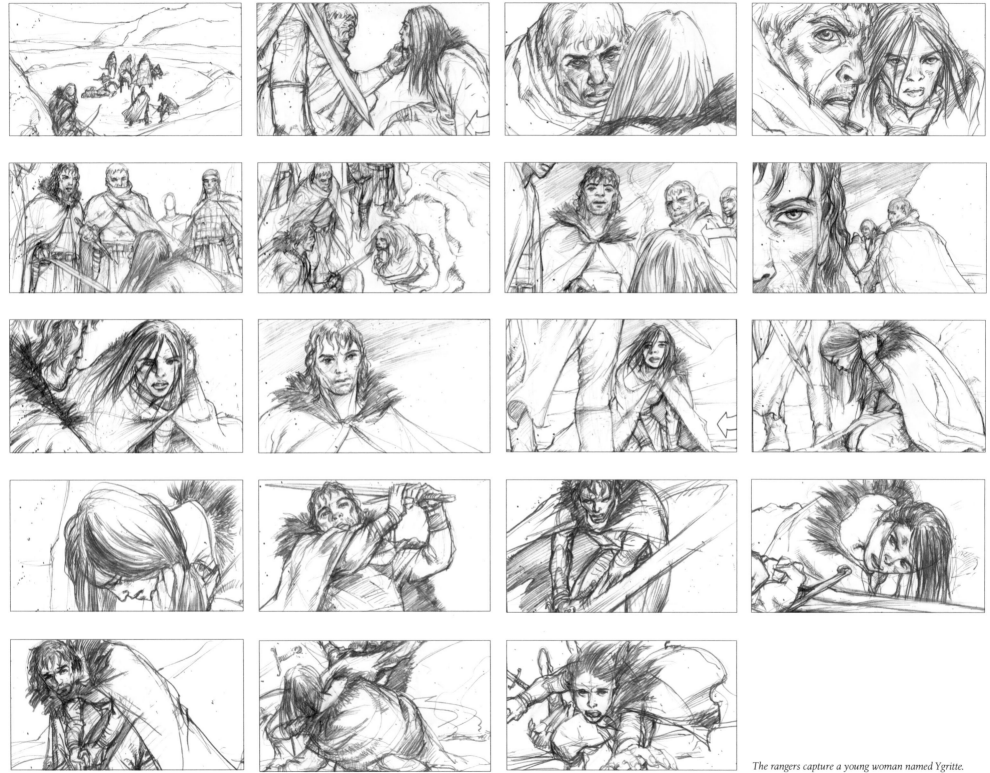

The rangers capture a young woman named Ygritte.

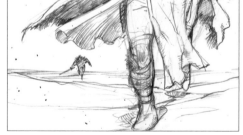

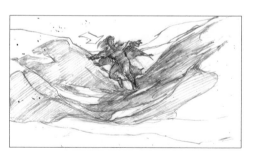

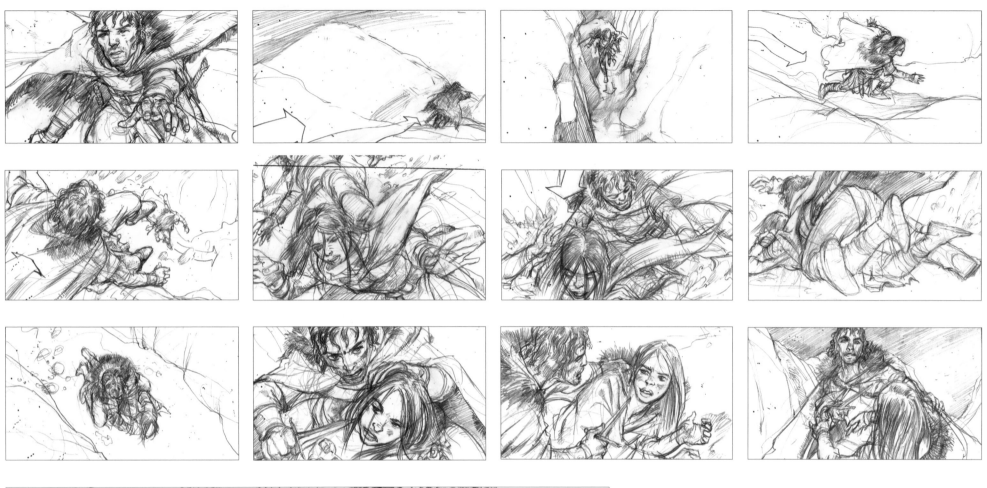

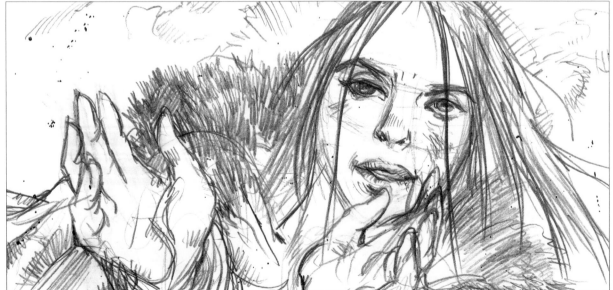

Jon Snow catches up to Ygritte and captures her again.
They travel through the icy wastes, searching for Qhorin
and the scouting party.

 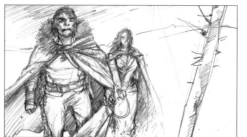 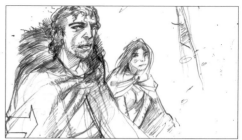

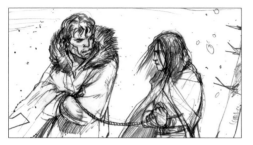 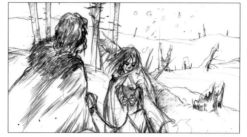 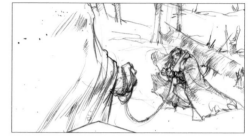

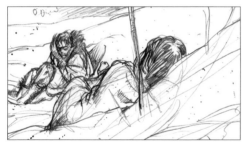 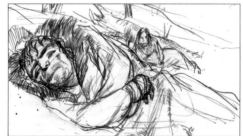 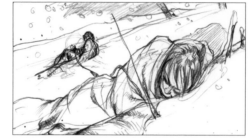

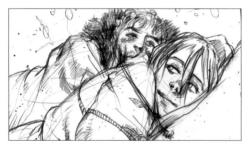 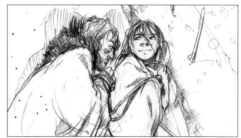

"Stop moving."

—JON SNOW

"I'm just trying to get comfortable."

—YGRITTE

Episode 207

A Man Without Honor

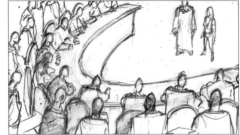
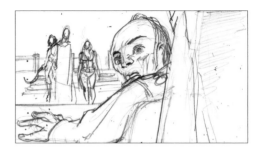

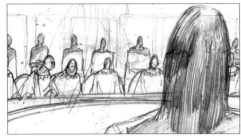
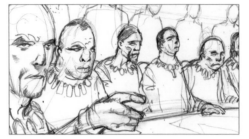
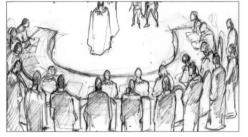

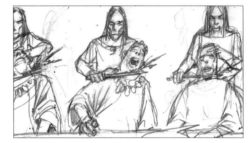

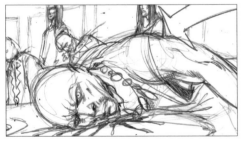
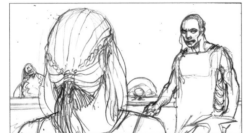
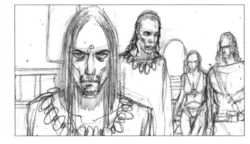
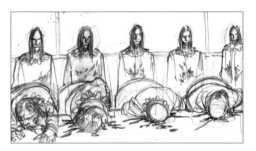

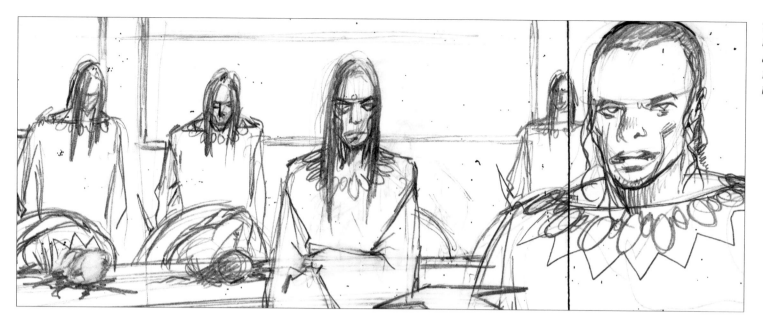

The Thirteen, Qarth's ruling council, meets inside the home of Xaro Xhoan Daxos. Daenerys demands her dragons back. Pyat Pree reveals that he made a deal with Daxos to steal her dragons before he uses his magic to kill the other council members.

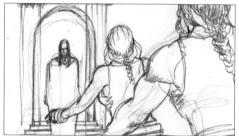
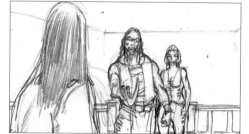

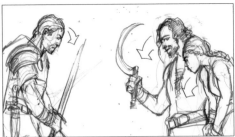

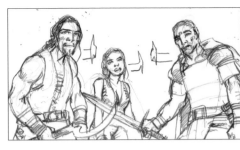

Pree appears in a hall, telling Daenerys her dragons await her in the House of the Undying.

GAME OF THRONES - SEASON 2 - EP. 207. - SCENE 7.14

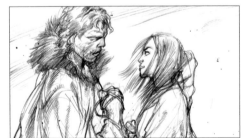
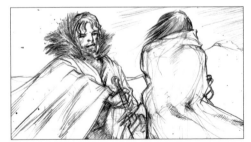

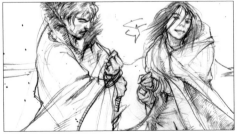

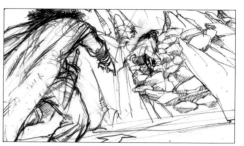

Jon Snow and Ygritte wander on the glacier, obviously lost, though Jon refuses to admit it. Ygritte tricks Jon, and he falls. When he recovers, he finds he's surrounded by armed wildlings. He is now their prisoner.

Episode 209

BLACKWATER

Davos was described in the original scripts as a barbaric pirate. In these storyboards, Simpson has drawn Davos as a grizzled pirate with a flowing mane of hair.

 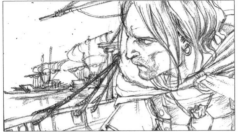

GAME OF THRONES - SEASON 2 - EP 209

 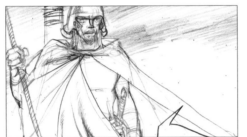 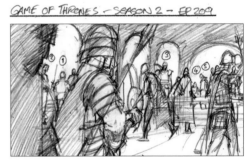

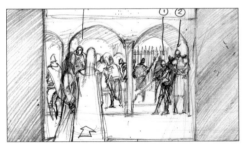

Before riding off to battle his uncle's invading forces, Joffrey makes Sansa kiss his new sword, Hearteater. She does.

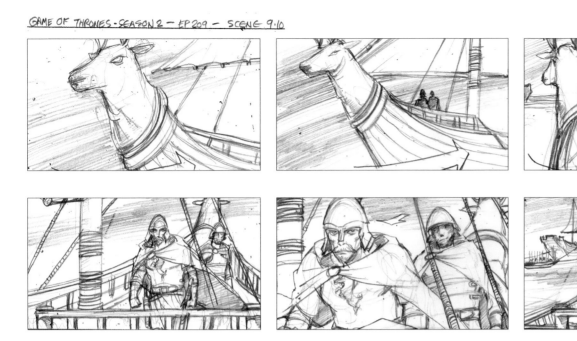
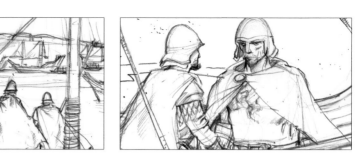

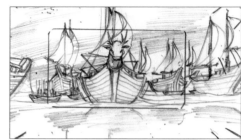

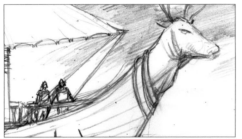

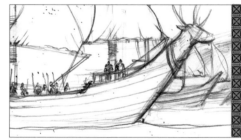
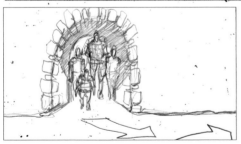

GAME OF THRONES - SEASON 2 - EP 209 - SCENE 9.12

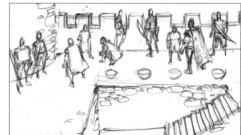

As Stannis stands on the deck of his flagship, the Fury,
with Ser Imry Florent, Stannis's soldiers are armed and
ready below decks.

To illustrate large naval sequences like those seen in the
Battle of the Blackwater, Simpson watched sailing films,
took reference photos in harbors, and walked around
the Game of Thrones ship sets.

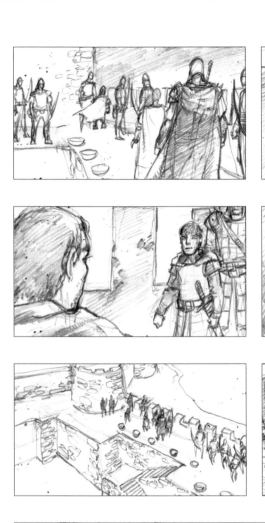

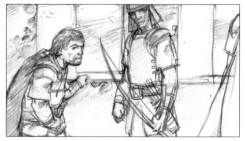

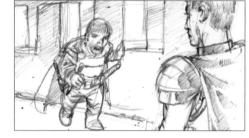
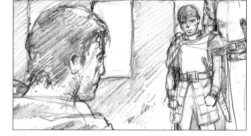
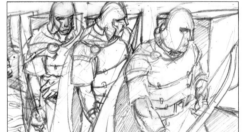

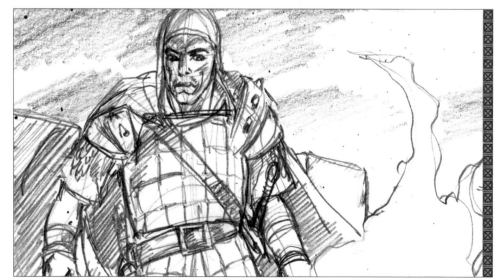

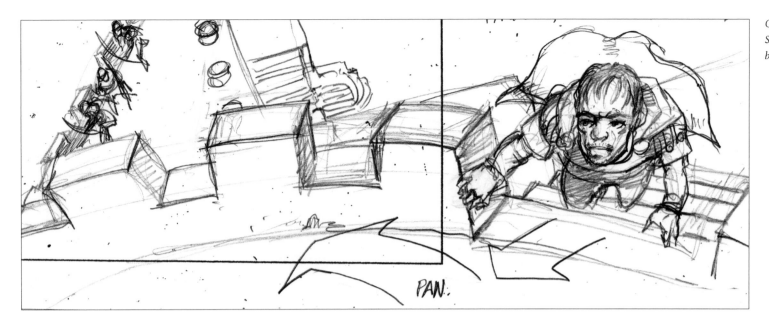

On the parapet of the Mud Gate, Tyrion watches as Stannis's ships approach. Lannister archers ready their bows.

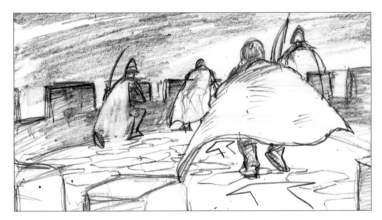

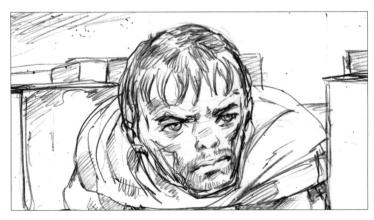

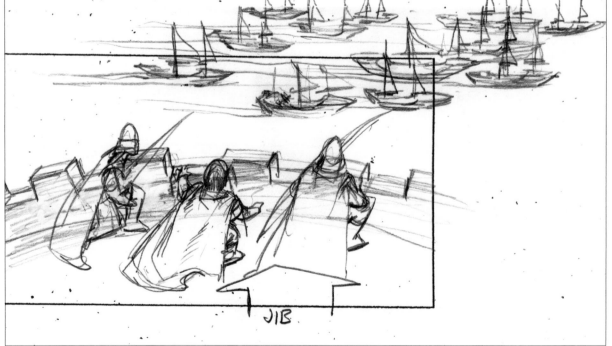

 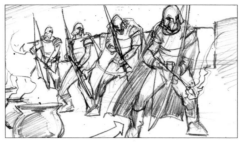 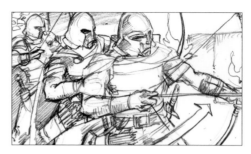 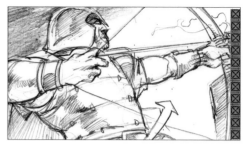

GAME OF THRONES – SEASON 2 – EP 209 – SCENE 9.15

 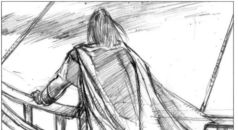 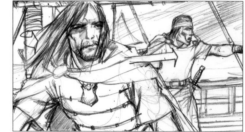

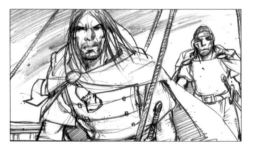 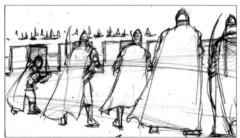 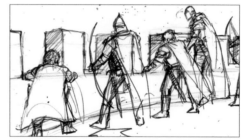

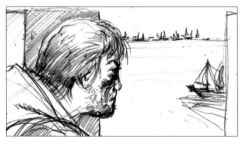 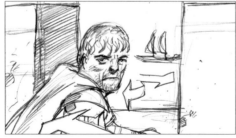

Hallyne the Pyromancer, leader of the Alchemists' Guild, ascends the stairs of the Mud Gate. In the episode, he bears a torch.

The lone ship approaches the Black Betha, its tiller arm rigged to move on its own.

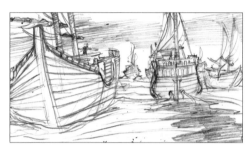 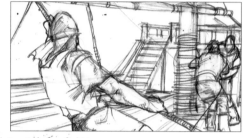

Green liquid springs from holes in the side of the ship to coat the water in the bay.

The storyboards show Hallyne lighting a piece of wood from a pitch pot. In the episode, his torch is already aflame.

GAME OF THRONES SEASON 2 - EP 209 - SCENE 9.22

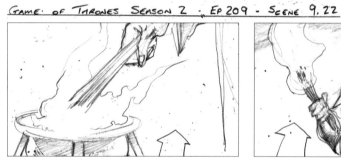 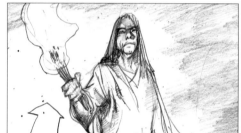 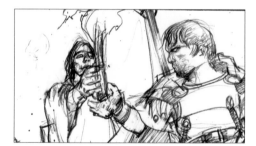

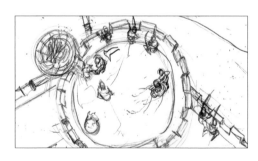 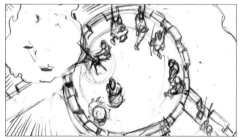 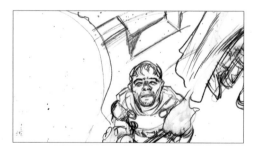 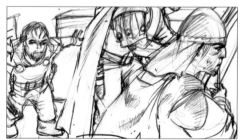

Hallyne gives the burning brand to Tyrion. Tyrion tosses the torch over the ramparts. Bronn sees Tyrion's signal and fires a burning arrow.

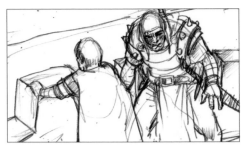

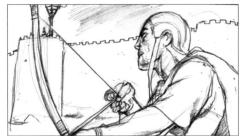
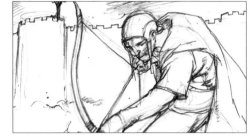

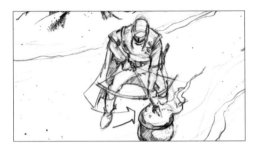
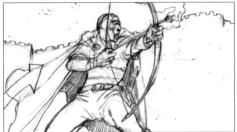
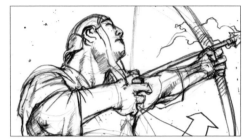

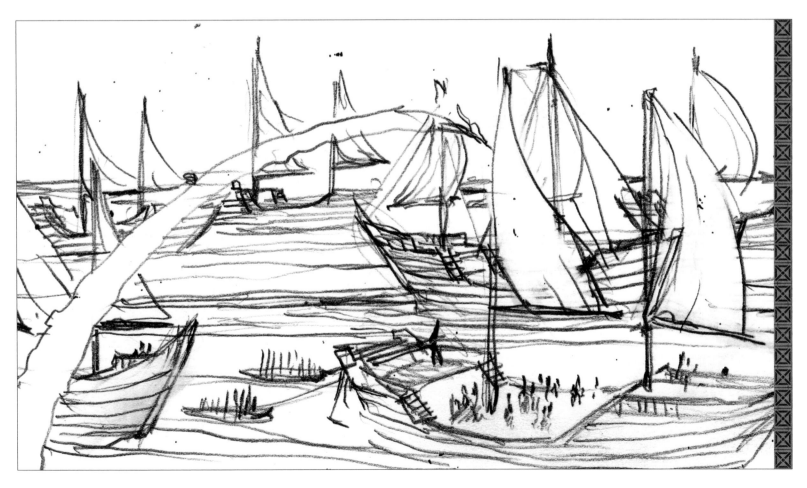

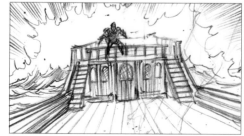

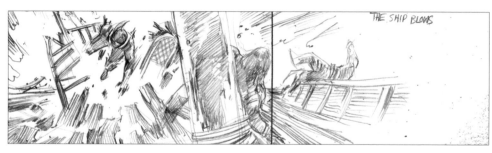

Seeing the green liquid catch fire, Ser Davos screams to his son, Matthos, to get down as the wildfire ignites and causes catastrophic damage, blowing apart many ships in Stannis's fleet and hurling Ser Davos and Matthos into the water.

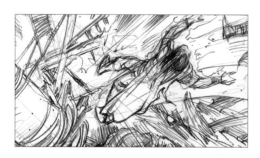
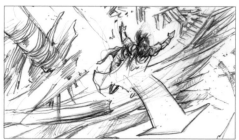
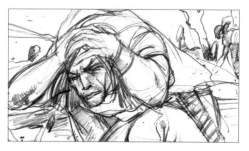
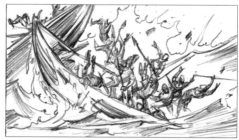

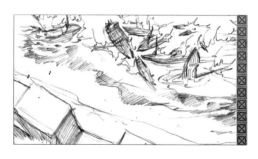

The soldiers who don't die in the blast find themselves on fire from the napalm-like qualities of the wildfire. Despite their heavy losses to the wildfire, Stannis orders the sailors to land. He knows that the next battle might cost thousands.

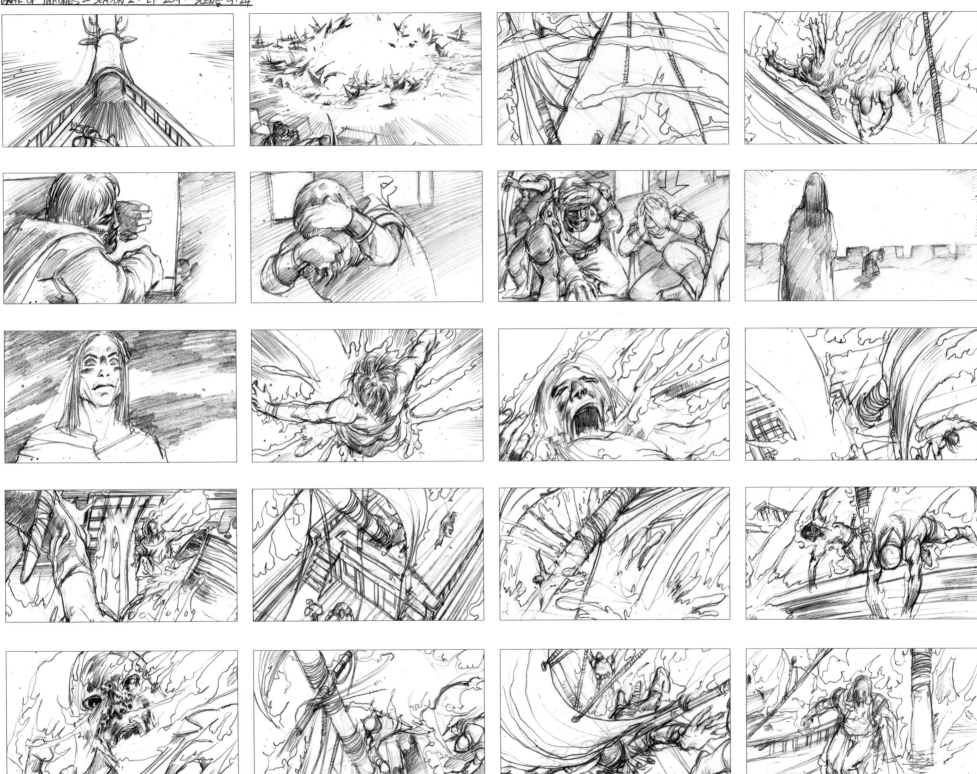

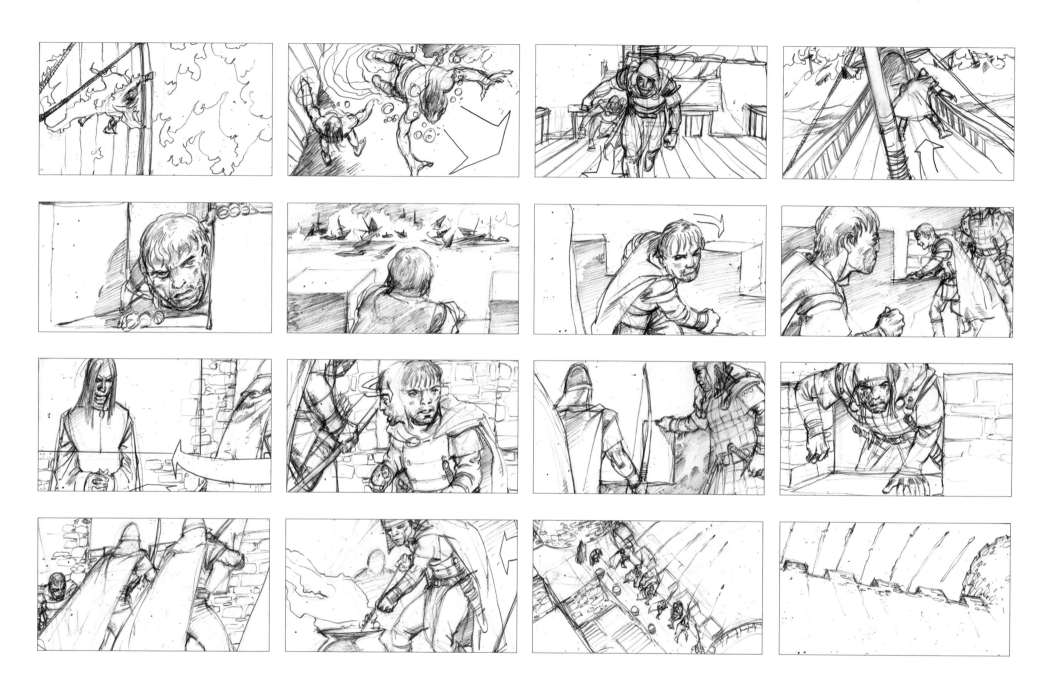

Tyrion, Joffrey, Hallyne, and the Hound watch the ships burn.

"My initial 'Hound' drawing focused on his gritty costume, helmet design, and gnarly weaponry. Everything connected to the Hound was meant to sum up the warrior side of his character, which had to be brutal, so his imagery was damaged and damaging," says Simpson.

Simpson continues, "He was to be the weapon of mass destruction, capable of carving up anything in his path. His weaponry and armor reflected this persona, and thus a collaboration of casting, my drawings, and the costume design pushed this character into being. It's the way a production is developed, with foundations and additions on top of improvements that create a whole."

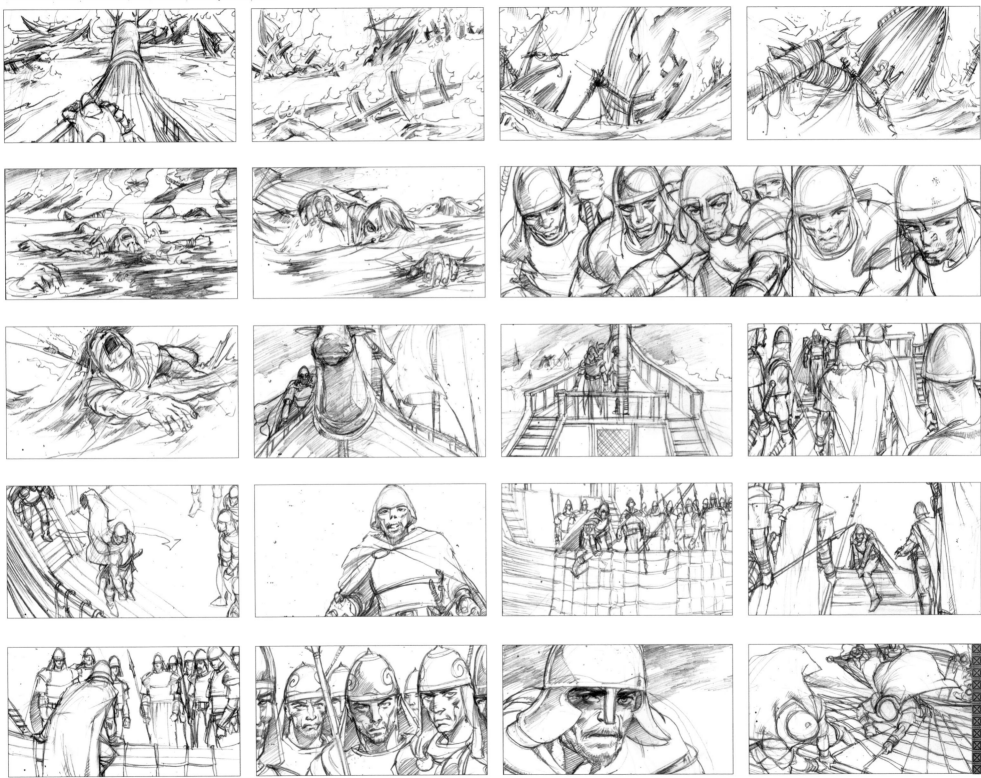

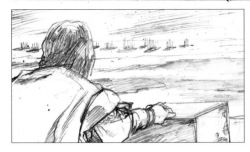
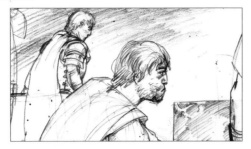
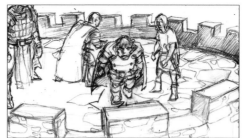
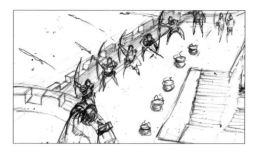
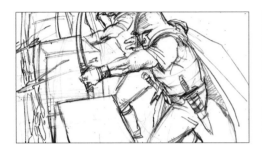
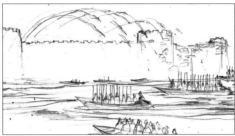

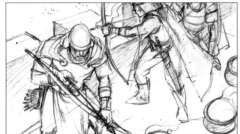
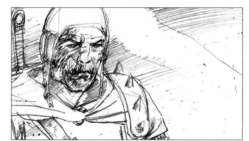

On the parapet, Tyrion orders the archers to rain fire on the skiffs and sends the Hound down to form a "welcoming party" to any soldiers that make it ashore. He has his squire, Podrick Payne, run to the King's Gate to bring more men.

"He's a serious man, Stannis Baratheon."

—TYRION LANNISTER

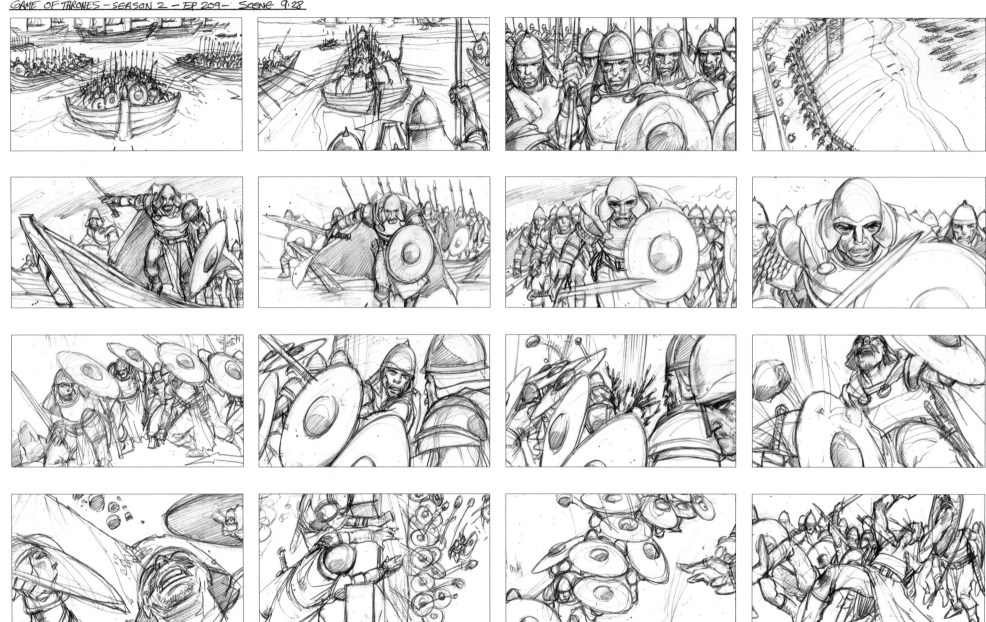

Stannis's longboats land near the shore. Archers loose
more arrows down on them while other soldiers drop
rocks on Stannis's men.

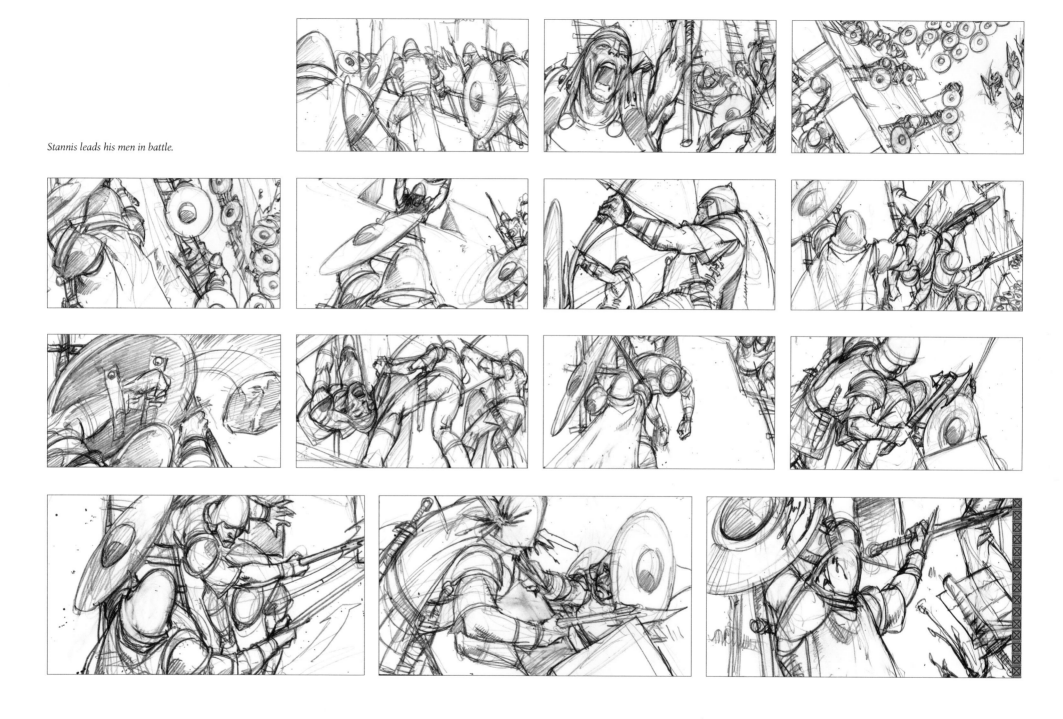

Stannis leads his men in battle.

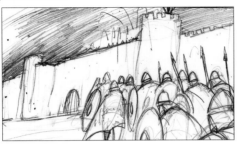
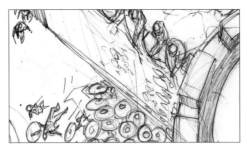
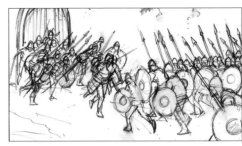

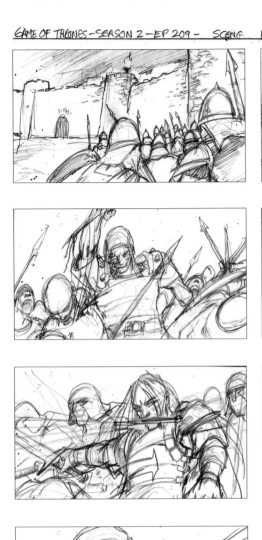
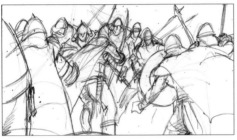
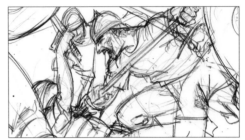
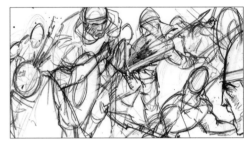

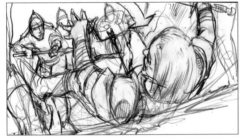

The Hound and Bronn fight through the battle at the base of the gate.

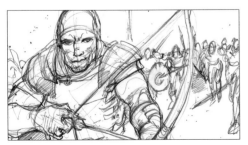

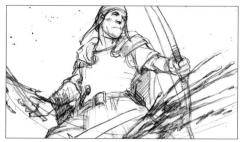

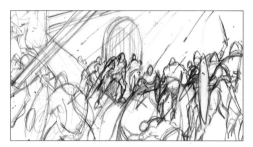
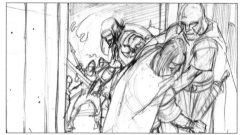
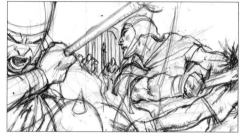

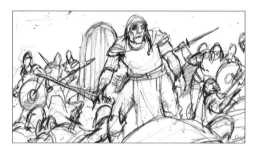
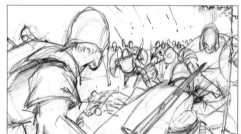

Joffrey's forces fall back to the Mud Gate, the Hound with them.

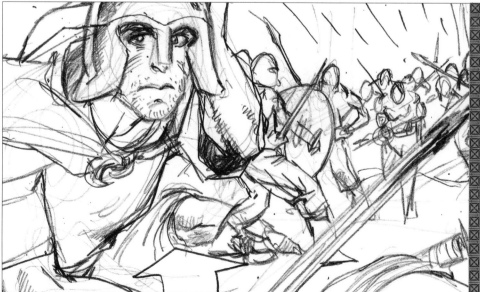

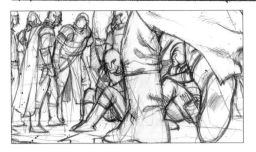
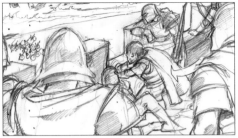
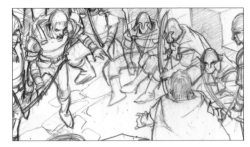

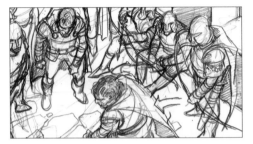
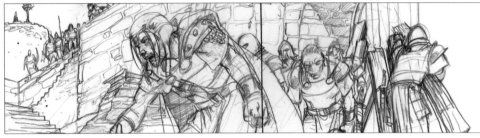

King Joffrey screams at the Hound, calling him a dog and ordering him to go back and fight. Tyrion reminds the Hound he is a member of the Kingsguard. If he doesn't beat Stannis's forces back, they will take the king's city.

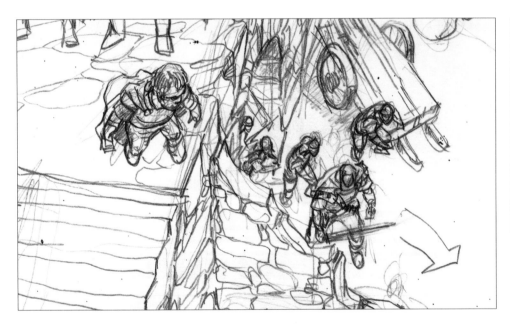
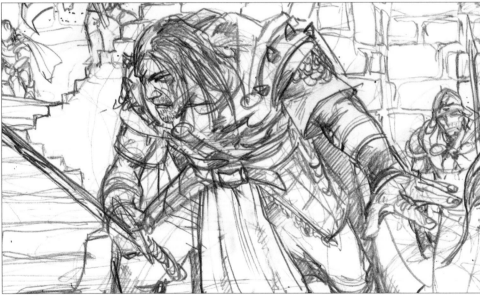

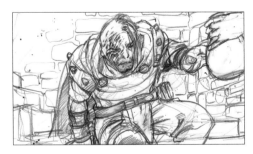

The Hound curses the Kingsguard, the city, and the king, and then walks off.

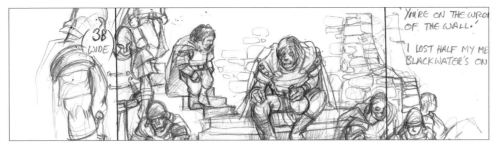
YOU'RE ON THE WRO[NG]
OF THE WALL!

I LOST HALF MY ME[N]
BLACKWATER'S ON

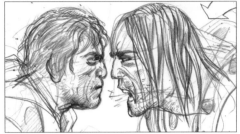
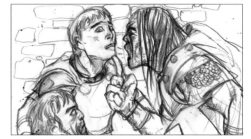
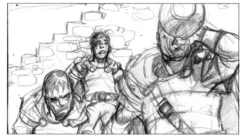
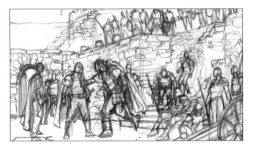

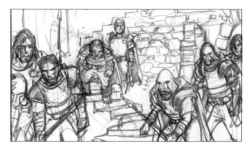
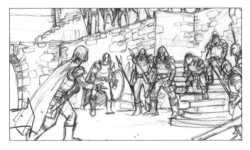

Joffrey is conflicted. Tyrion tells him it's time for him to lead his men into battle. But Joffrey instead departs with Lancel.

With their king gone, the soldiers have no leader and begin to question their loyalty. As Stannis's ram knocks against the gate, Tyrion decides he will lead the attack and rallies the men with a speech to defend their city, else they might lose everything they have.

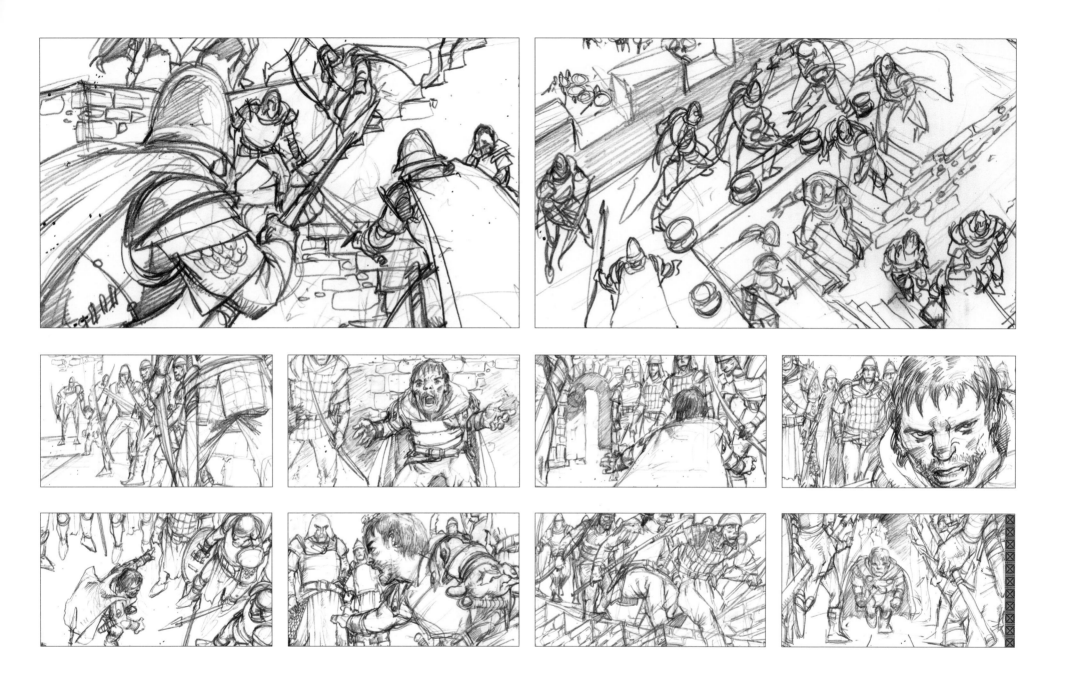

"The director's first words, after seeing the initial boards, were 'We need more blood!'
I thought to myself, 'Now we're cooking!' A lot of extra drawing and version four of
these boards—full of boulders [flung over walls], was the final result. The director
had an amazing eye for compacting the essential form into super dramatics. It was an
incredibly intense episode to work on and it remains a favorite scene because of it," says
Simpson.

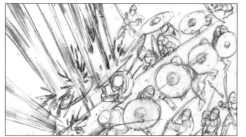
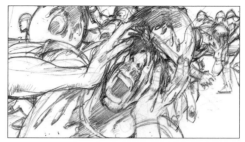
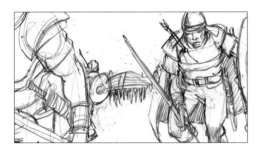
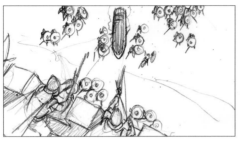
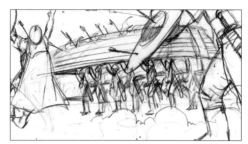
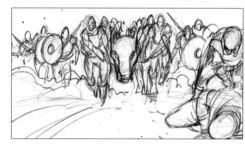
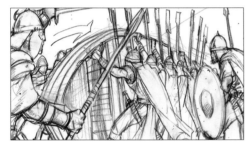
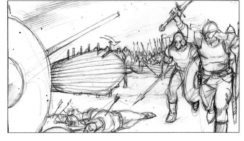

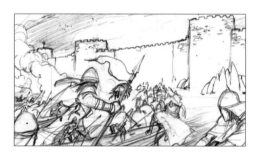

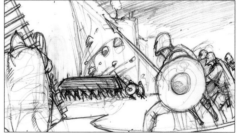
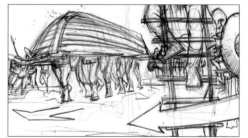
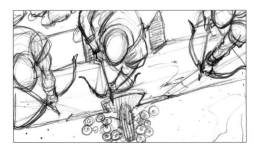
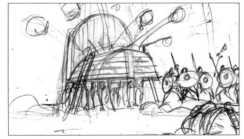

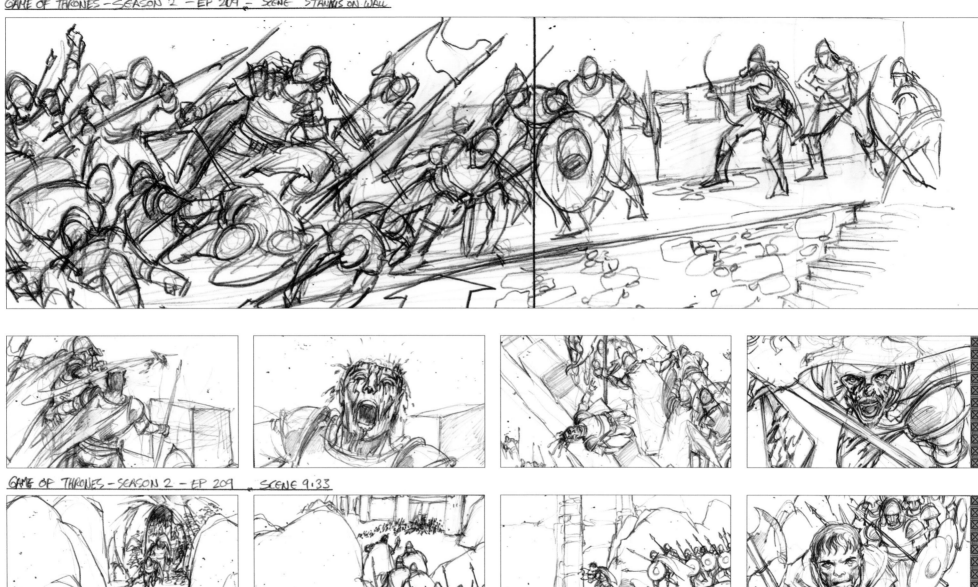

GAME OF THRONES - SEASON 2 - EP 209 - SCENE STANNIS ON WALL

GAME OF THRONES - SEASON 2 - EP 209 - SCENE 9.33

Tyrion takes the Kingsguard through a tunnel out of the wall. Unlike in the storyboards, he wears an oversized helmet in the episode. The storyboards show Tyrion leading the Kingsguard around the wall for a sneak attack. In the episode, he leads them straight into battle.

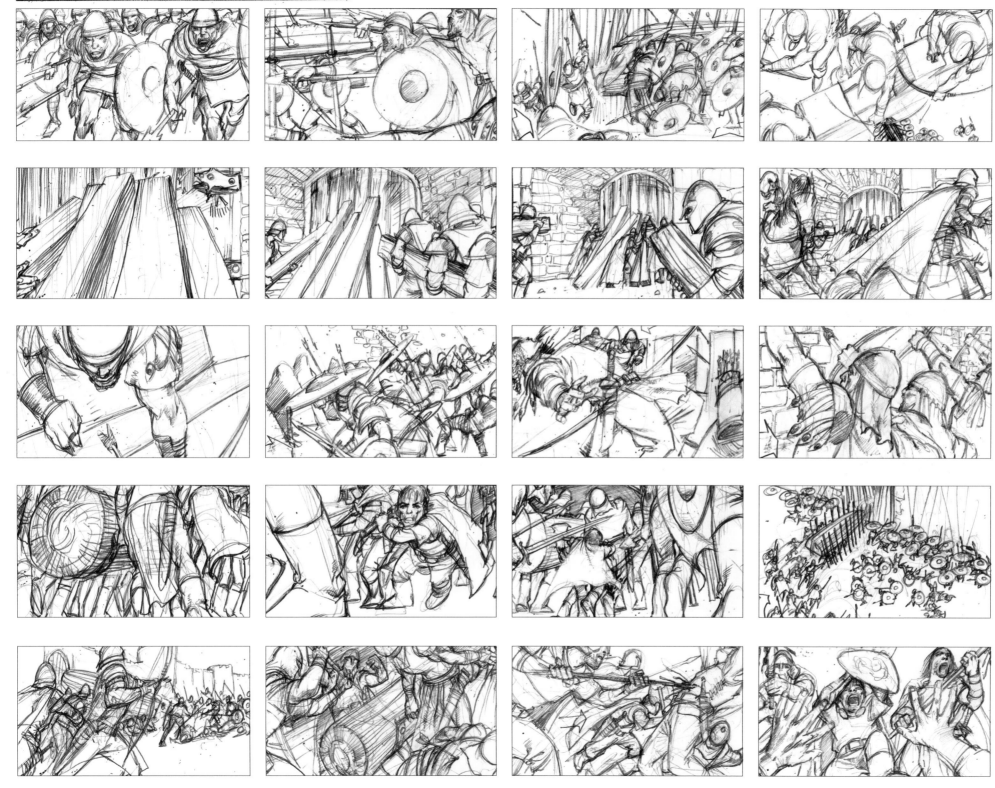

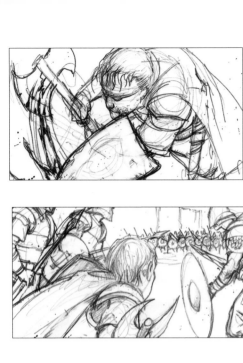
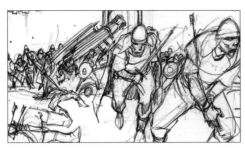
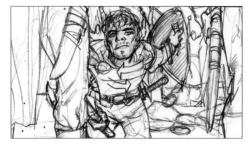
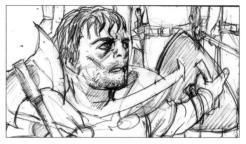

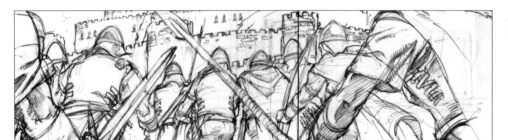

Armed with an axe, Tyrion chops an opponent down at his legs and yells for the Kingsguard to attack.

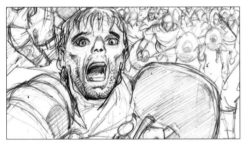
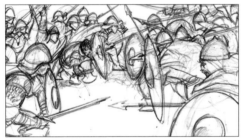
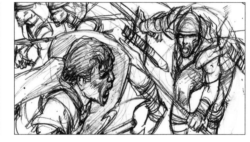
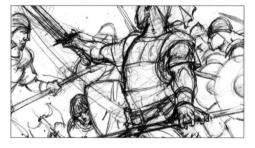

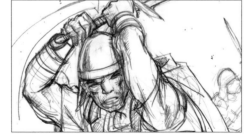

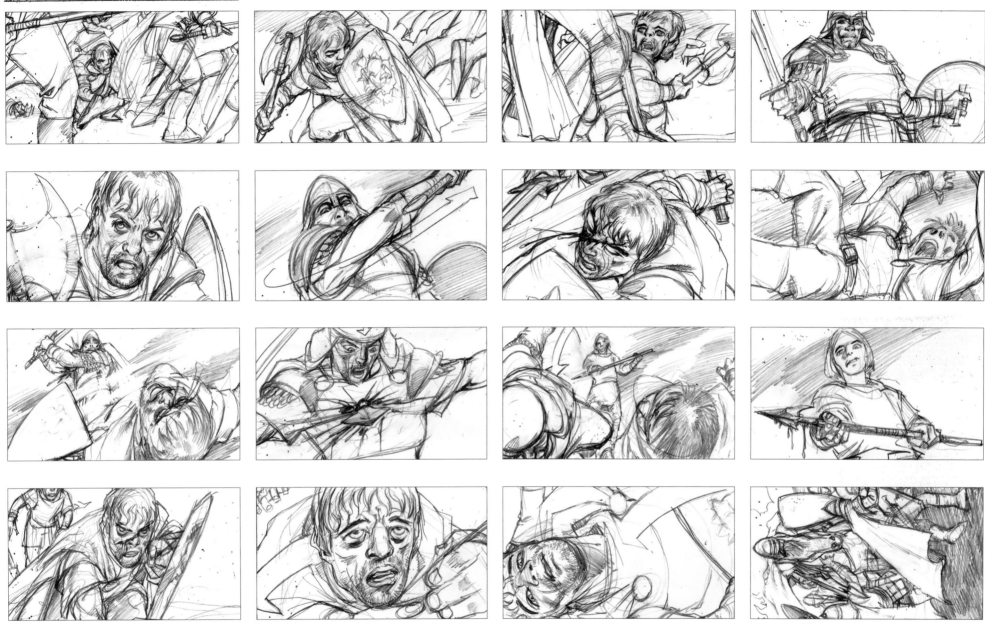

Tyrion holds a shield in the storyboards, but in the episode, all he has is his weapon.

Ser Mandon Moore of the Kingsguard sees Tyrion in the battle and attempts to kill him on the battlefield. His first swing of his sword slashes Tyrion across the face. Tyrion falls but is saved by Podrick.

Stannis Baratheon has climbed the Mud Gate's wall and leads the assault, bringing down the Kingsguard and archers one by one.

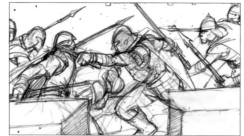

GAME OF THRONES - SEASON 2 - EP 209 SCENE 9·84D.

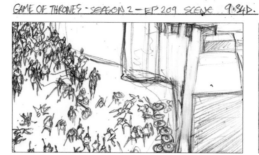
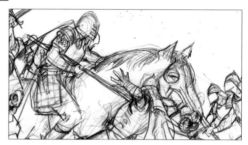

At the sound of a horn and the clatter of hooves, Stannis looks over the battlements. A cavalry arrives, holding high the lion banner of House Lannister. They go to work battling Stannis's troops.

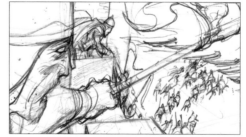

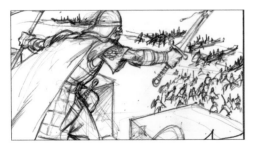

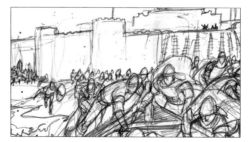

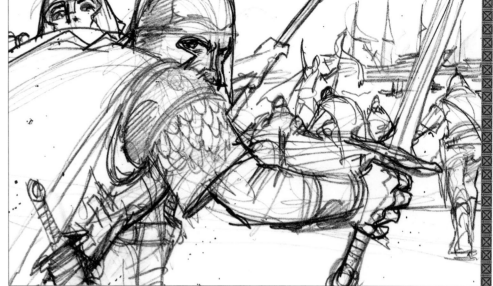

"Stand and fight!"

—STANNIS BARATHEON

GAME OF THRONES – SEASON 2 – EP 209 – SCENE 9.34 F

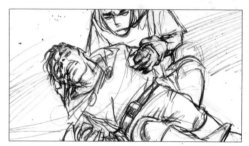

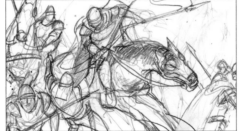

Episode 210

VALAR MORGHULIS

GAME OF THRONES — SEASON 2 — EP 210 SCENE 10.2

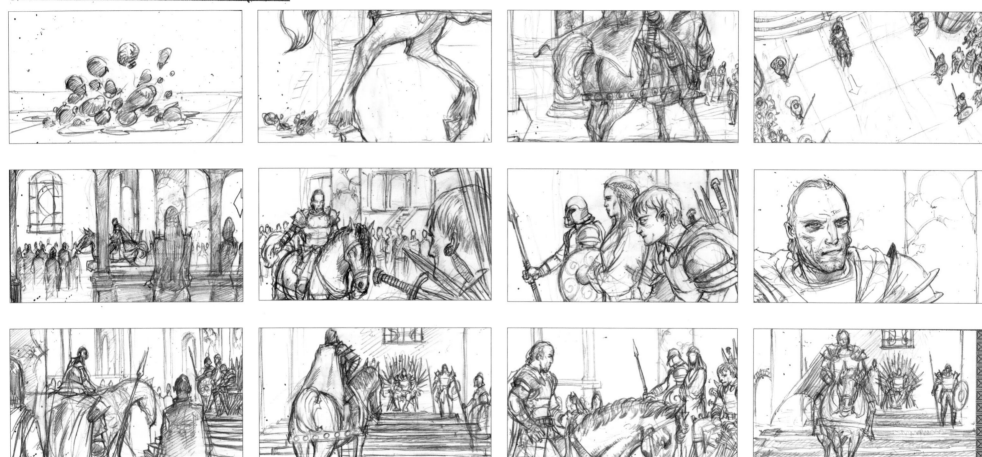

"I, Joffrey of the House Baratheon, first of my name, the rightful King
of the Andals and the First Men, Lord of the Seven Kingdoms and
Protector of the Realm, do hereby proclaim my grandfather, Tywin
Lannister, the savior of the city and the Hand of the King."

—JOFFREY BARATHEON

GAME OF THRONES - SEASON 2 - EP 210 - SCENE 10.07 - 10.25

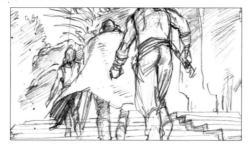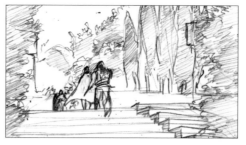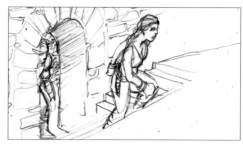

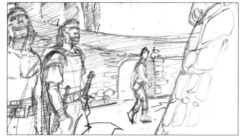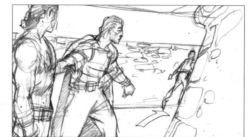

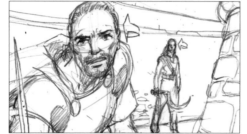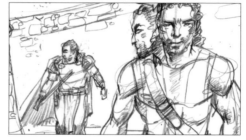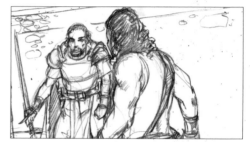

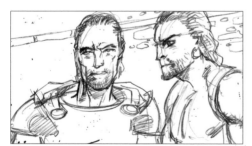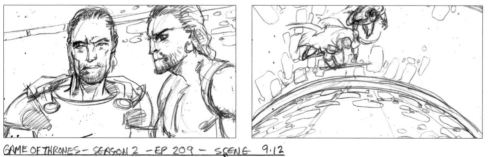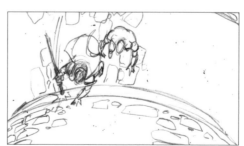

At the House of the Undying, Daenerys, Kovarro, and Ser Jorah search for a doorway into the tower.

GAME OF THRONES - SEASON 2 - EP 209 - SCENE 9.12

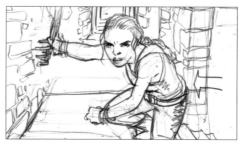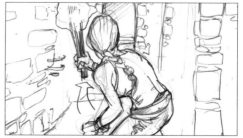

Daenerys has found a way into the tower. She takes a
lighted torch off a sconce and walks up a staircase. Jorah
attempts to follow, but she manages to always be a few
steps ahead, until finally he loses her altogether.

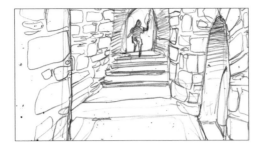

 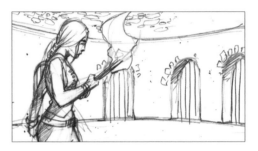

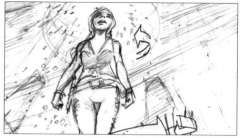

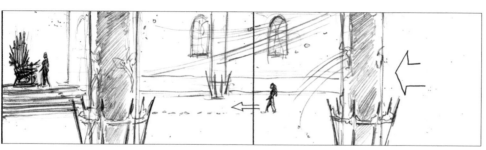

Daenerys opens a door and walks into the Great Hall of the Red Keep. When she comes into the center of the room, near the Iron Throne, she puts her torch down on the ground. She reaches to touch the throne but stops when she hears the screeching of the dragons again.

The sound of dragons leads her to another door. She exits the gate of the Wall into a wintry landscape.

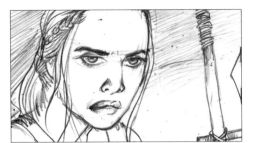

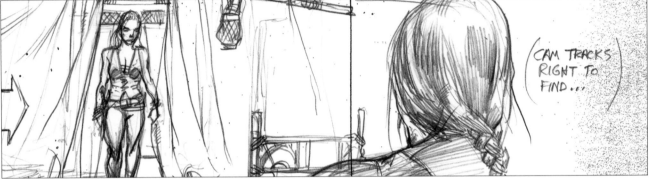

(CAM TRACKS RIGHT TO FIND...)

A Dothraki tent lies in the blizzard beyond, its flaps rippling in the harsh wind. Daenerys enters and finds Khal Drogo sitting inside the tent, holding their unborn son in his lap. When Daenerys pushes the flap to leave, she finds herself in the circular chamber with the surrounding doors. Chained to a stone dais in the middle are her three dragons.

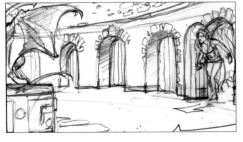
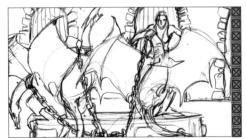

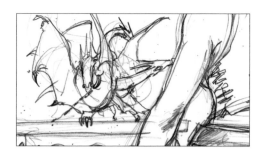
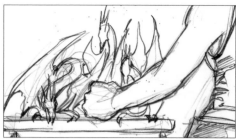

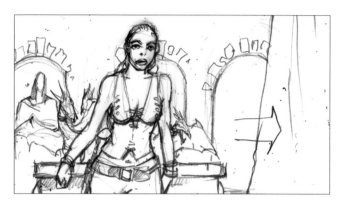

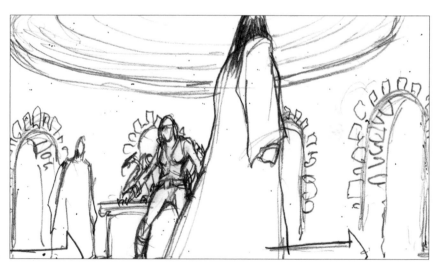

Daenerys goes up to her dragons to calm them. Pyat Pree appears behind her and then all around her. Shackles bind Daenerys's wrists.

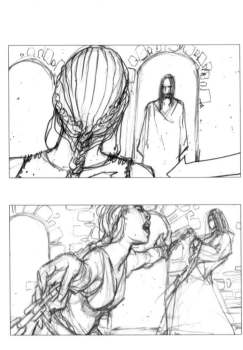
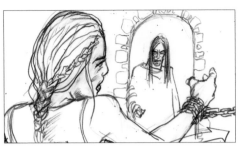
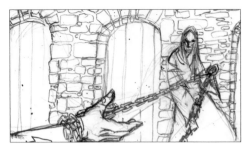
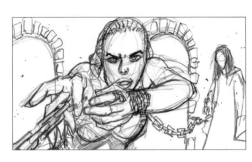

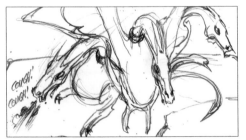
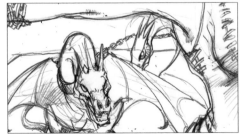

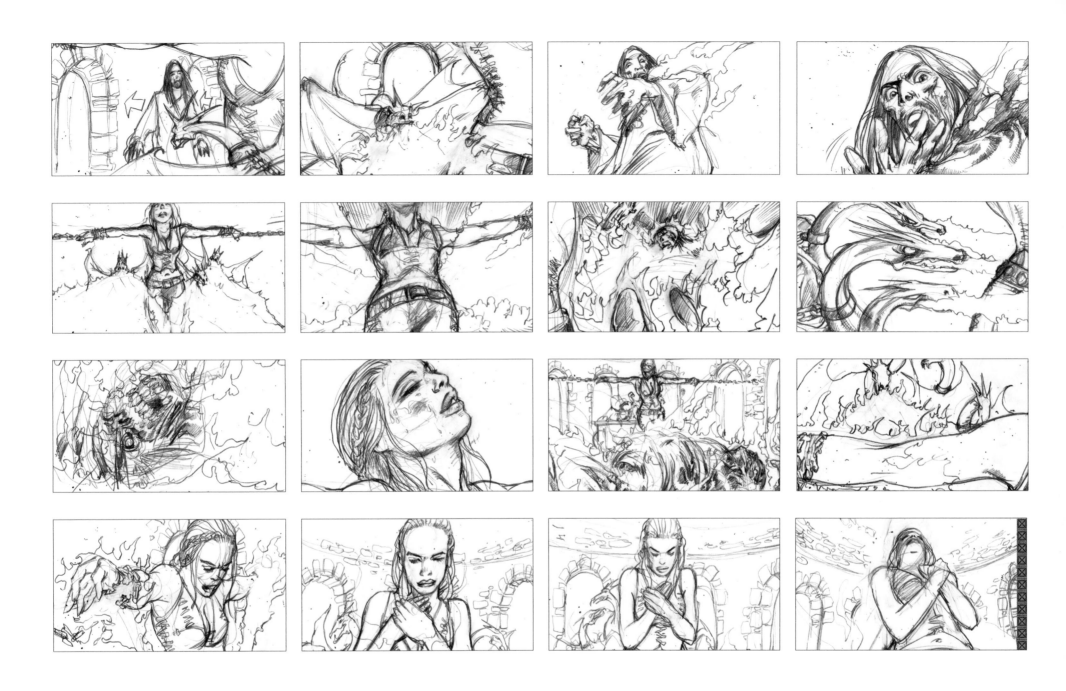

Chains pull Daenerys's arms out toward the walls, but she won't be Pree's prisoner. She commands her dragons with the High Valyrian command Dracarys.

The dragons breathe fire at Pyat Pree, consuming him and their chains in flame. The episode only implies that the dragons melt Daenerys's chains.

> *"Thank you, Xaro Xhoan Daxos. Thank you for teaching me this lesson."*
>
> —DAENERYS TARGARYEN

Ser Jorah, Kovarro, and Daenerys find Xaro Xhoan Daxos in bed with Daenerys's handmaiden, Doreah.

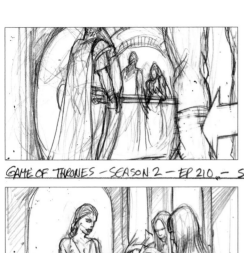

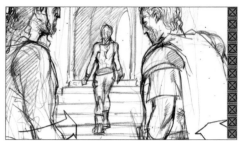

GAME OF THRONES – SEASON 2 – EP 210. – SCENE 10.32

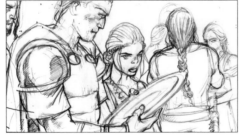

Kovarro unlocks Daxos's vault with his keys. Daenerys looks into the vault, finding nothing inside. She has Daxos and Doreah locked inside.

Daenerys has Ser Jorah and the Dothraki loot Daxos's house. What they find is enough to buy a ship.

North of the Wall, a dead horse carries a man with a spear, its tip seemingly made of ice. That rider is a White Walker, with burning blue eyes. In the episode, it sees Samwell hiding behind a stone but ignores him, raising its spear and shrieking.

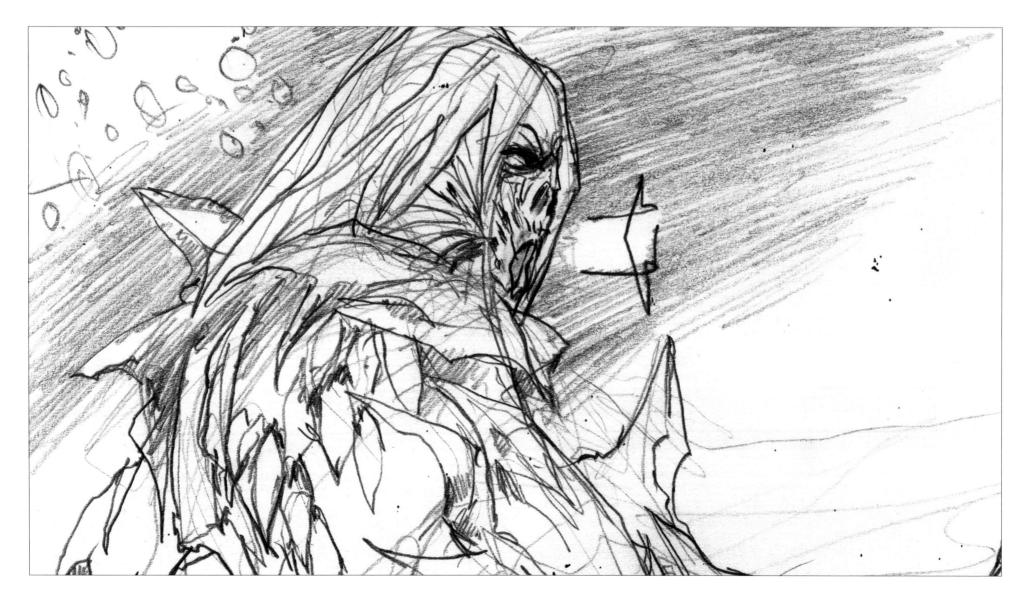

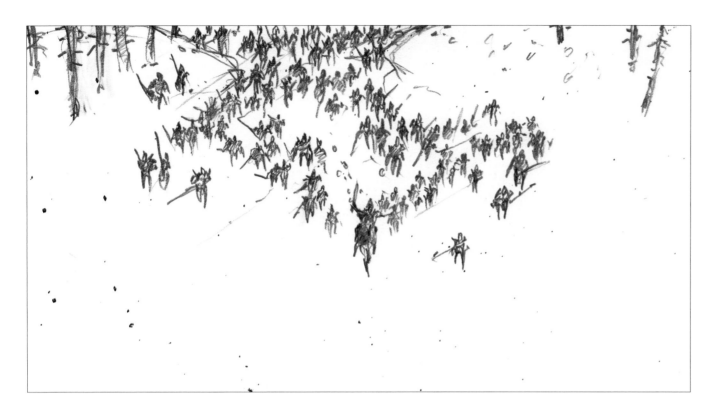

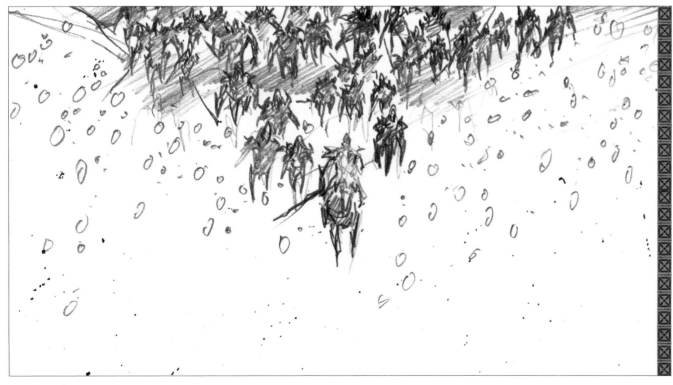

Behind the White Walker marches an army of the dead—
armed and armored.

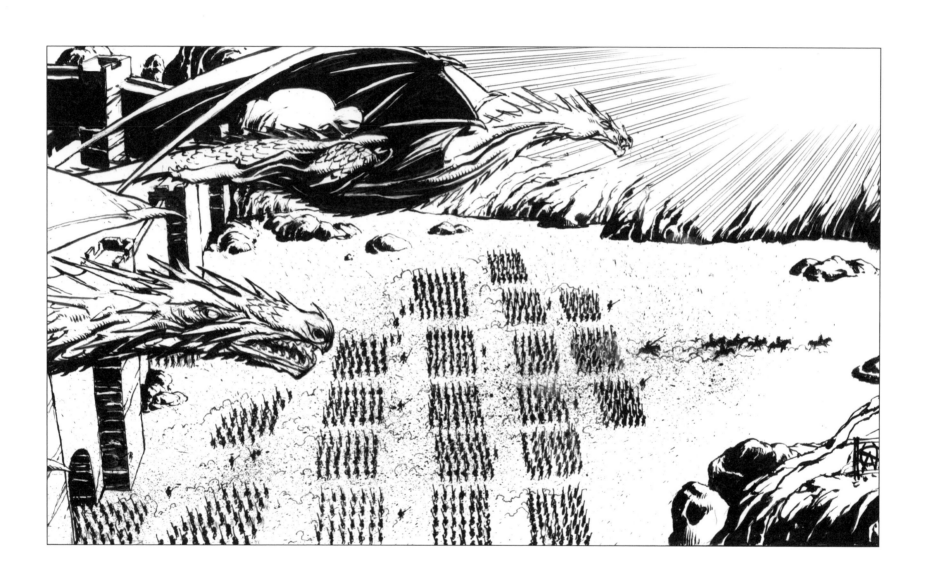

SEASON 3

Great losses have been sustained by all sides in the contest for the Iron Throne. Stannis Baratheon's army is but a vestige of what it was after the Battle of the Blackwater. Theon Greyjoy and Winterfell are now in the hands of the Boltons, with the house's illegitimate son, Ramsay, holding the castle that was once the property of the Starks. A cowardly King Joffrey stays clear of the action, allowing his mother, Cersei, and grandfather, Tywin, to plot and strategize. Robb and Catelyn Stark become two victims of Tywin's schemes during a massacre at the Twins of House Frey. Jaime Lannister manages to return to King's Landing with his life intact, though he has lost a hand.

A mutiny among the Night's Watch at Craster's Keep sends Samwell Tarly and the wildling woman he's sworn to protect, Gilly, back to Castle Black. Farther in the North, Jon Snow pretends to befriend the Free Folk to discover the ultimate plan of their leader, Mance Rayder.

The younger Stark siblings face their own array of troubles. Joffrey breaks his betrothal pledge with Sansa, instead forcing her to marry his uncle, Tyrion, while he plans to wed Margaery Tyrell. Arya joins the Brotherhood Without Banners on the road, witnessing some of their miraculous doings in the service of their god, the Lord of Light. Bran and his companions travel north, first to seek the safety of the Night's Watch, then to venture past the Wall and follow Bran's dreams of the Three-Eyed Raven.

Having defeated the merchants and warlocks of Qarth, Daenerys gains an army by bringing the slave soldiers known as the Unsullied into her fold and freeing them in the process. Her benevolence secures their loyalty to her, and one among them, Grey Worm, is made her advisor. With her dragons and soldiers, she liberates the slaves in the city of Yunkai. She is now the most well-known leader in Essos. Her main goal remains the Iron Throne.

Simpson has fond memories of working on the wildlings. "The wildlings are great fun to draw—any of those characters, like Tormund," he says. "Being able to play around with drawings of Tormund in scenes was just really appealing. One could say I have a soft spot for barbarians—I seem to click with them."

Episode 301

VALAR DOHAERIS

GAME OF THRONES – SEASON 3 – SCENE 1.19 EP 301

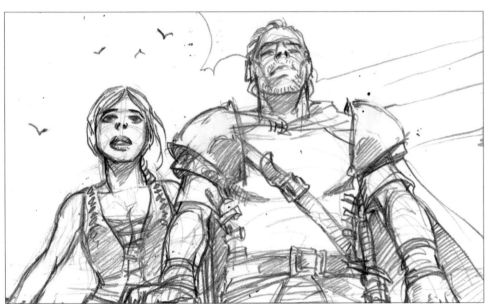

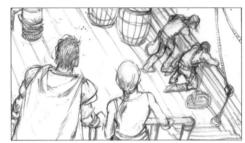 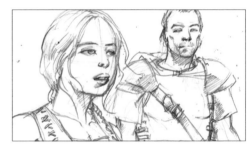

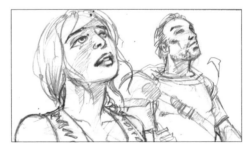

Daenerys's three dragons swoop over the ship Daenerys has bought with Xaro Xhoan Daxos's valuables. From the upper deck of the ship, Ser Jorah Mormont and Daenerys watch the dragons cartwheel in the skies, catch fish from the seas, and cook their prey with fire.

"They're growing fast."

—SER JORAH MORMONT

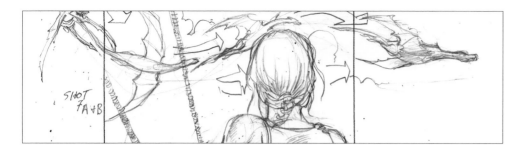

SHOT
7A+B

SHOT
10 A

(10B)

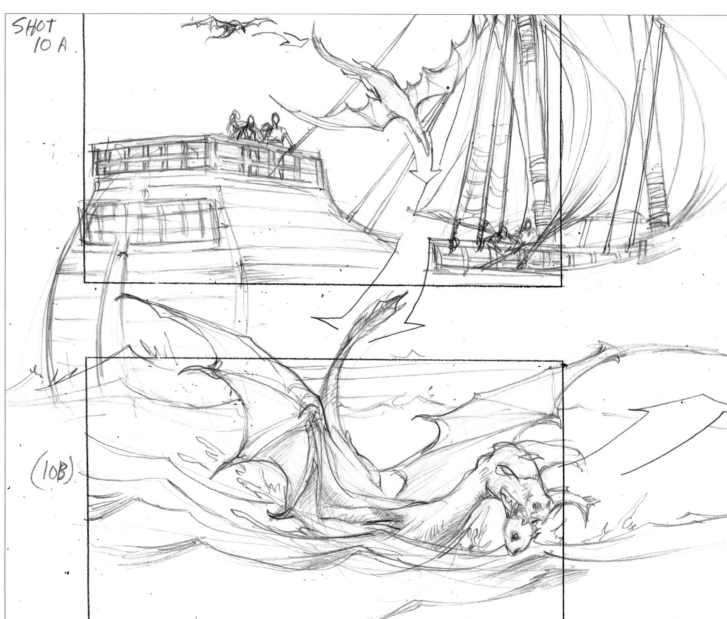

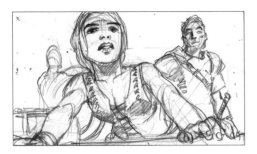
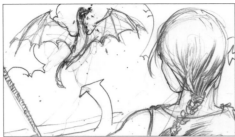
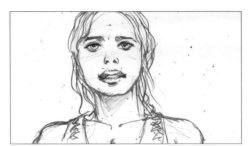
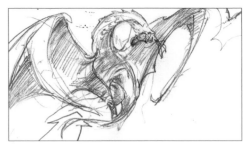

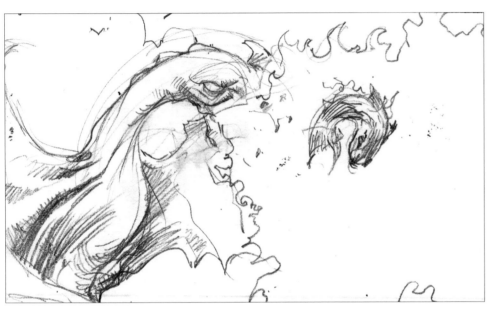

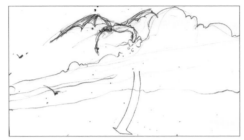
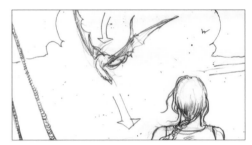

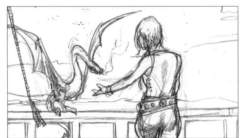
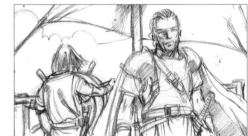

Ser Jorah says that, according to some, the soldiers they'll find in Astapor—known as the Unsullied—are the greatest soldiers in the world.

Daenerys reminds him the Unsullied are slave soldiers, reiterating her distaste for slavery.

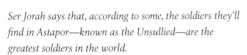
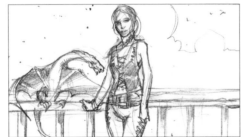
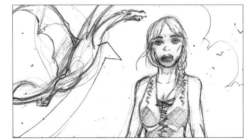

"Not fast enough. I can't wait that long. I need an army."

—DAENERYS TARGARYEN

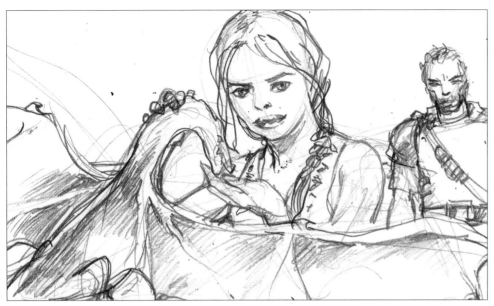

On the decks below them, the Dothraki are uneasy, having never sailed on the open seas before.

Episode 303
WALK OF PUNISHMENT

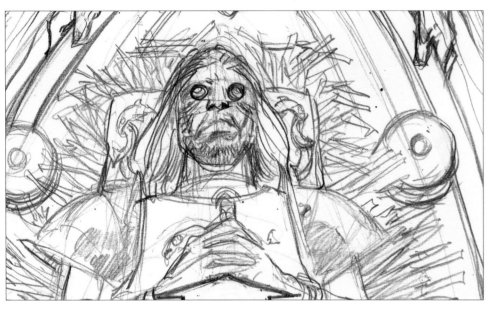

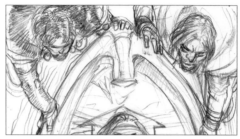

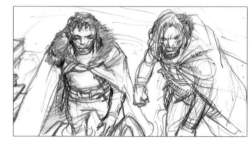

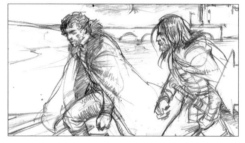

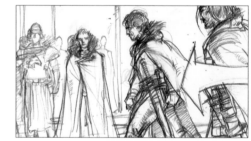

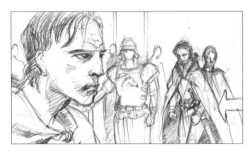

After succumbing to illness, Ser Hoster Tully, Catelyn Stark's father, is laid to rest in a funeral boat. Robb Stark and Hoster's brother, Brynden Tully, nicknamed Blackfish, push the boat out into the Trident River. Robb and Blackfish join Catelyn, Talisa, and a party of mourners on the riverbank. Catelyn's younger brother, Edmure, walks to a fire pot and lights the arrow in his bow.

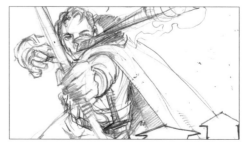

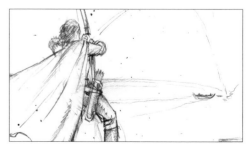

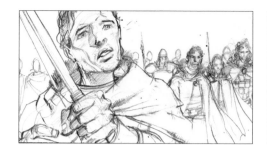

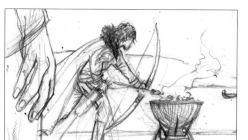
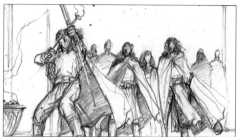

His first shot lands short of the funeral boat. His second shot also misses.

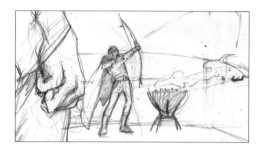
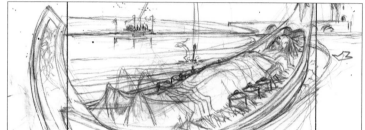
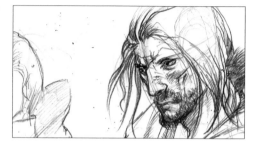

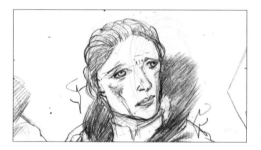
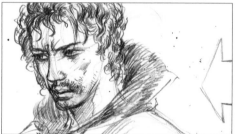
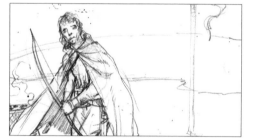

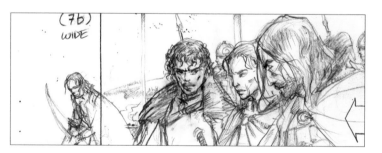

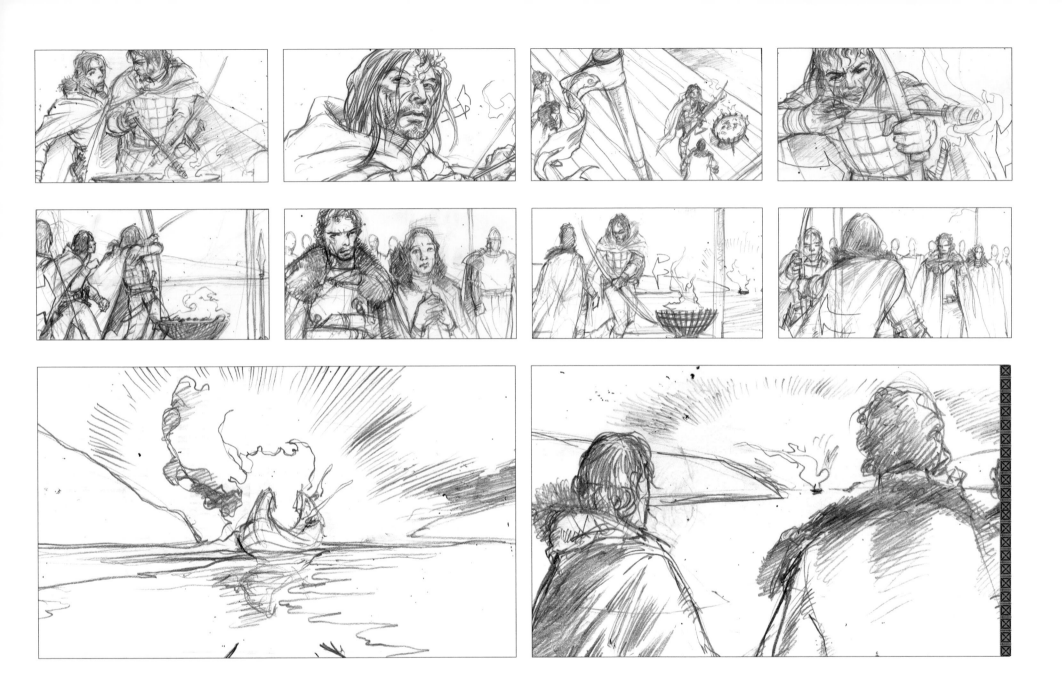

Catelyn, Robb, and Talisa watch Edmure's mishaps with chagrin. When Edmure's third arrow doesn't strike the boat, an annoyed Blackfish strides up to his nephew, yanks the bow from him, lights the arrow, and shoots. In the episode, his arrow turns the boat into a funeral pyre.

Episode 304

And Now His Watch Is Ended

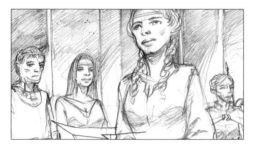

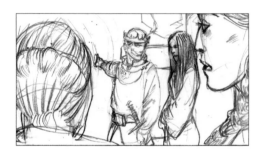

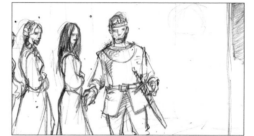
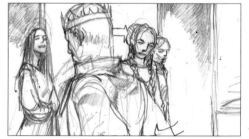

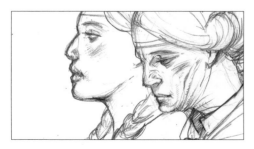

As Joffrey takes Margaery on a tour of the Great Sept, Cersei and Olenna Tyrell discuss the upcoming wedding. Clergy wander about in the background. Cersei keeps an eye on her son, who seems to be growing enamored of Margaery and her flattery.

Simpson draws a storyboard panel showing an urn decorated with a dragon that contains the ashes of Aerion Targaryen. This object is not seen in the episode.

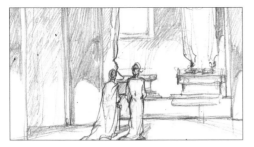
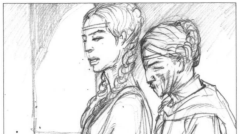
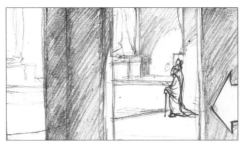
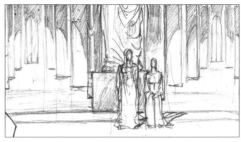

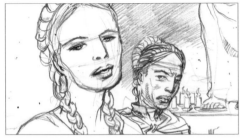

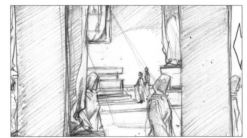

Olenna and Cersei talk about how the world belongs to the sons they mother and to whom they try to impart good sense. Joffrey takes Margaery down into the tombs, showing off where the Targaryens are buried.

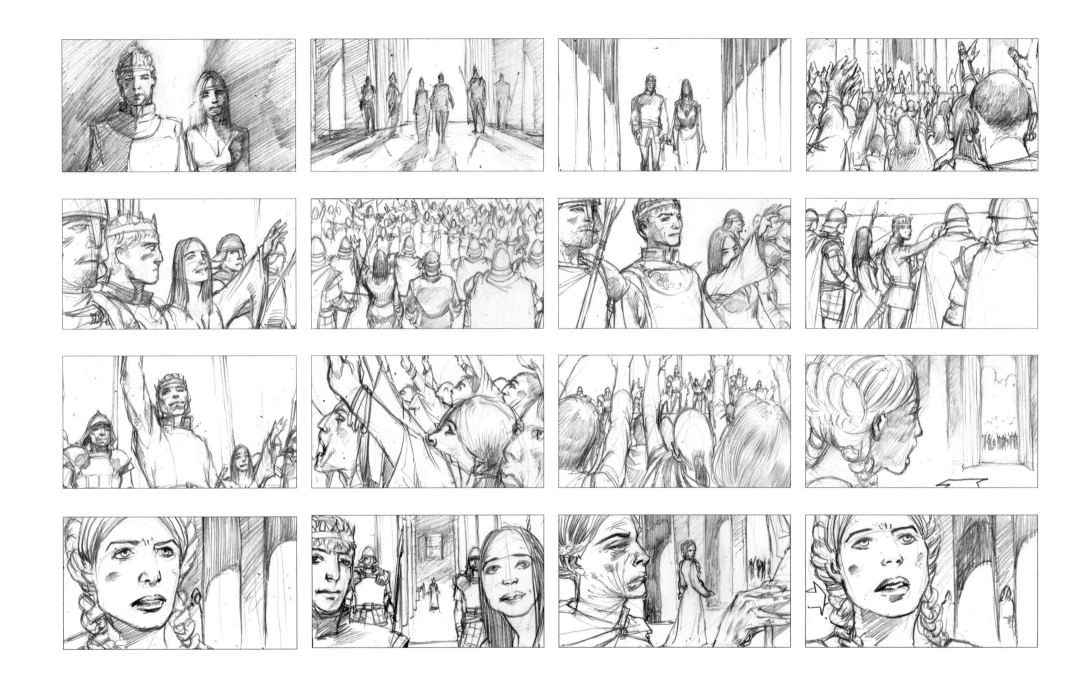

The crowd's roar can be heard outside. Margaery convinces Joffrey to go out and see the people. The crowds cheer for Lady Margaery, who has shown benevolence toward the poor in the city. When she waves back with Joffrey next to her, the crowds also cheer for their king. Joffrey smiles and waves back at the crowd. Scowling at the couple from behind, Cersei is none too pleased at Margaery's influence over her son.

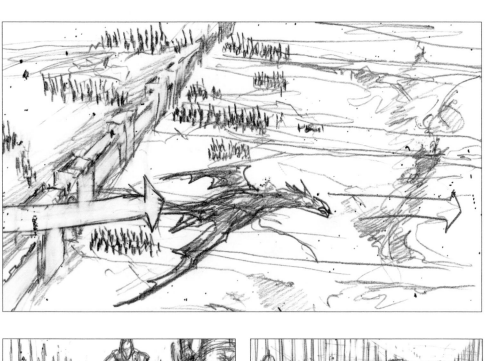
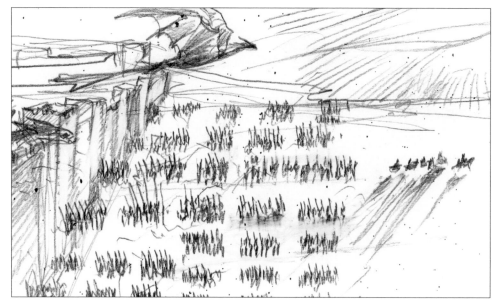

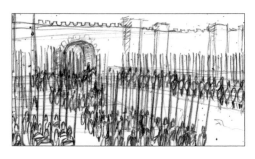

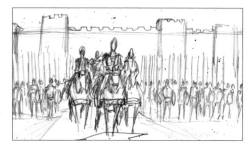
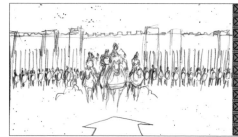

"*Unsullied! You have been slaves all your life. Today you are free. Any man who wishes to leave may leave, and no one will harm him. I give you my word. Will you fight for me? As free men?*"

—DAENERYS TARGARYEN

Episode 306
THE CLIMB

Tormund Giantsbane leads a group of Free Folk in a perilous climb up the Wall. Jon Snow and Ygritte share the rope with Tormund and another wildling, Orell.

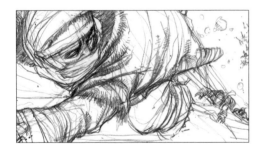
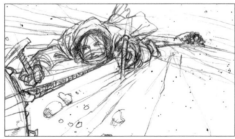
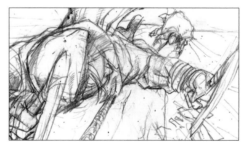
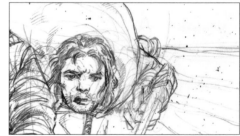

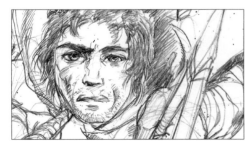

"The climb up the ice wall was one of those special sequences that I was given a free hand in breaking down. The producer wanted a version that would give us everything in the script but also take into account the small piece of ice wall set that we had," Simpson recounts.

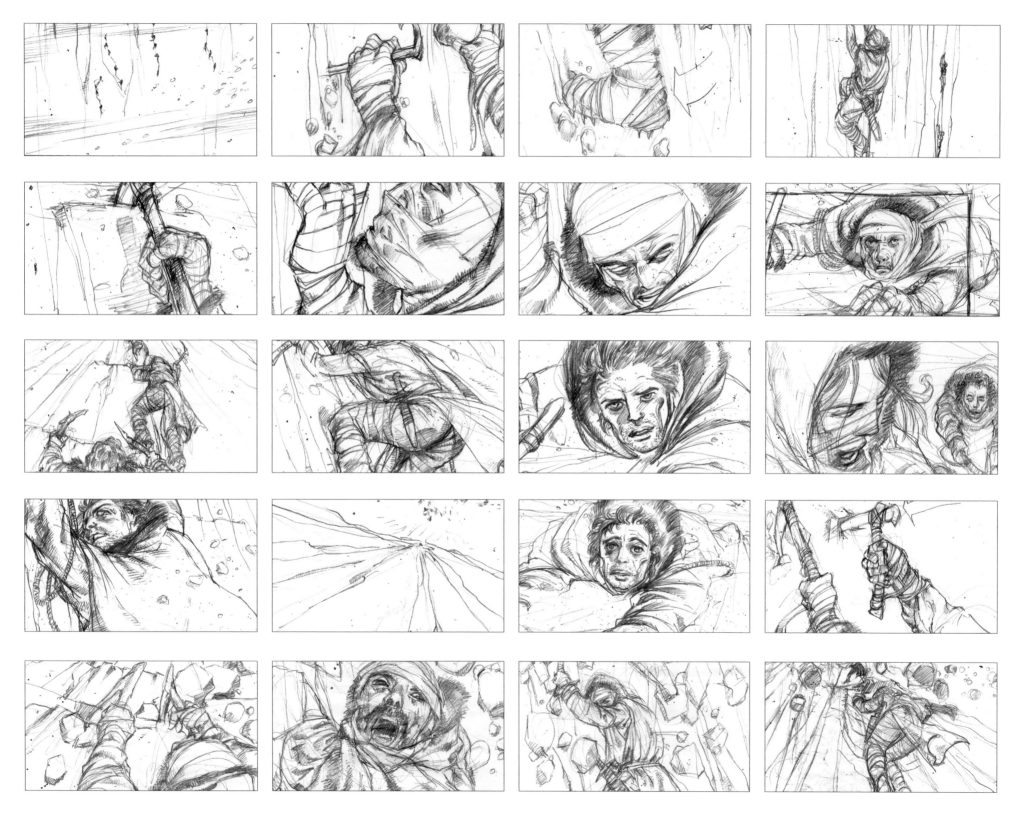

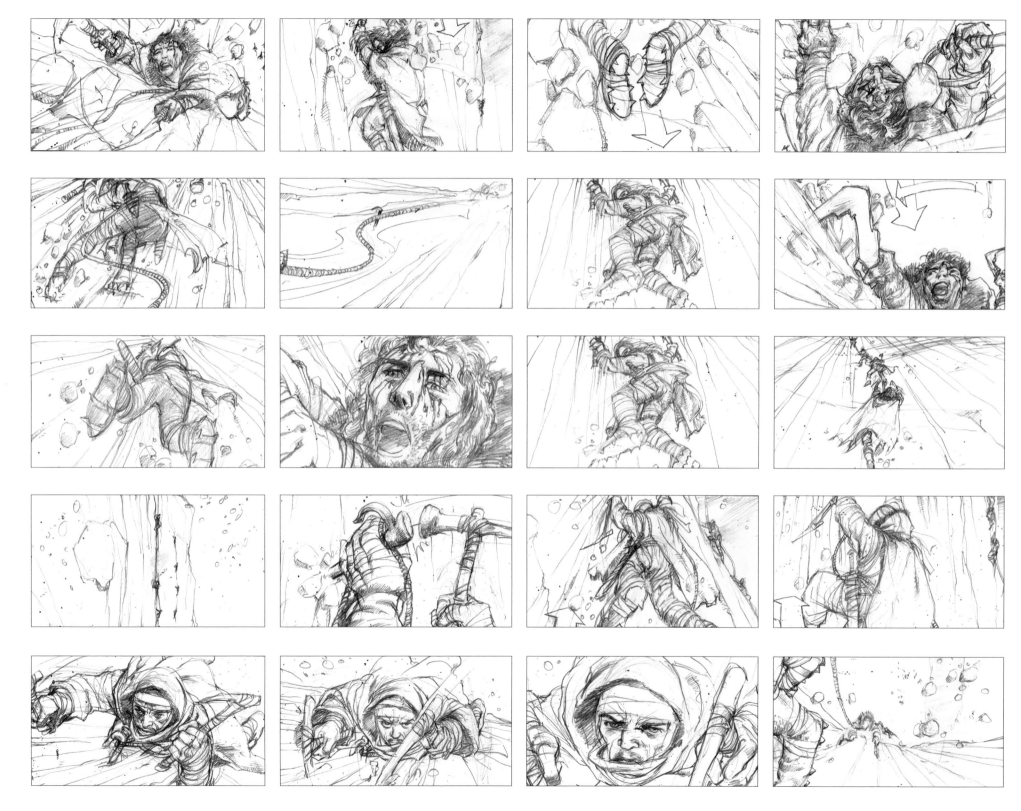

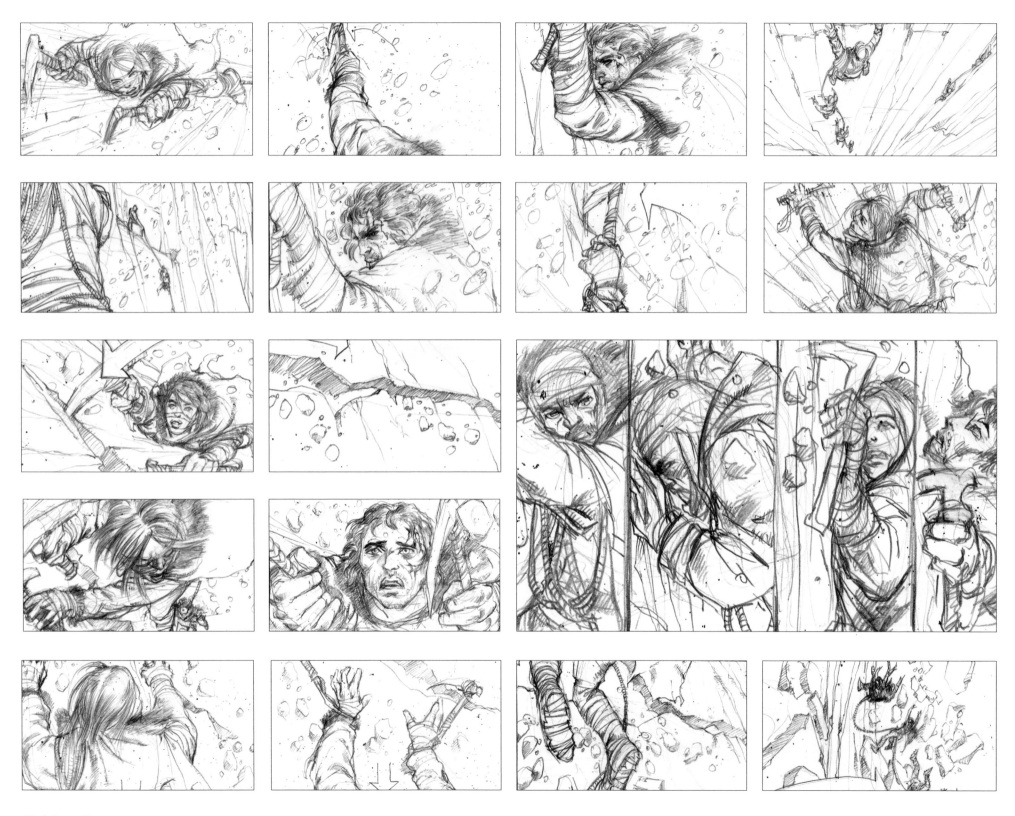

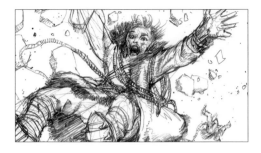

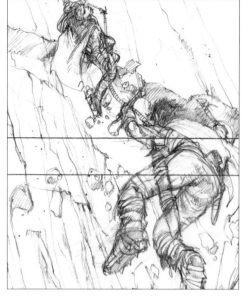
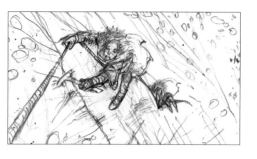

"Just seeing if you could take a hit, lad!"
—TORMUND

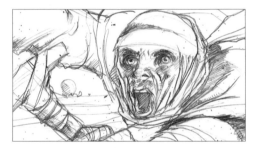

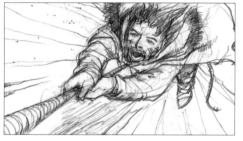
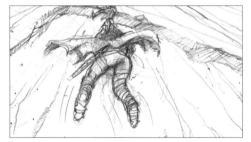

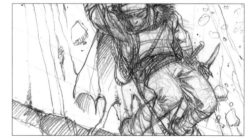

Simpson says, "[This sequence] was just pure comic art intensity! You have to constantly move the shots around, seeing it from both the lead character's and other character's perspectives. You have to get into the emotions of the characters in that given situation, and this was all about Jon."

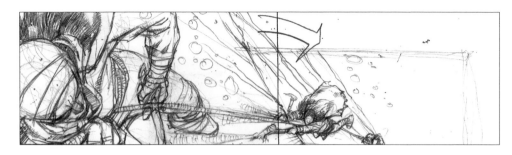

"I feel the shots out, like I'm seeing an edit, so it becomes a lot of back-and-forth close shots, knowing that dry ice is smoking on set and the visual effects team will create the background. I put in lots of perspective shots to emphasize the height they were climbing and the danger involved," says Simpson.

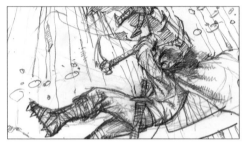
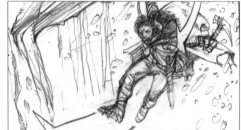

"Take my hand!"

—JON SNOW

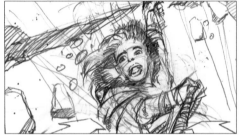
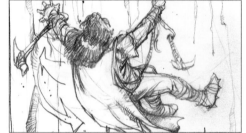
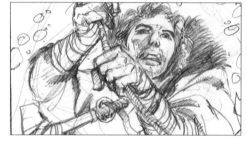

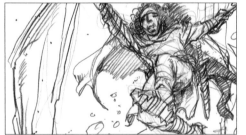

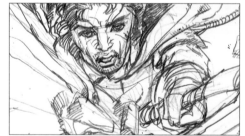
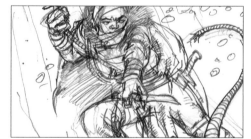

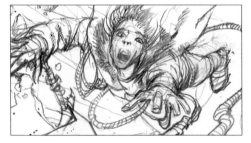
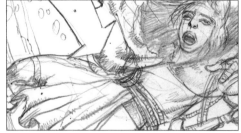

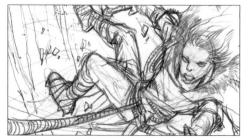

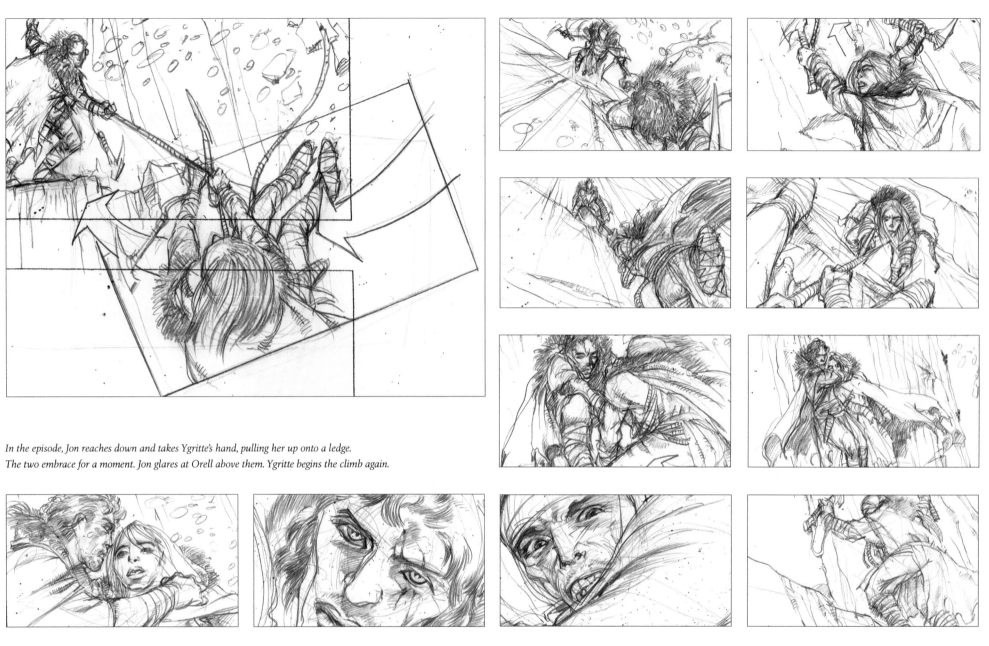

In the episode, Jon reaches down and takes Ygritte's hand, pulling her up onto a ledge.
The two embrace for a moment. Jon glares at Orell above them. Ygritte begins the climb again.

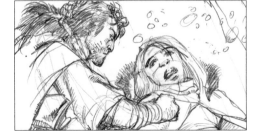
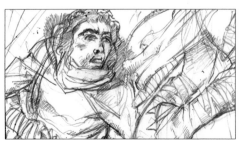
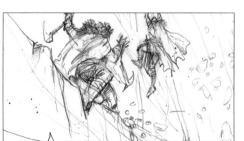
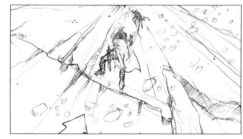

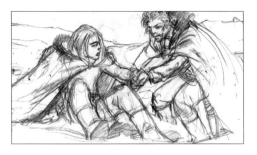
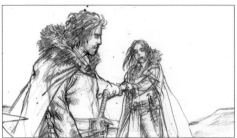
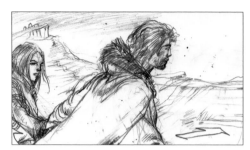

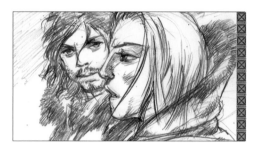

GAME OF THRONES – SEASON 3 – EP 306 – SCENE 6·19A

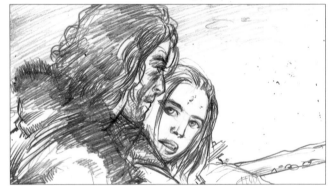
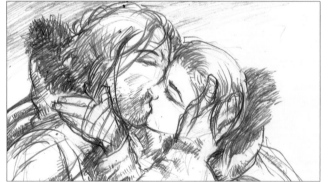
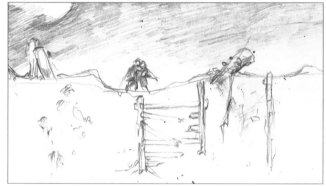

"When the director saw the boards, he loved them and said he'd shoot it as it was. [Once he was on set in Belfast,] he asked to add the romantic bit on the top of the wall looking south over Westeros," Simpson recalls. "The director did a beautiful job on it. These are the parts of the job that really make it all worthwhile."

Episode 307

The Bear and the Maiden Fair

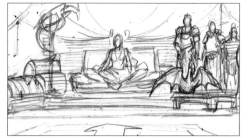

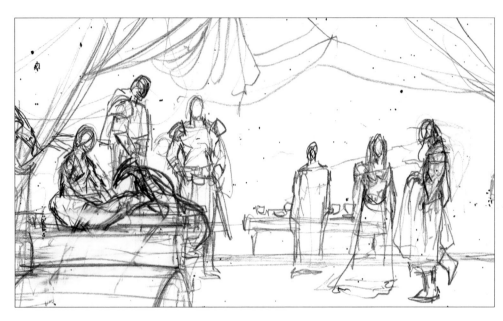

In Yunkai, Daenerys receives Razdal mo Eraz, a member of the ruling council, in her pavilion.

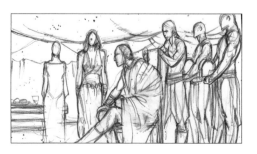

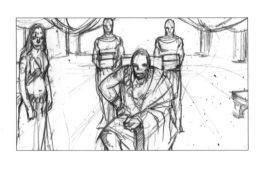

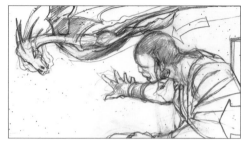
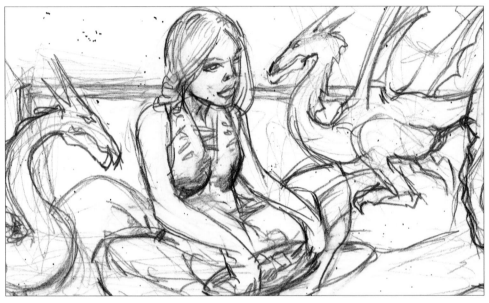
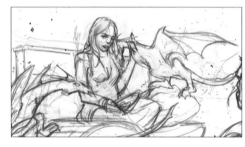
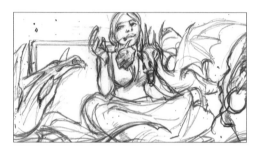
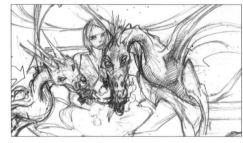

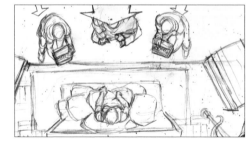
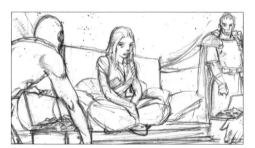

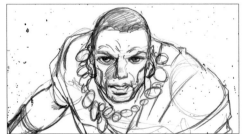
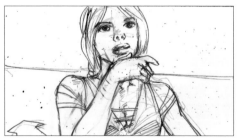

Daenerys throws a piece of meat to her dragons, who snap and fight over it, startling Razdal.

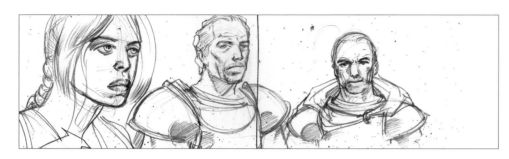
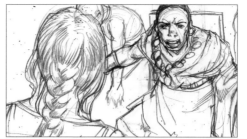

Razdal's servants present the queen with gifts of gold, saying they placed more on the deck of her ship. He offers Daenerys as many ships as she desires, as long as she sails to Westeros and leaves Yunkai in peace.

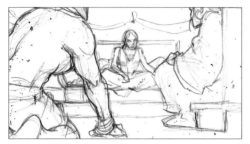
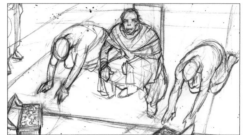
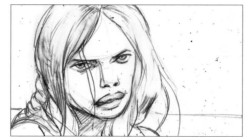
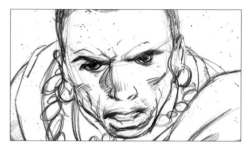

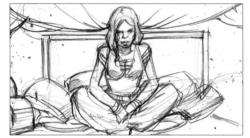

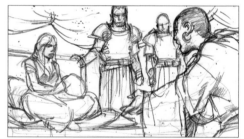

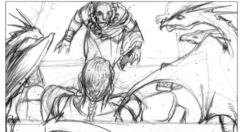
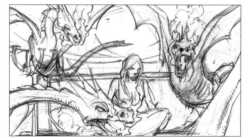
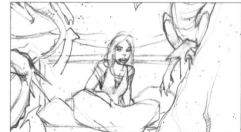

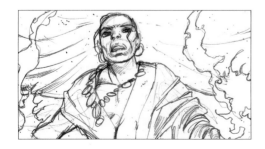

"My gold. You gave it to me, remember? And I shall put it to good use. You'd be wise to do the same with my gift to you. Now get out."

—DAENERYS TARGARYEN

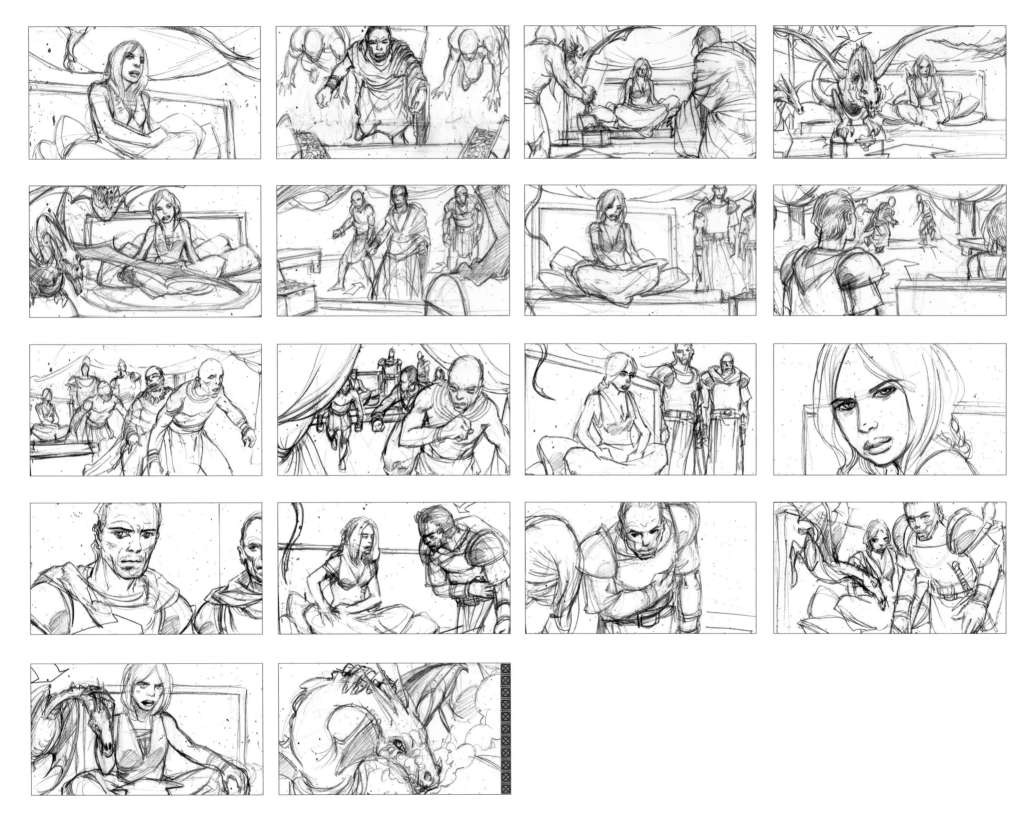

GAME OF THRONES – SEASON 3 – EP 309 – SCENE 9.1

Episode 309

The Rains of Castamere

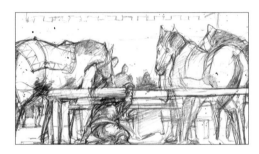 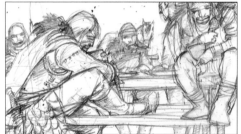 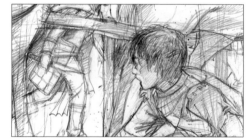 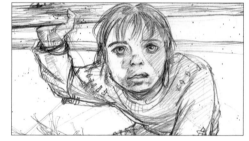

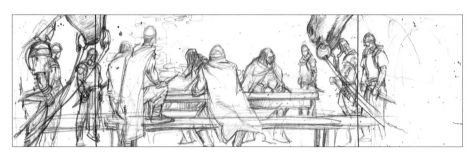 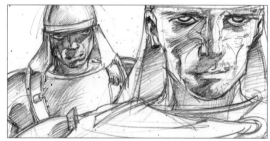

Arya sneaks around the castle grounds of the Twins. She sees soldiers for House Frey approach a bench of House Stark soldiers and slaughter them. In the episode, they overturn the bench in the short battle. Simpson sketches close-ups between Arya and a dead Stark soldier, but these do not appear in the episode.

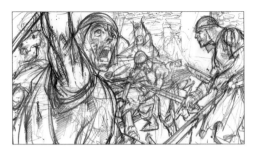
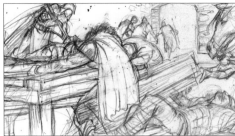
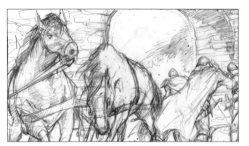
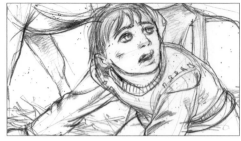
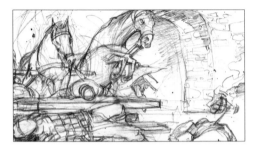
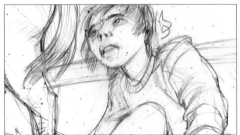

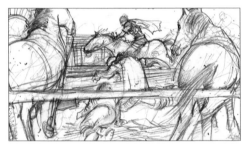

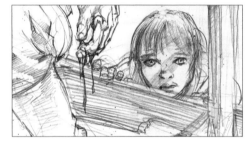

Robb's direwolf, Grey Wind, howls and bangs the doors of his pen as House Frey crossbowmen converge on him. Arya hides behind a pile of corpses.

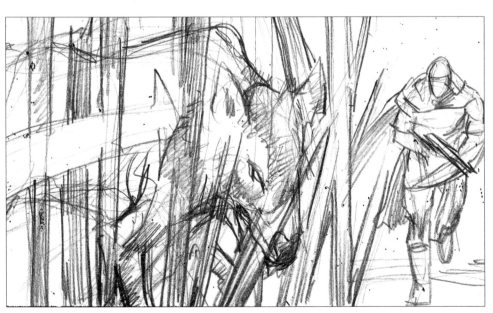
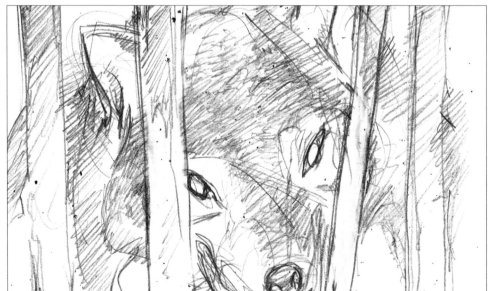

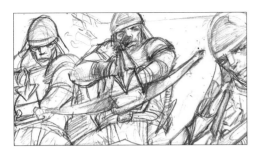

Arya watches in horror as the Frey crossbowmen shoot bolts into Grey Wind's pen and kill the direwolf.

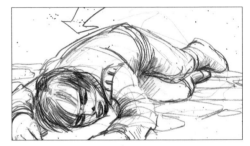

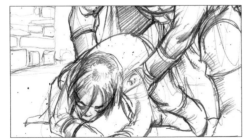
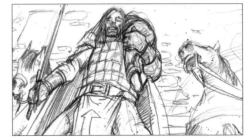

Ser Sandor Clegane grabs Arya from behind. She tries to keep running, but he knocks her unconscious. He carries her over his shoulder out of the castle.

SEASON 4

The murders of Robb and Catelyn Stark have fortified the Lannisters' grip on the Iron Throne, though King Joffrey's sudden assassination throws the court into chaos. Joffrey's younger brother, the gentler Tommen Baratheon, swiftly assumes the throne and weds his brother's wife, Queen Margaery. Queen Cersei pegs her brother Tyrion as her son's killer, and Tyrion is put on trial, but Jaime helps Tyrion escape.

As political intrigue consumes King's Landing, Littlefinger helps Sansa Stark slip out of the city. They head to the Eyrie, where Littlefinger marries Sansa's aunt, Lysa.

After witnessing the massacre known as the Red Wedding, Arya Stark is captured by Ser Sandor Clegane, the Hound, who wants to hold her ransom to her aunt, Lysa Arryn, in the Vale. Brienne of Tarth, who had pledged an oath to protect Catelyn Stark, and her squire, Podrick, come across this odd couple. Desiring to live up to her oath and defend Arya, Brienne battles the Hound. Arya, however, escapes both of them.

The wildling army led by Mance Rayder attacks Castle Black. Jon Snow, back with the Night's Watch, rallies the rangers and pushes back the wildlings. Jon then travels beyond the Wall to seek out Mance Rayder, intending to kill him.

Bran Stark and his group seek the Three-Eyed Raven in the frozen lands north of the Wall. Wights attack them as they near a giant weirwood tree. After the battle, Bran encounters the Three-Eyed Raven—not a raven at all, but a man who is now a part of the root system of the tree. The Raven begins Bran's training that will allow him to "fly" into the past, present, and future through prophetic visions.

Daenerys Targaryen and her army march on Meereen, where she compels the slaves to rebel against their masters. She takes the city, liberates the slaves, and rules from the Great Pyramid. Her dragons have become uncontrollable, forcing her to chain up Viserion and Rhaegal, though Drogon flies free, terrorizing the people around Meereen. She also exiles her once-trusted counselor, Ser Jorah Mormont, after she finds out he was spying on her when they first met.

When asked about his process and involvement in the production, Simpson gives credit to the whole team. "The production team is composed of some of the most creative, talented, and dedicated individuals in the business," Simpson says. "As a visual representation of sequential shots, the storyboards serve as an important form of communication for directors to the various production departments. Much of my personal involvement in the collaborative process revolves around discussions with the directors. Early on in a season, these discussions are often limited to one director. As a production season progresses, it becomes routine to simultaneously collaborate with multiple directors, each of whom is responsible for different episodes. The bulk of my work coincides with the preproduction and production stages.

"At the outset of collaborating with a director, we typically discuss the details of specific scenes. My goal is to interpret the director's vision of a scene and represent it on paper. First, I rough them out in thumbnail form while ideas are shaped. Once the concepts are established, I begin drawing the detailed versions. During the first couple seasons, this process would commence earlier in the course of preproduction to provide other departments with sufficient time to address issues that could be problematic. But as the seasons progressed, the look of the show had been established significantly enough that storyboarding could happen later in the cycle."

Episode 401
Two Swords

GAME OF THRONES - SEASON 4 - EP 401 - SCENE 1.2

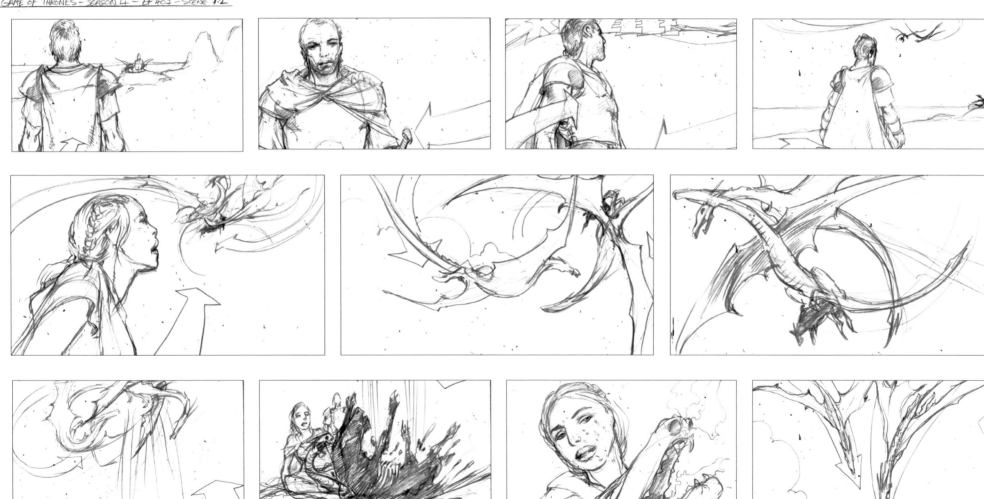

In Slaver's Bay, Daenerys sits on a rocky ledge over the sea with her dragon Drogon while Rhaegal and Viserion tussle over food. The food drops from the sky and lands before Drogon, exciting him.

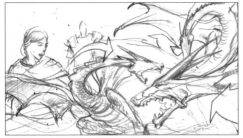

Daenerys tries to stroke Drogon's back and calm him, but he snarls at her and flies off to fight his brothers and claim the meal.

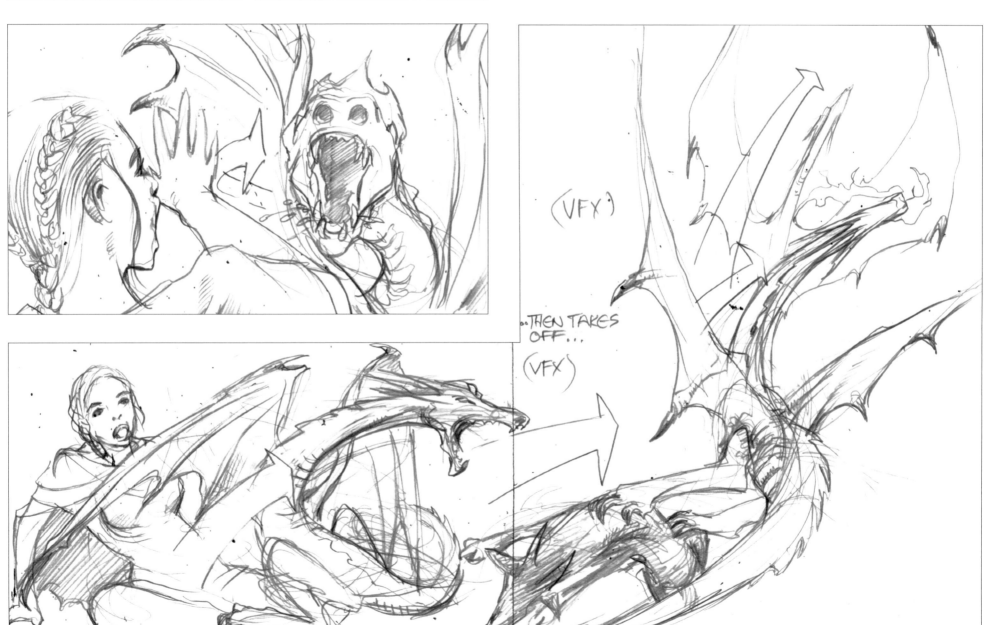

(VFX)

...THEN TAKES OFF...

(VFX)

Ser Jorah Mormont walks up from behind them and says that dragons can't be tamed, not even by their mother. Simpson ends this sequence with Daenerys and Ser Jorah looking at the three dragons fighting in the sky. The episode keeps its focus on the humans.

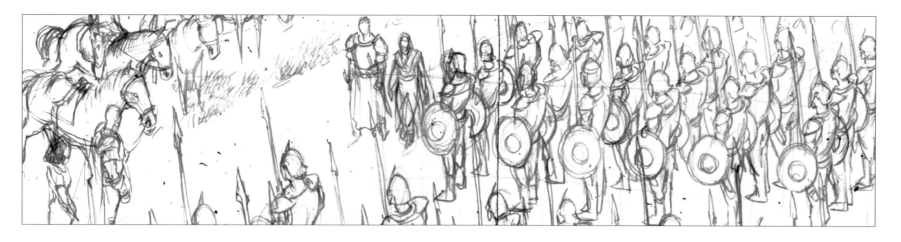

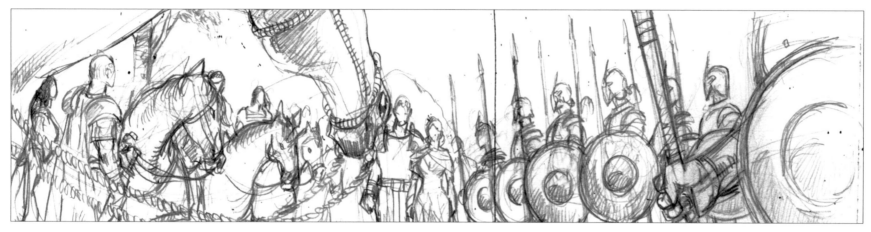

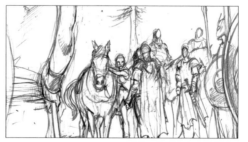

Daenerys and Ser Jorah Mormont come to the army of the Unsullied, which stands in formation. There they meet Ser Barristan Selmy and Missandei.

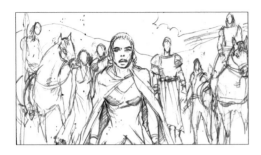

Daenerys asks where her advisors Daario Naharis and Grey Worm went. Ser Barristan divulges they're gambling.

In the episode, Missandei follows behind Daenerys as she walks past the lines of men. The storyboards show Missandei following later.

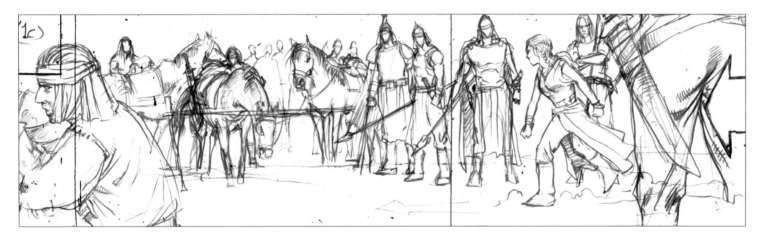

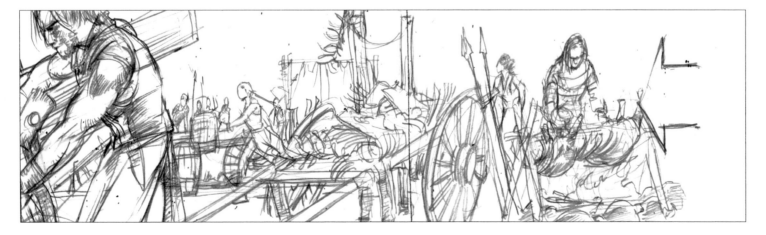

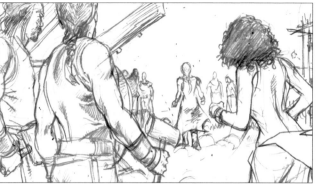
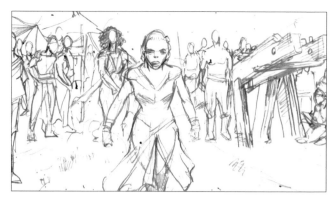
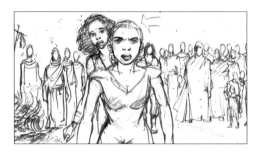
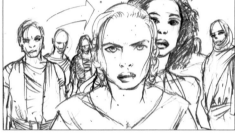

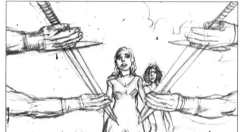
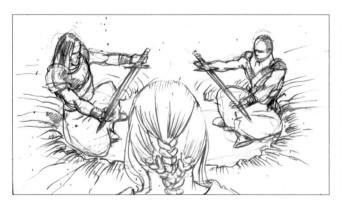

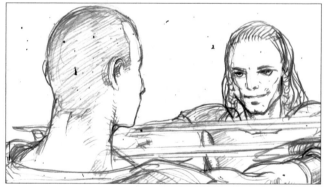
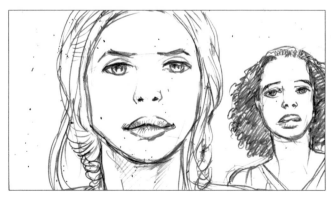
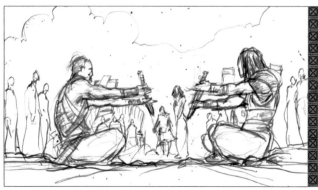

Daenerys discovers Daario and Grey Worm holding their sword blades with both hands in a challenge to win the privilege to ride in the vanguard with Daenerys. Angry that they've wasted time with this contest, Daenerys says the two men will ride with the livestock.

Episode 404

Oathkeeper

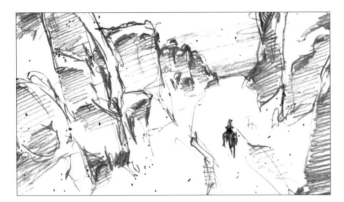

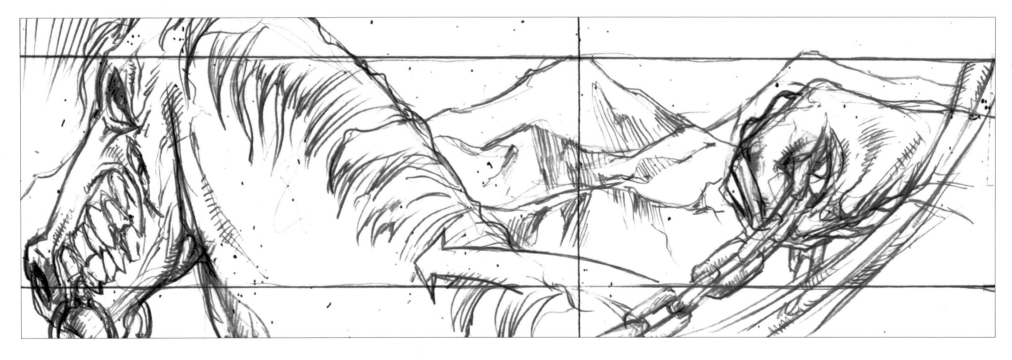

A single White Walker on horseback brings the infant son
of Craster into the Lands of Always Winter.

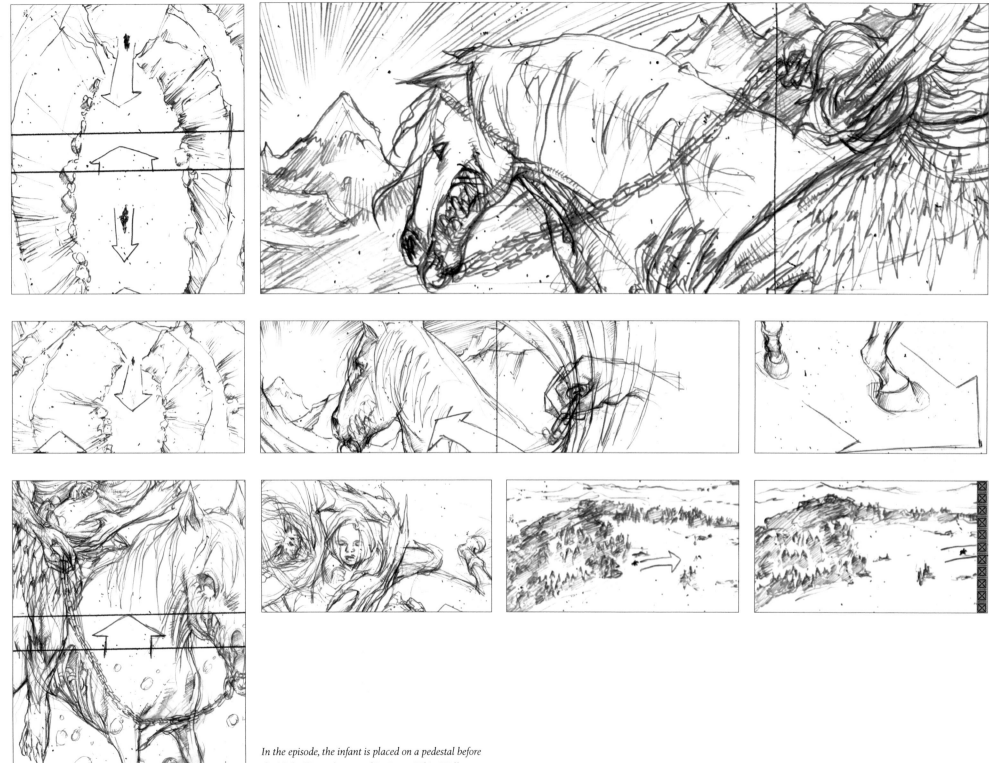

In the episode, the infant is placed on a pedestal before the Night King, who turns him into a White Walker.

Episode 405
FIRST OF HIS NAME

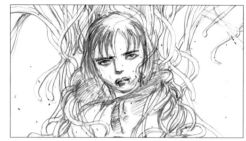

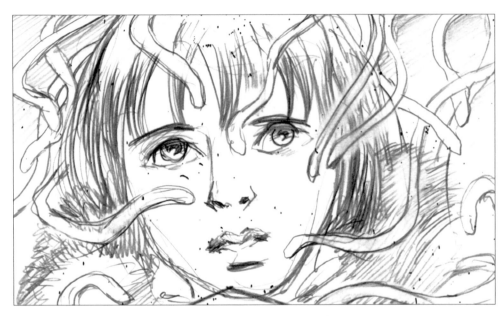

Bran Stark, Jojen Reed, Meera Reed, and Hodor are captured by mutineers at Craster's Keep. Jojen has a vision of Bran's dream of the weirwood tree. Simpson's storyboards presage weirwood branches entwining Bran—something that was not depicted in the episode but would be shown later in the series.

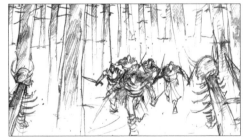

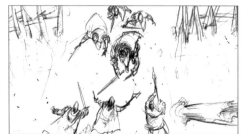
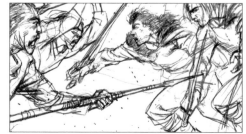

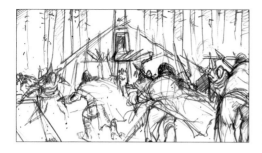 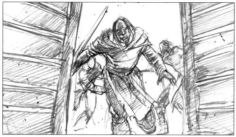

Meanwhile, Jon Snow and his group of men attack
Craster's Keep to expel their former brethren who have
mutinied against the Night's Watch.

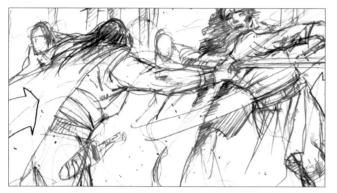 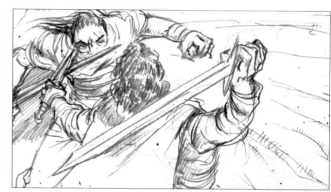

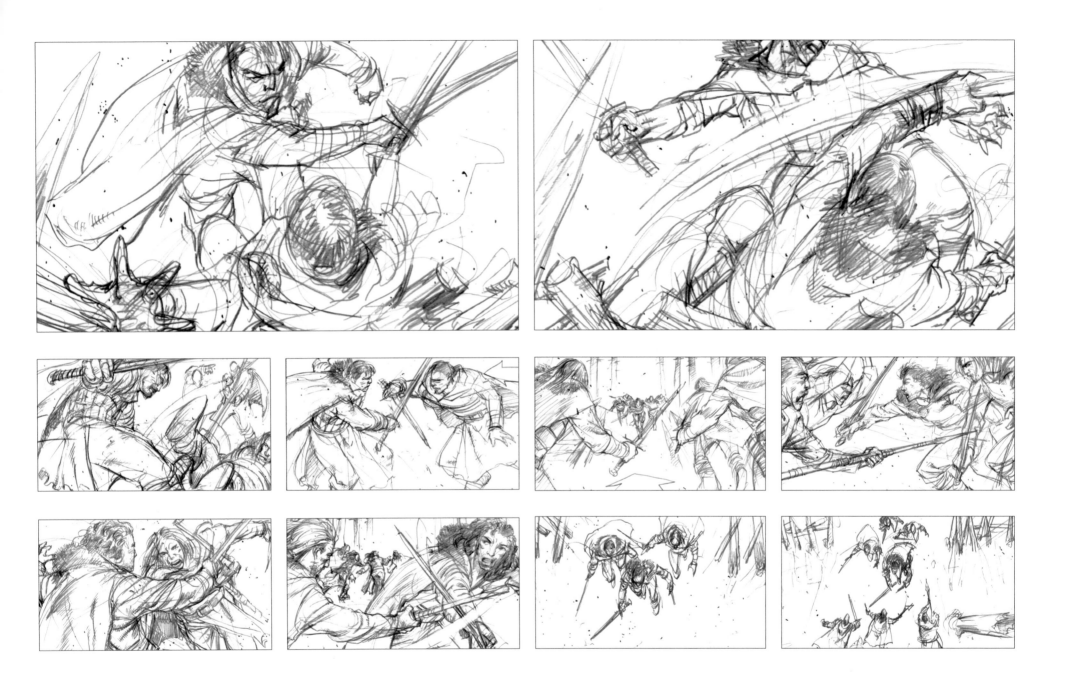

*The battle against the traitors rages. Jon Snow silences
many mutineers in combat with his sword forged from
Valyrian steel, Longclaw.*

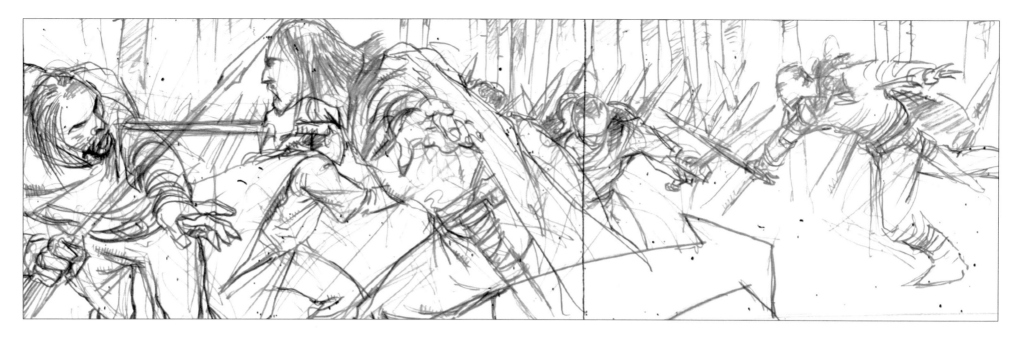

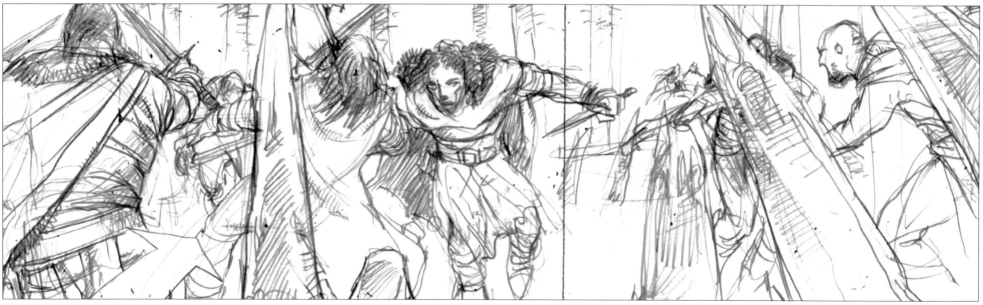

GAME OF THRONES - SEASON 4 - EP.#?S - SCENE 5·24

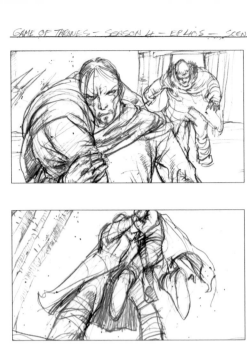

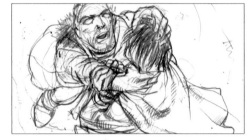
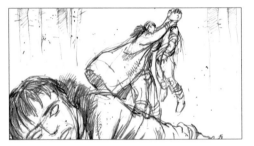
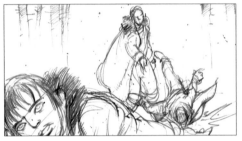
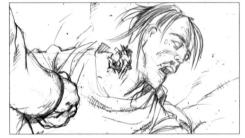
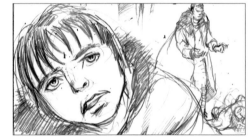
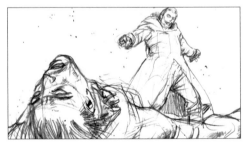

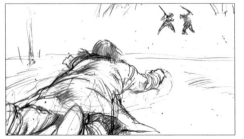
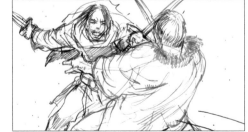

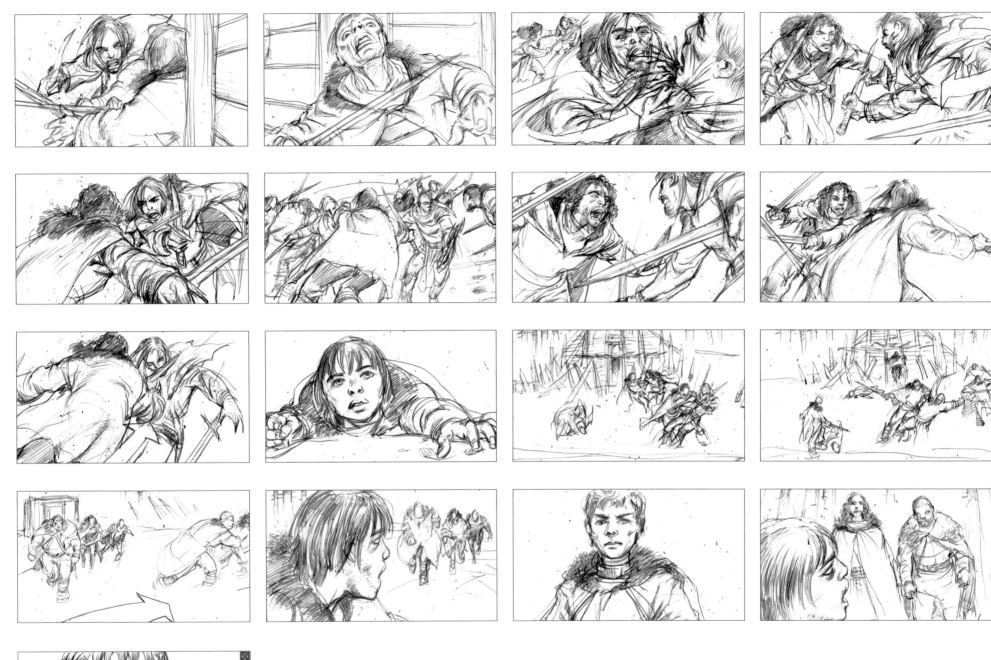

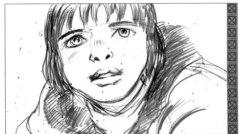

Locke, a spy for House Bolton in the Night's Watch, tries to kidnap Bran, but the boy wargs into Hodor and kills Locke. Bran watches as Jon fights against the mutineers and tries to reach him. Jojen convinces him to continue north to find the Three-Eyed Raven.

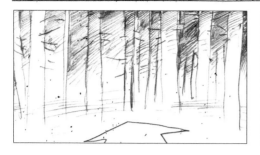
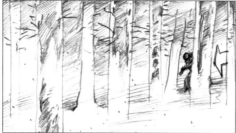
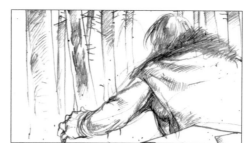
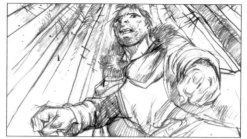
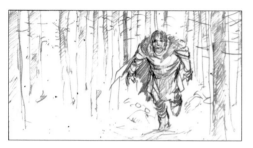
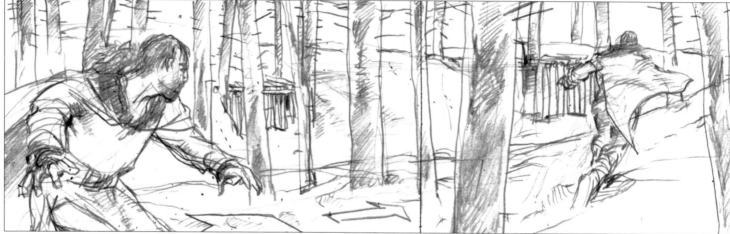

Rast, the last of the mutineers, flees into the forest.

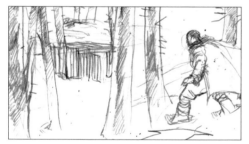
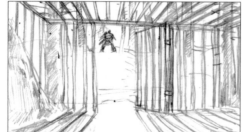

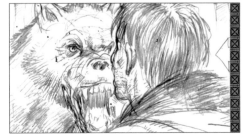

Rast finds no sanctuary in the forest. Freed from the cage, Snow's direwolf, Ghost, pounces on him.

Episode 407
MOCKINGBIRD

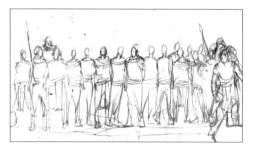

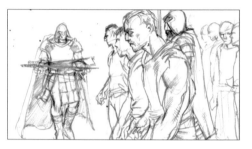

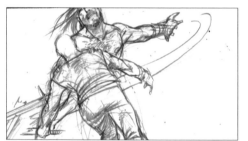
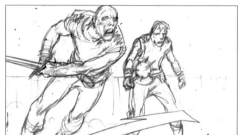
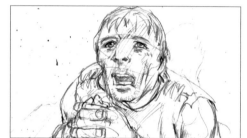
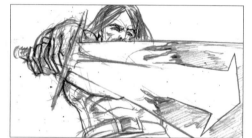

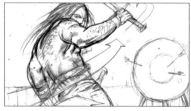

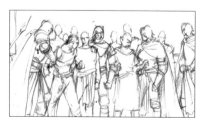

Ser Gregor Clegane, known as the Mountain, battles prisoners in a small arena.
Cersei thanks the hulking guard for agreeing to fight for her in the trial by combat against her younger brother, Tyrion.

Episode 409

The Watchers on the Wall

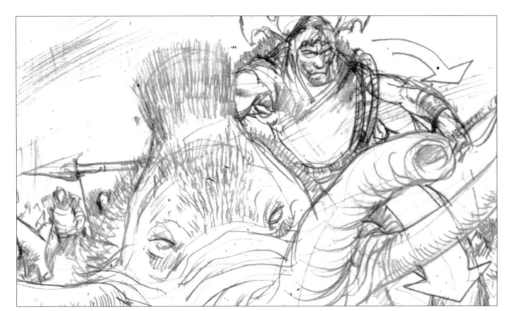

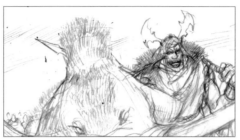

The king of the giants, Mag Mar Tun Doh Weg, also known as Mag the Mighty, rides toward the gate in the Wall on the back of a mammoth. Simpson depicts Mag wearing a cloth cap and necklace of human skulls. In the episode, Mag is dressed in thick furs and has long brown hair, a thick beard, and a wide nose that protrudes from a furrowed face.

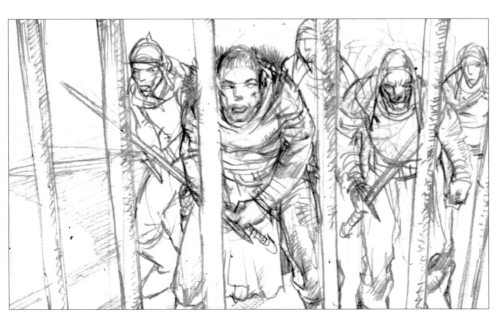

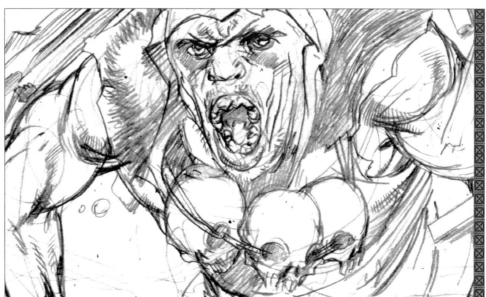

Episode 410
The Children

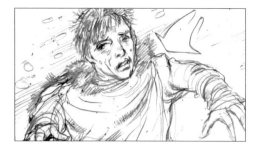

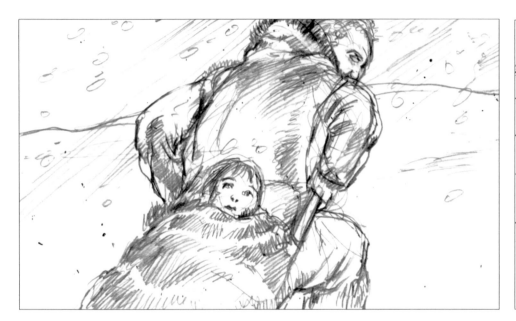

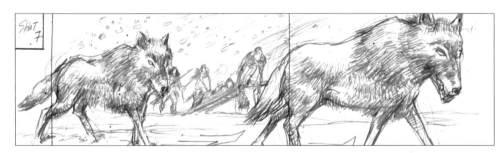

*Bran's group travels through the frozen north. Simpson's
storyboards feature the wolves prominently, but the
episode focuses on the human characters.*

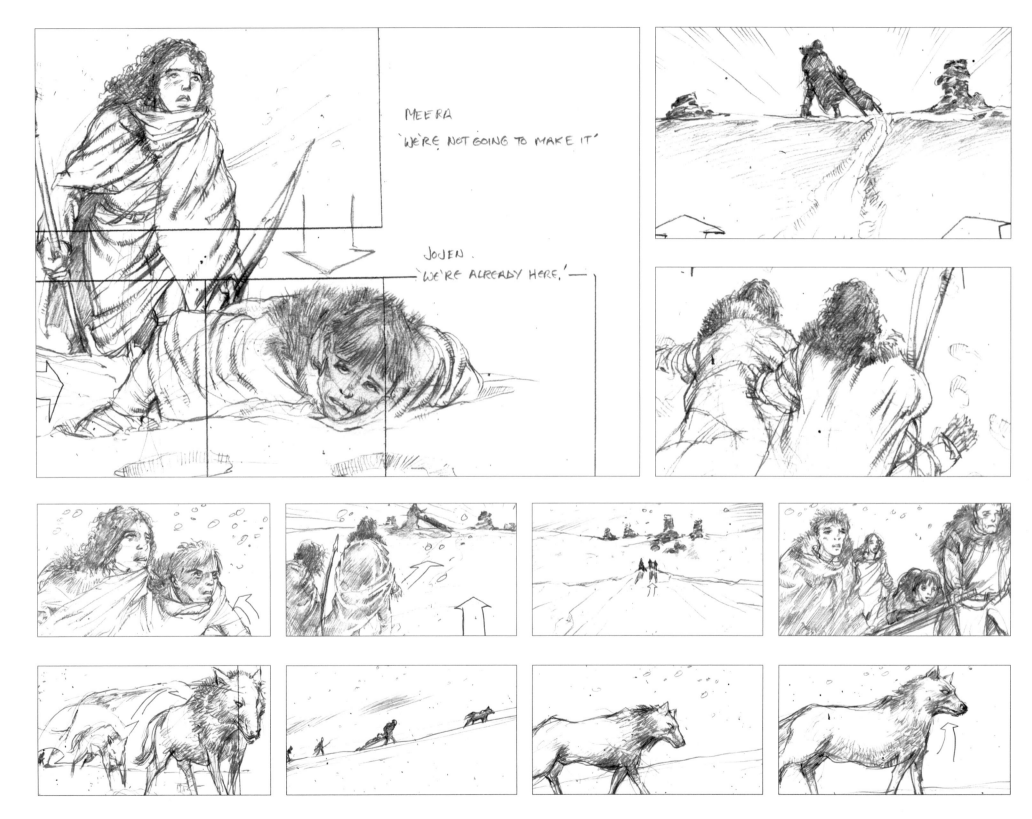

MEERA

'WE'RE NOT GOING TO MAKE IT'

JOJEN.

'WE'RE ALREADY HERE.' —

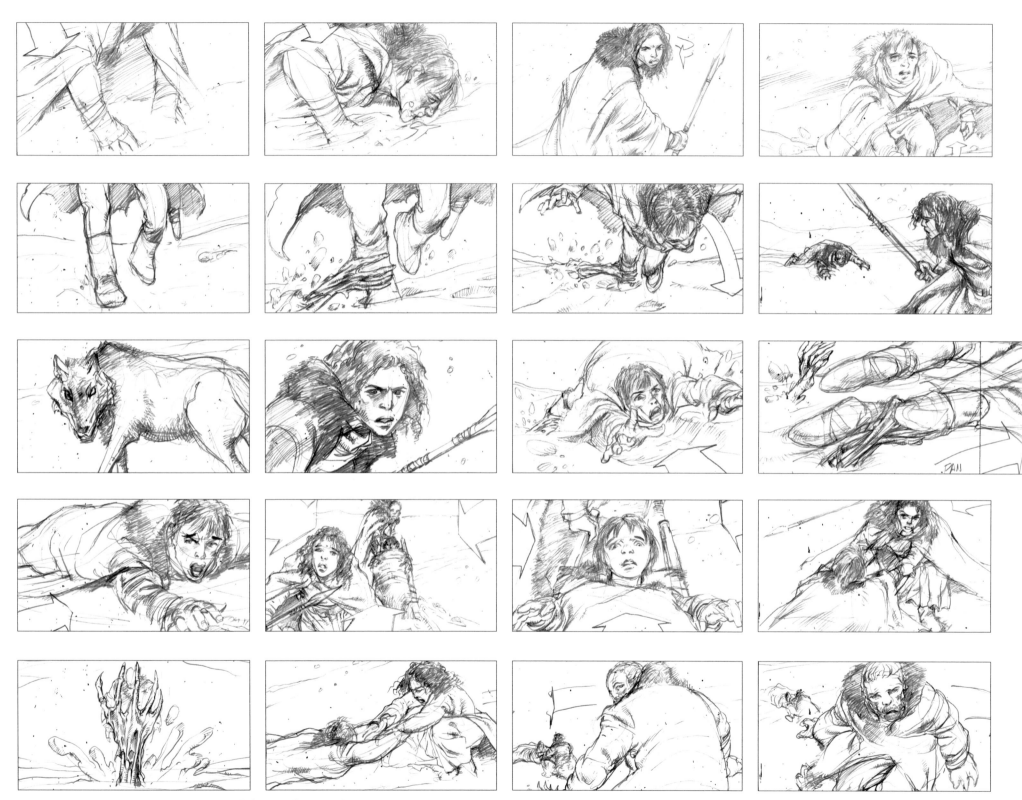

As Bran's group nears the heart tree he's seen in his visions,
skeletal wights rise from the snow and attack.

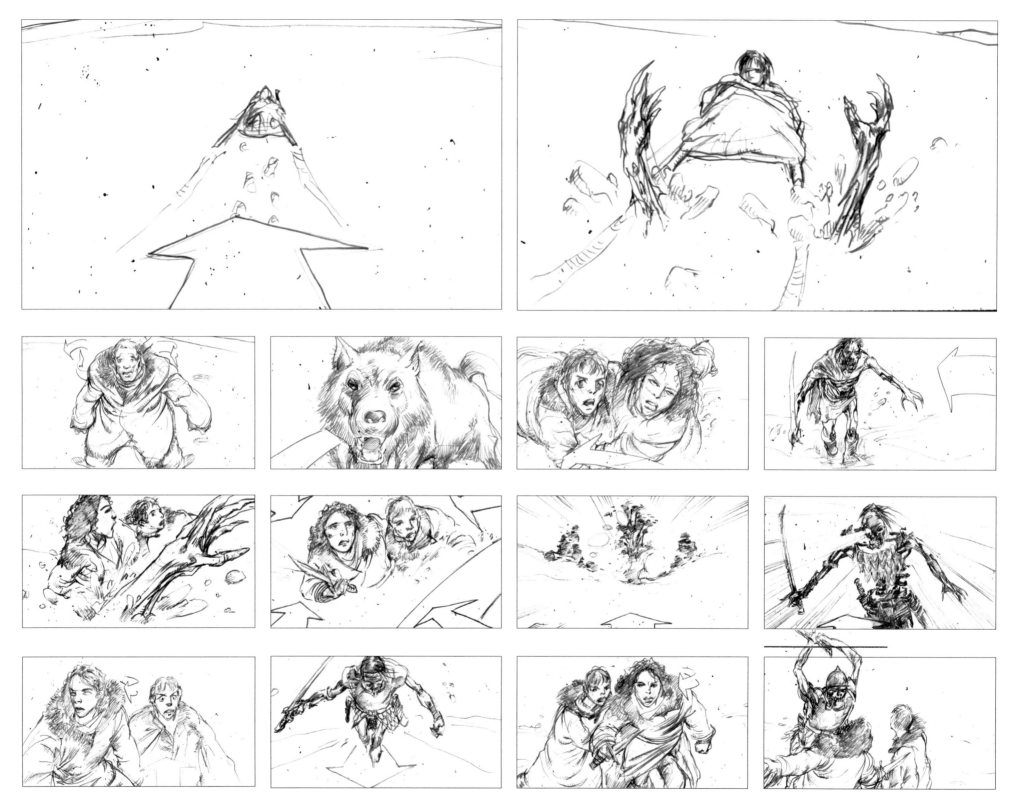

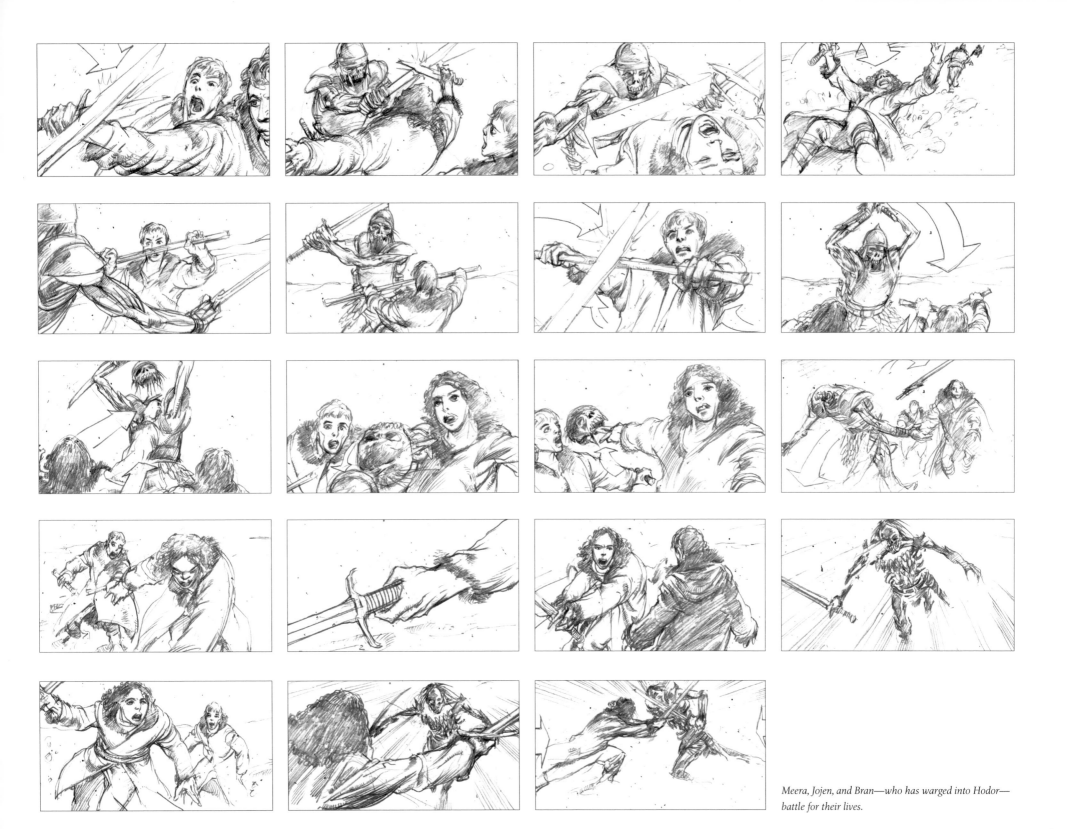

Meera, Jojen, and Bran—who has warged into Hodor—battle for their lives.

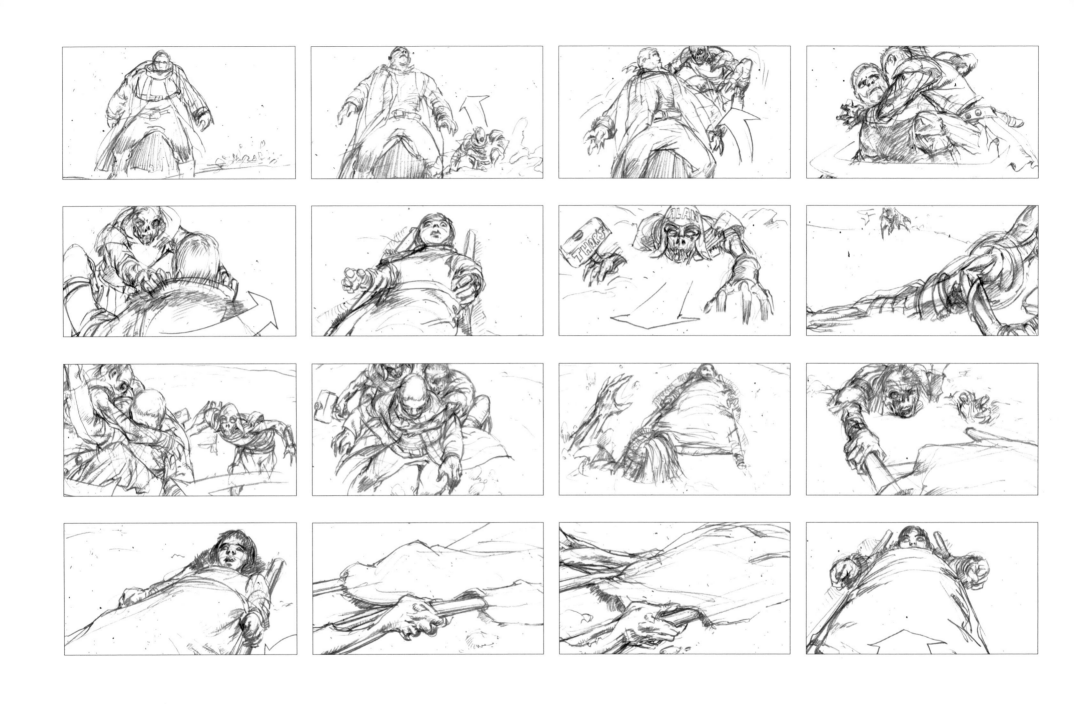

"Come with me, Brandon Stark. He is lost.
 Come with me or die with him."

—LEAF

In the episode, a wight plunges a knife into Jojen's chest. His sister, Meera, has to slit his throat to give him a swift death.

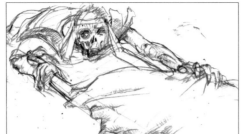

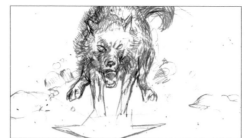

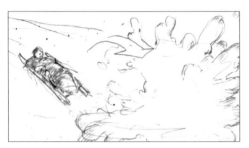

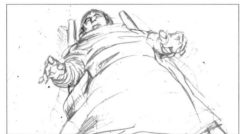

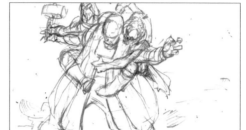

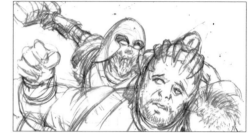

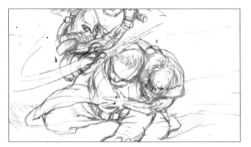

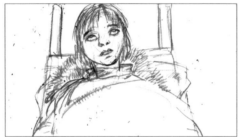

Leaf, one of the Children of the Forest, suddenly appears and throws balls of flame at the wights, saving Bran and the others from a fate worse than death.

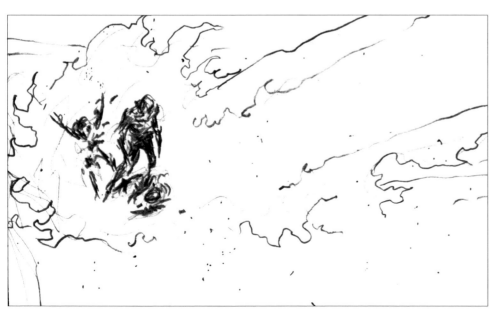

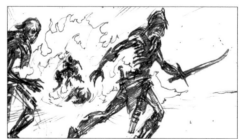

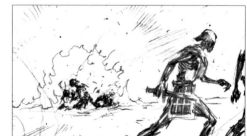

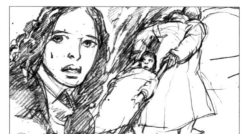

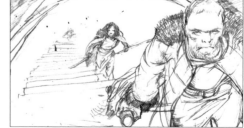

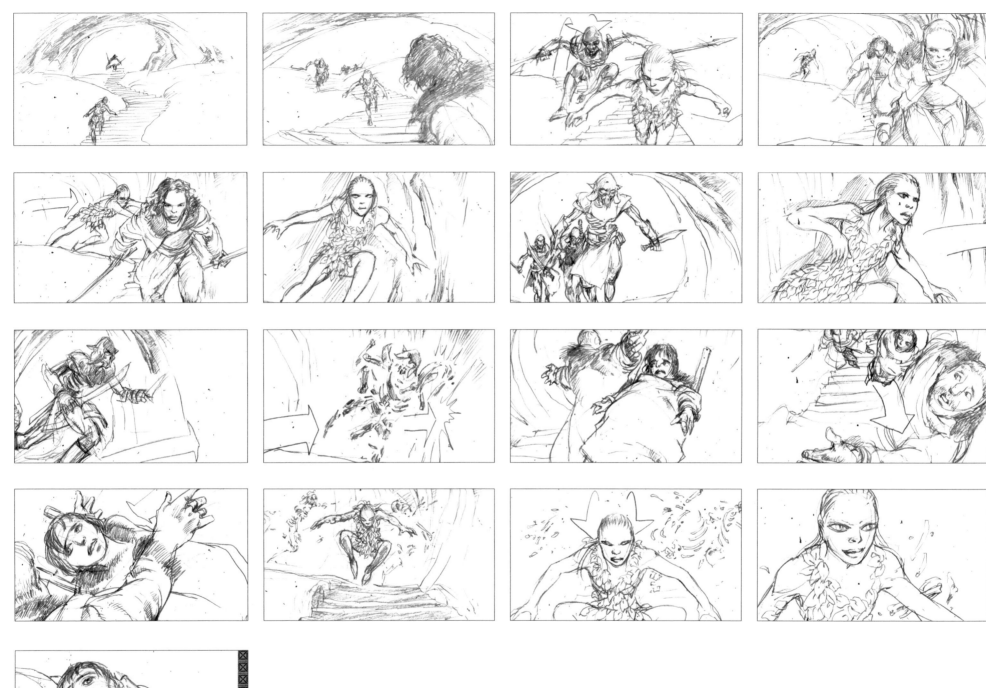

Hodor carries Bran, and the group runs into a cave at the base of the tree.
The wights pursuing them burst apart when they enter the cave. Simpson
draws Leaf jumping around, but in the episode, Leaf is shiftier and less
acrobatic in her movements.

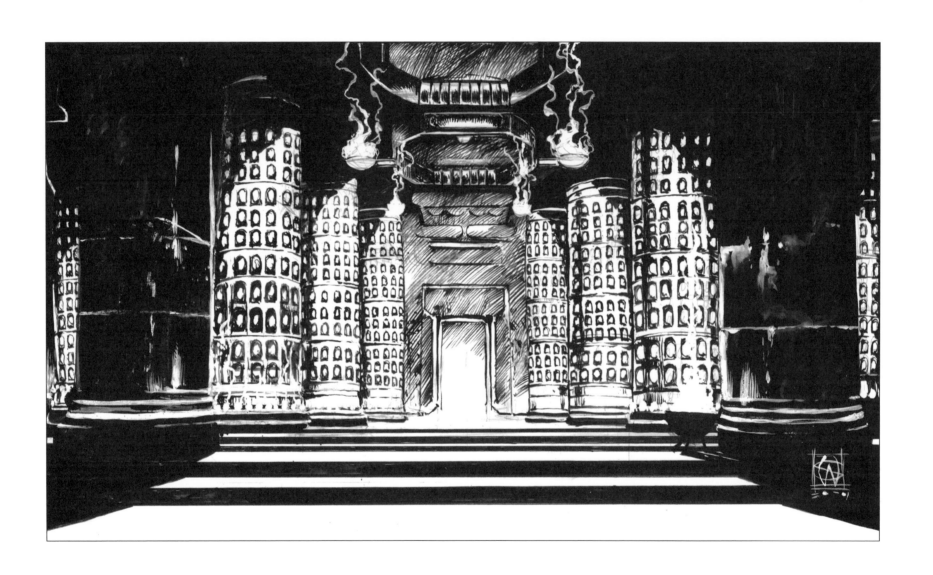

SEASON 5

The Night's Watch elects Jon Snow as their Lord Commander after the victory over the wildlings in the previous season. This peace is short-lived, for Snow fears an enemy greater than the Free Folk or the Lannisters: the White Walkers and their army of the dead. The Walkers have the power to turn the dead into animated corpses known as wights, and their army grows with each creature they kill.

On the other side of the world, Tyrion Lannister is now an advisor to Daenerys Targaryen in Meereen. He assists her in trying to figure out how to root out and quash the Sons of the Harpy, a covert society of ex-slavemasters who desire to reestablish Meereen's old order. The group launches a surprise attack on Daenerys and her Unsullied guards during a gladiatorial event in the fighting pits.

Jaime Lannister and Bronn travel to Dorne to retrieve Myrcella from the Martells. In the Red Keep, Cersei continues her machinations, desperate to dissuade Tommen from Margaery's charms and the influence of a new spiritual leader, the High Sparrow. Religious fanatics under the High Sparrow have reinstituted a centuries-old organization known as the Faith Militant. They roam the city and royal court, demanding that both peasants and nobles recant their sins and return to the one true Faith of the Seven.

The other Stark children continue to develop their skills. Arya begins to learn the secrets of the Faceless Men, a guild of assassins based in Braavos, while Sansa studies the art of manipulation under the tutelage of the master himself, Petyr "Littlefinger" Baelish. And inside the giant weirwood tree beyond the Wall, the Three-Eyed Raven shows Bran moments from the past, including how the White Walkers came to be.

There are many moments from Simpson's work on the show that stand out to him, but season five contains a sequence that was one of Simpson's favorites to storyboard. "While the scale and dramatic impact of the White Walkers' attack on the wildling village of Hardhome in season five is equally epic as the Battle of the Blackwater in season two, the 'Hardhome' episode is a favorite of mine for entirely different reasons," he recounts. "The storyboarding process moved smoothly, inspired by fluid discussions with the director. The imagery was exciting and the drawings were very detailed, so mentally it was a breeze and a sequence we could all be proud of. Sometimes it's just about the enjoyment of drawing, and my experience with 'Hardhome' was one of those times."

"Storyboarding episodes falls under the 'how long is a piece of string' approach," he continues. "There is never a firm rule regarding how much art an episode requires, as each episode is unique. The 'Blackwater' episode was huge, as was 'Hardhome.' Contrarily, some episodes are collections of smaller scenes. Regardless of the nature of the content, there's never a need to storyboard every moment of an episode. For example, storyboards for the talking head conversation scenes aren't always necessary since directors can easily visualize those moments. When artwork is necessary, I strive to refine the ideas that the directors want to portray. Realizing their versions of the story is most important to me. They are the creative visionaries entrusted with bringing this epic into reality."

Episode 501

THE WARS TO COME

Flanked by guards, Cersei steps out of her carriage and ascends the staircase to the Great Sept of Baelor, where her deceased father, Tywin Lannister, lies for viewing.

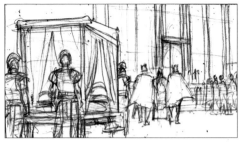

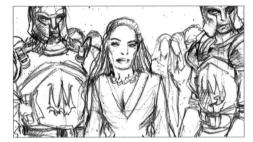

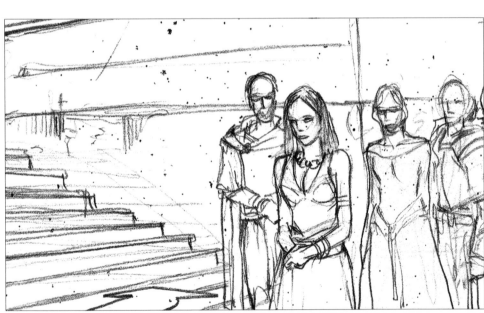

"Your grace, we are honored by your presence. The mourners are waiting."

—PRIEST

"They will keep waiting. I want a moment alone with him."

—CERSEI LANNISTER

 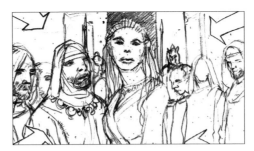

 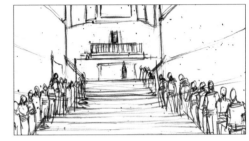

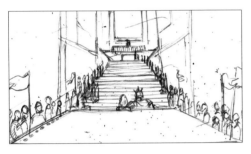 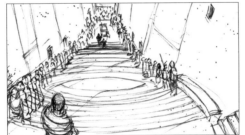 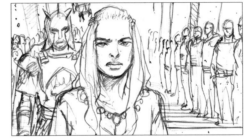 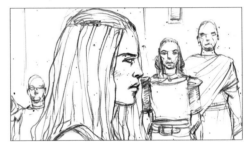

 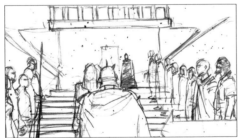 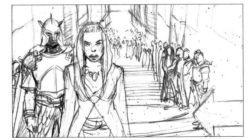 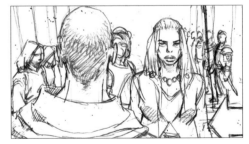

 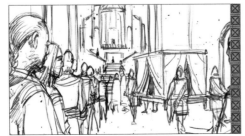

Simpson's storyboards pan down from the top of the Great Sept to emphasize its size, but this shot does not appear in the episode.

In the storyboards, Cersei looks down at the masses, before continuing into the Sept.

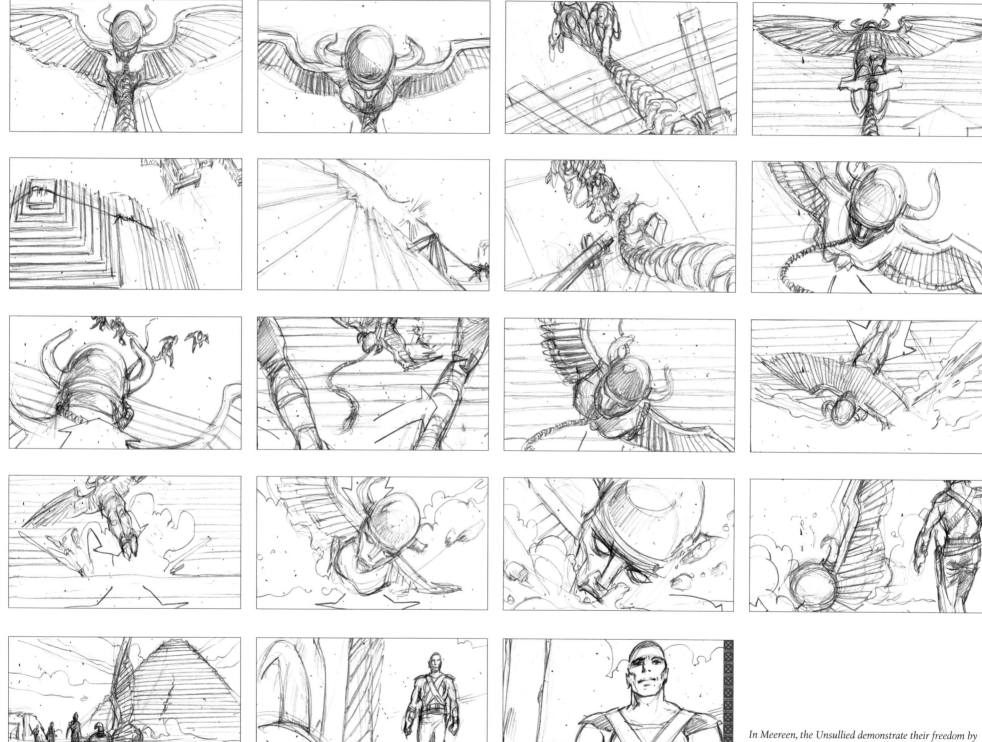

In Meereen, the Unsullied demonstrate their freedom by pulling down the golden harpy from the Great Pyramid. Their commander, White Rat, smiles proudly.

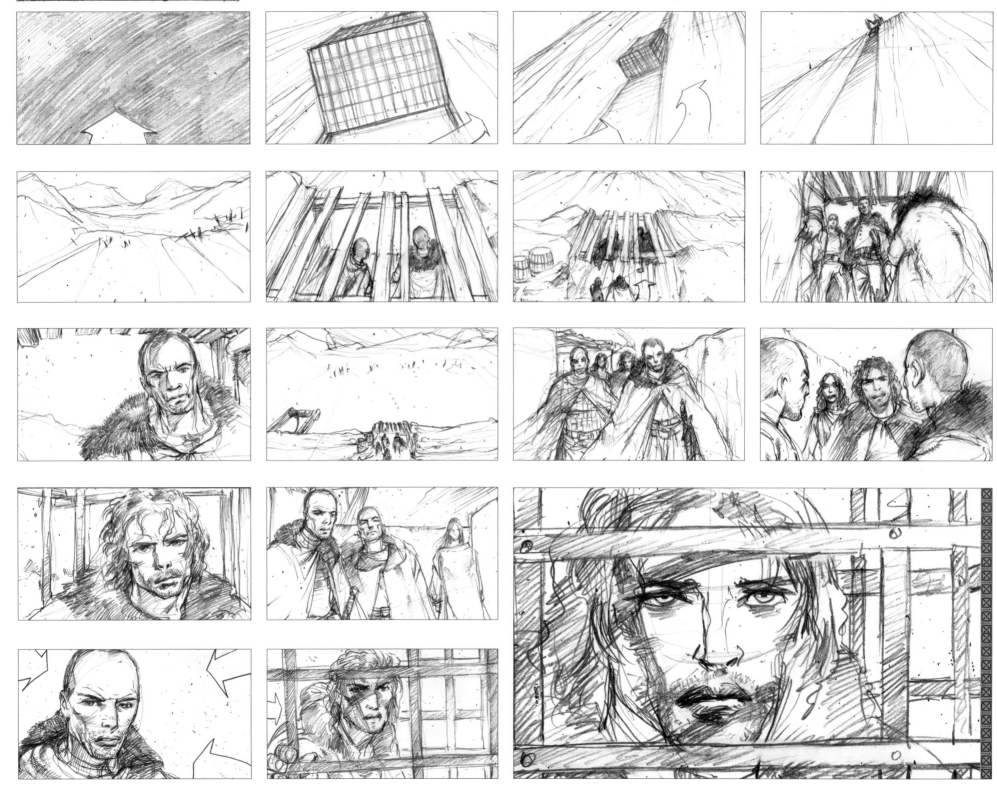

At Castle Black, Stannis tells Jon he wants Mance Rayder and his Free Folk tribes to swear loyalty to him and help him seize the North from Lord Roose Bolton. If Rayder does not kneel to Stannis, he will burn.

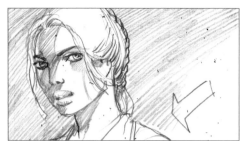

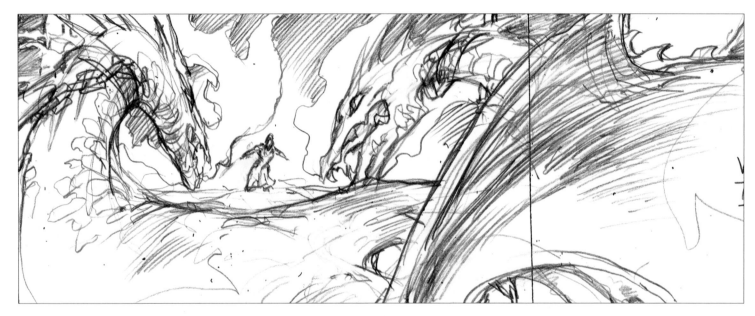

Daenerys goes to see her dragons Rhaegal and Viserion in the catacombs of Meereen, where they are chained.

The dragons breathe fire at Daenerys, and she flees into another room.

Simpson's contact sheets show a wry sense of humor, as this scene is labeled Dragon Day Care.

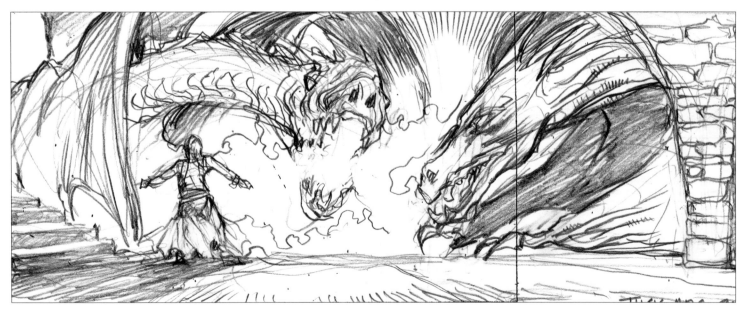

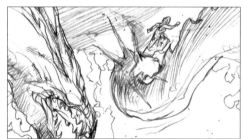

 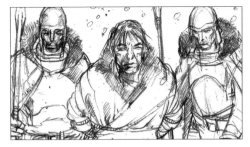 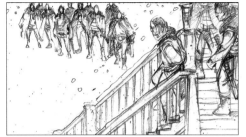 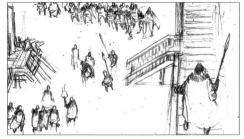

Mance Rayder is brought before Stannis. He refuses to bend the knee and order the Free Folk to fight for Stannis.

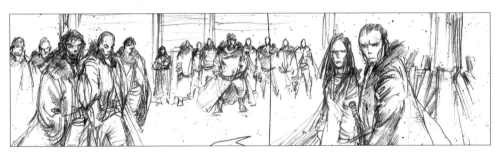

 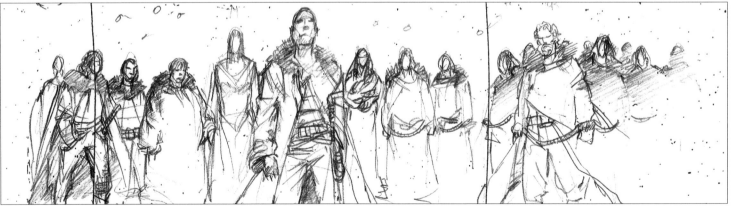

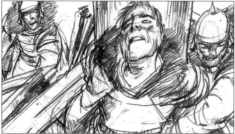
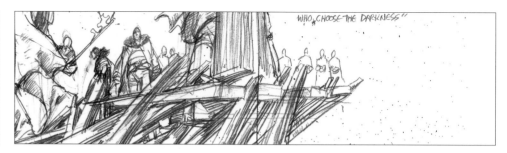

WHO "CHOOSE THE DARKNESS"

For his refusal, Mance Rayder is burned at the stake. Jon Snow shoots him with an arrow to limit his suffering and hasten his death.

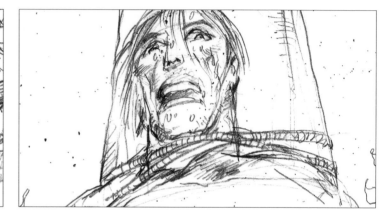

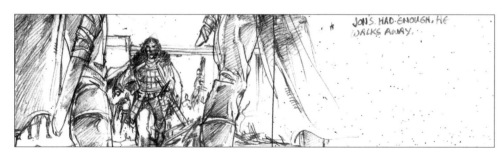

JON'S HAD ENOUGH, HE WALKS AWAY.

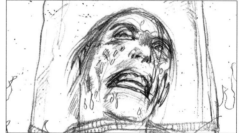

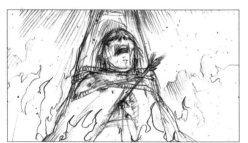
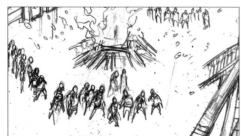

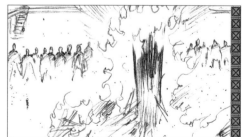

Episode 502

The House of Black and White

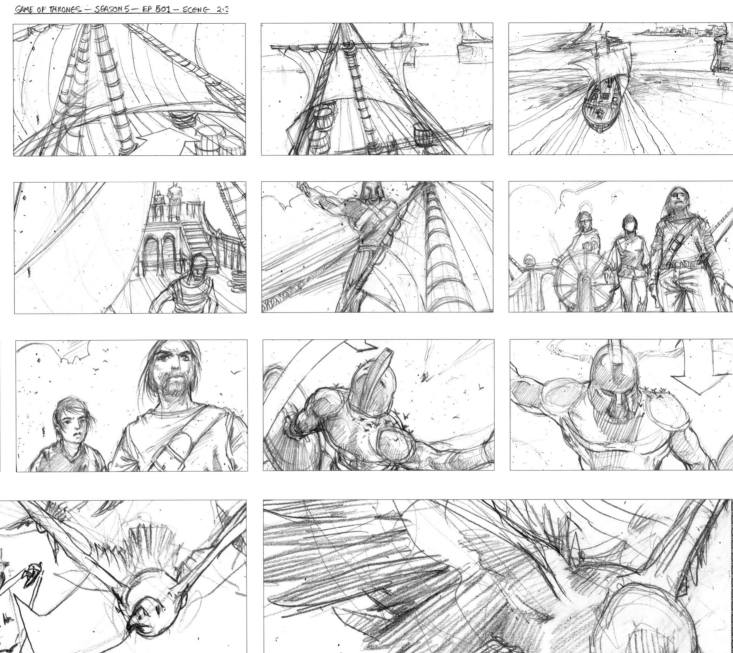

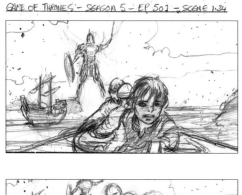
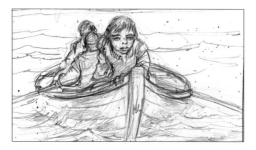

Arya arrives in Braavos and travels in a skiff down the canals to the House of Black and White.

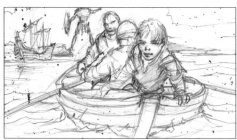

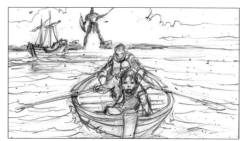

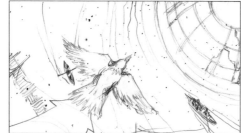
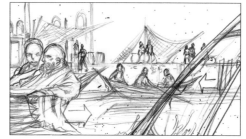
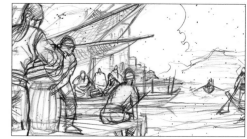

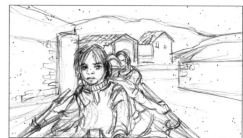

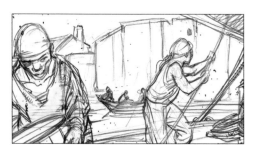
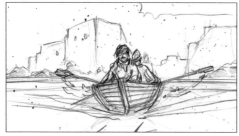
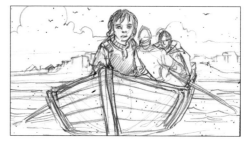

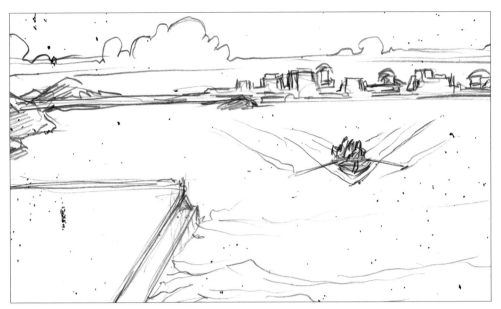
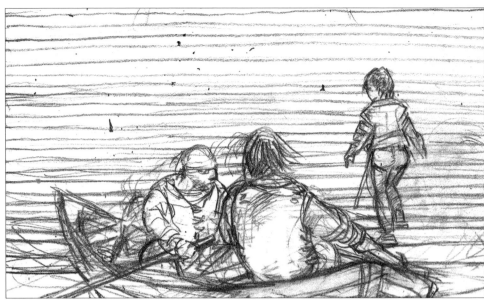

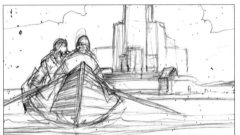

Arya knocks on the door of the House of Black and White.

Arya is denied entry to the House of Black and White, though she holds the coin given to her by Jaqen H'ghar. She waits on the steps for days, holding the coin and reciting the names of her enemies. Eventually, when the door doesn't open, she throws the coin into the waters and leaves.

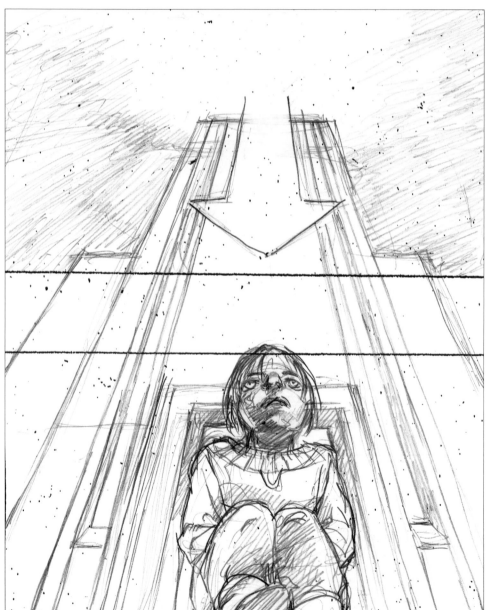

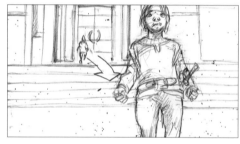

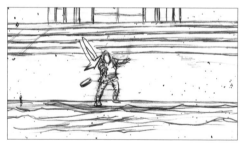

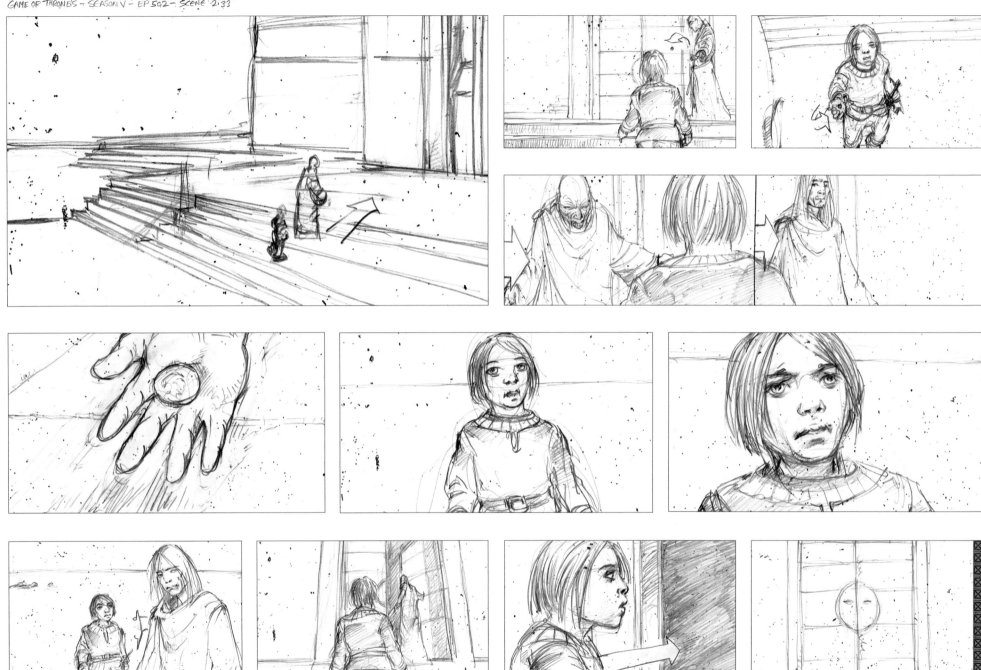

The old monk leads Arya back to the House of Black and White. Near the doors, he tosses her back the coin she threw into the bay.

To her surprise, the monk changes into Jaqen H'ghar. He opens the door so she can enter.

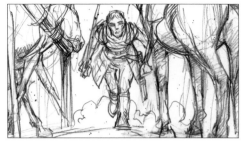
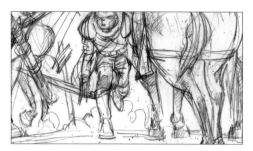
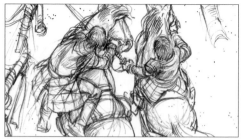

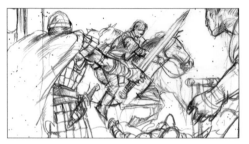

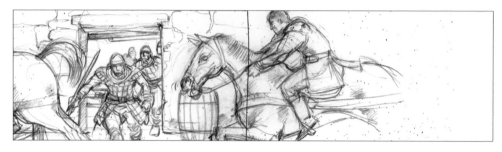

After Sansa Stark refuses Brienne of Tarth's petition to protect her, Brienne and her squire, Podrick, steal horses and gallop away from the inn where they all dined.

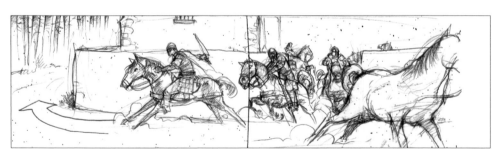
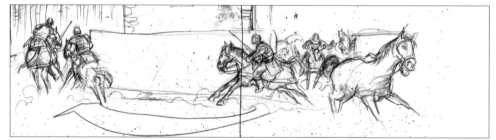

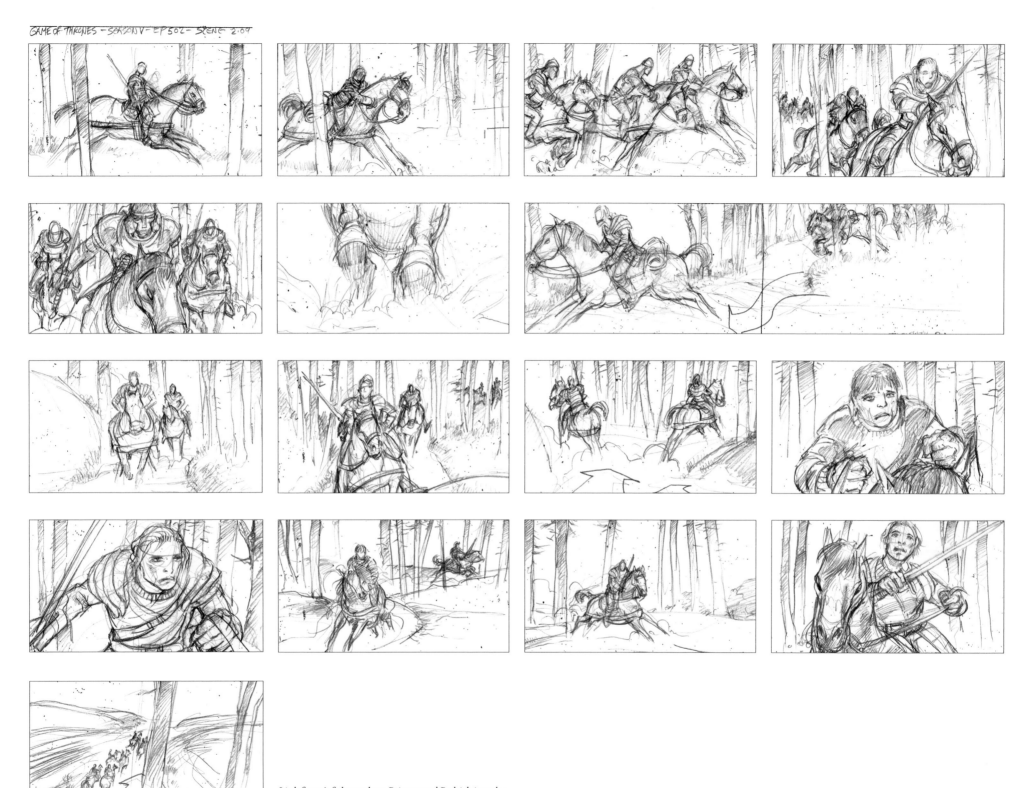

Littlefinger's fighters chase Brienne and Podrick into the forest. Podrick can't keep up and is split from Brienne.

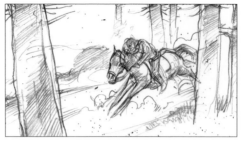
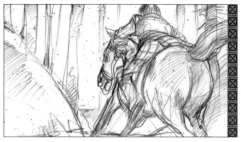

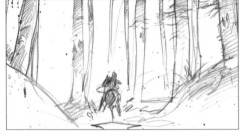
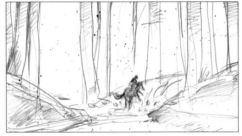
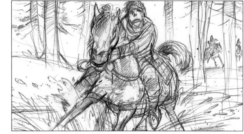
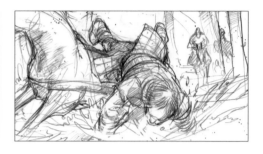

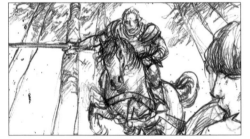
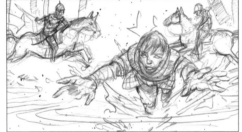
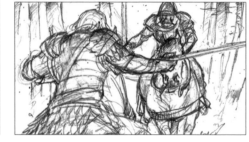
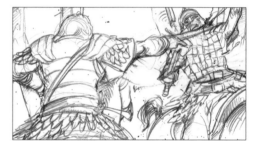

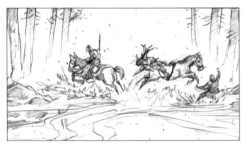

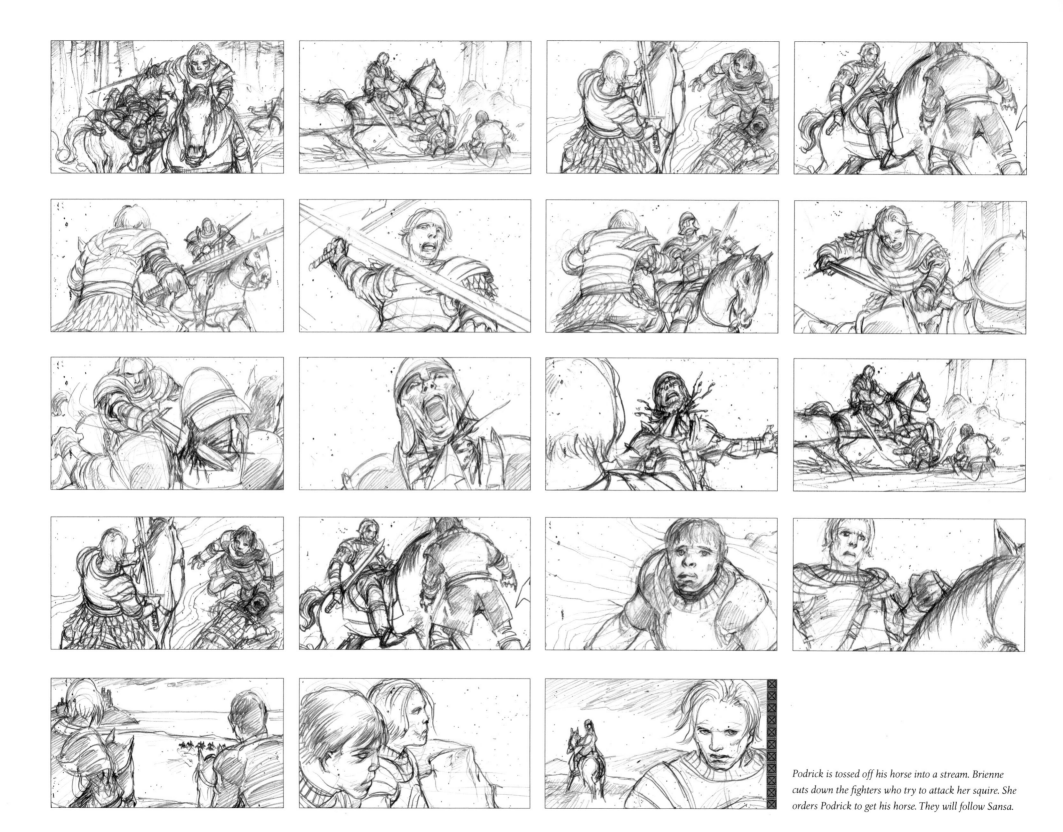

Podrick is tossed off his horse into a stream. Brienne cuts down the fighters who try to attack her squire. She orders Podrick to get his horse. They will follow Sansa.

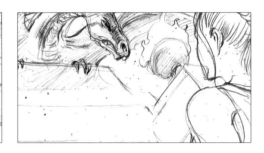
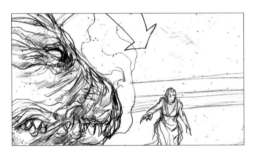
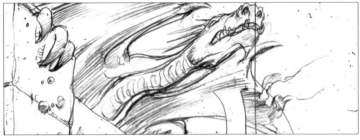

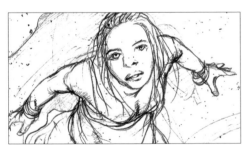
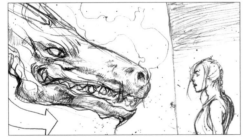
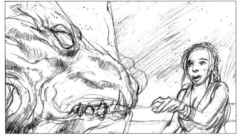
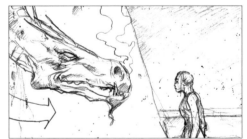
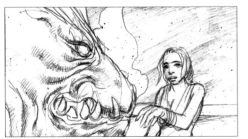
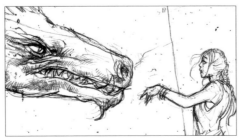

Drawn for episode four, this scene was moved to episode two. Having taken up residence in Meereen's Great Pyramid, Daenerys comes out to her balcony. Drogon sits atop the pyramid. He's grown bigger since the last time she saw him.

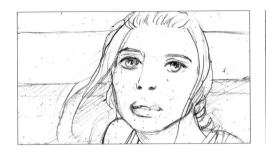
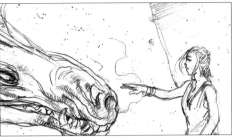
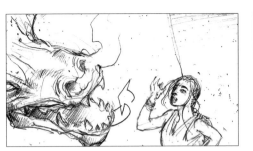

The dragon crawls down toward her. She reaches out to his snout, nearly touching it. He sniffs her hand and then flies away.

Episode 504

SONS OF THE HARPY

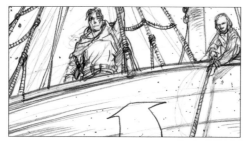
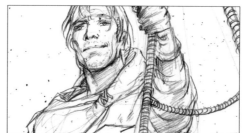

On the deck of a merchant ship, Jaime Lannister looks out at a nearby island. He asks the captain if it's Estermont, but the captain tells him it's Tarth.

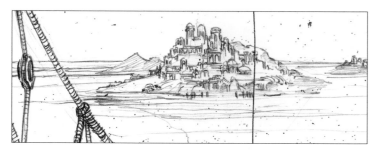
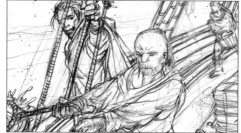
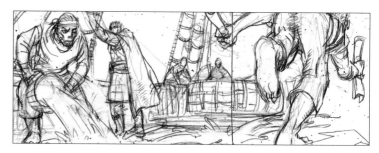

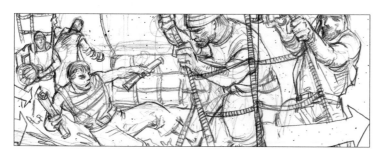
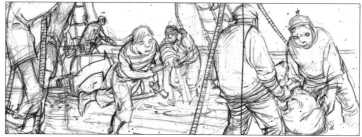

The storyboarded activity of buckets pulled on board and the young deckhand slipping on spilled water isn't featured in the episode.

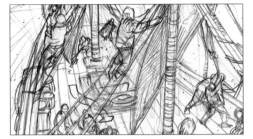

 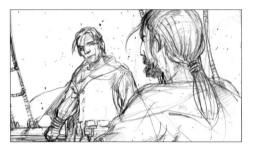 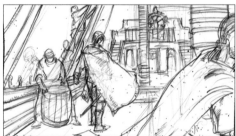

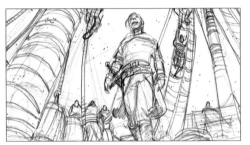 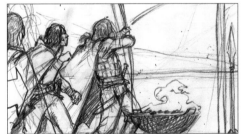 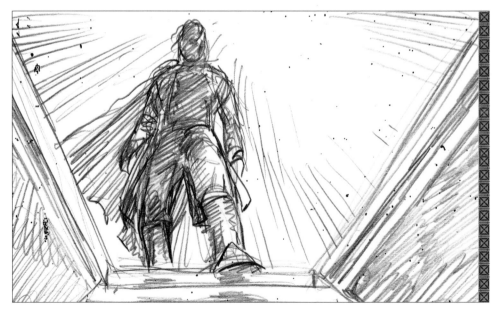

On their way to Dorne, Jaime descends into the bottom of the ship to speak to Bronn.

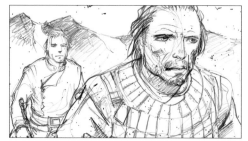
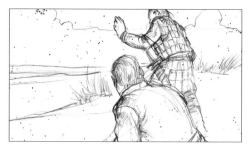
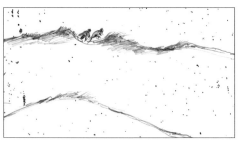

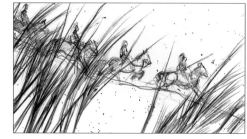
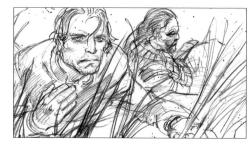
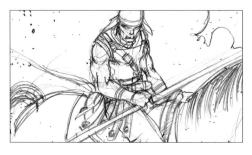

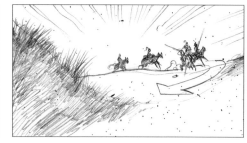
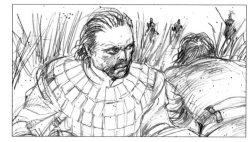
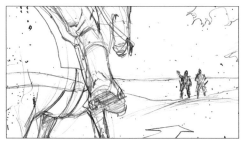
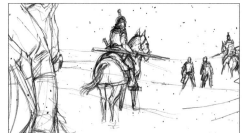
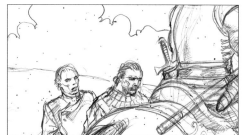

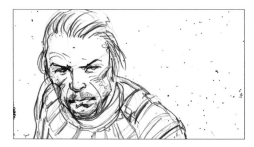

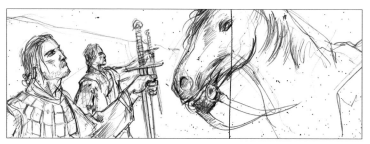

Jaime and Bronn are walking along the beach when they hear Dornishmen on horseback approach.

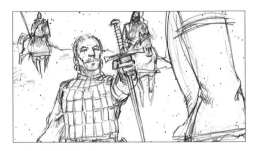

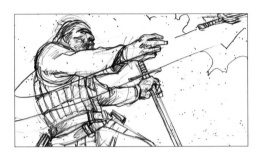
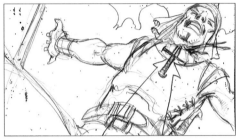
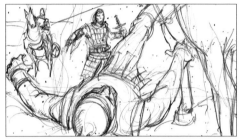
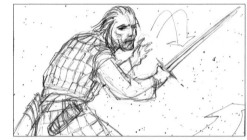

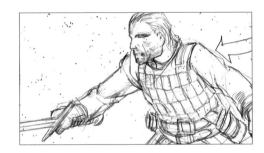

"Throw your sword in the sand."

—DORNISH SOLDIER

"There's no need for this. Just point us in the right direction. We'll find our way home."

—BRONN

Since he's lost his sword hand, Jaime must duel a Dornish sentry with his less-skilled hand and falls back. However, the hard golden hand that's replaced his severed one hooks the sentry's sword, giving Jaime a chance to land a killing stroke of his own.

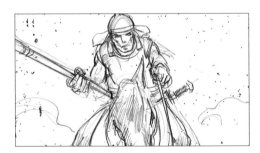
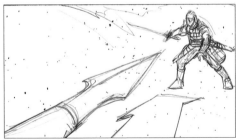
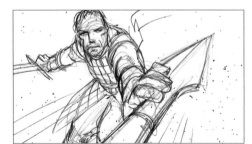
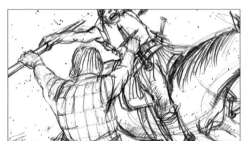

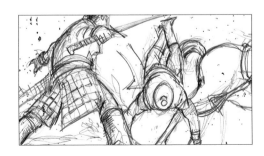
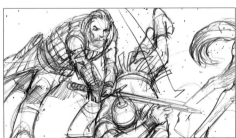
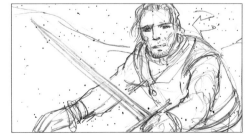
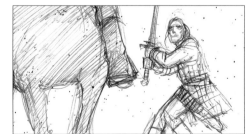

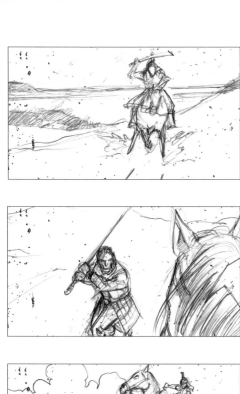
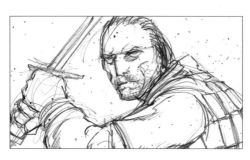
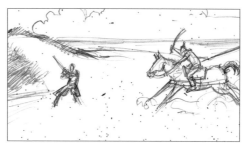

Bronn defeats a sentry on horseback.

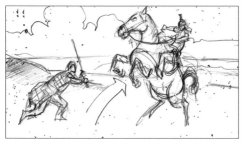
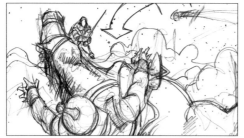
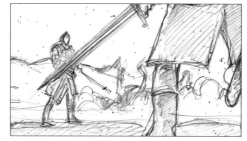
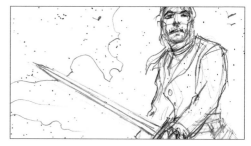

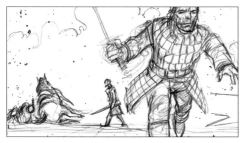
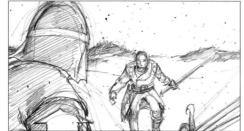
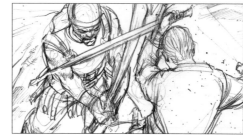
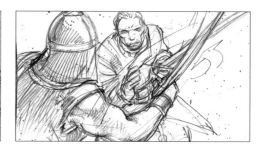

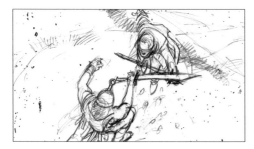
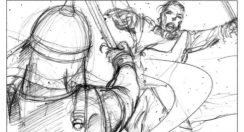
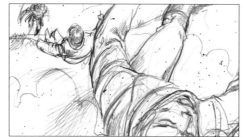
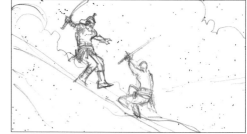

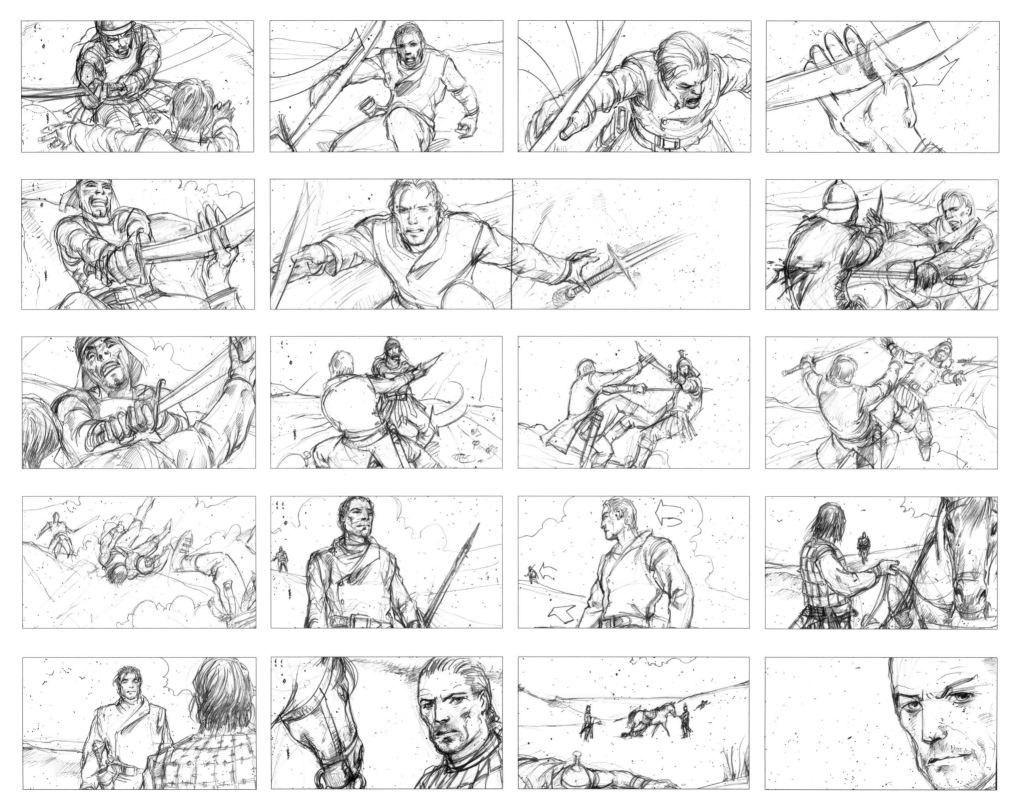

 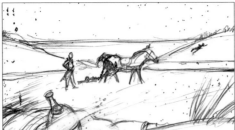 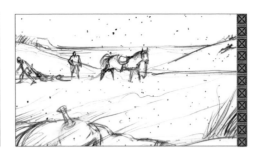

Ellaria Sand tells the Sand Snakes that Prince Doran Martell will not wage war against the Lannisters for killing their father, Prince Oberyn Martell. To incite a war and achieve revenge for their father, Ellaria suggests they kill Myrcella, Cersei's daughter.

GAME OF THRONES — SEASON V — EP S04 — SCENE 4·9

 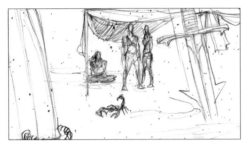 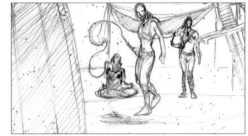

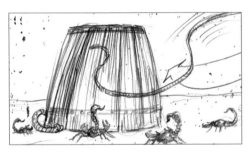 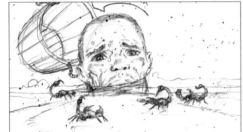 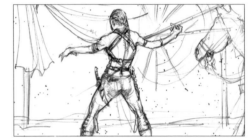 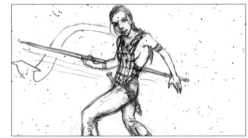

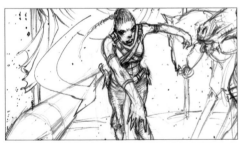

While they talk, scorpions scuttle around the head of the merchant captain who brought Jaime and Bronn to Dorne. The Sand Snakes tortured the captain for this information and then buried the captain in the sand up to his neck. Obara, the oldest of the Sand Snakes, throws her spear and impales the captain's head.

GAME OF THRONES — SEASON V — EP S05 — SCENE 5·4A

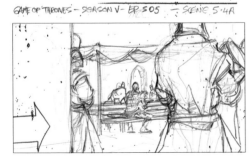 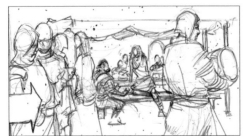 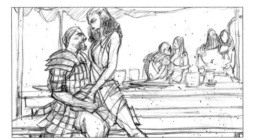

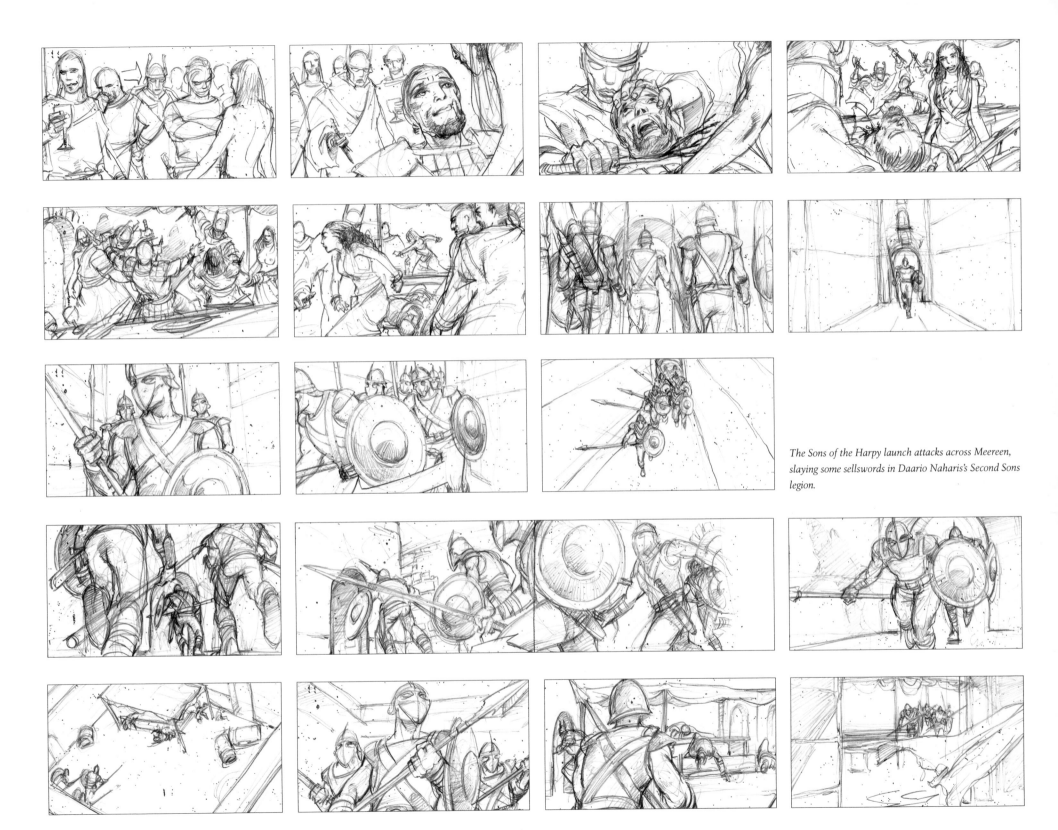

The Sons of the Harpy launch attacks across Meereen, slaying some sellswords in Daario Naharis's Second Sons legion.

 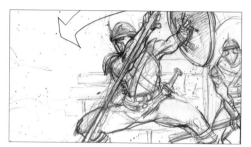 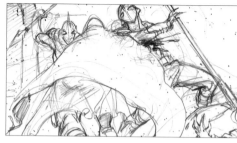

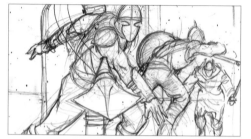

Grey Worm and other Unsullied soldiers go after the Sons of the Harpy and fight them in a stone corridor. The Sons of the Harpy outnumber and overwhelm the Unsullied.

Ser Barristan joins the battle, saving Grey Worm but receiving mortal wounds in the process.

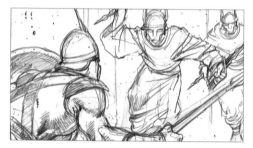 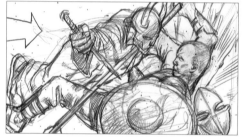 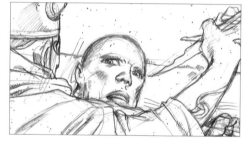 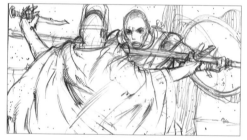

 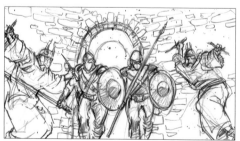

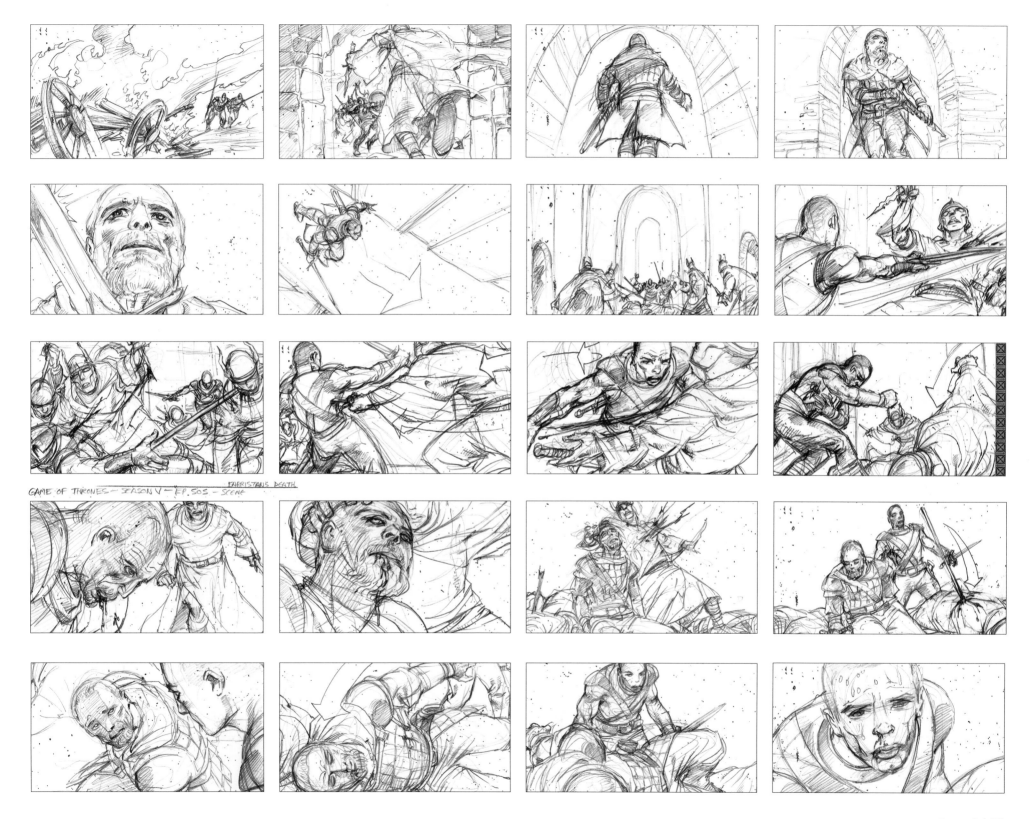

GAME OF THRONES — SEASON V — EP. 505 — SCENE BARRISTAN'S DEATH

Episode 505

Kill the Boy

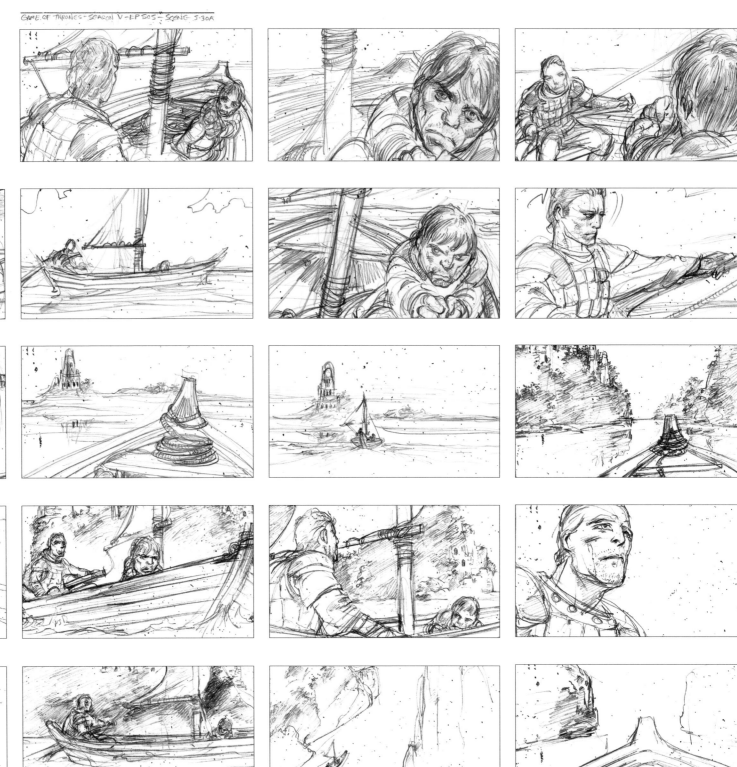

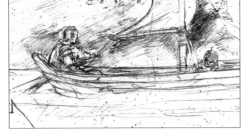

Jorah and his prisoner Tyrion sail past the edge of the ruins of Old Valyria, which triggers Tyrion to recite a poem about the city's doom.

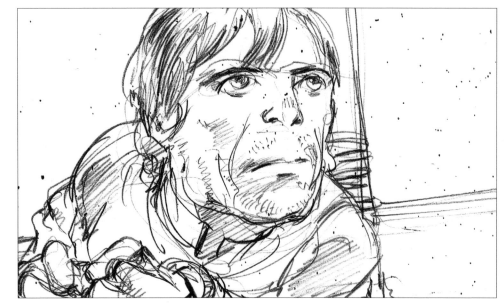

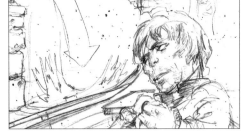

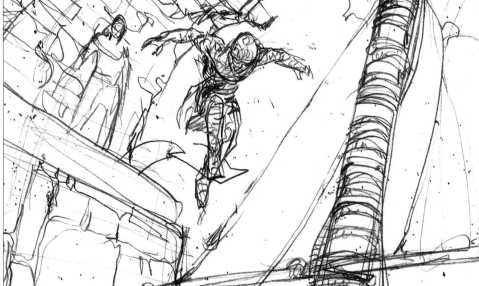

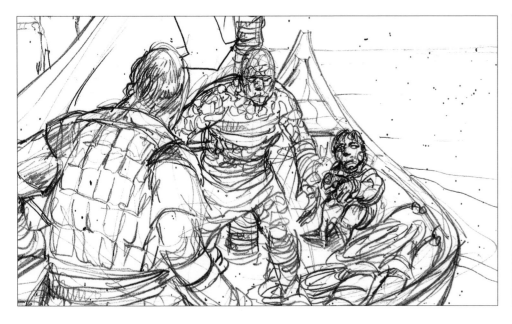

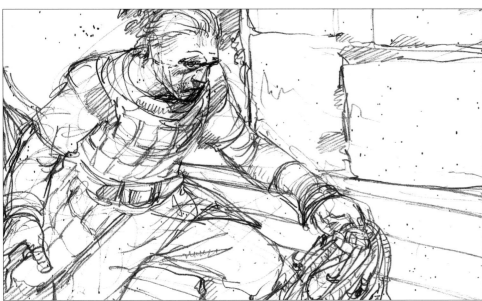
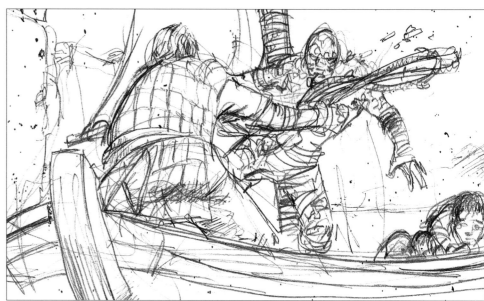

Humans afflicted with the greyscale disease—called colloquially Stone Men—leap onto the boat and attack. As Jorah fights them on the deck, Tyrion falls off into the water.

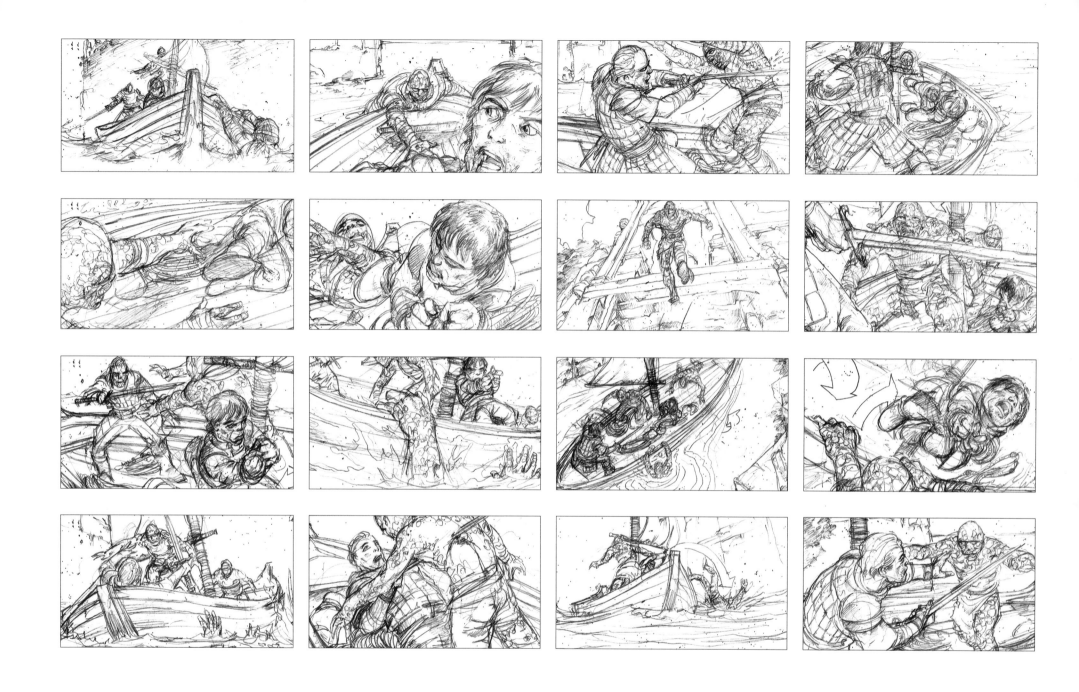

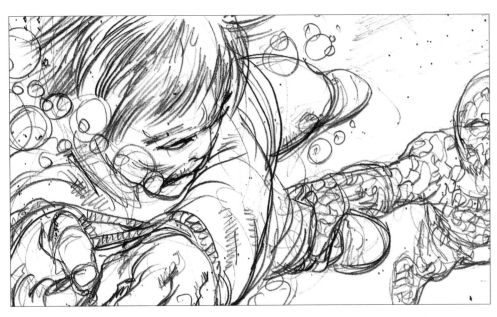
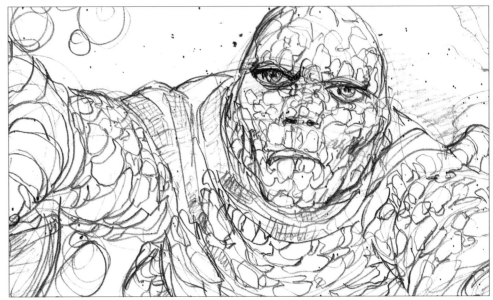

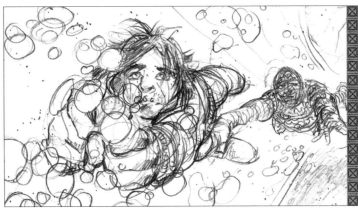

A Stone Man grabs Tyrion's boot and pulls him deeper underwater.

Episode 506

UNBOWED, UNBENT, UNBROKEN

Jaqen H'ghar, one of the assassins known as the Faceless Men, brings Arya into the Hall of Faces. Throughout the chamber are stone pillars shelved with human faces taken from the dead.

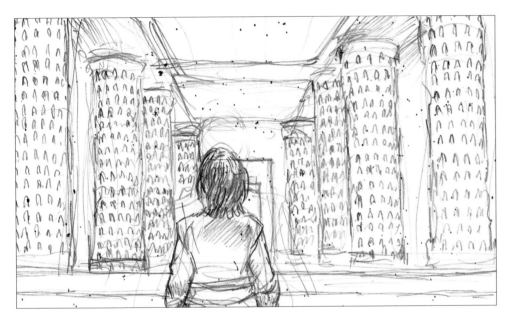
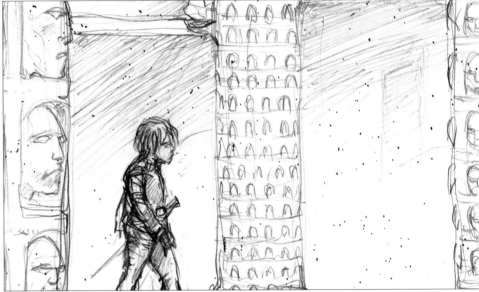

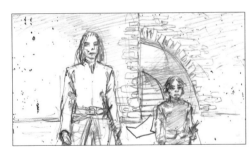

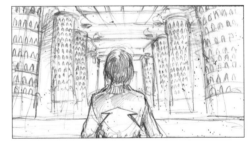
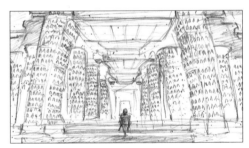

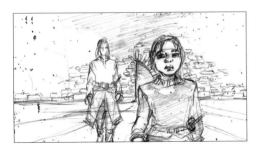
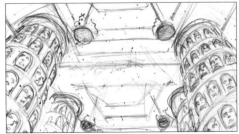
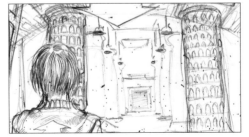

Jaqen tells Arya she isn't ready to become "no one," but she is ready to become someone else.

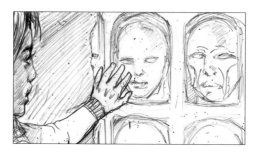

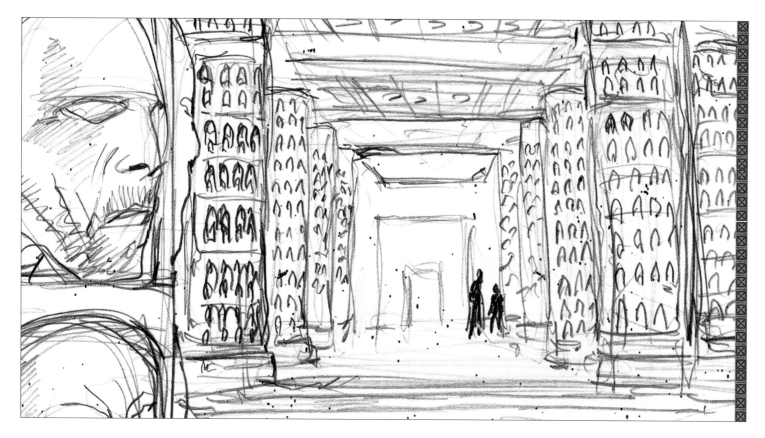

Episode 508

HARDHOME

Jon Snow, Tormund, and a combined force of Free Folk and brothers of the Night's Watch sail in ships toward the wildling fishing village of Hardhome in the North. Snow wants to persuade more wildlings to join his small army to confront the White Walkers.

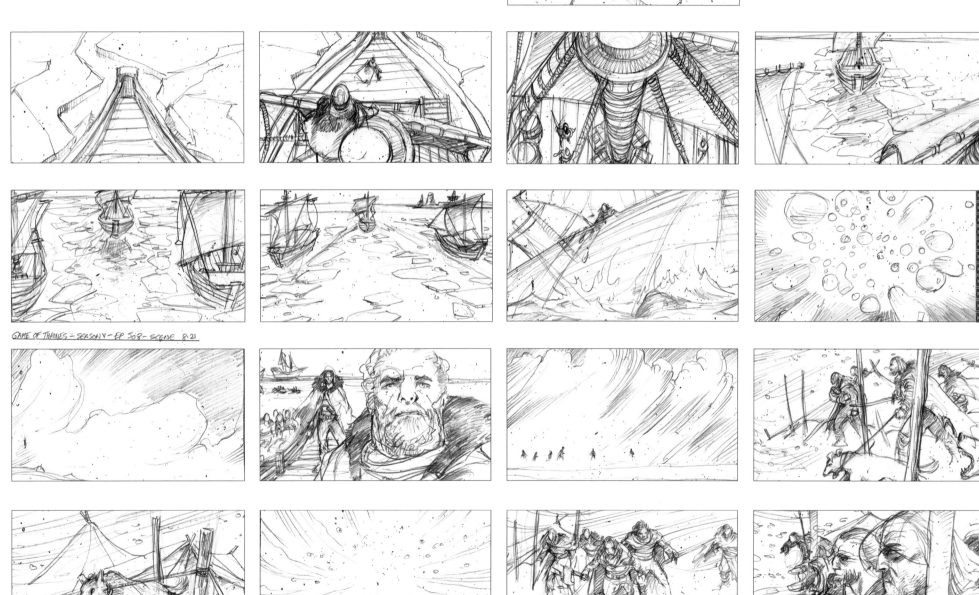

GAME OF THRONES - SEASON V - EP 508 - SCENE 8.21

Dogs in Hardhome start to bark as a strange blizzard rolls toward Hardhome.

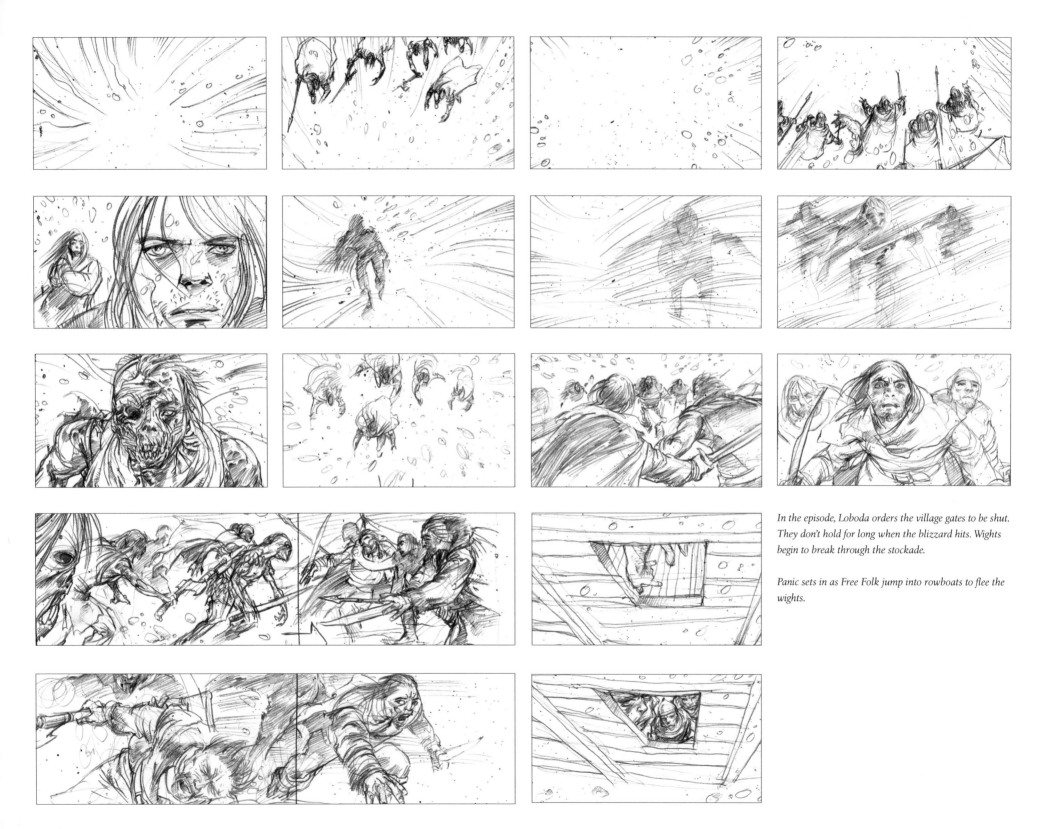

In the episode, Loboda orders the village gates to be shut. They don't hold for long when the blizzard hits. Wights begin to break through the stockade.

Panic sets in as Free Folk jump into rowboats to flee the wights.

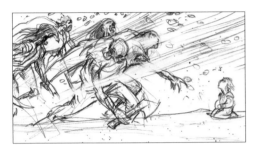
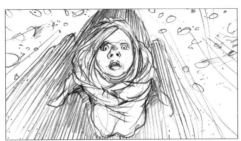
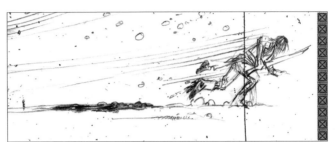

An army of the dead emerges from the fierce wind and blustery snow.

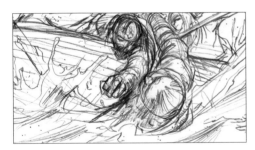
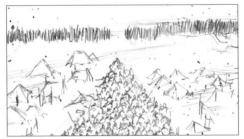
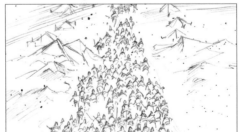
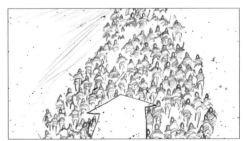
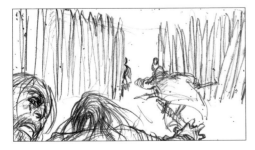
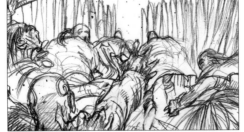
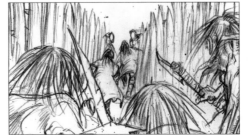
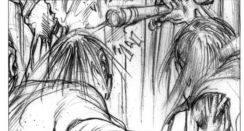

GAME OF THRONES - SEASON V - EP 508 - SCENE 8-21 - 8-22

Jon Snow rallies the Night's Watch and warriors of the Free Folk to defend the stockade so that some villagers can get away.

In the episode, their defense is more a chaotic melee than seen in the storyboards. Archers shoot arrows, but Snow doesn't call them as a unit.

FROM WIGHTS TO WHITE WALKERS

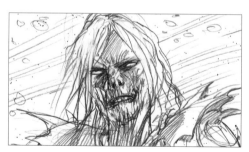

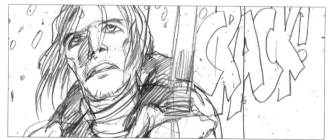

The wights continue to swarm the gate as the wildlings attempt to shore up their defenses.

The wights break through the gate.

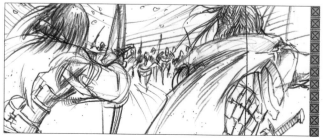

Episode 509

THE DANCE OF DRAGONS

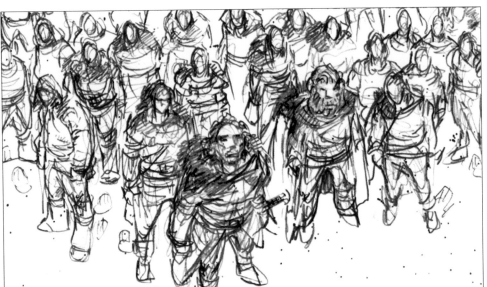

Jon Snow leads the surviving wildlings and rangers from the massacre at Hardhome to the Wall's northern side. Ser Alliser Thorne and the Night's Watch survey them from the top. Reluctantly, Thorne orders the gate opened.

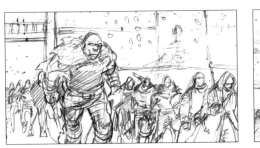

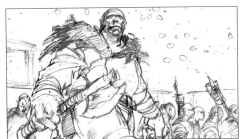

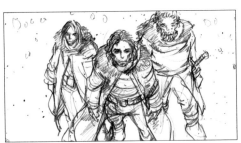

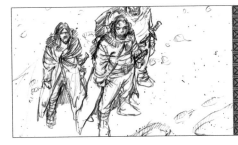

Jon Snow watches the giant Wun Weg Wun Dar Wun stoop under the gate and stomp past into the courtyard of Castle Black.

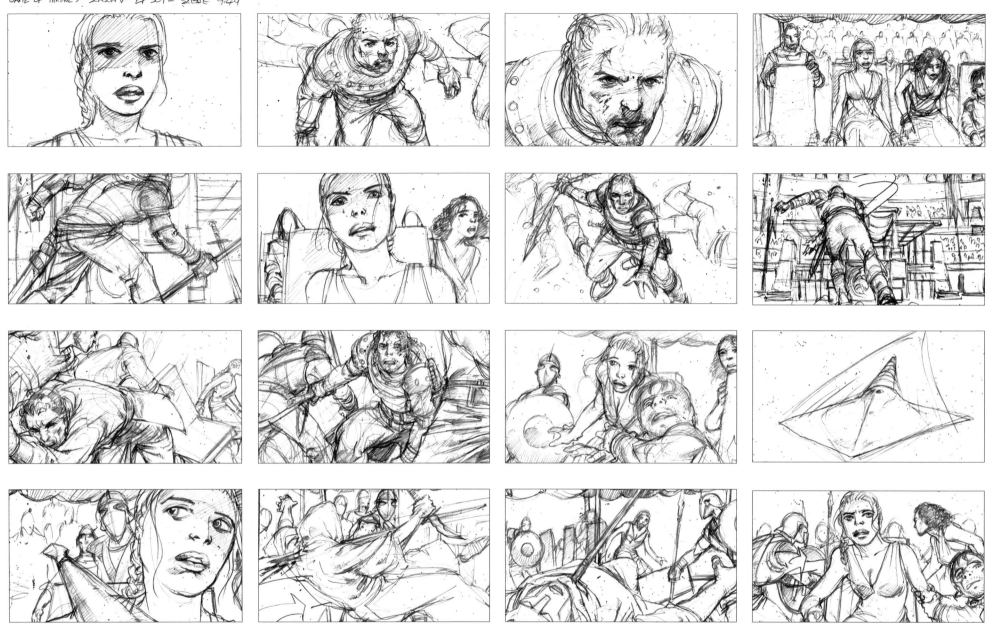

From the royal box, Daenerys and Hizdahr zo Loraq, a former slave master who is now intended to be her husband, watch Ser Jorah Mormont kill his gladiatorial opponents in Daznak's Pit in Meereen. Daenerys continues to be unsure of Jorah's loyalty after he confessed spying on her.

Ser Jorah proves his loyalty by throwing a spear at a Son of the Harpy who appears behind Daenerys, trying to assassinate her. Simpson breaks down the sequence in multiple panels, but in the episode, it happens much faster, in just a few shots.

As the Sons of the Harpy attack, Hizdahr zo Loraq calls
to Daenerys to follow him out, until the Sons plunge
daggers into his chest.

Daario Naharis and Jorah cut down many of the masked assassins around Daenerys. Jorah reaches a hand out to her. She accepts it. He leads her out of the royal box.

Tyrion stabs an enemy in the back, rescuing Missandei.
The two follow Daenerys.

The battle spills into the pit.

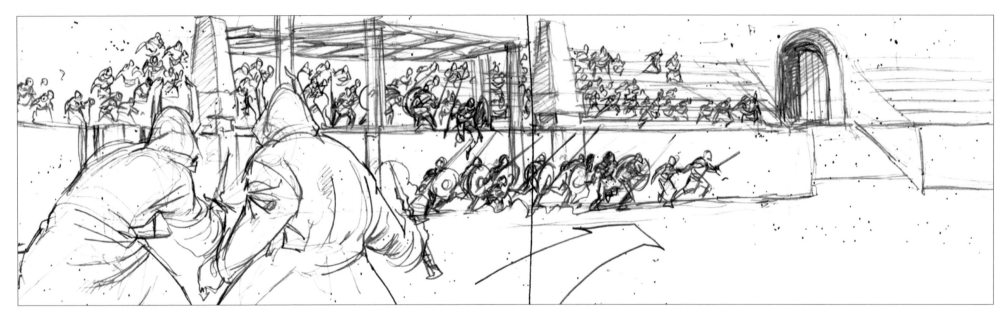

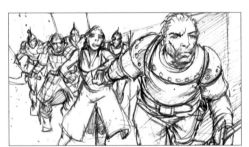
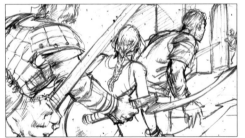

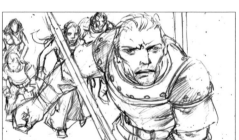

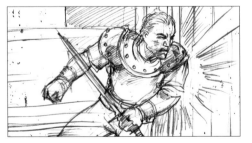
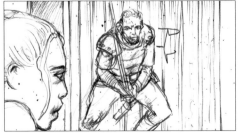
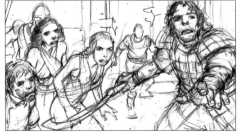
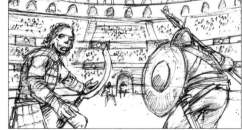

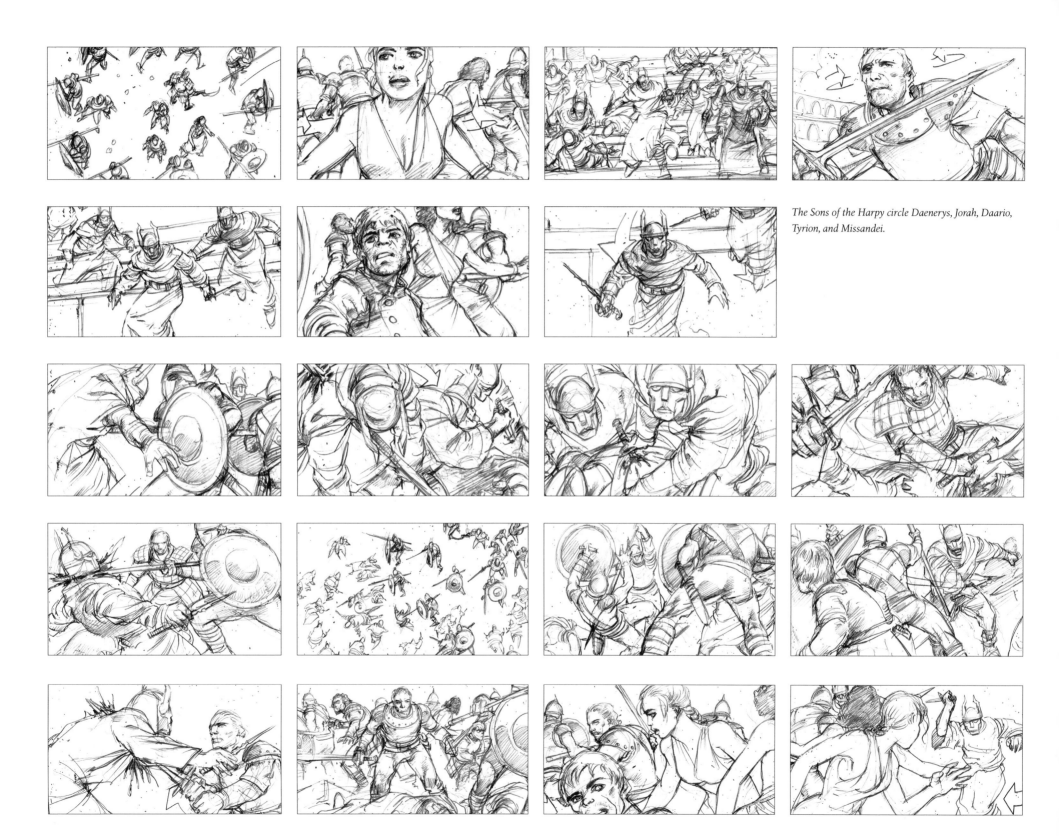

The Sons of the Harpy circle Daenerys, Jorah, Daario, Tyrion, and Missandei.

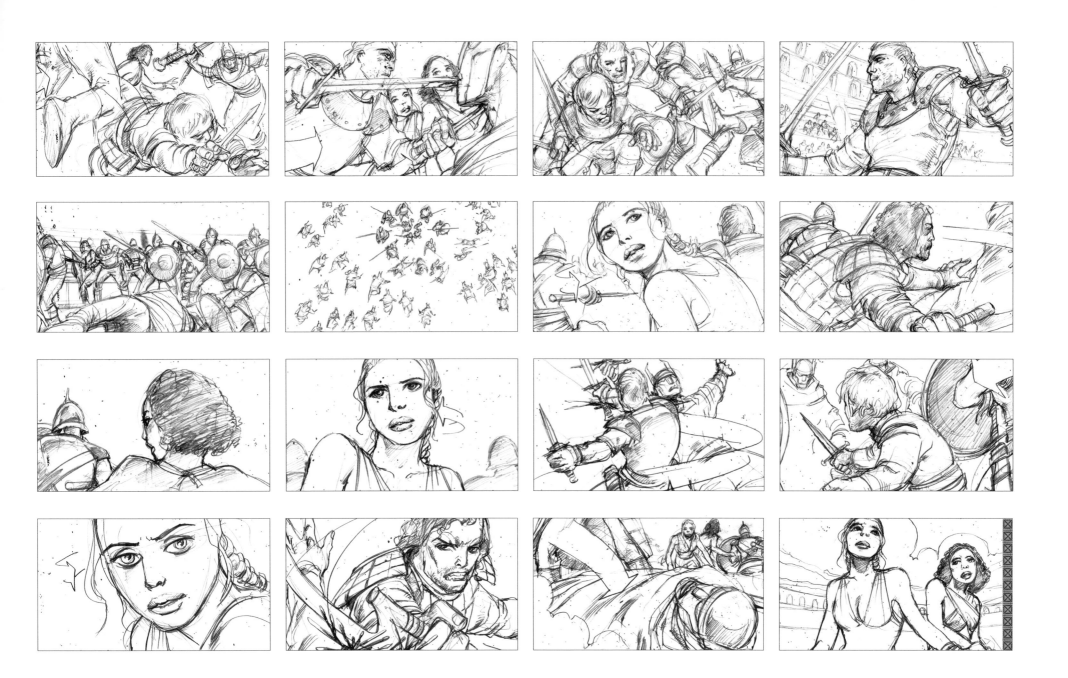

*Though Jorah, Daario, and even Tyrion take out many Sons, they are
outnumbered. Daenerys looks for a way out. There is none.*

*Daenerys holds Missandei's hand, prepared for the end. In the episode,
she closes her eyes until she hears Drogon's screeching roar.*

To end the sequence, Simpson writes: Enter Drogon!

Episode 5.10

MOTHER'S MERCY

 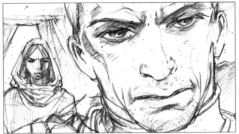 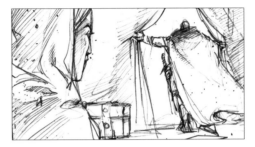

While Stannis Baratheon dresses for battle in his tent, Melisandre informs him that he will take Winterfell. The Lord of Light has shown her burning banners of Winterfell's current occupant, Ramsay Bolton.

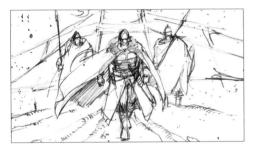 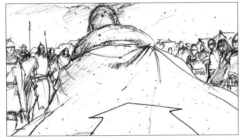 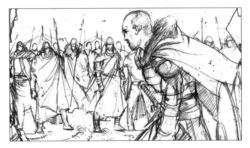

 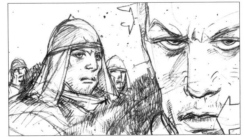 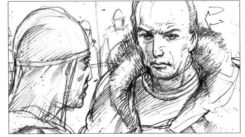 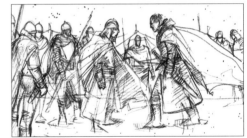

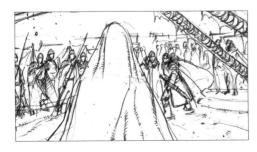 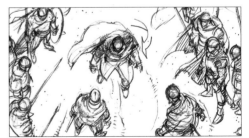

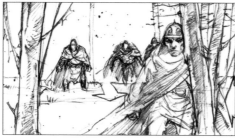
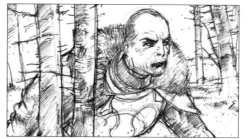
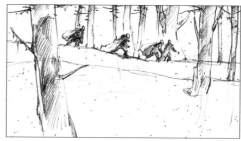
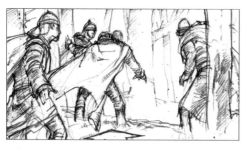

Walking through camp, Stannis learns that half of his army has left with the horses after he burned his daughter at the stake.

A soldier leads Stannis into the forest, where his wife, Selyse, hangs from a tree. Even this bad omen does not change Stannis's plans to wage war against Winterfell.

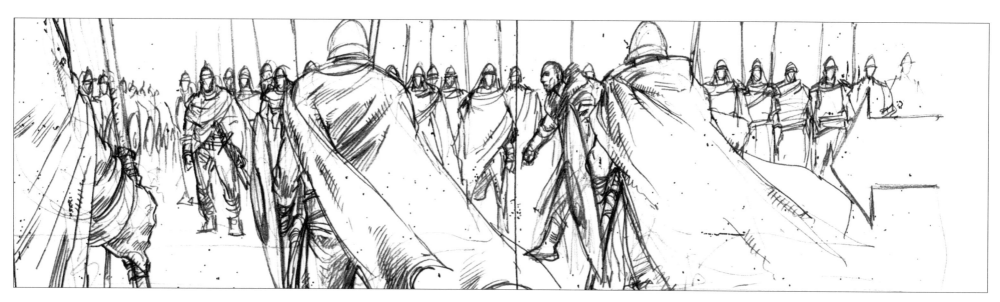

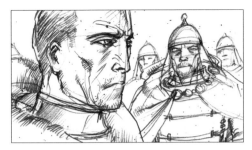
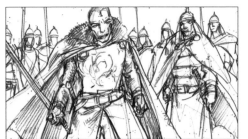

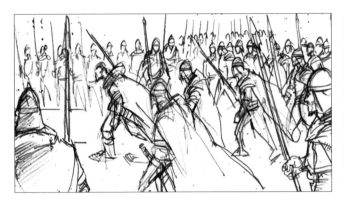

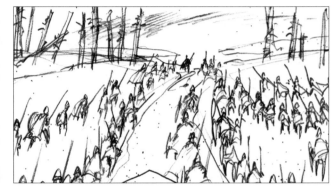

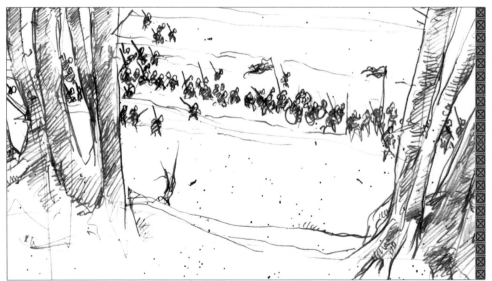

Stannis walks down the line of his soldiers. Melisandre is nowhere to be found. He orders his men to march on Winterfell. This sequence does not appear in the episode.

Having caught game in the forest, Podrick spots Stannis's army marching toward Winterfell. In the episode, game and firewood hang from Podrick's shoulder straps.

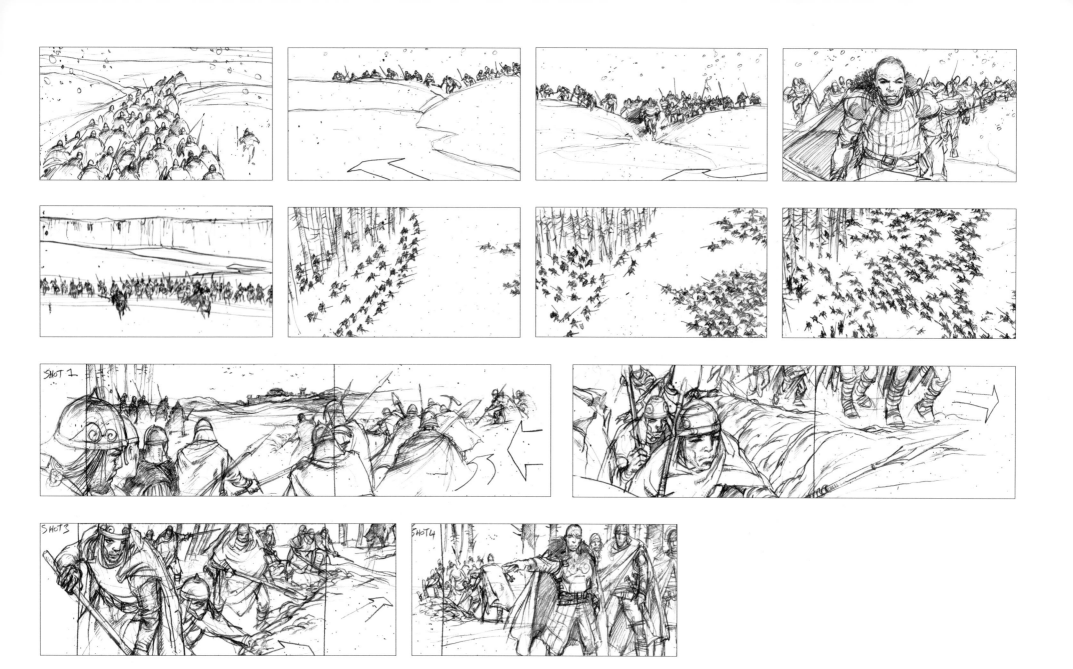

Stannis commands trenches to be dug to begin the siege. His general tells him there won't be a siege. Bolton's army rides on horseback over a rise toward them.

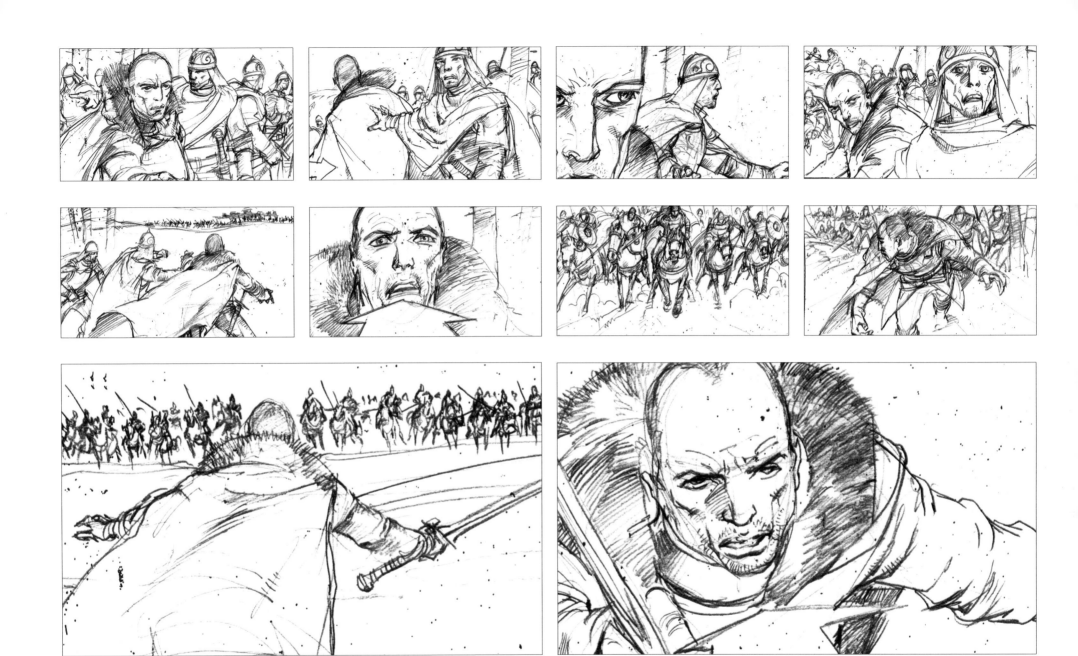

In lieu of a speech, Stannis draws his sword.

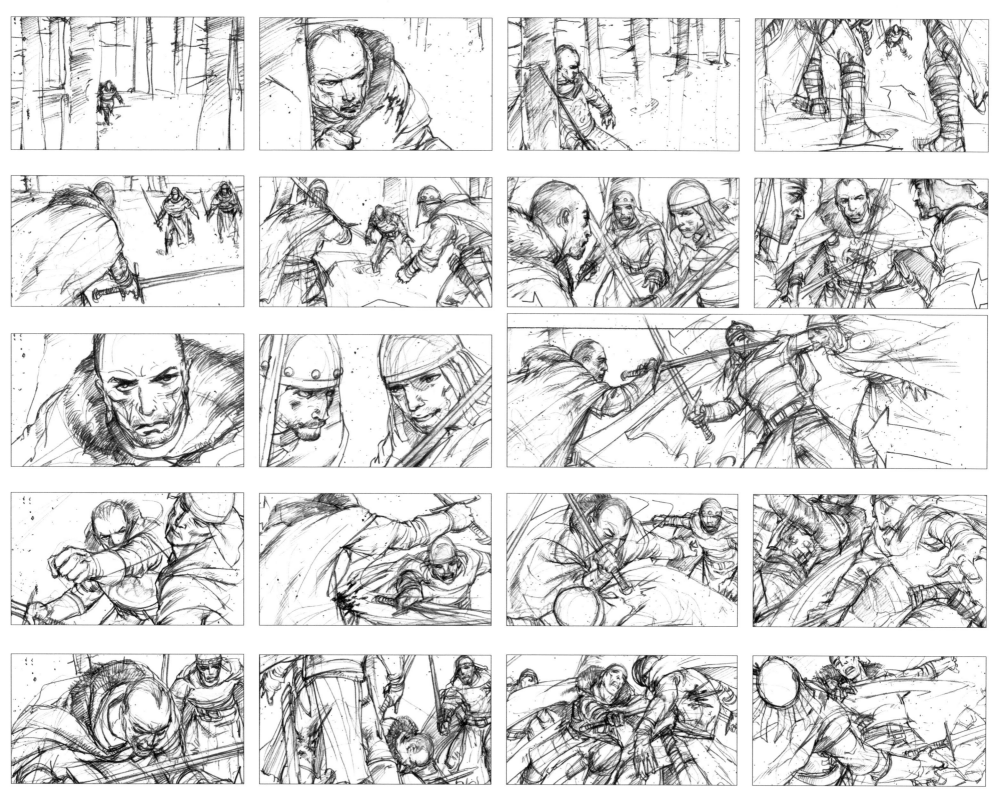

The storyboards show a wounded Stannis struggling alone in the forest, but in the episode, bodies of his men lay strewn about on the forest floor.

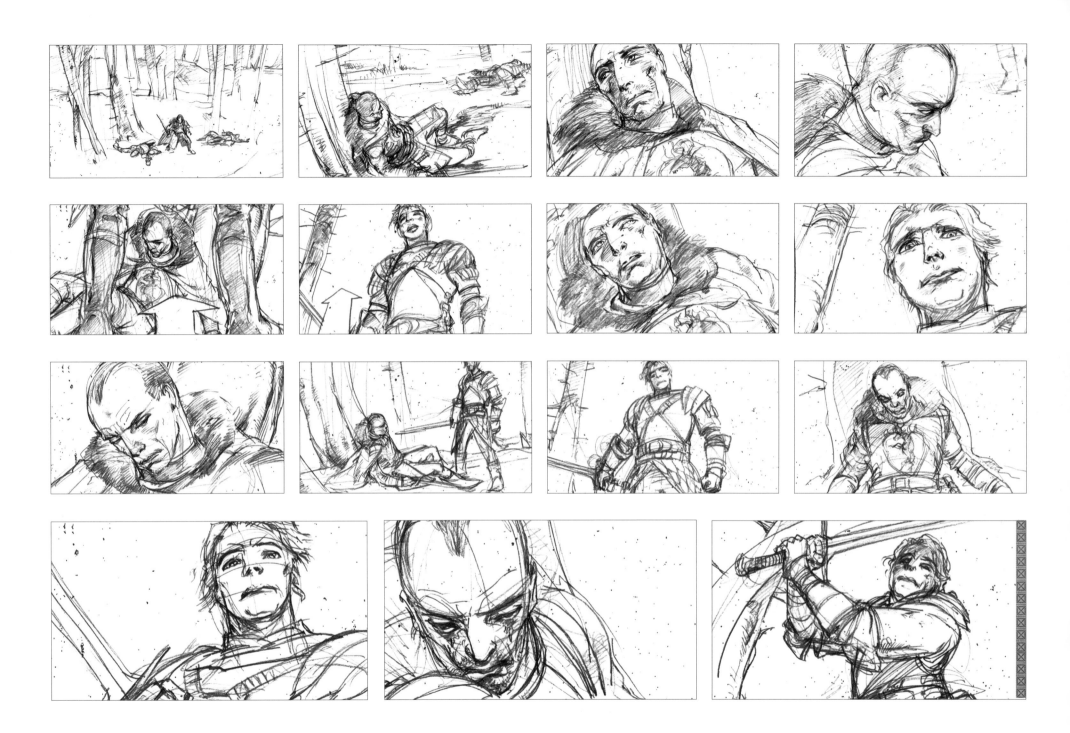

Stannis kills two Bolton soldiers who come at him, but he is further hurt in the process.
He slumps against a tree.

Brienne of Tarth finds him and executes him for the murder of the king to whom she
pledged loyalty, Stannis's brother, Renly Baratheon.

On the castle ramparts, Theon Greyjoy, now known as "Reek," and Myranda, Ramsay Bolton's servant and lover, block Sansa from escaping. Myranda targets her with an arrow.

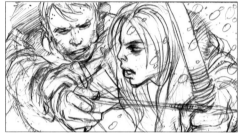
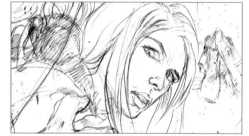
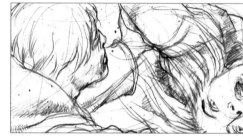

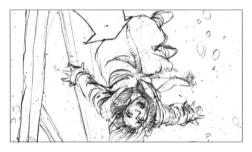
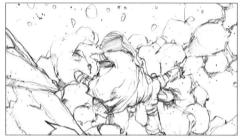
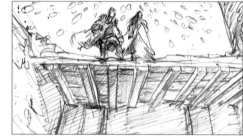
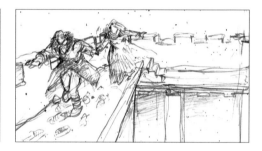

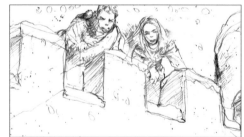
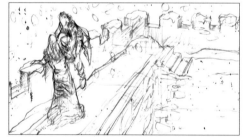
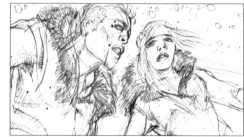

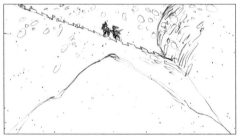
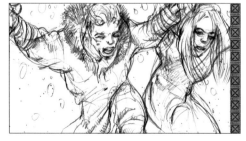

Reek grabs Myranda from behind and pushes her off the rampart, killing her. With Bolton soldiers returning from the battle, there's no easy route for Sansa and Reek out of the castle before Myranda's body is found, so they make a perilous leap off the ramparts into the snow far below on the other side.

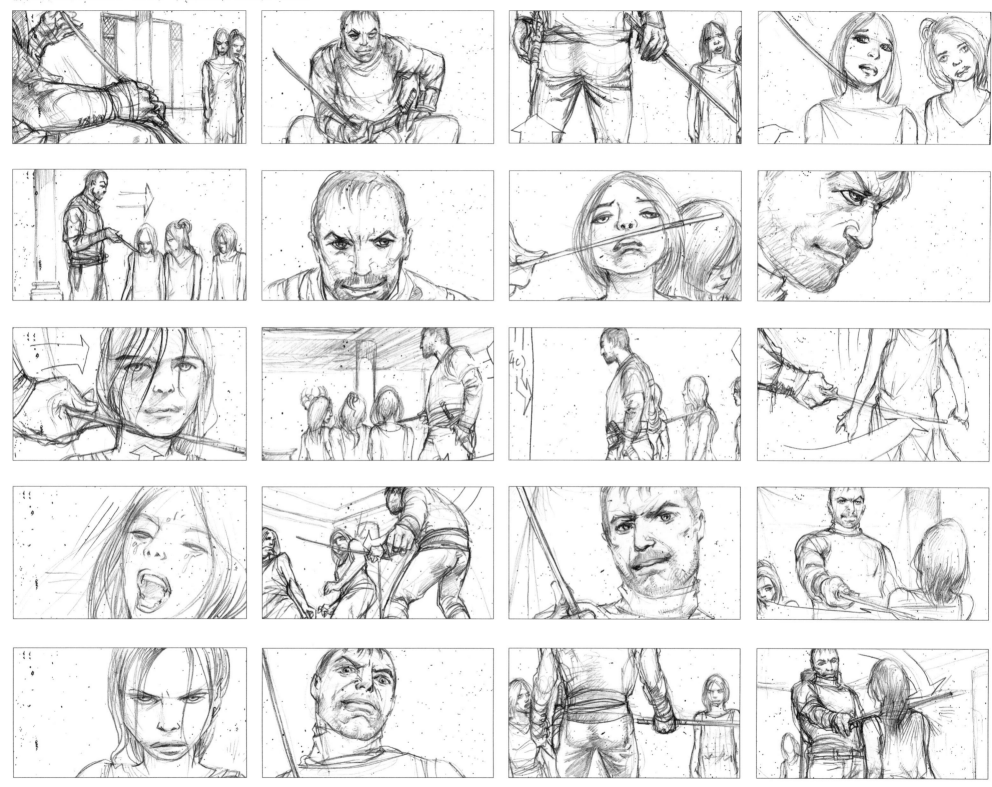

Ser Meryn Trant menaces three young girls with a switch.

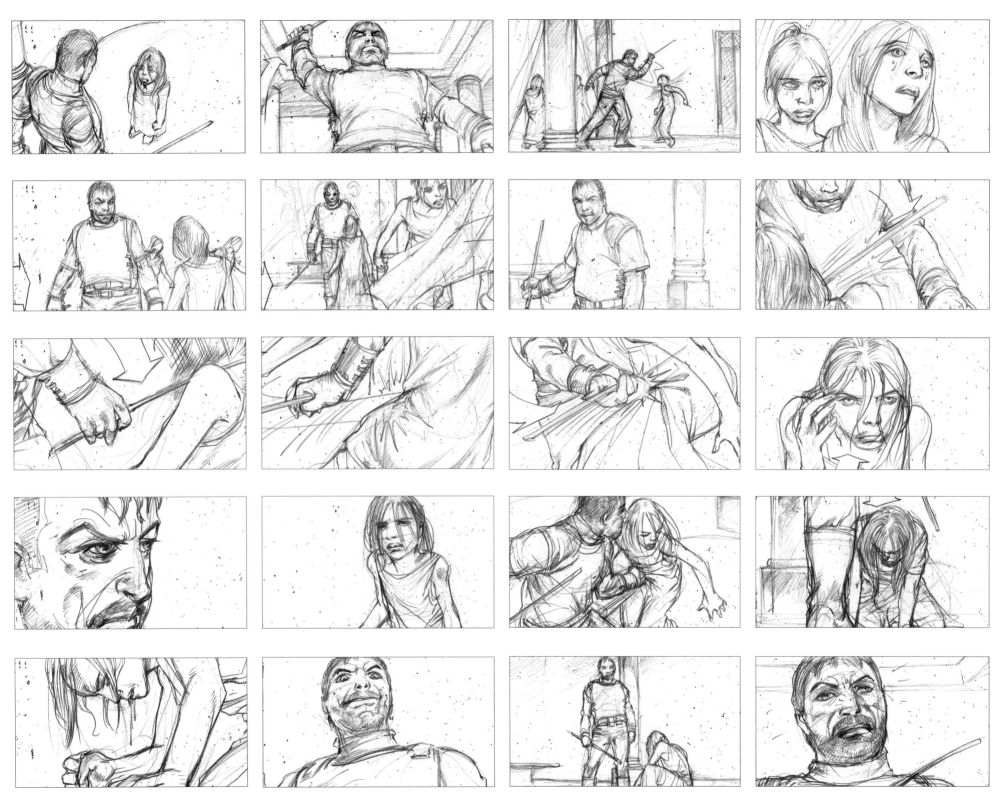

When Ser Meryn Trant strikes the third girl, she makes no noise.

The girl falls to her knees, revealing the face of Arya Stark, who brutally attacks him.

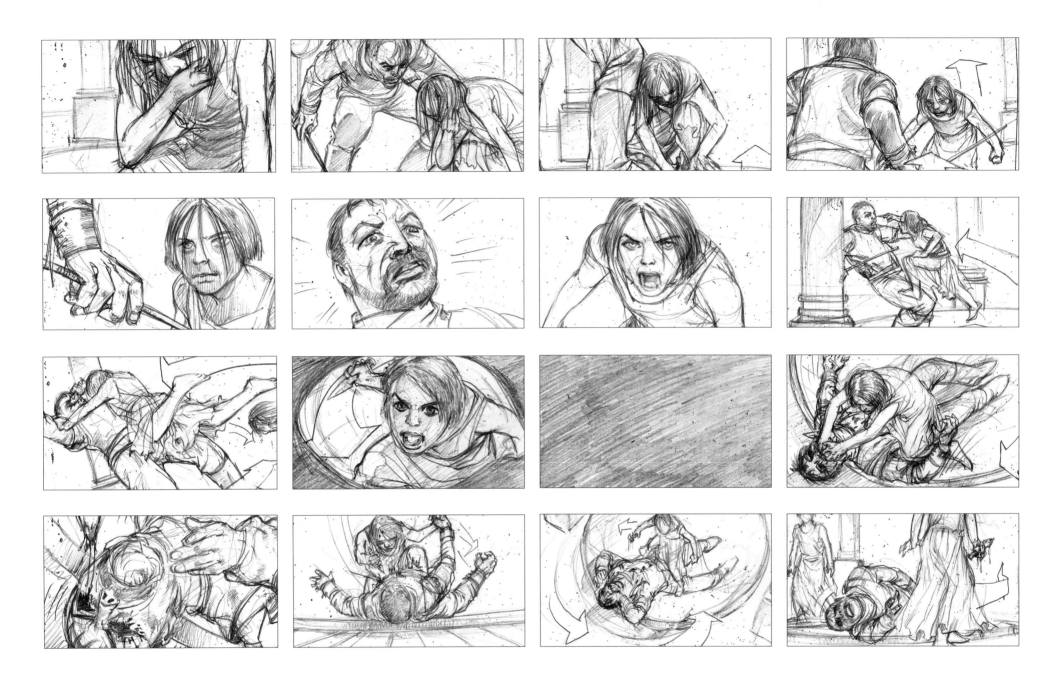

"You were the first person on my list, you know. For killing Syrio Forel, remember him? Probably not. I've gotten a few of the others. The Many-Faced God stole a few more from me. I'm glad he left me you."

—ARYA STARK

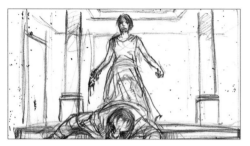
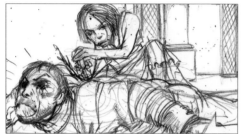
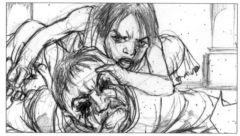
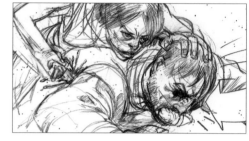
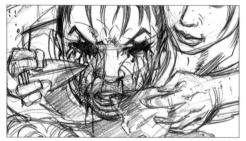

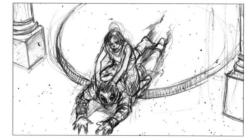
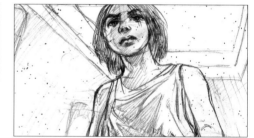
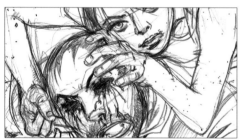
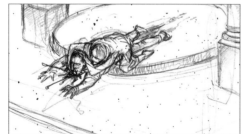
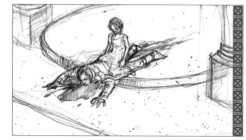

Arya tells Trant her name before she kills him, telling him he is "no one."

GAME OF THRONES · SEASON V – EP 510 – SCENE 10·18

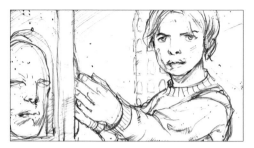
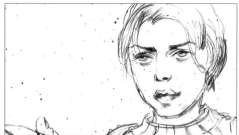
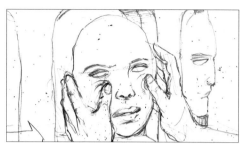
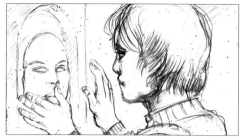

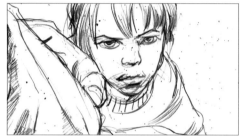

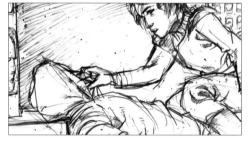

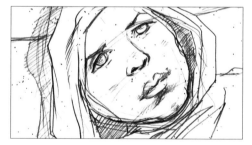

At the House of Black and White, Arya returns the false face she used to trick and kill Ser Meryn Trant. Jaqen H'ghar and the Waif come behind Arya. Not shown in these storyboards is Jaqen's admonishment of Arya for killing Trant—"That man's life was not yours to take."

Jaqen drinks a poison to pay the debt Arya owes. But when the Waif's face becomes Jaqen's, Arya begins peeling off faces from Jaqen's corpse until she comes to her own. Blindness suddenly strikes her, and her eyes go glassy as she lifts her head.

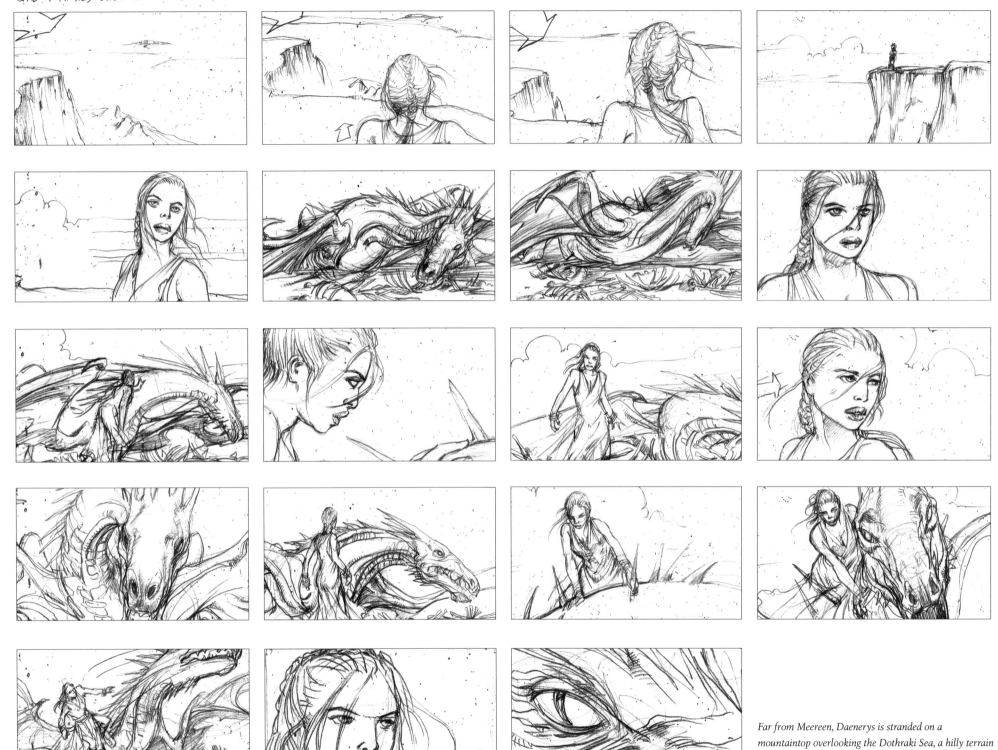

Far from Meereen, Daenerys is stranded on a mountaintop overlooking the Dothraki Sea, a hilly terrain covered in green grass. Drogon lies near her, recuperating from injuries sustained during the arena battle.

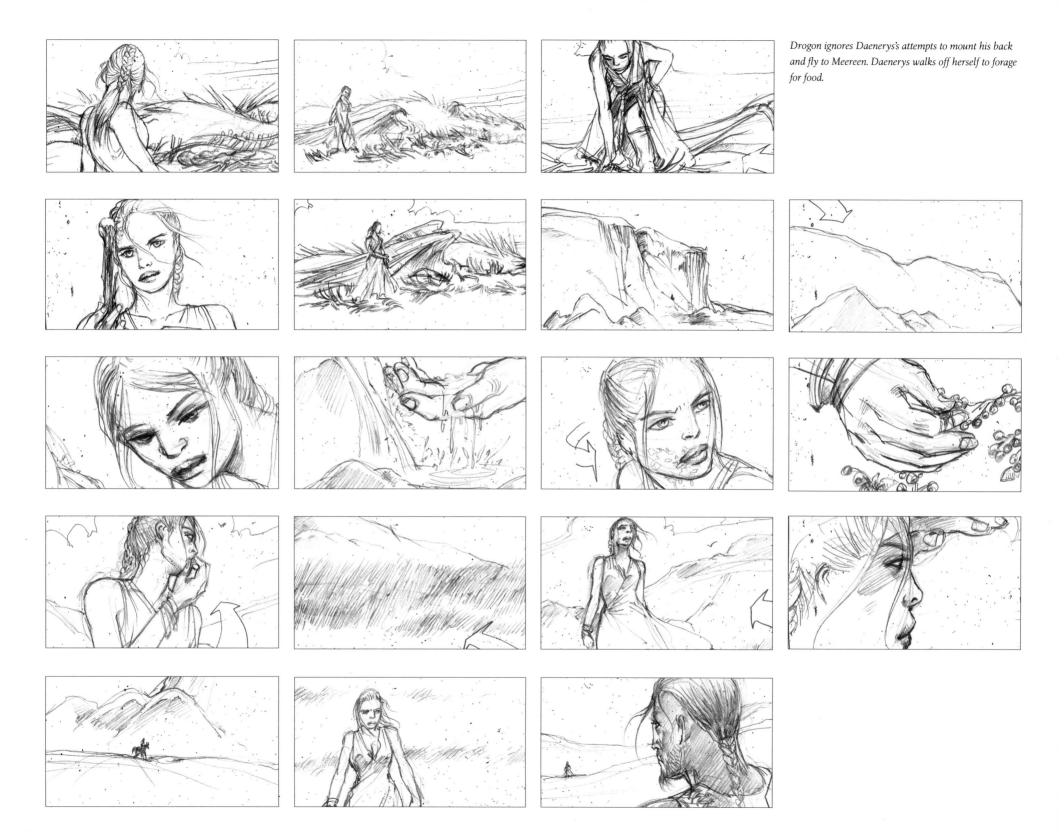

Drogon ignores Daenerys's attempts to mount his back and fly to Meereen. Daenerys walks off herself to forage for food.

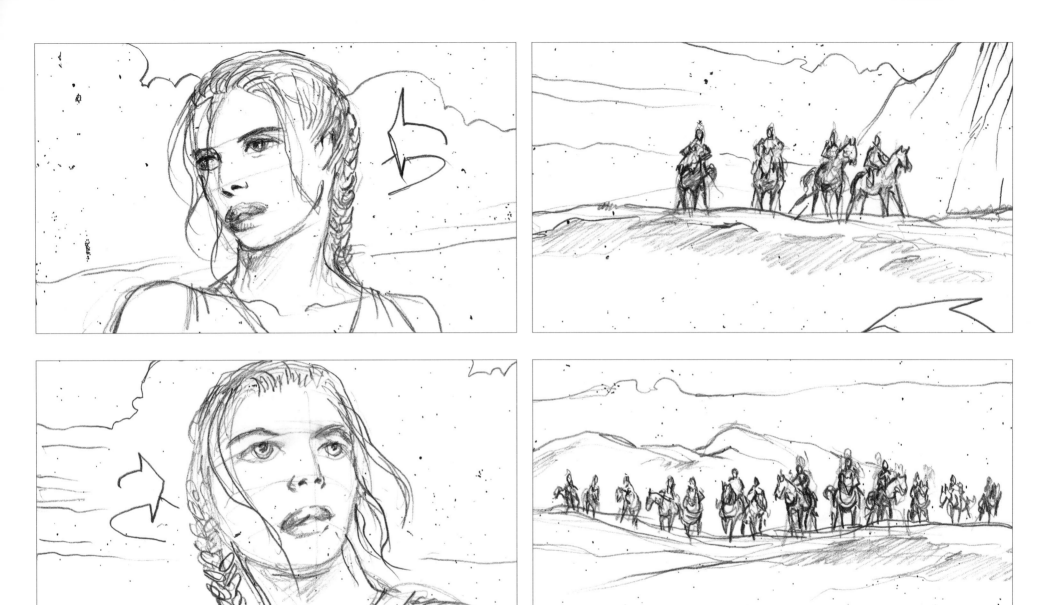

A band of Dothraki appears above a ridge. In the episode, Daenerys preemptively drops her ring for someone to find.

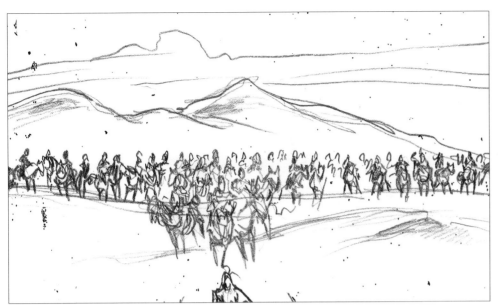

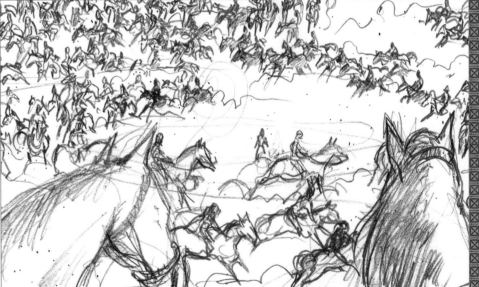

The Dothraki circle Daenerys as the khalasar converges on her.

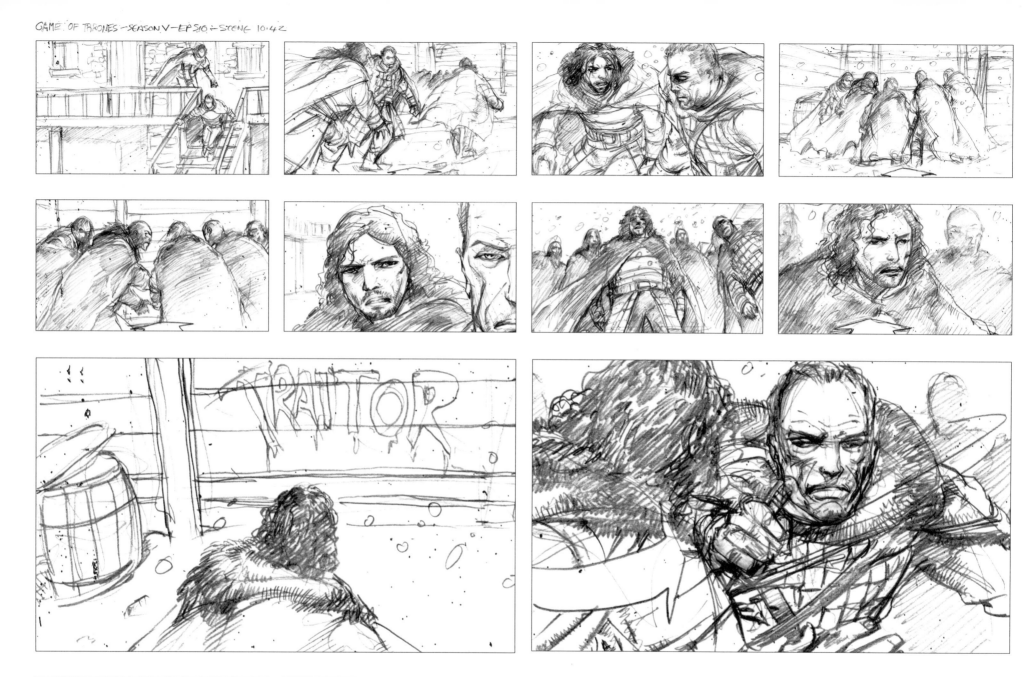

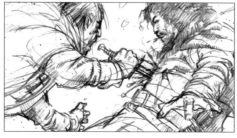

A band of the Night's Watch, led by Ser Alliser Thorne,
mutiny against Lord Commander Jon Snow.

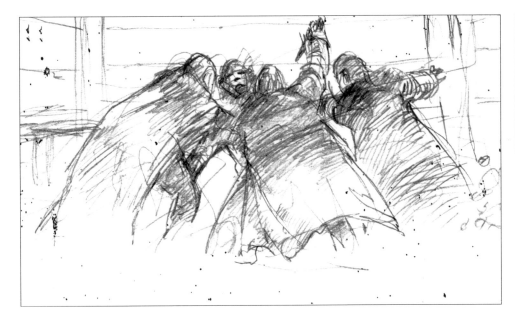

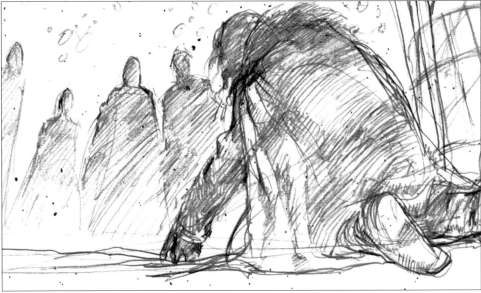

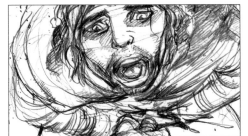

Olly, the recruit Snow trained in the first episode of the season, is the last to stab Snow, killing him.

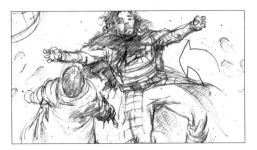

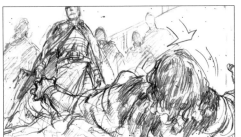

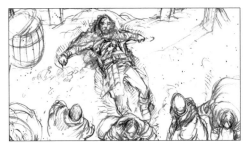

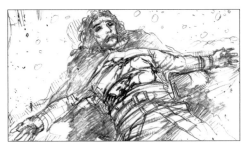

"For the watch."

—OLLY

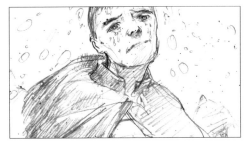

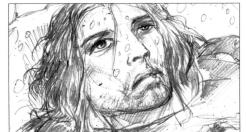

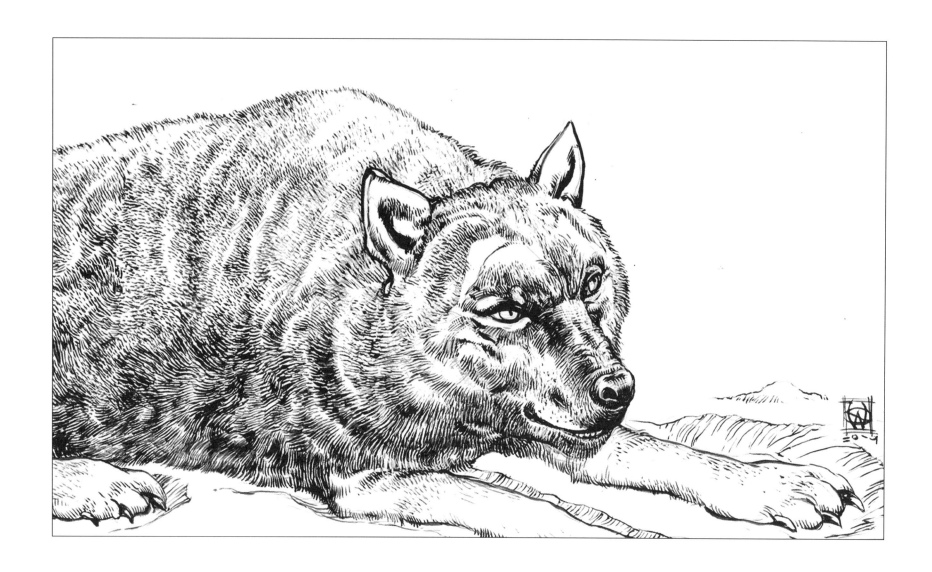

SEASON 6

Renewing both her spirit and strength following her imprisonment and torture by the Faith Militant, Cersei exacts revenge and kills her enemies by igniting wildfire in the Great Sept of Baelor.

Jon Snow is also recalled to life after his murder at the hands of Ser Alliser Thorne and his conspirators. Stannis Baratheon's counselor and priestess of the Lord of Light, Melisandre, summons the powers of the Lord of Light to revive Snow's body. He gets his revenge against the mutineers and relinquishes his position as Lord Commander.

When Daenerys's Dothraki captors take her to the Temple of the Dosh Khaleen in Vaes Dothrak, Daenerys sets fire to the temple, burning all the khals locked within. She emerges unscathed, and the Dothraki bend their knees to her. She flies to Meereen with Drogon, and after freeing Rhaegal and Viserion, she destroys the fleet of former slave masters. With much of Essos under her control, she feels confident she has acquired the military might to retake the Iron Throne.

Just as Bran transforms into the new Three-Eyed Raven, Arya is no longer the wide-eyed tomboy of her childhood but rather an expert assassin, trained in the methods of the Faceless Men. She puts what she has learned to use, killing those who have wronged her or others in the past.

Sansa relies on her inner strength to stay alive under the brutal treatment of her husband, Ramsay Bolton. She escapes and goes to Jon Snow at Castle Black to ask for his help in reclaiming Winterfell and saving Rickon, who has been imprisoned by Ramsay. The Stark forces clash with the Boltons in the Battle of the Bastards.

Numerous seasons into the show, Simpson still chose to use paper and pencil as his medium of choice for the storyboards. "Part of my brain suggests I should get into the computer world. But I'm old school and prefer my paper and pencil, because they're what I'm most comfortable with," he says. "I tend to work on A3-size paper with four frames per page and the flexibility to reduce for tighter clarity and the director's need. This approach comes from my background in comic strips, and it's never made any sense to me to go against the wisdom that 'if it ain't broke, don't fix it!'

"All of the knowledge and experience from my work in comics has influenced what I've done in storyboarding over the years," he says of his process. "But I also understand storytelling in film and TV has a different approach to it. Often the director wants the camera to move around, so the way you break down a scene into panels tends to lean [more toward] an animation-like style. You draw multiple angles of a camera moving around a human being or around a scene so that you're seeing them from slightly different variations.

"My comic-book style was based on film a lot of the time," he continues. "The comic books that appealed to me were more dramatic, more cinematic in their approach. For most of my life I've sat watching movies while I was drawing, so the stuff of cinema is imbedded in my head. This includes every genre of films, such as film noir, Westerns, war epics, and B-grade sci-fi pictures, all which have very different approaches to storytelling and shot selection [compared to] the films we are seeing today. When I was working in comics, I strove to make my comics more cinematic, not realizing that I was ever going to work in film. It's quite interesting to me when I analyze myself that much of my work is based on what I'd seen on the screen and transferred into comic books, then back on to screen again. I don't think I've ever been that far away from what I consider to be cinematic storytelling."

Episode 601
THE RED WOMAN

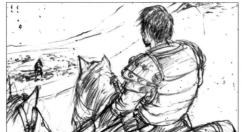

*Ser Jorah Mormont and Daario Naharis search for Daenerys in the grasslands of the
Dothraki Sea. They find a ring that Daenerys purposely left behind as a mark that she
was there.*

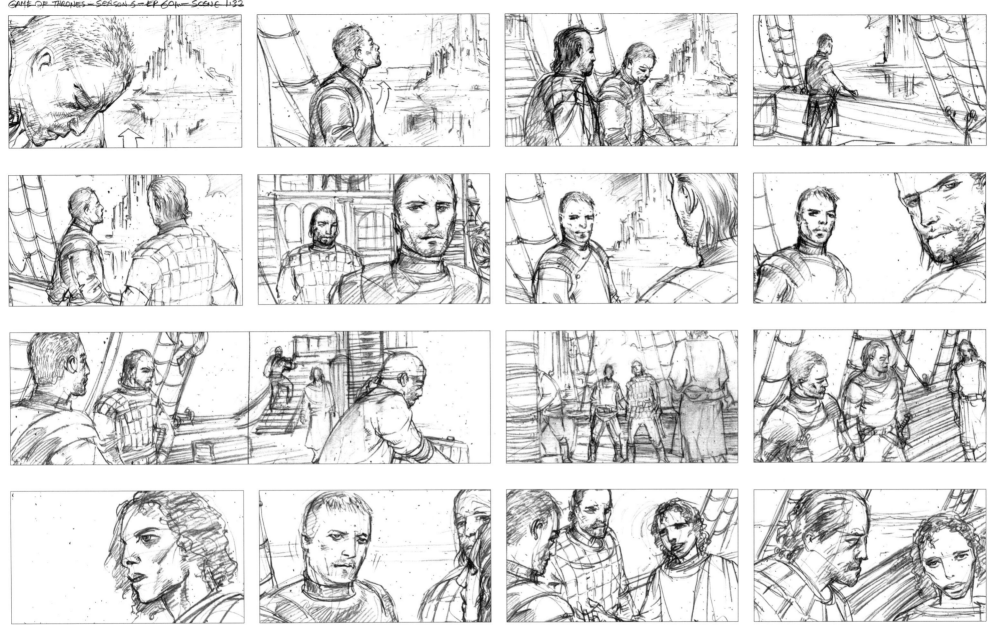

These storyboards present a sequence that is not featured
in the episode. Jaime and Bronn sail back to King's
Landing, where Cersei awaits. Jaime knows he must tell
his sister that their daughter, Myrcella, was poisoned.

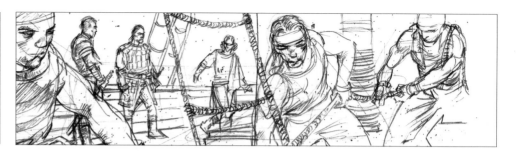
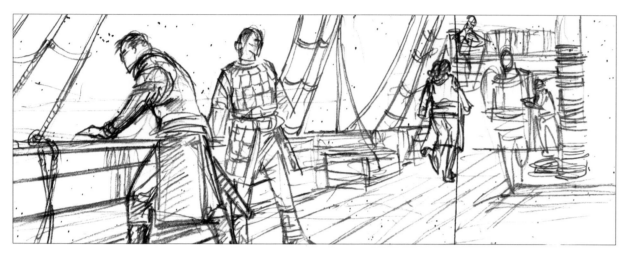

Prince Trystane, Myrcella's intended, says he had nothing to do with the princess's death. She was the love of his life.

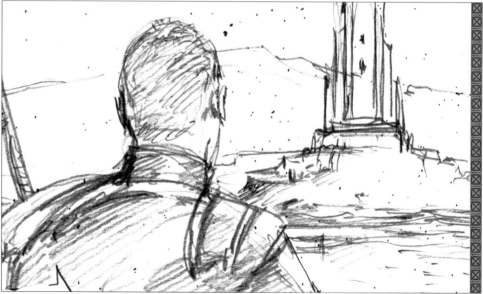

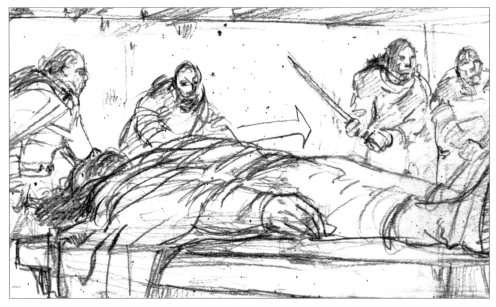

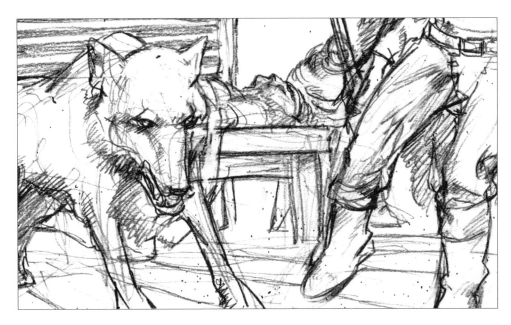

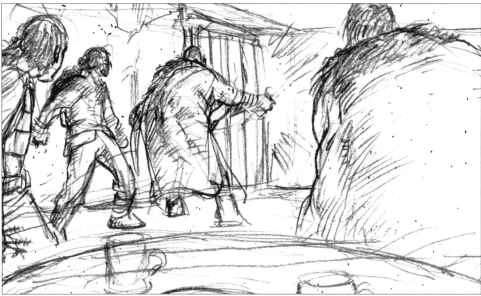

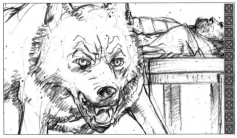

Ser Thorne pounds on the door of the room where Jon Snow lies. Ghost growls, and the men inside grab their weapons. Thorne offers amnesty if they leave.

Episode 602

Home

GAME OF THRONES - SEASON 6 - EP 602 -, SCENE 2.8

 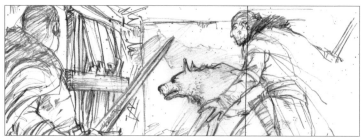

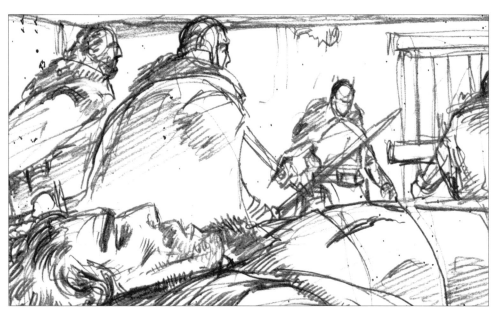 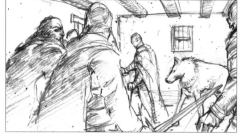

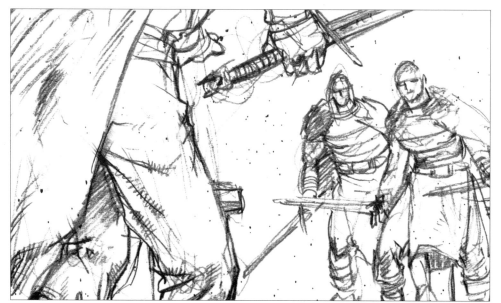

Ser Davos Seaworth, Ghost, and those loyal to Jon Snow wait inside Davos's room as Ser Alliser Thorne tries to persuade them to open the door and surrender.

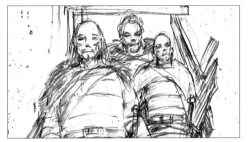 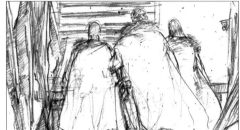

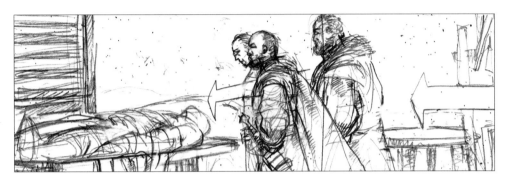

After Tormund and his wildling army enter Castle Black and overwhelm Thorne's mutineers, they enter the room where Jon lies dead. Tormund pays his respects to Snow. He'll have the Free Folk build a funeral pyre.

Ramsay Bolton feeds his infant half brother to the hounds of Winterfell.

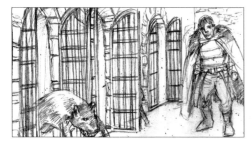
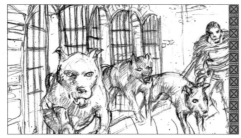

"Please, Ramsay. He's your brother."
—WALDA FREY

"I prefer being an only child."
—RAMSAY BOLTON

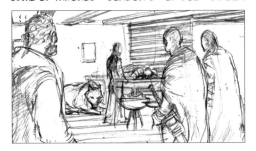
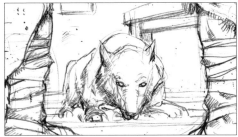
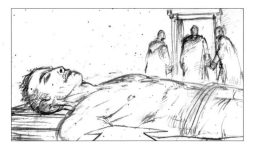

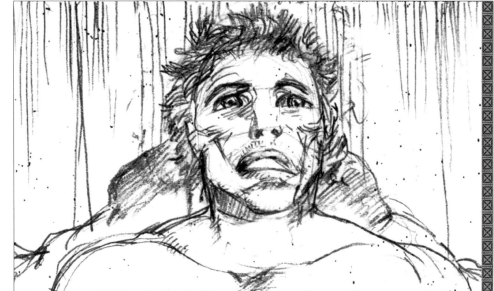

Melisandre brings Jon Snow back to life as Ghost looks on.

Episode 603

Oathbreaker

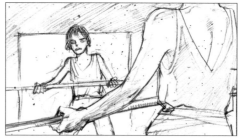
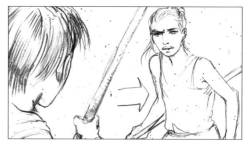

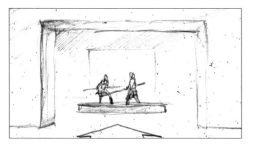
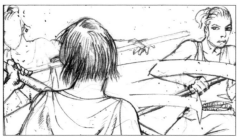
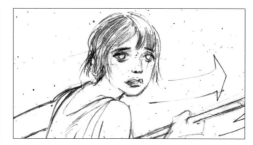

The Waif interrogates a blind Arya about her background. Arya's answers to her questions remain unconvincing, and for each the Waif smacks the girl with her staff.

The two spar. Arya will not be beaten. She gets back up and swings.

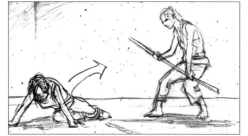

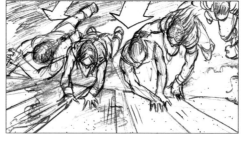
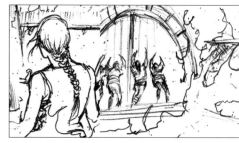

Episode 604

Book of the Stranger

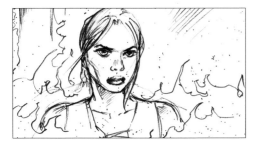
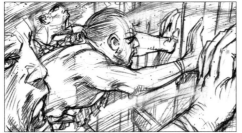
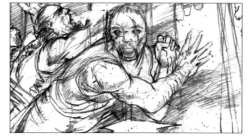
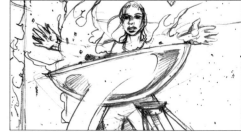

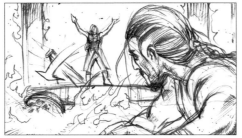
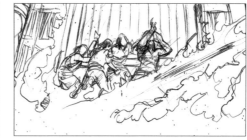

In the Temple of the Dosh Khaleen, Daenerys repudiates the threats of the assembled khals and tips over the braziers, lighting the temple on fire. Since the door is barred, the khals can't get out and are caught in the blaze, Khal Moro last of all.

The Three-Eyed Raven shows Bran a vision of a man tied to a heart tree while Leaf and other Children of the Forest commingle around standing stones nearby.

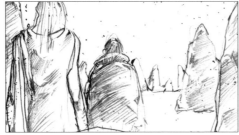
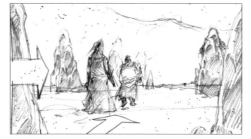

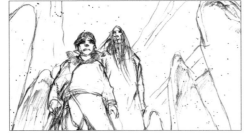
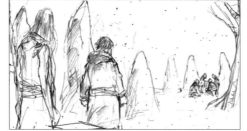
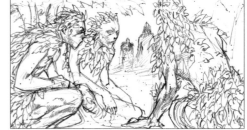

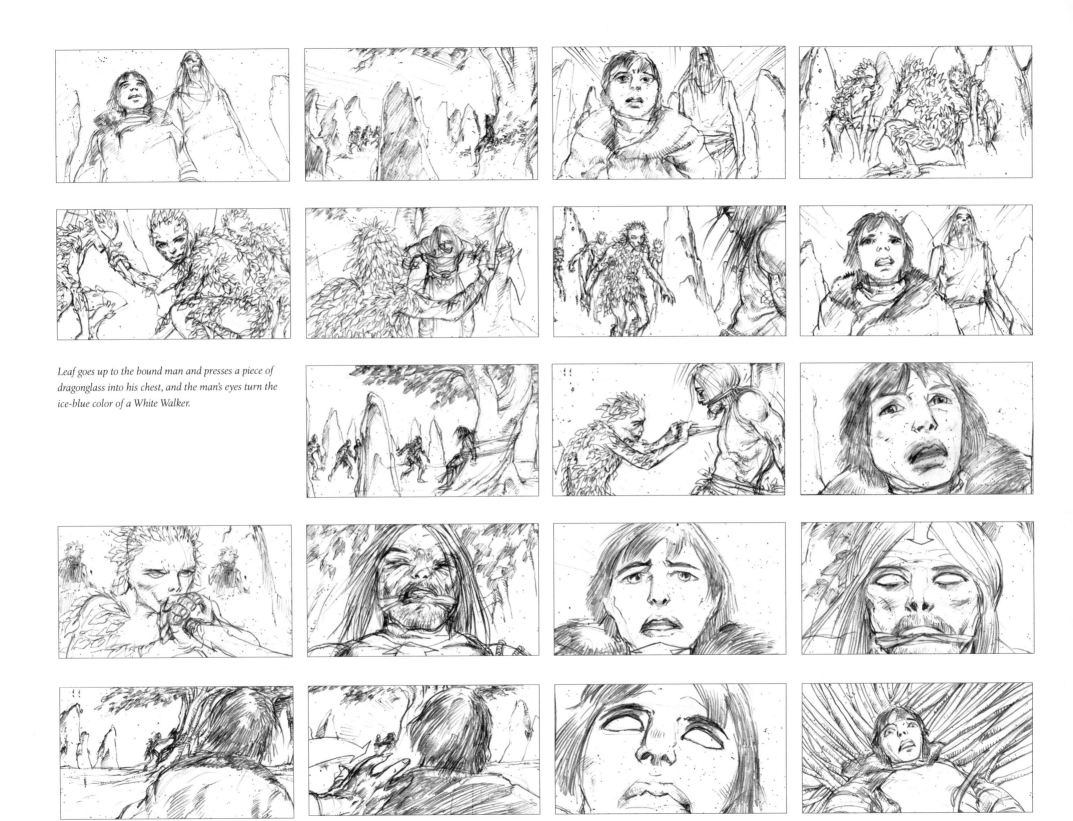

Leaf goes up to the bound man and presses a piece of dragonglass into his chest, and the man's eyes turn the ice-blue color of a White Walker.

Episode 605

THE DOOR

GAME OF THRONES – SEASON 6 – EP 605 – SCENE 5.1

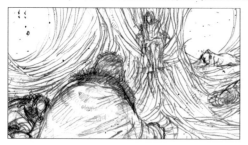 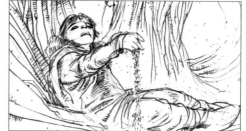 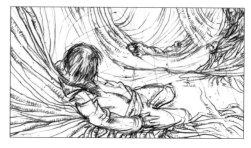

Bran wakes up inside the weirwood cave. Everyone else seems to be sleeping.

Bored, Bran throws a bone at the Three-Eyed Raven, but he does not awaken. He crawls forward and reaches for a weirwood root. Grasping it, he wargs into the tree and has another vision.

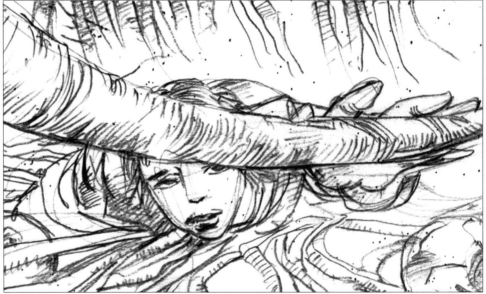

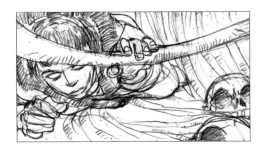

Episode 606
Blood of My Blood

Meera pulls Bran on a sled through the forest, in flight after the White Walker attack on the weirwood tree during which Hodor was killed. Roots tangle the sled, causing it to stop.

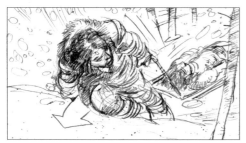
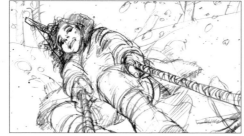

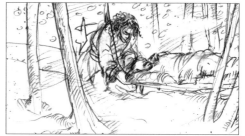

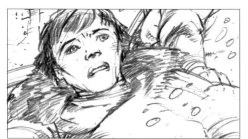
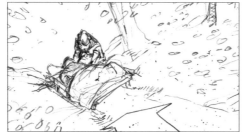

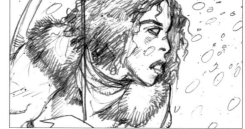

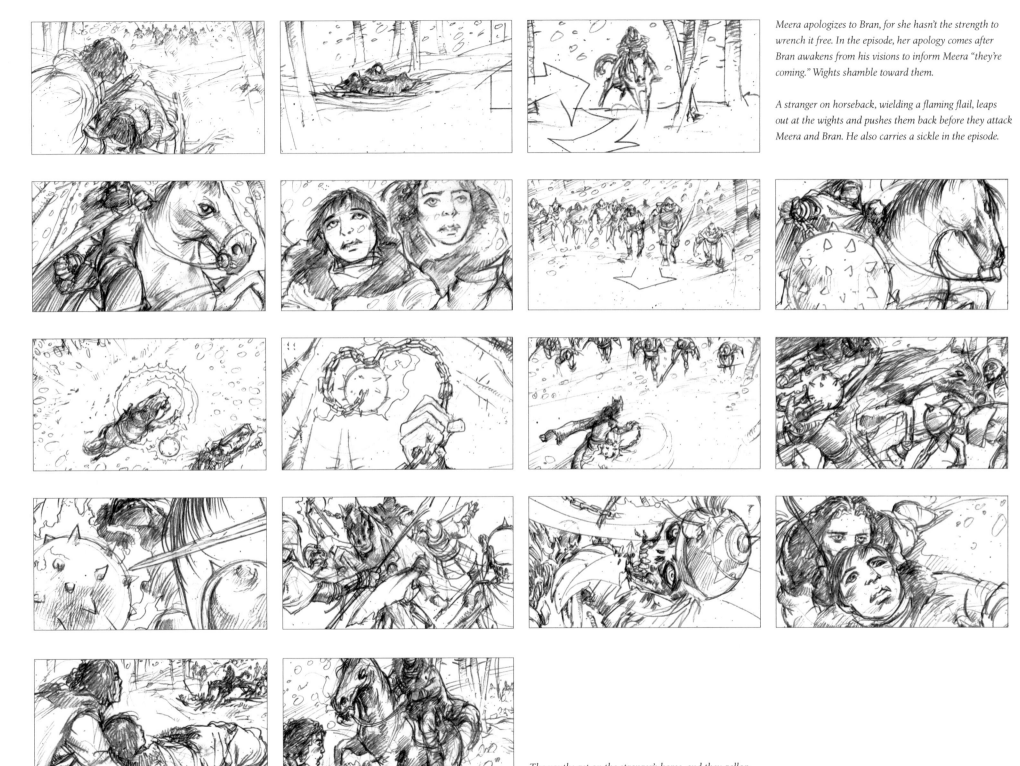

Meera apologizes to Bran, for she hasn't the strength to wrench it free. In the episode, her apology comes after Bran awakens from his visions to inform Meera "they're coming." Wights shamble toward them.

A stranger on horseback, wielding a flaming flail, leaps out at the wights and pushes them back before they attack Meera and Bran. He also carries a sickle in the episode.

The youths get on the stranger's horse, and they gallop away from the wights into a snowstorm.

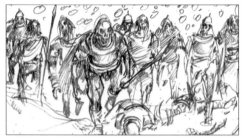

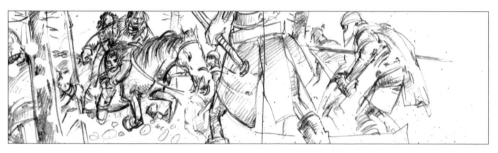
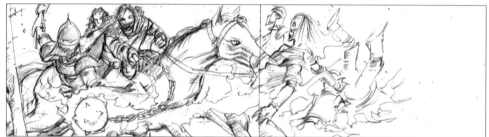

"Come with me, now. The dead don't rest."

—BENJEN STARK

Episode 607

THE BROKEN MAN

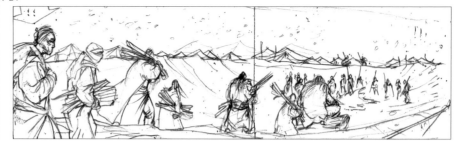

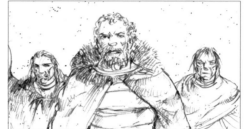
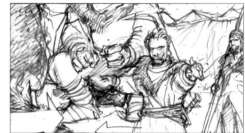

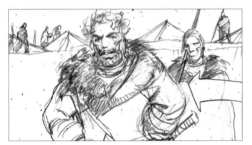
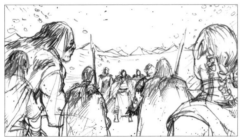

Jon Snow and Sansa enter the new wildling camp and meet with the leaders to ask if they will help defeat Ramsay Bolton's army and take Winterfell.

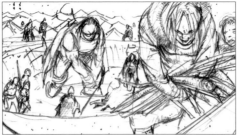

Though Dim Dalba argues against the battle, Tormund defends Jon, saying that he died for the Free Folk.

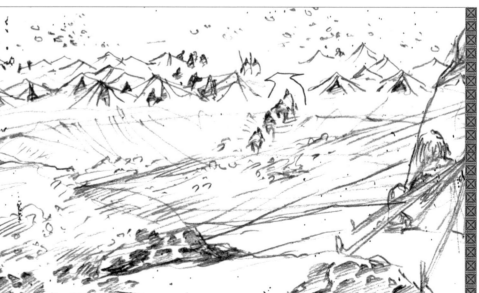

The giant Wun rises and thunders by the humans, grunting one word to show for whom he will fight: "Snow." Dim Dalba agrees to fight, shaking Jon Snow's hand.

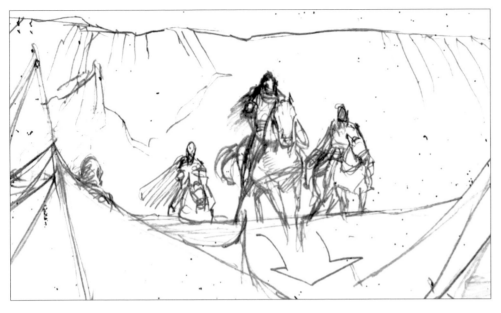
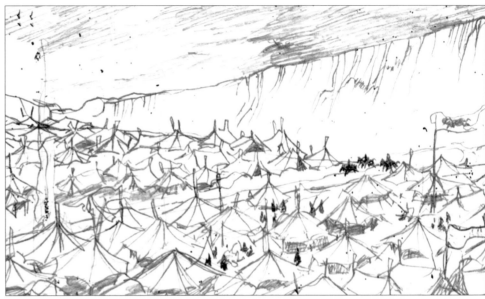

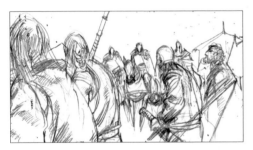

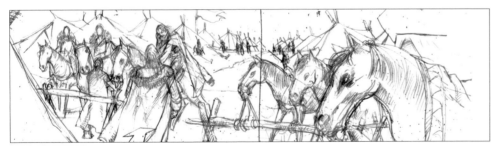

Sansa tells Jon she thinks they need to bring more houses to their side before they fight the Boltons. Jon disagrees, believing they have no more time and must fight with the army they have.

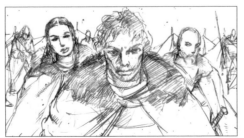

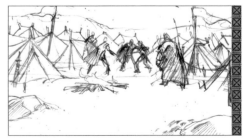

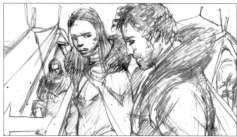
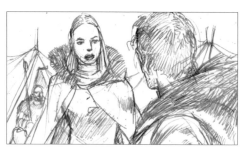

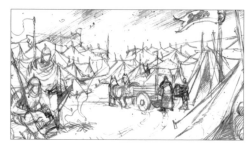

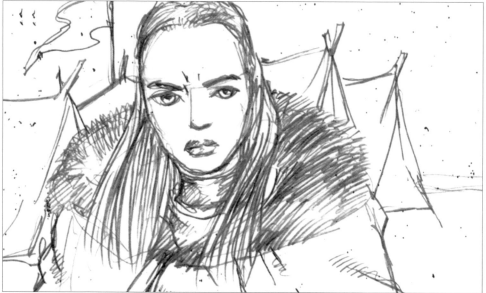

*Frustrated she's being ignored, Sansa sees Lyanna Mormont
with a raven and an idea strikes her.*

Episode 608
No One

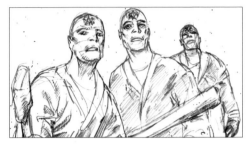

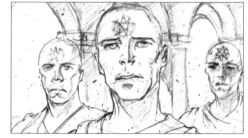
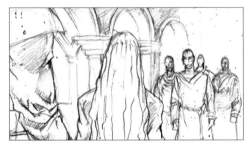
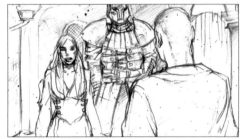

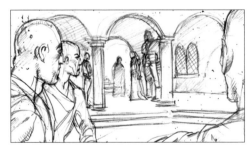

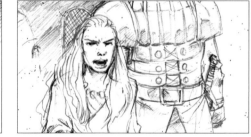
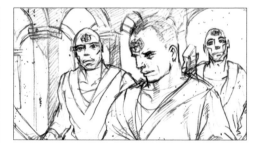
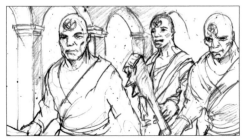
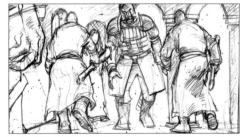
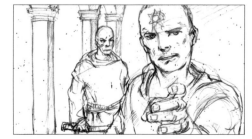

Cersei, her fully armored bodyguard, Ser Gregor "the Mountain" Clegane, and the Hand of the Queen, Maester Qyburn, descend stairs to meet Lancel and the Faith Militant, who demand that Cersei go with them to the Great Sept of Baelor.

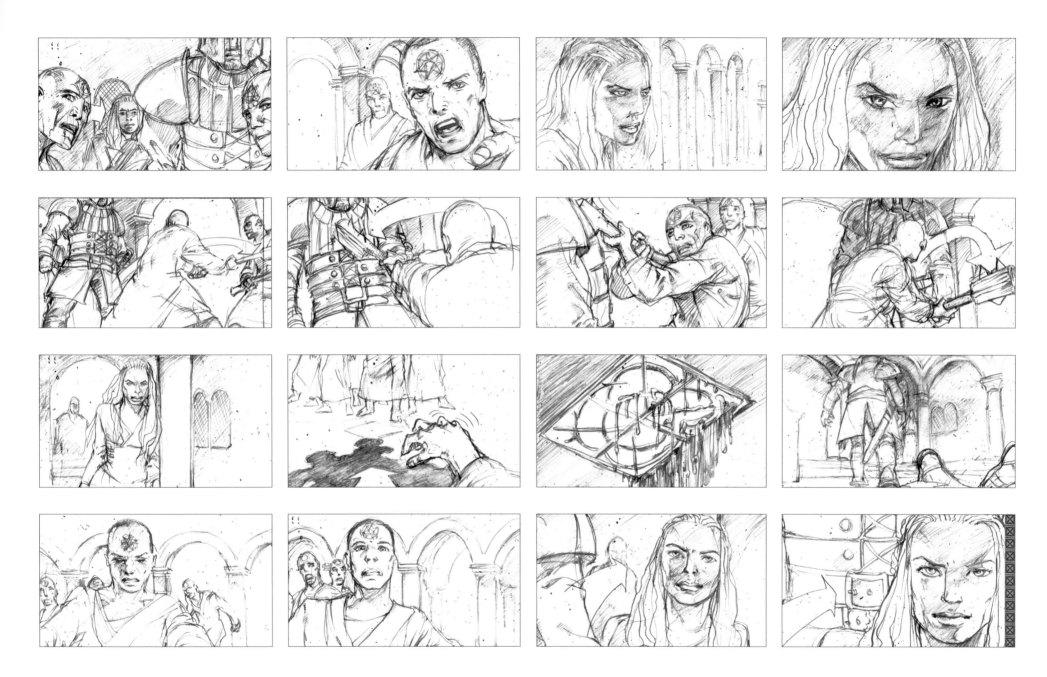

"Order your man to step aside, or there will be violence."

—LANCEL LANNISTER

"I choose violence."

—CERSEI LANNISTER

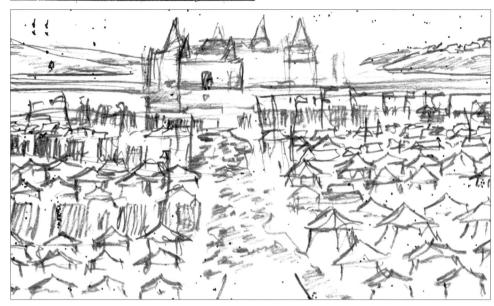

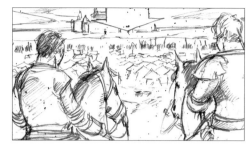

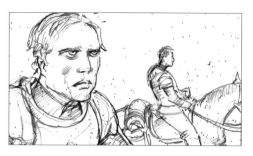

Brienne of Tarth and her squire, Podrick, ride to Riverrun to deliver Sansa's letter asking House Tully to join the fight against the Boltons. They find the castle besieged, and Brienne can see Ser Jaime Lannister battling.

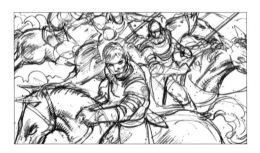

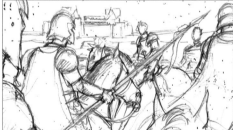

Brienne appeals to the Blackfish, presenting the letter from Sansa Stark. Looking down from his ramparts, Brynden Tully won't be moved to surrender.

Lord Edmure Tully, freed by Jaime Lannister, walks alone to the castle at night and demands to be let inside.

GAME OF THRONES – SEASON 6 – EP. 608 – SC 8.21

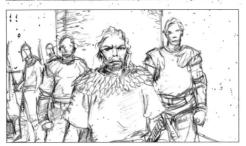
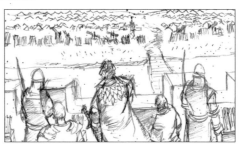

GAME OF THRONES – SEASON 6 – EP 608 – SC 8.23

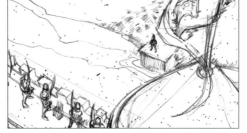

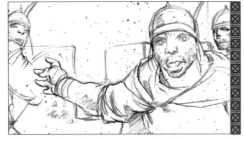

"Who goes there?"
—SOLDIER

"Edmure Tully, son of Hoster Tully, and the rightful lord of Riverrun. I demand entry."
—EDMURE TULLY

GAME OF THRONES – SEASON 6 – EP 608 – SC 8.25

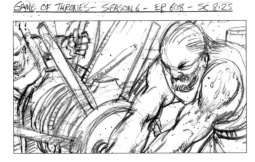

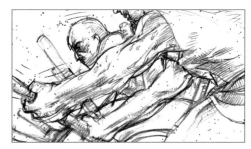

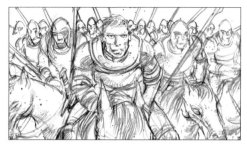

GAME OF THRONES – SEASON 6 – EP 608 – SC 8:29

As Edmure goes inside the castle and the drawbridge raises again, Walder Rivers tells Jaime that if he's wrong, he's just surrendered their most valuable prisoner.

The castle drawbridge is lowered once again in accordance with Lord Edmure's command. The gate men aren't featured in the episode, but in the storyboards they're shown looking upset.

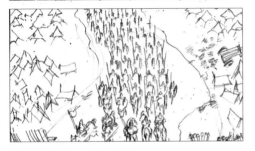 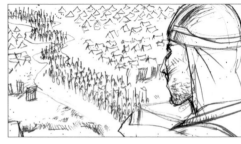

From the ramparts, a bewildered castellan watches the army of House Frey ride into the castle after Edmure's surrender. Edmure stands nearby, a broken man. In the episode, the camera stays on Edmure, who tells the castellan to find his uncle, Ser Brynden Tully, put him in irons, and hand him over to the Freys.

GAME OF THRONES - SEASON 6 - EP 608 - SC8.32

 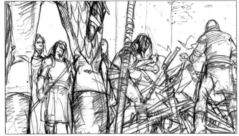 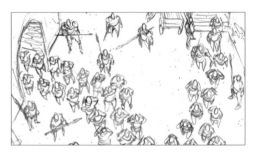

Jaime Lannister stands on the battlements and spies a boat rowing out to a tributary. Brienne and Podrick are in the boat. She waves to Jaime, and the knight she admires waves back.

Episode 609

BATTLE OF THE BASTARDS

Jon Snow, Ramsay Bolton, and their armies face each other at Winterfell.

In the episode, Bolton dismounts from his horse and pulls his hostage, Rickon Stark, forward by a rope.

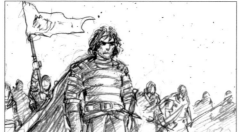

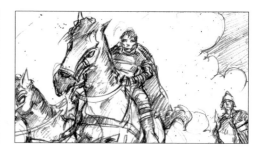

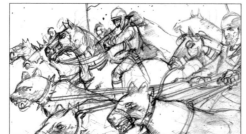
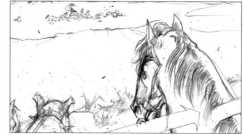
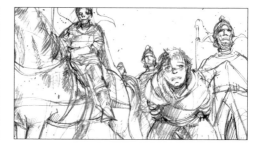

Episode 610
THE WINDS OF WINTER

After his father expels him from their home, Samwell Tarly arrives in Oldtown with Gilly and her son. Here Samwell would study at the Citadel to become a maester.

GAME OF THRONES - SEASON 6 - EP 610 - SCENE 10.41

Disembarking from the wagon, Samwell and Gilly gape in wonder at the impressive structure known as Hightower.

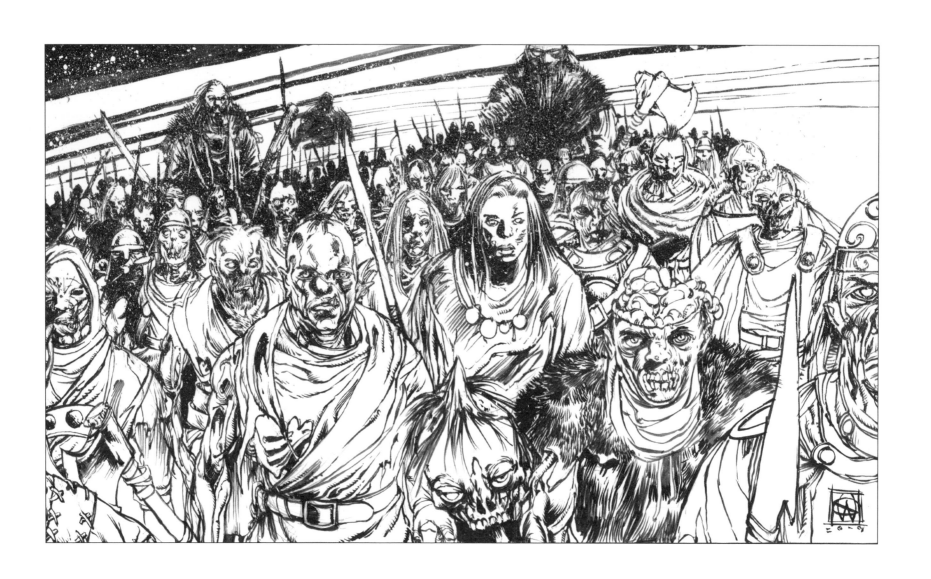

SEASON 7

The series' penultimate season draws together all the central characters who are still alive. Daenerys lands at her ancestral home of Dragonstone in Westeros and plots to defeat Cersei Lannister and seize the Iron Throne. Against the wishes of Sansa, Jon Snow leaves Winterfell and ventures south to Dragonstone to beg for Daenerys's aid against the oncoming threat of the White Walkers and their army of the dead. Daenerys refuses to help until he bends the knee to her, but Tyrion's counsel softens her, and she allows Jon to dig for dragonglass under Dragonstone and forge weapons from it to destroy the White Walkers. As she becomes more and more impressed by his determination—a quality they share—she eventually pledges her soldiers to his cause.

Cersei and Jaime outmaneuver Daenerys and thwart the Dragon Queen's initial incursions against their forces. Going against the advice of Tyrion, Daenerys attacks Jaime's army at Highgarden, deploying the Unsullied, the Dothraki horde, and her dragons to decimate the Lannisters and their allies. Jaime escapes to King's Landing to warn Cersei of the devastating advantage Daenerys wields with her dragons.

With the Night King and the White Walkers on the march, Jon is not interested in who occupies the Iron Throne. He believes everyone in the Seven Kingdoms needs to band together to defeat the invaders. Cersei will need more than words to be persuaded of this threat, so Jon takes a ranging party north of the Wall to capture a wight. They do so but are soon surrounded by the army of the dead. When all looks lost, Daenerys and her dragons swoop down to save Jon's party, but the Night King is able to deliver a fatal blow against the dragon Viserion.

While these battles rage, the responsibilities of being Lady of Winterfell mature Sansa as a leader. She reunites with her sister, Arya, and the two of them outwit Littlefinger. With Bran's arrival, the Stark children are back together. Bran has learned new secrets through his visions about Jon Snow's birthright and true parentage.

Cersei agrees to meet Daenerys and Jon in King's Landing for a summit. The Hound brings out the captured wight, and Cersei pledges her forces to help fight this menace on one condition: Jon Snow remains neutral in the North.

Jon can't accept that demand—Daenerys has convinced him of her rightness to rule the Seven Kingdoms as its queen. Cersei storms away, unwilling to unite with the others until Tyrion coaxes her into keeping the truce against the Night King. In Jaime's presence, however, she reveals she will not keep her pledge and will instead let the creatures destroy her enemies. Jaime finds her turnabout dishonorable and departs, vowing he will abide by the pledge she made and do battle to stop the White Walkers.

This battle comes soon. Not long after the summit, the Night King rides the dead dragon Viserion and brings down the Wall with dragonfire. Now no barrier blocks his army of wights from rushing south to invade the Seven Kingdoms.

When looking back at his involvement in the show, Simpson muses, "I think the storyboarding process in the beginning was more intimate since we had a little more time on our hands, but by the end it was a well-oiled machine as I met with the directors and worked out their thoughts. By season eight, we were very used to each other, and it was like meeting with old friends.

"I hope my artwork has evolved after eight seasons, but I'm probably not the right person to judge. That said, my overall approach has remained the same. My first priority is always to interpret the director's vision as best as I can. I still do the strongest work I can deliver in the given moment, and I still want my contributions to matter when it comes to what we finally get to see on-screen. Like so many of my colleagues, I am a perfectionist at heart who always strives to do his best—and that overrides everything."

Episode 701
Dragonstone

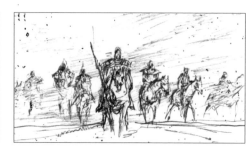

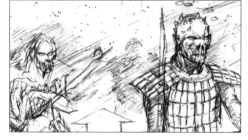

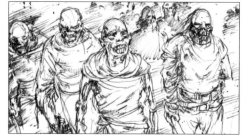

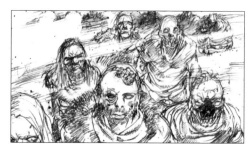

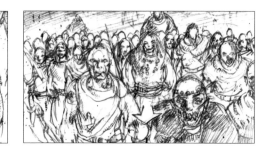

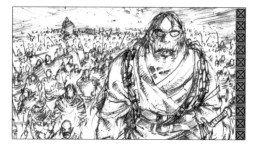

With a snowstorm blowing around them, the Night King and his White Walker lieutenants lead the army of the dead toward the Wall.

Simpson's storyboards focus on the disparate groups in the walking horde: brothers of the Night's Watch, Free Folk villagers from Hardhome, Karsi, and a giant.

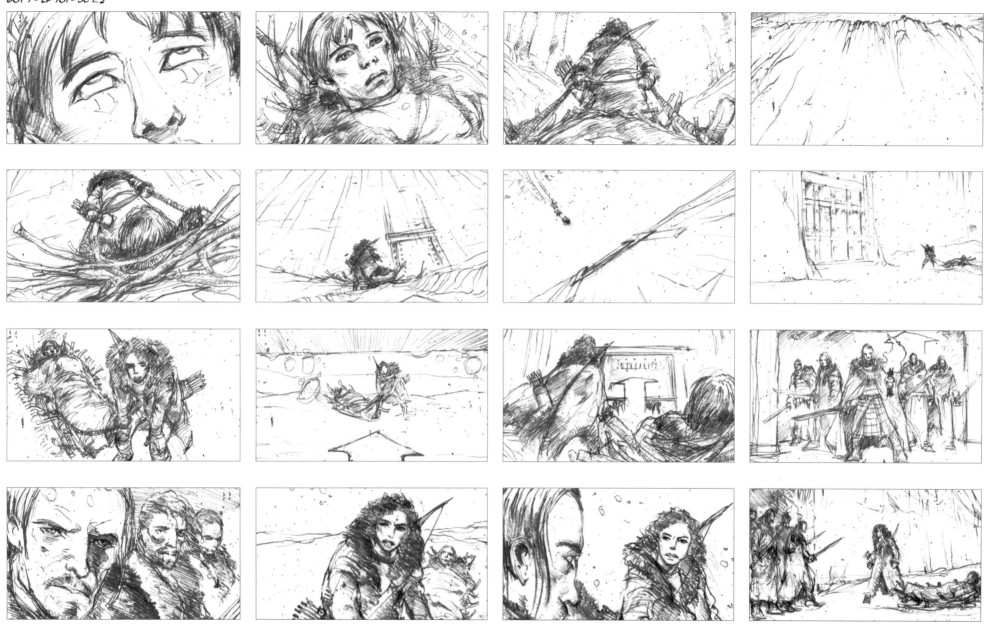

Meera drags Bran on the sled to the gate in the Wall
leading to Castle Black.

The gate opens and Lord Commander Eddison Tollett
and some of the Night's Watch emerge. Meera identifies
herself and Bran, but Tollett isn't convinced.

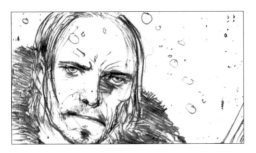
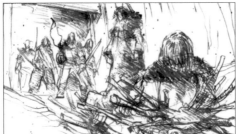
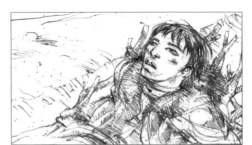
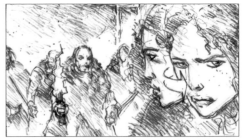
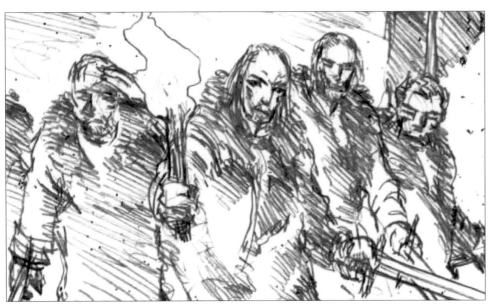
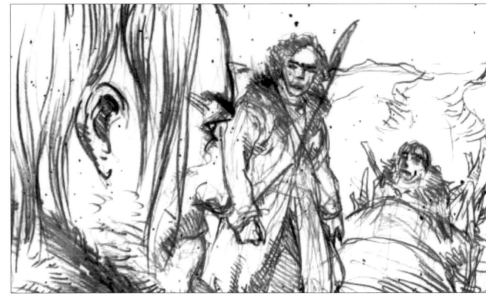

Having seen Tollett while warging, Bran tells Tollett specific details of his movements. Spooked but persuaded, Tollett has the rangers help them through the gate.

Before the gate closes, Tollett looks north. The episode doesn't reveal anything other than Tollett's general apprehension, but the storyboards indicate the storm of the Night King is closing in on the Wall.

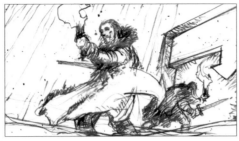
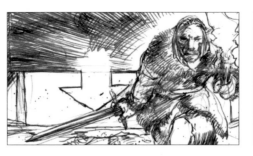

GOT 7 – EP 701 – SC 1.4 + 1.5

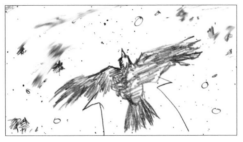
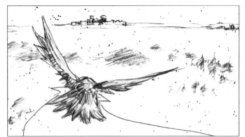
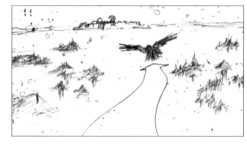

A raven flies over the snowy countryside to Winterfell and lands in the courtyard. This storyboarded sequence doesn't appear in the episode.

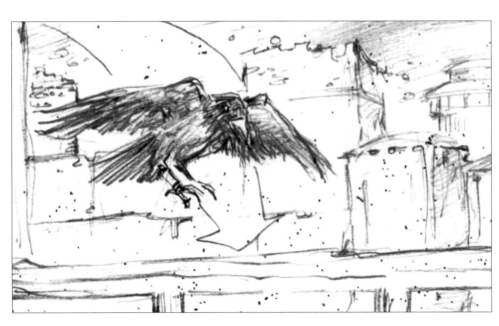

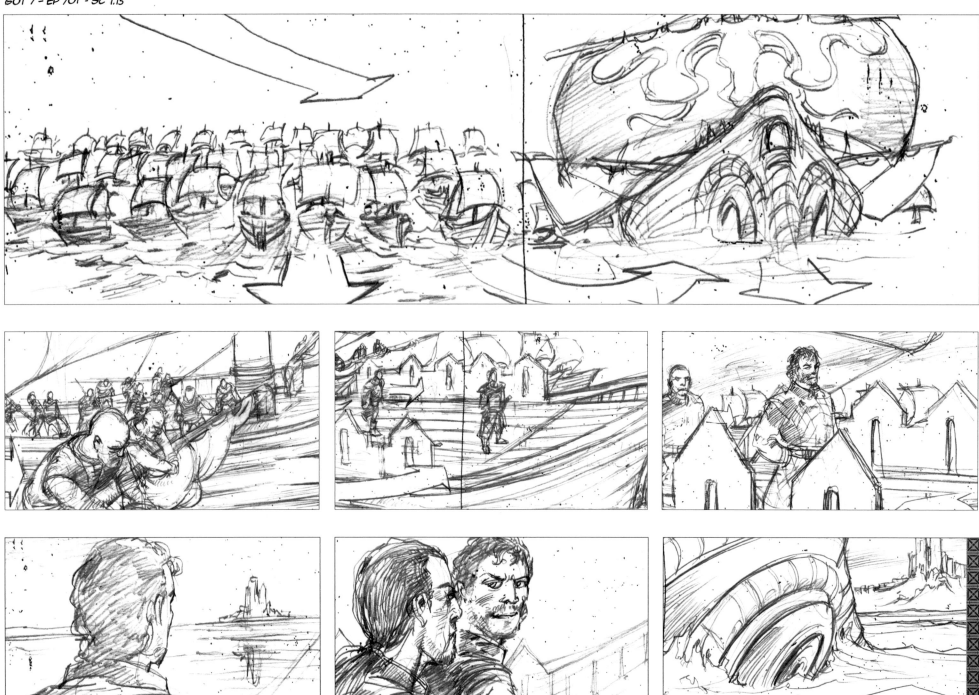

Euron Greyjoy, murderer of his brother Balon and usurper of the Salt Throne, sails into the bay of King's Landing with
the Iron Fleet. In these storyboards, a sweeping tracking shot of the lead vessel closes in on Euron on deck.

With her dragons flying overhead, Daenerys and her fleet near her ancestral home of Dragonstone.

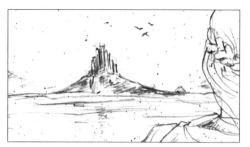

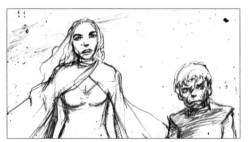

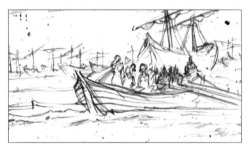
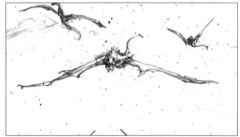
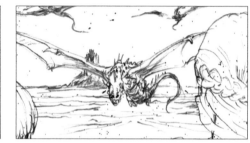

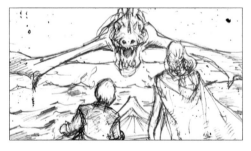
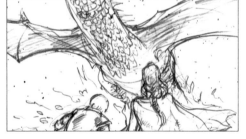
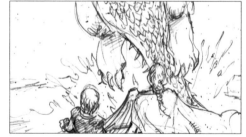

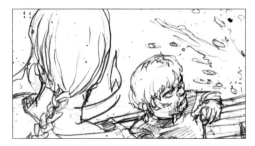
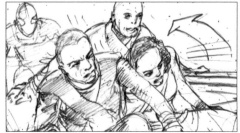

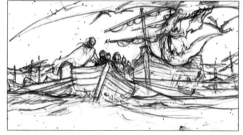

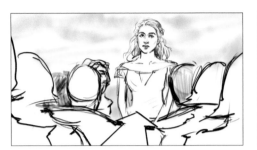 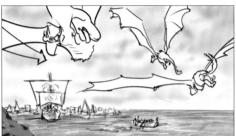 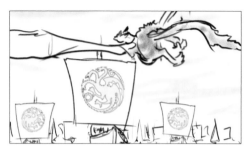 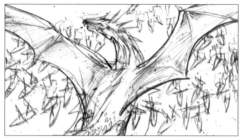

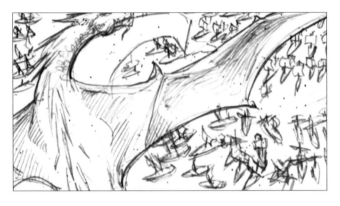 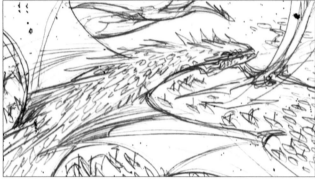 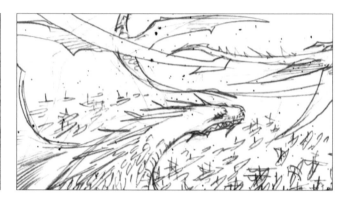

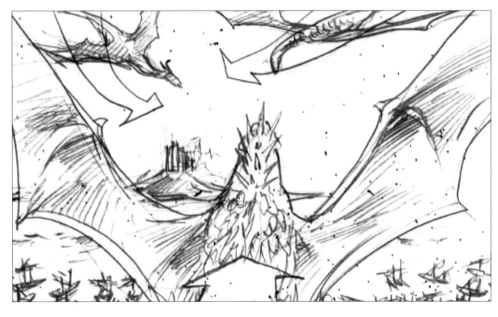 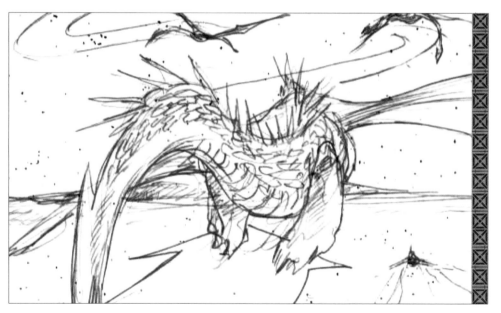

Depicted in the storyboards are the dragons' antics of veering too close to the skiffs and terrorizing Tyrion and the rowers in the process, but this is not shown in the episode.

Episode 702
STORMBORN

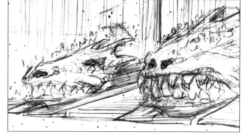

THE BIG TREE 7 - EP 702 - SC DRAGON SKULL ROOM

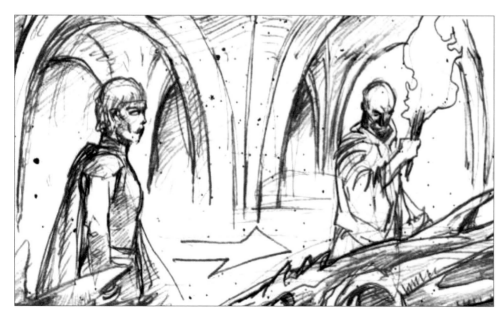

In the crypts of the Red Keep, Cersei looks at the scorpion, a portable ballista commissioned by her Hand, Maester Qyburn. The large weapon is pointed at the giant skull of the dragon Balerion the Black Dread.

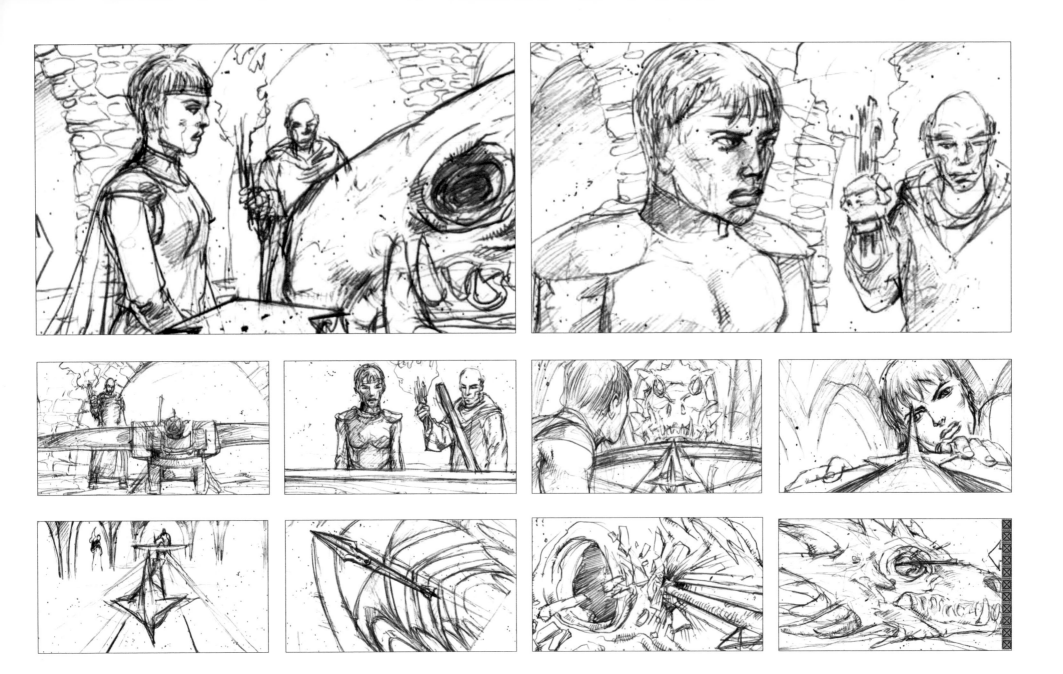

Cersei pulls the lever of the scorpion. The bolt smashes through the hard dragon skull near one of its eyes, shattering bone.

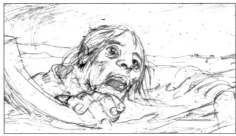
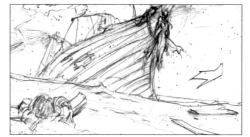
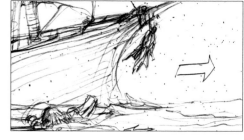

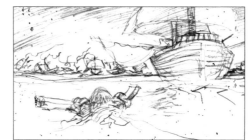

Theon Greyjoy clings to driftwood in the aftermath of the naval battle in which Euron's forces destroyed Yara's ships. In the episode, the surrounding ships of Yara's fleet are burning.

Later, one of the surviving ships in Yara's fleet rescues Theon from the Narrow Sea and pulls him up onto deck.

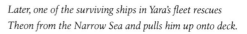
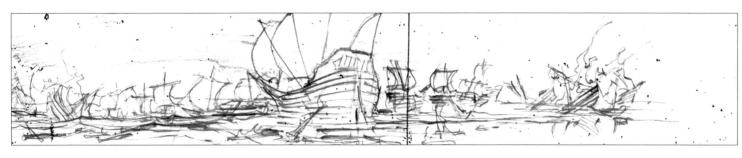
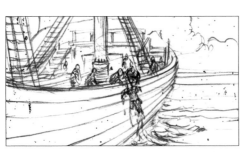

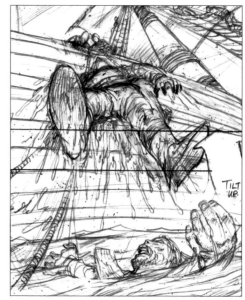

Episode 703

THE QUEEN'S JUSTICE

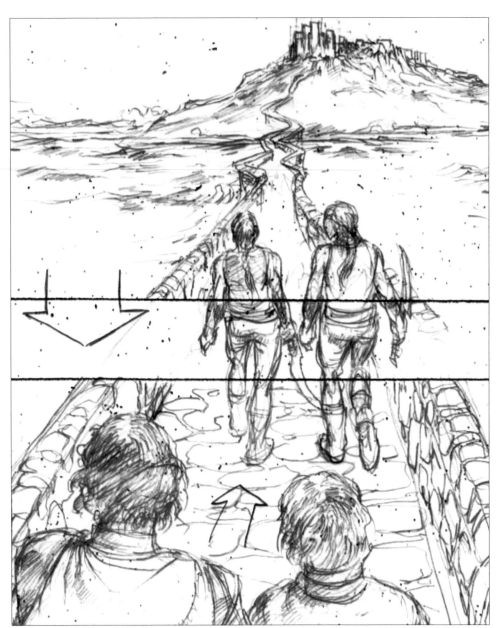

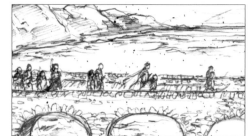

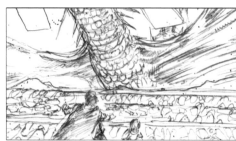
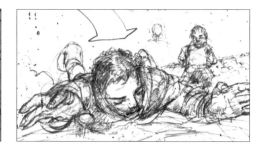

Tyrion, Missandei, and Dothraki warriors escort Jon Snow and Ser Davos Seaworth up the cobblestone walkway to the castle at Dragonstone.

A dragon swoops low over the party, startling Snow and Davos. The men drop to the ground. Both Tyrion and Missandei remain standing, amused.

"I'd say you get used to them, but you never really do."

—TYRION LANNISTER

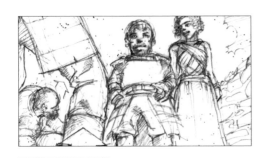

CASTERLY ROCK

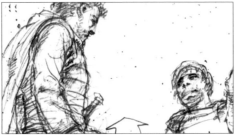

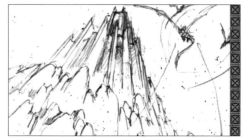

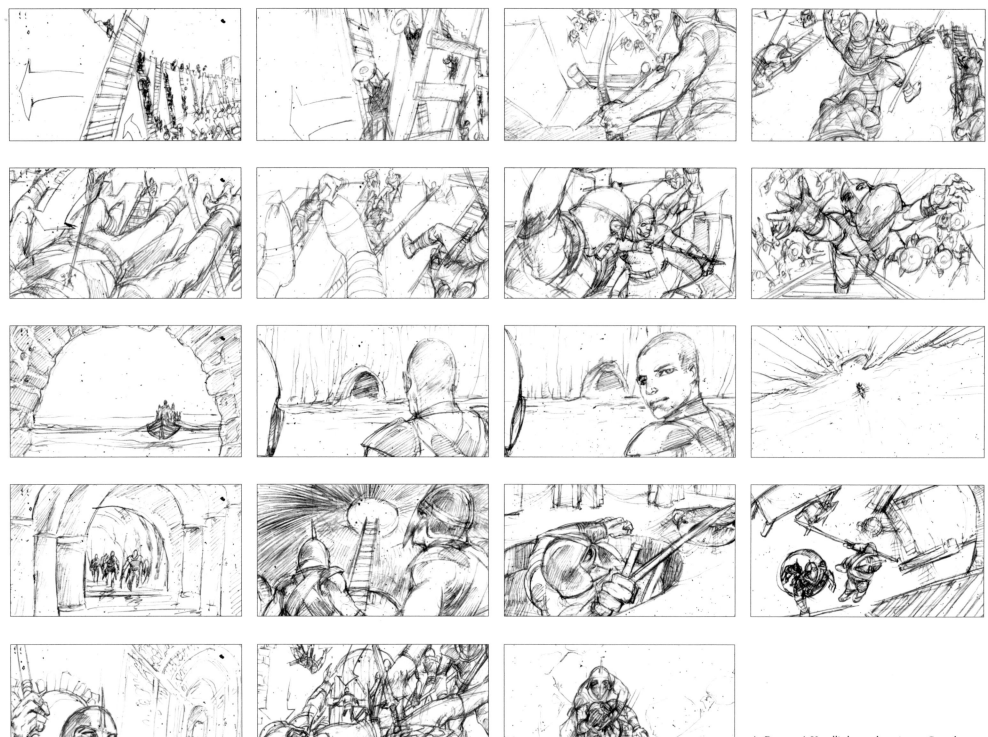

As Daenerys's Unsullied army lays siege to Casterly Rock, Grey Worm and a small company of his men row to a storm drain on the side of the island.

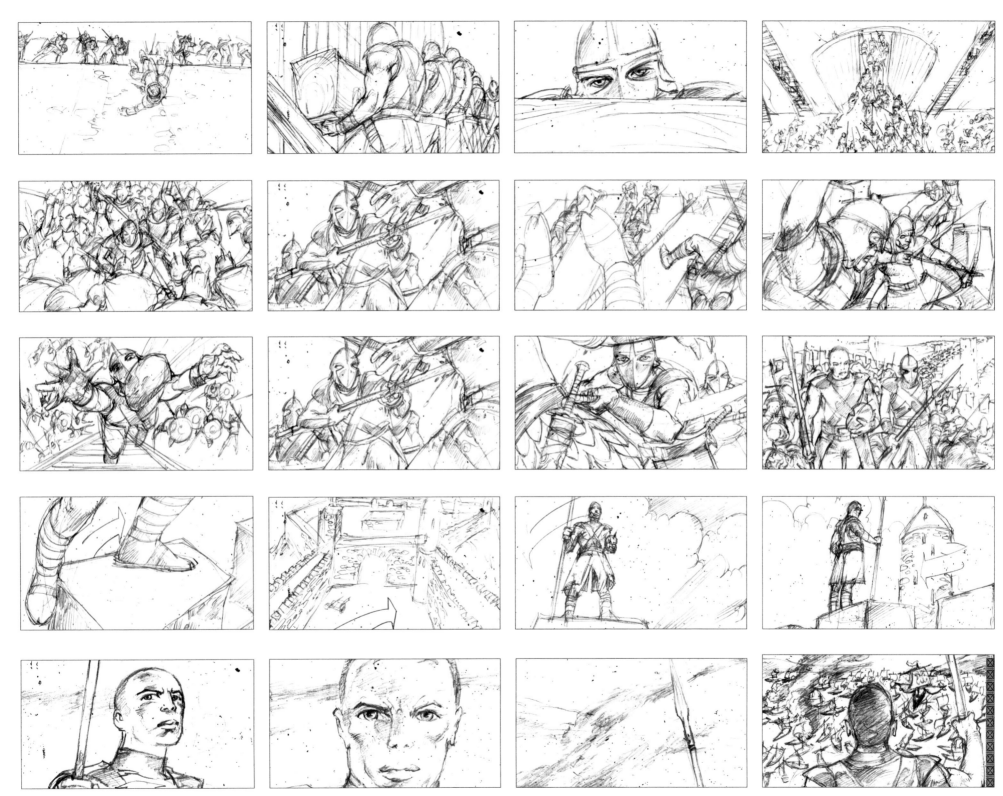

After taking Casterly Rock for Daenerys, Grey Worm climbs to the parapets. In the waters beyond, he sees Euron Greyjoy's Iron Fleet setting Grey Worm's boats on fire. This was all a trap. The main corps of the Lannister army is elsewhere.

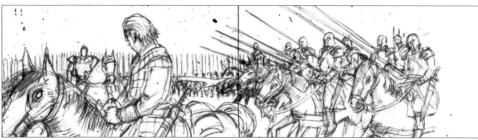

In a brilliant strategic move, Jaime allowed Daenerys to take Casterly Rock so he could launch a surprise attack on the fortress of House Tyrell.

From her Highgarden balcony, Olenna, the matriarch of House Tyrell, watches the Lannister army approach.

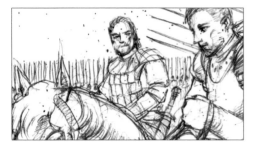
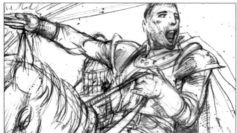
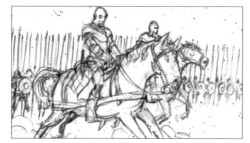

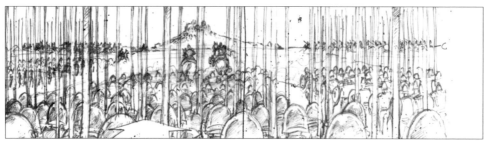

On a cliff at Dragonstone, Daenerys watches her dragons in the skies. Jon Snow approaches her, mentioning that the creatures are an amazing thing to see.

During their conversation, Daenerys agrees to Snow's request to mine dragonglass from Dragonstone and forge weapons from it, along with any resources or men he needs.

Episode 706
Beyond the Wall

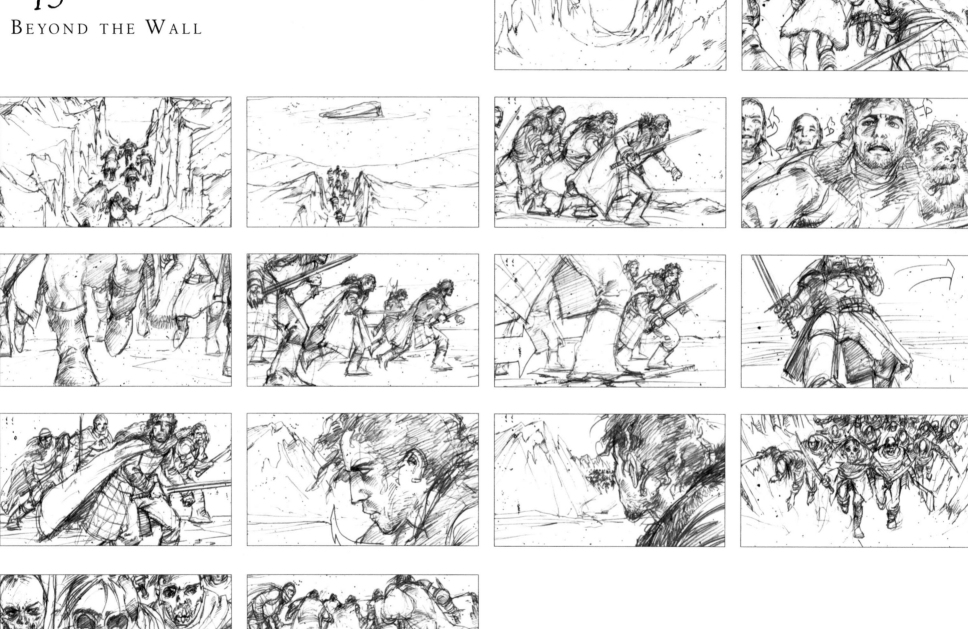

Questing in the North to bring back a wight to King's Landing, Jon Snow and his small company cross paths with the army of the dead.

Wights chase Snow and his men to a frozen lake.

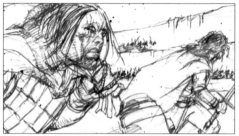

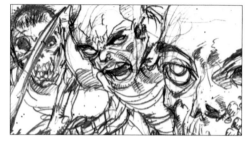

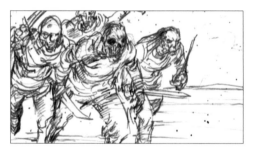
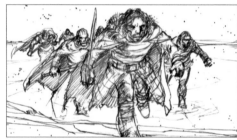
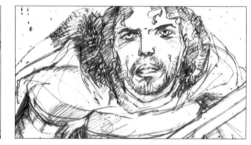
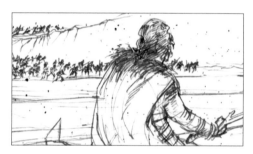

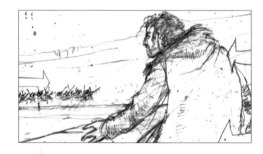

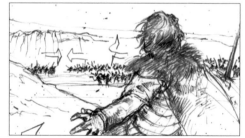
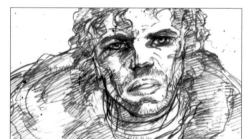

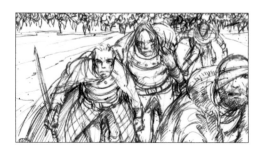

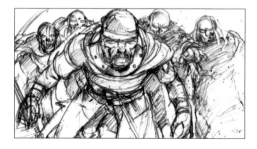

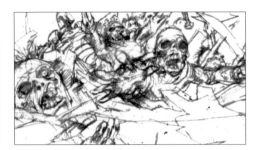
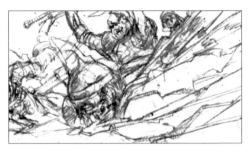

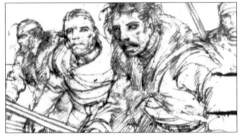
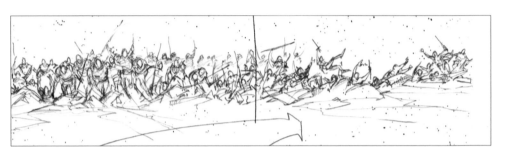

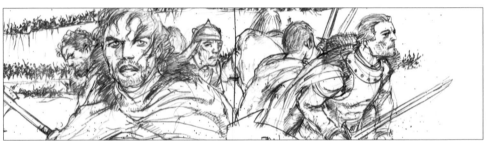

The ice breaks under the heavy weight of the horde, stranding Snow and his group on an island in the middle of the lake. More and more wights converge on the lake, encircling Snow's band. All Snow can do is wait and hope Gendry made it back to the Wall to alert Daenerys by raven.

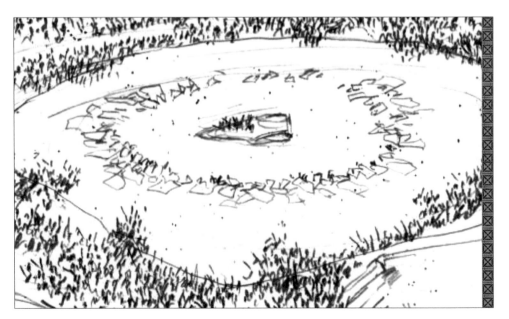

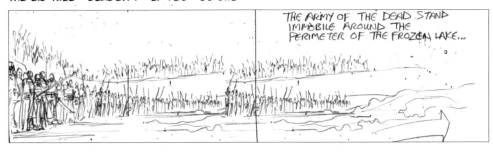

THE ARMY OF THE DEAD STAND
IMMOBILE AROUND THE
PERIMETER OF THE FROZEN LAKE...

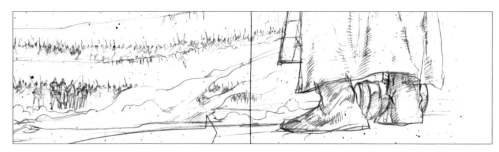

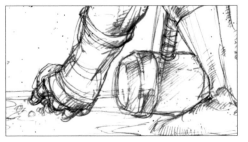

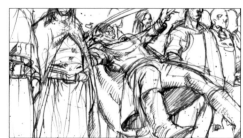

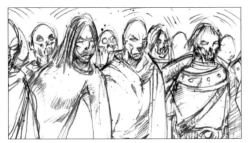

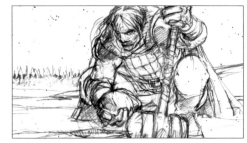

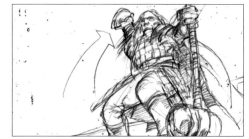

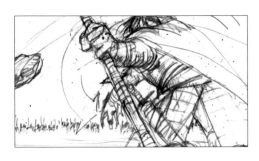

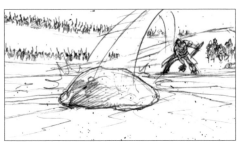

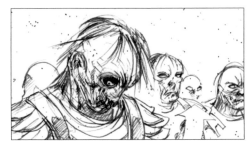

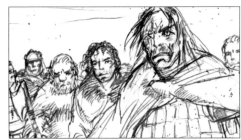

The Hound, bored and frustrated, tosses a stone at the surrounding army of wights.
A second thrown stone lands on the ice and skids, halting near the feet of the army.

The wights notice that the rock didn't break the ice, indicating the lake had frozen
over during the night.

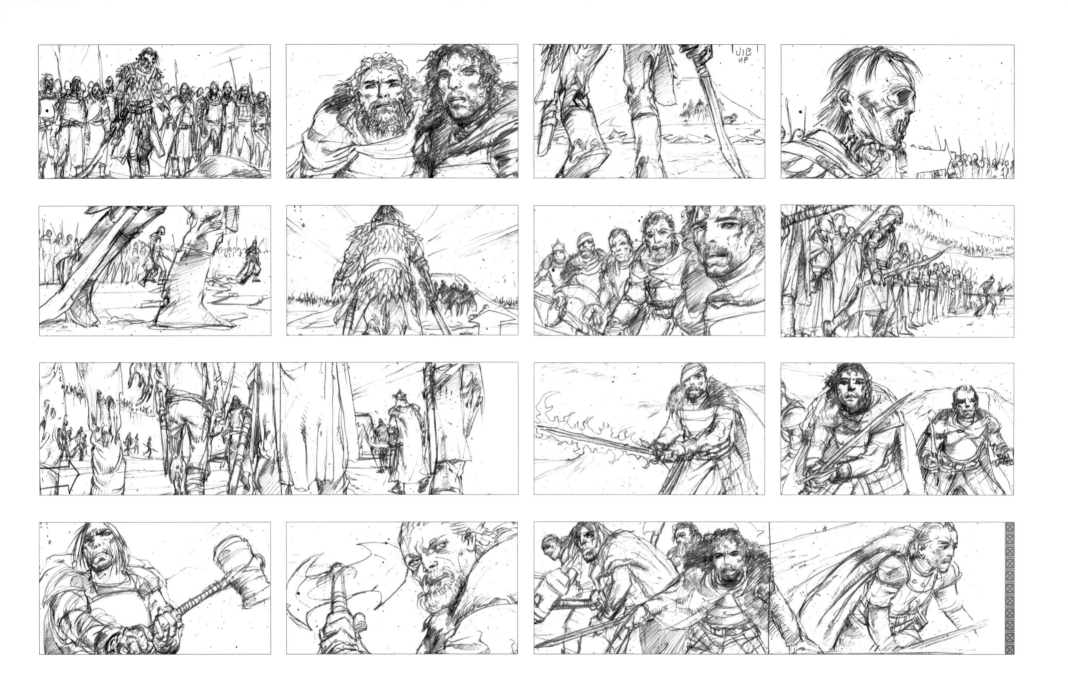

Jon and his companions form a defensive position, ready
for a battle that will surely take their lives.

Episode 707

The Dragon and the Wolf

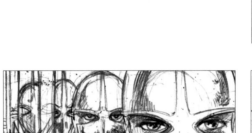
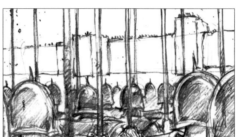
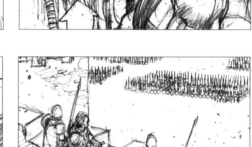

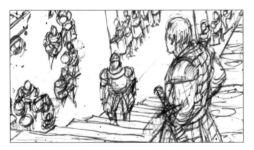
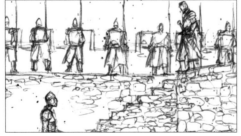

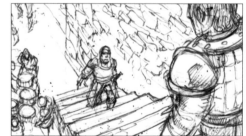
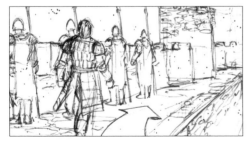

The Unsullied arrange themselves in battle lines outside the walls of the Red Keep.

Bronn doubles the barrels of pitch to be produced to fend off the siege.

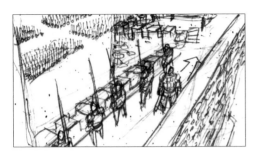

 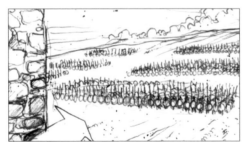

Bronn and Jaime look out at the enemy troops arrayed against them.

 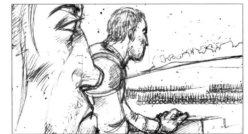

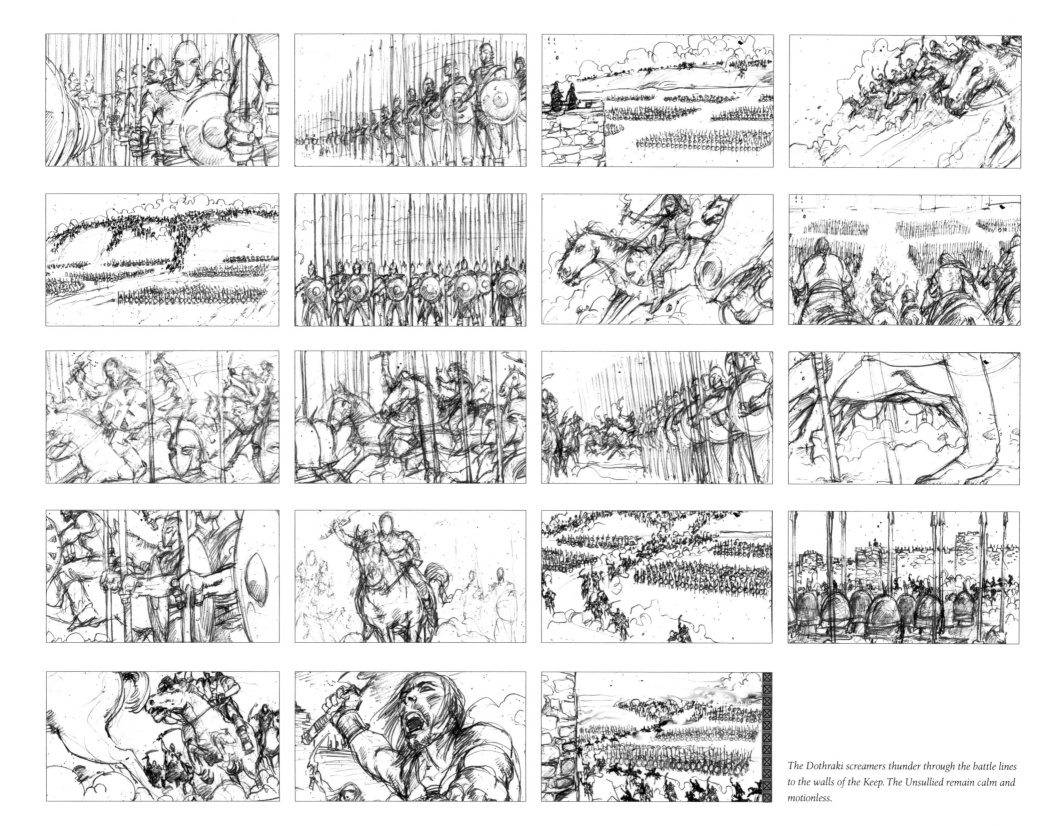

The Dothraki screamers thunder through the battle lines to the walls of the Keep. The Unsullied remain calm and motionless.

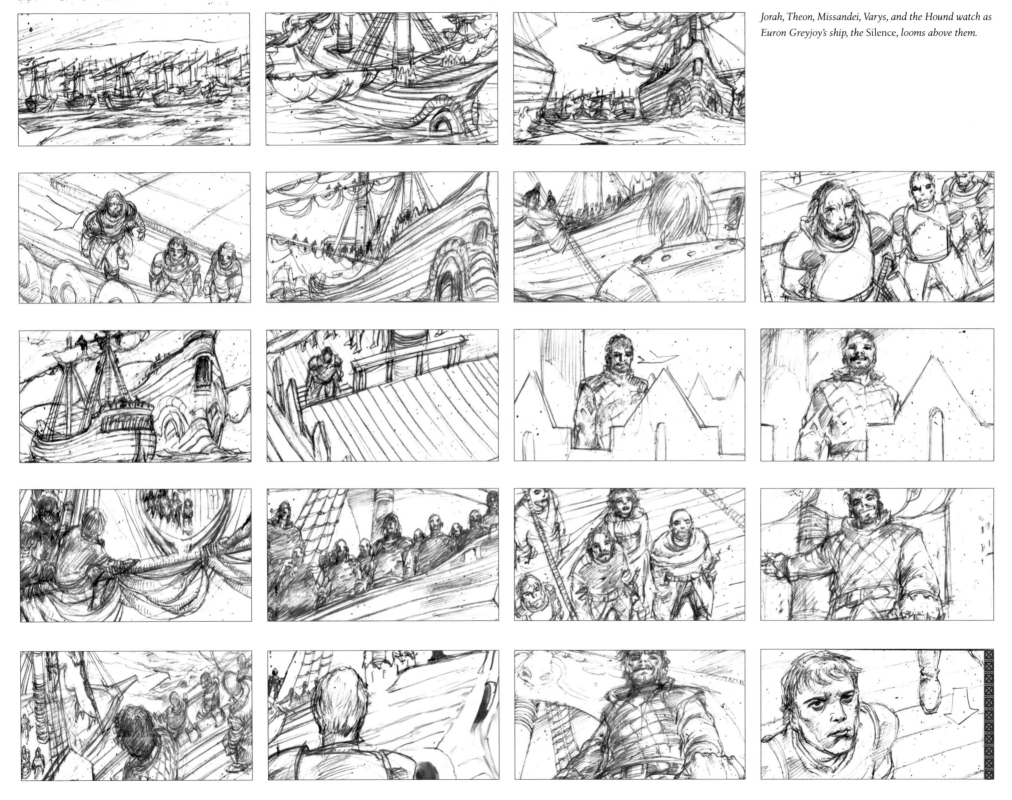

Jorah, Theon, Missandei, Varys, and the Hound watch as Euron Greyjoy's ship, the Silence, looms above them.

GOT 7 – EP 707 – SC 7.10

Tyrion, Missandei, Jon Snow, and the rest of Daenerys's diplomatic mission walks toward the ruins of the Dragonpit in King's Landing. The Hound walks into the Dragonpit with a crate tied to his back.

GOT 7 – EP 707 – SC 7.15

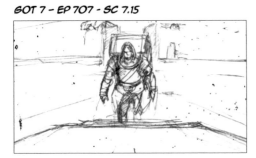
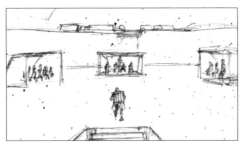
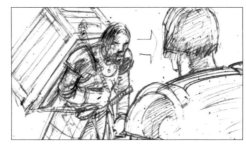

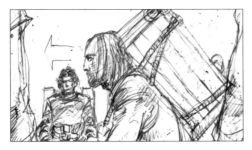
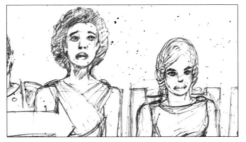

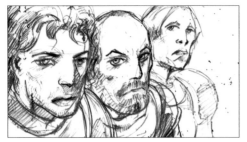
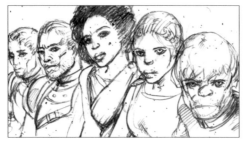
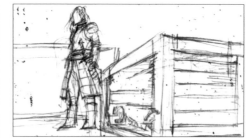

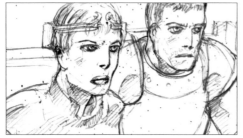
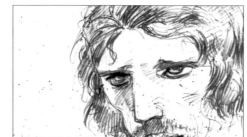
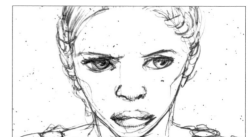

A wight tumbles from the box and charges at Cersei, but a chain holds the creature back from her. The Hound yanks the chain back and cleaves the wight into wriggling parts.

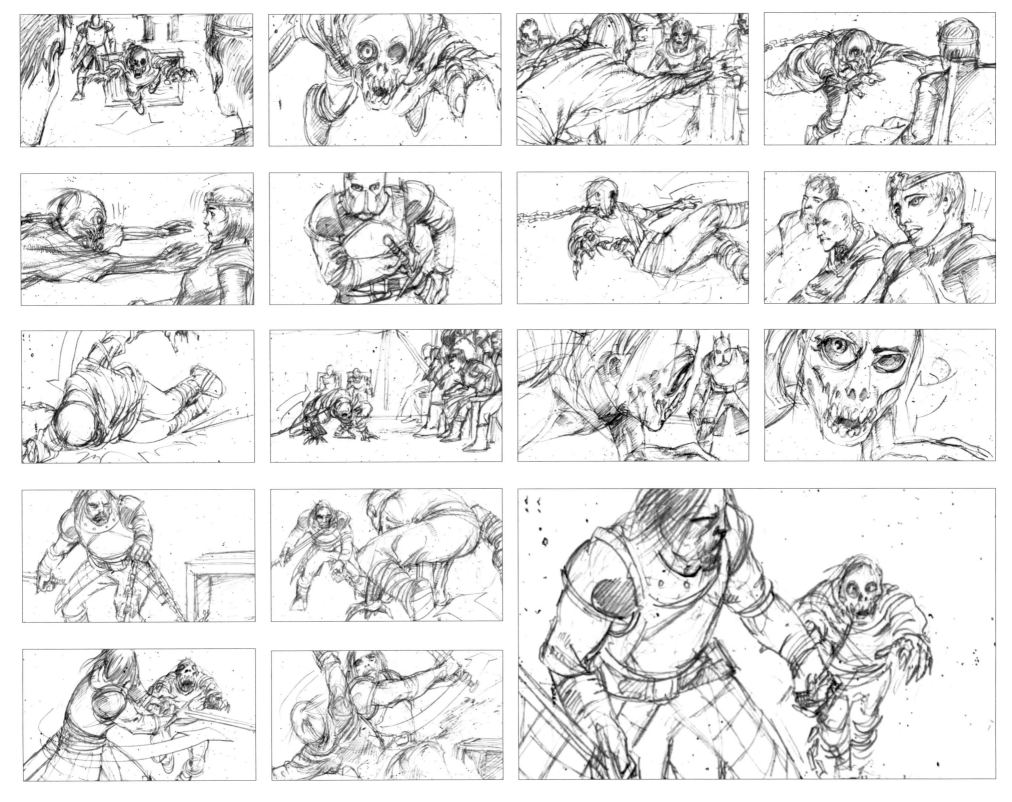

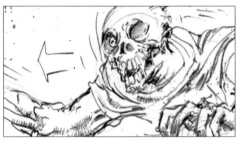
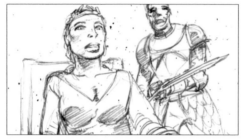

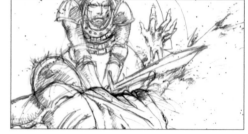

Cersei and Jaime are shaken by the evidence of the wight.

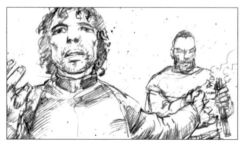
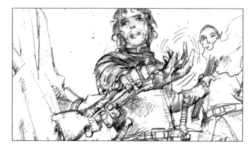
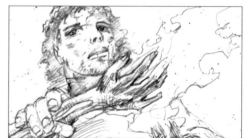

Qyburn picks up the wight's chopped-off hand. Snow lights a torch and demonstrates how either fire or a weapon made of dragonglass can destroy the wights.

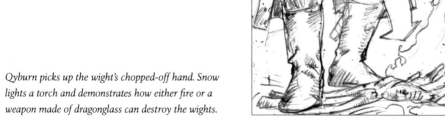

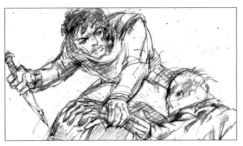
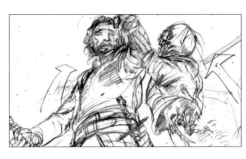
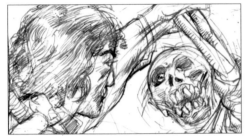
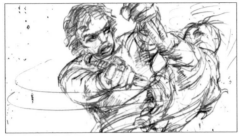

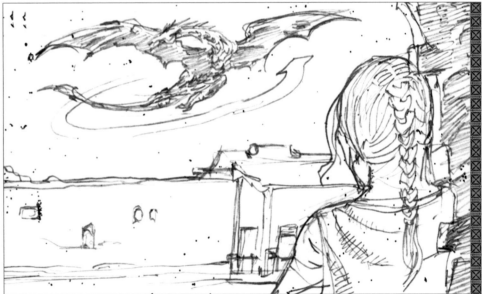

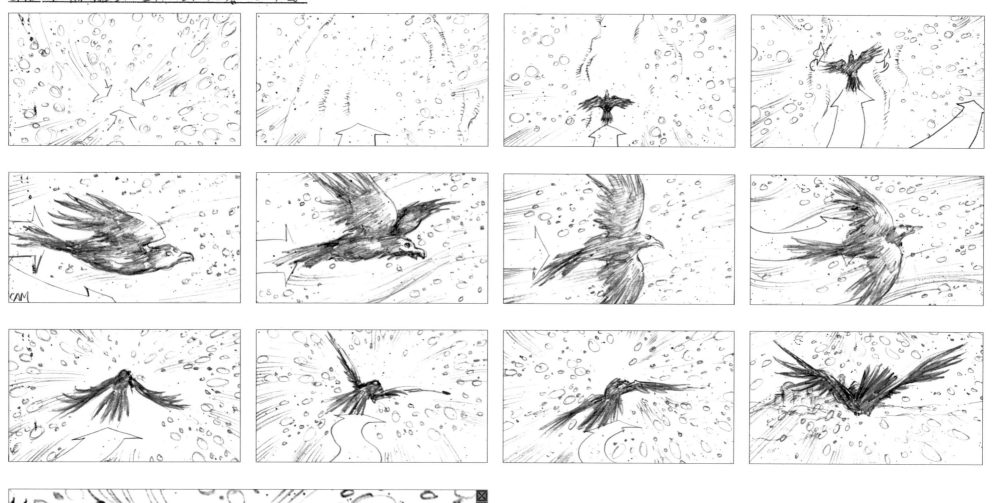

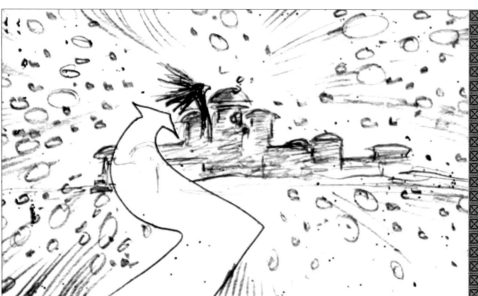

A raven struggles through a blizzard to deliver Jon Snow's message to Sansa in Winterfell.

As snow falls, Jaime departs King's Landing on horseback for the North.

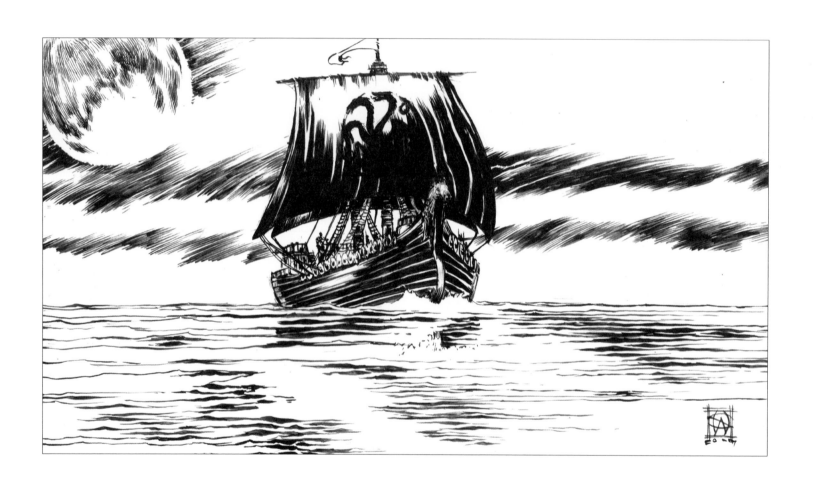

William Simpson got his start as a comic book artist drawing stories about the legendary Irish hero Cúchulainn for a British fanzine, which led to work for Marvel UK, DC Comics, and other top publishers in the industry. He moved into storyboarding for film, television, and animation, and a decade later he joined the crew of *Game of Thrones*, where he could channel his love of the fantasy genre into rich, illustrative storyboards for the series.

Michael Kogge is an author and screenwriter living in Los Angeles. His original work includes *Empire of the Wolf*, an epic graphic novel about werewolves in ancient Rome. He is also writer of the best-selling *Star Wars: The Last Jedi* and *Star Wars: The Force Awakens* junior novels, *Batman v Superman: Dawn of Justice: Cross Fire*, and *Harry Potter and Fantastic Beasts: A Spellbinding Guide to the Films*.

INSIGHT
EDITIONS

PO Box 3088
San Rafael, CA 94912
www.insighteditions.com

f Find us on Facebook: www.facebook.com/InsightEditions
🐦 Follow us on Twitter: @insighteditions

HOME BOX OFFICE.

Official HBO Licensed Product © 2019 HOME BOX OFFICE, INC. All rights reserved.
HBO and related trademarks are the property of Home Box Office, Inc.

Published by Insight Editions, San Rafael, California, in 2019.

No part of this book may be reproduced in any form without written permission from the publisher.

Library of Congress Cataloging-in-Publication Data available.

ISBN: 978-1-68383-616-2

Publisher: Raoul Goff
Associate Publisher: Vanessa Lopez
Creative Director: Chrissy Kwasnik
Designer: Ashley Quackenbush
Senior Editor: Amanda Ng
Editorial Assistant: Maya Alpert
Senior Production Editor: Elaine Ou
Senior Production Manager: Greg Steffen
Production Associate: Eden Orlesky

 ROOTS of PEACE 🌳 REPLANTED PAPER

Insight Editions, in association with Roots of Peace, will plant two trees for each tree used in the
manufacturing of this book. Roots of Peace is an internationally renowned humanitarian
organization dedicated to eradicating land mines worldwide and converting war-torn lands into
productive farms and wildlife habitats. Roots of Peace will plant two million fruit and nut trees in
Afghanistan and provide farmers there with the skills and support necessary for sustainable land use.

Manufactured in China by Insight Editions

10 9 8 7 6 5 4 3 2 1